Make Your Own Algorithmic Art

A Gentle Introduction to Creative Coding with P5js

Contents

Introduction

What's Our Aim?

The aim of this guide is to inspire more people to create algorithmic art - and enjoy doing it!

To do that we'll will gently introduce:

- The key ideas we need to create art with computers - like pixels, colour and shapes.

- How we tell our computers to draw and paint what we want - using a language that computers can understand.

- Cool (but simple) mathematical ideas that help make amazing art - ideas like repetition, randomness, recursion, and even something called chaos!

We'll avoid lots of technical jargon and unnecessary equations. We won't assume you know lots of maths already, and you don't need to have programmed a computer before at all.

We'll keep things friendly and informal, start from the very basics and gently build up from there, taking every opportunity to explain ideas visually and with lots of examples.

We don't want to leave anyone behind!

If you work your way through this book, by the end you should:

- Be able to code confidently, and with enough knowledge of coding for it never to be a barrier to any creative ideas you have.

- Have a good feel for a good range of algorithms and mathematical ideas that can be used to create really interesting visual forms.

- Have had some hands-on experience of the process of creating algorithmic art, from creative inspiration, experimenting and learning from failure, using mathematical tools to solve problems, and refining a work to finalise a good composition.

Who Is This Book For?

This book is for anyone who is interested in art, computing or maths and wants to see how they combine to create beautiful things!

This book was written for three communities in particular:

- Artists who have never coded before, and want to take their first steps.

- Technologists who may be able to code and want to explore their own artistic creativity.

- Teachers seeking a visual approach for teaching programming and algorithms.

If you're a student of digital art, you will find this book helpful to get you started and confident with coding, before progressing onto more advanced topics in your course.

How We'll Work, And How We Won't

This book is firmly aimed at beginners. For that reason, this book won't go fast, and it won't try to be too concise.

We'll introduce each new idea with a nice friendly chat, and use lots of pictures, analogies and examples. Many of us prefer to learn visually, not by staring at a page of text.

As we discuss a topic, you'll be encouraged to experiment with the examples and ideas we come across. This hands-on work is really important. You can't become a good artist without practice and without trying new things. The same is true for coding. We learn by breaking things, seeing what works and what doesn't.

After each new idea, we'll work through a small example project illustrating how that new idea can be used. We'll include all the steps and preparatory work, often unseen, to really understand and experience how a work of algorithmic art is created.

Also, this isn't a reference book. We won't try to talk about everything related to coding or algorithms. It's a practical guide to get you started with algorithmic art, and give you enough confidence to explore and continue learning, making use of the great online resources and references yourself.

There's one area of algorithmic art that we won't cover in this book, and that's animation. Animation isn't best explained in a book where the images on the page don't move. We'll cover animation topics on the blog that accompanies this book.

Digital Art for A Digital Age

Over the centuries, as new materials, new science and new philosophical ideas have emerged, artists haven't been shy about adopting them. This digital age is no different.

Every aspect of our lives is massively and increasingly permeated by code, data and algorithms. It would be increasingly impossible to avoid using these to create the art of our time. And artists

are increasingly using code, data and algorithms as their new tools and media. Some even consider their algorithms as art, as their new means of expression.

Even if you're not so interested in all that philosophical stuff, creating art with code, data and algorithms is fun and exciting in ways that traditional art isn't.

Programming? Processing? P5js? Coding?

If we want our computers to create art for us, we need to talk to them so we can tell them what we want. We need to use a language that they can understand precisely and without ambiguity. These languages are called **computer programming languages**. We can't use our own languages like English or Spanish because they're not precise or unambiguous enough.

Processing is the name of the programming language that was designed to make creating art with computers easy. And it worked. **Processing** has grown in popularity amongst algorithmic artists, designers, creative technologists, and is increasingly taught in art schools and universities. Because it's so easy, and so visual, there is growing interest in using it to teach children to program computers and to think algorithmically.

p5js is a version of **Processing** designed to work on the **web**. A web browser on a computer, laptop, tablet or smartphone is all that's needed to view and interact with art created with **p5js**. That's a powerful thing, because your audience could be any one of the three billion people on the internet all over the world.

In this book we'll not be too strict about distinguishing **Processing** from **p5js**, but whenever something is unique to **p5js** we'll say so.

Coding is just a modern term for programming. Decades ago scientists **programmed** the computers that controlled space flight. Today artists do creative **coding**. It just sounds fresher!

Open Source Culture

All the software we'll use is **open source** - which means it is free to get, change, and share. For most people this means there is no need to pay for it, a great advantage if you're a student on a budget, or keeping an eye on costs teaching children to code.

More than just being cost-free, open source is a culture. It's a culture of sharing what we're working on, encouraging others to use it, being generous with our skills and honest about things that don't work so well so others can have a go. The open source movement has created some of the world's best and most important technology - and all available to anyone without being asked to pay.

We'll also be making our art available on the web. The web is the most open and widely accessible exhibition space in the world, open to people from many cultures and backgrounds,

using their own choice of technology to experience our creations, be that a cost-effective laptop or a convenient smartphone.

All the art that we create in the book, together with the code to make it, will be freely available on the internet for anyone to see, share and experiment with themselves.

Author's Note

You can join in and discuss your questions or ideas online. A blog accompanying this book, which also covers additional topics and questions raised by readers, is at:

- https://makeyourownalgorithmicart.blogspot.co.uk

You can also contact me by email makeyourownalgorithmicart@gmail.com or on Twitter @algorithmic_art. I'd love to hear about what you're working on, share what you've created online, or talk about any problems you're having with this book, coding or art in general.

And I really encourage you to join in with a local group interested in algorithmic art. Having a community around you is part of the amazing experience of creating art with code. And if a group doesn't exist near you, go along to a related computing or art group and recruit friends to start your own movement!

I run the mostly London based Algorithmic Art meetup, where you're always welcome to come along, share what you're working on, find out what others are doing, and make new friends.

I will have failed as a teacher if any reader feels left behind because something in this book wasn't explained well enough. So do get in touch if this happens!

Have fun!

Tariq

Prologue - Algorithmic Art?

The best way to understand what we mean by **algorithmic art** is to see a simple example in action.

Let's jump right in. Imagine building a pyramid out of small blocks, just like the ones many young children play with.

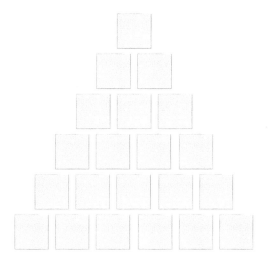

Easy enough. Now let's write numbers on the blocks. We'll start by writing a **1** on all the bricks that lie around the outside edge. We'll leave the inside bricks alone for now.

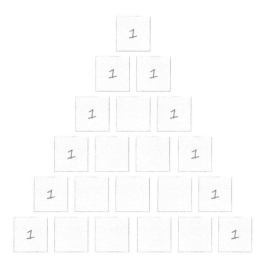

Again, that's easy enough. Let's now fill in the empty bricks. Looking closely at any empty brick, we can see that two other bricks rest directly on it. To fill in a brick, let's add together the numbers in those two bricks above it.

For this to work, we'll need to start at the top. Looking at that pyramid again, we can see the top-most empty brick. Above it are two bricks with the number **1** in each. Adding those two numbers together gives us **2**, so that's the number we'll write in the empty brick.

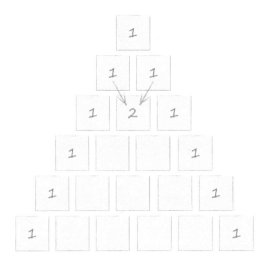

That's not so difficult. Filling in that empty brick means we can start to fill in the empty bricks in the row below it. That new **2** and the **1** next to it add to make **3**, which we can write into the brick directly below.

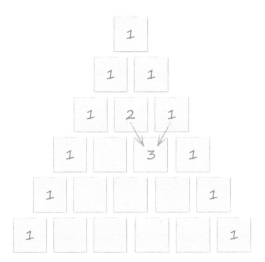

You can see that we can continue filling in the empty blocks in this way, moving further down the pyramid.

Here's a pyramid with all **6** rows completed.

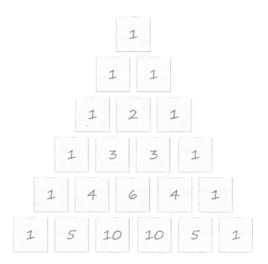

Now we'll do one last bit of easy maths. Looking at all those numbers in the pyramid, let's colour, with a darker shade, those bricks which have an **odd number**. Odd numbers are **1**, **3**, **5**, **7**, **9**, **11** and so on.

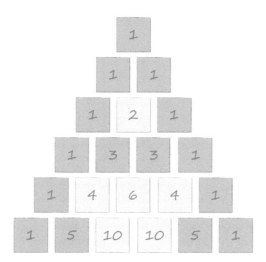

That's starting to look interesting. There seems to be a pattern emerging. Squinting our eyes makes the pattern look like a letter **A**.

What does that pattern look like if we our pyramid had **8** rows?

That's even more interesting. It looks like the overall triangle has three smaller triangles inside it. How did that happen? All we're doing is colouring in the odd numbers after adding lots of numbers together.

Let's keep going. Let's try a pyramid with **16** rows. That's a lot of work adding numbers and colouring in the odd ones. Luckily, we can get computers to do all that hard work for us, which we'll learn how to do in this book.

Things keep getting more interesting. That big triangle now seems to be made of three of the triangles we just saw, each one of which is made of even smaller triangles.

Is there something actually creative inside mathematics that we've just exposed? Perhaps a secret that's hidden from us when we learn about mathematics at school?

Let's be ambitious and jump straight to a pyramid with **512** rows. That involves an incredible amount of work adding up the numbers and colouring all the odd ones, but computers don't mind lots of work and they're very quick at doing it.

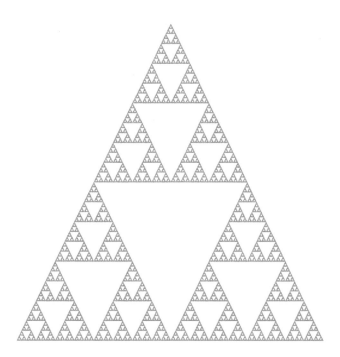

That is a really intricate pattern. It seems to be made of triangles within triangles, and those triangles within other triangles. We could explore that detail for quite a few moments. Stepping back and looking at the image afresh, we might notice the white triangles instead of the red bits. Those white triangles seem to have smaller white triangles on their edges, and in turn, those smaller triangles have even smaller ones on their edges.

What we've just seen is a **recipe** of mathematical steps, known as an **algorithm**, create a rather sophisticated pattern. And that is the foundation of **algorithmic art** - forms created by a carefully chosen series of mathematical steps.

Appreciating the contrast between the simplicity or elegance of an algorithm and the impact of the resulting image, is an important way of appreciating algorithmic art.

That also means we can't fully appreciate **algorithmic art** if we can't appreciate the **algorithm**. Whenever we share algorithmic art, we should also share the algorithm.

Part 1 - First Building Blocks

In Part 1 we'll learn about the basic building blocks we can use to create our art - shapes, colour, arrangement, and repetition.

Before We Get Started

To get started we need somewhere to work. Somewhere we can put our digital canvas, on which we can make our marks. Somewhere we can write instructions to our computer to tell it what marks to make, what colours, which shapes, their position, and how many.

In the past this would have meant having to learn some boring technical stuff before we could get anywhere near being creative.

Luckily, today we can avoid all that technical gubbins because there is a great free online service called **openprocessing**. It's just a website like many other websites we use all the time. The great thing about it is that it lets us experiment with code and see the visual results without needing any additional software or complicated steps. It's as simple as typing in some code - just like we might type an email - then pressing a button to see the results. You'll love it!

We need to register an account with **openprocessing** so let's do that first. Go the website which is at https://www.openprocessing.org.

You should see something like the following web page - the actual artwork might be different when you do it.

There's a red button called **Join**, which we need to click because we want to become a member. You'll be taken to a new page which has a form asking for your details. The following shows me filling in the form as if I was called Jane Smith, just to show how it is done - use your own name and details.

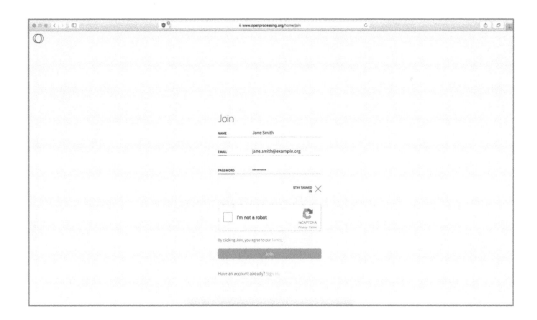

You may be asked to prove you're not a robot by ticking that box and answering some questions.

The important details are the email address and the password, because you'll need these details to sign into **openprocessing** in future. Clicking **Join** takes you to your own fresh personal **openprocessing** page, which looks like the following.

You should see your own name in big letters, instead of Jane Smith.

We've now successfully joined **openprocessing** and created our own account. Great job!

One more small step before we're ready to start making art.

Click the big button in the middle labelled **Create a Sketch**. You should now be taken to the place where we'll be doing much of our experimenting and learning. It should look like the following. Don't worry if it looks overwhelming, we're only interested in three things on that page.

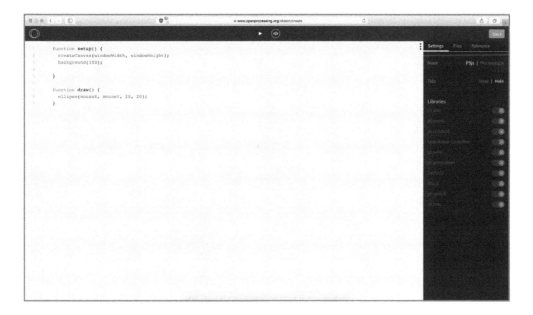

The main thing we see is a big white area with some strange coloured writing in it. Ignore that stuff for now. We only need to know that this white box is where we will be writing our own instructions to our computer.

What else do we see? Near the top, in the middle, you can see what looks like a **play** button, the kind you see on audio or video equipment. That button is what "plays" the instructions that we have typed into that white box.

What would happen if we pressed that play button? Well, it would run the code that's already there. And **openprocessing** has been helpful enough to have some example sample code just to help us check everything is working ok. We won't try to work out what it does right now - we're just interested in testing that the play button works. So let's click that play button!

Boom! Something happened. The page is now changed to a mid-grey colour. And if you move your mouse pointer over that area, you'll see that it leaves a trail of little white circles. Cool!

You should see something like the following. Your own pattern will be different.

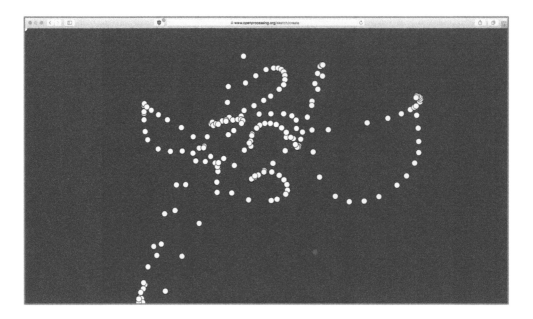

If that worked, it means we can successfully get our computer to take those instructions, and act on them.

Don't worry if you don't know how or why that worked. This is just a test to check the various bits of technology involved do actually work. We have the rest of this book to learn about those computer instructions and how they made those circles.

Time for a bit of terminology. Many people now call computer instructions **code**. And they say that the code is **run**, rather than executed, which sounds much less scary! So, we've successfully **run** that **code**!

One more button to look at. The play button has changed to a different symbol, which some people would recognise as a **replay** button. It just means "run the code again, from the beginning". That's really useful if we're experimenting and repeatedly changing that code.

But how do we see our code again? We click the button next to the replay button, which looks like two angle brackets around a forward slash. Believe it or not, but that's become a universal symbol for computer code! Clicking it takes us back to the code view.

Great! We've got ourselves up and running, and ready to code. That wasn't so hard.

Here's a picture showing the two buttons and code area again, just to show there are only three things we need to know about on the **openprocessing** page.

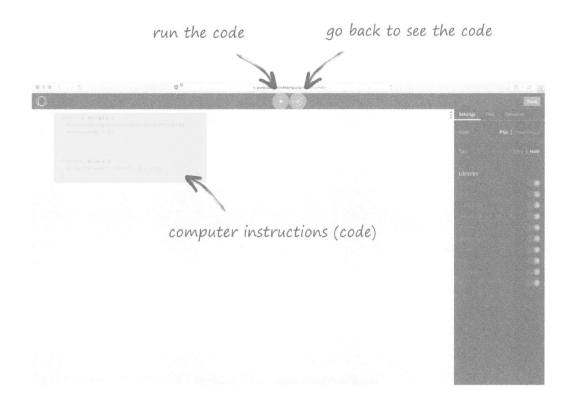

run the code go back to see the code

computer instructions (code)

First Things First - A Canvas

Before we can create any art we need a **canvas**, a place to put our marks, colours, lines.

If we were about to start a painting, that's what we'd set up first - a canvas. Of course, if we were using charcoal or watercolours, we'd probably use some kind of paper or card, but the idea is the same - we need to choose a surface to work on.

If we were getting a friend to make or buy our canvas for us, what would we ask for? How would we describe the canvas we wanted?

Well, we want the canvas to be of the right size. That means telling our friend the width and height of the canvas that we want. We don't want it to be too tall or too wide. We want it to be just right.

It's no different when we create computer art. We need to somehow tell our computer what size the work area needs to be.

If we think about it for a moment, we need to somehow pass two bits of information to our computer. These are the **width** and **height** of the canvas. These will just be two numbers. That's all we need to determine the size and shape of the canvas.

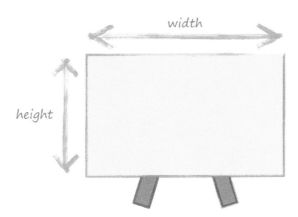

If we wanted our computer to create a canvas of width **10 cm** and height **6 cm** we would need to somehow pass the numbers **10** and **6** to the computer. Yes, I know that's a tiny canvas for painting on!

I can't just type **10** and **6** into my computer's keyboard and hope it knows what these numbers mean. Perhaps I'm asking the computer to buy **10** bags of flour and **6** bottles of milk? Perhaps I want my computer to sing those numbers back to me? Computers can't read minds ... yet.

We need something more that helps our computer to know what these numbers mean, and what to do with them. If someone walked up to you and simply said "ten, six", you wouldn't know what on earth they meant or what they wanted you to do. You might also think they were a bit strange and want to run away.

Those numbers need some kind of context. If someone walked up to you and said "please buy me a canvas of width **10 cm**, and height **6 cm**", you would understand that perfectly. So we need to tell our computer these numbers describe a canvas, and that it should interpret them as the width and height.

We could type "please create me a canvas of width **10 cm** and height **6 cm**" into our computers. But it wouldn't work. Computers don't speak English like we do. English is too imprecise, ambiguous and full of difficult things like local expressions and humour that computers just can't understand. They're getting better - you can ask your smartphone interesting questions with your voice and it'll understand what you want fairly well. But we need our computer to understand us precisely, correctly, and consistently every time.

That's why we use special languages when talking to computers. **Computer languages** are precise and very strict compared to how you and I might talk in English. There is no room for ambiguity or misinterpretation.

Processing is one computer language, and it's the one we're going to learn a bit about, because it's good for creating art. There are other computer languages that you may have heard of, like Python, HTML or C. They're all good at different kinds of tasks. Choosing one is just like choosing the right tool from a toolbox for your home improvement project. But don't worry if you've never heard of a computer programming language before, many people haven't.

Enough computer theory! Let's get back to making art.

Canvas Size

Let's set ourselves a small puzzle. Have a look at the following code:

```
createCanvas(10,6);
```

What do you think it does?

There are quite a few clues in that line. That funny word **createCanvas** gives us a huge clue. It creates a canvas. That was easy!

Processing instructions, or commands, have names which give us huge clues as to what they actually do. This is really helpful to us humans. Computers themselves don't really mind what these instructions are called as long as they're consistent.

What about the two numbers **(10, 6)** in brackets next to the word **createCanvas**?. Well, we've just been talking about how we tell our computer what size of canvas to create. We said we can't just type those numbers at the keyboard, or shout them out loudly and slowly. We have to have a proper way of telling our computer that they are the **width** and **height** of the canvas we require. And that's how we do it - by passing that information inside brackets next to the instruction that they relate to.

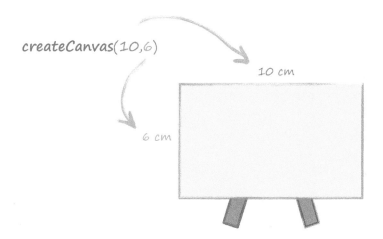

Phew! Well done for making it through that last paragraph!

Let's look at two more examples just to really make sure we're comfortable with these new ideas.

What do you think the following Processing instruction does?

```
createCanvas(5,10);
```

Well, it creates a canvas because that's what **createCanvas** does. We've already seen that. What about the next two numbers in brackets. We've seen how we can ask for a particular size of canvas by passing the width and height in brackets to the **createCanvas** instruction. But which is which? Is **5** the width or the height?

Previously we had the first number representing the width, which was **10**, and the second number was the height, **6**. So here we must have a width of **5** and a height of **10**. The order of those numbers matters. The first number is always the **width**, and the second is always the height. Remember, we said computer languages avoid ambiguity, and these order rules help keep things unambiguous. This new canvas is taller than it is wide, like a magazine, or paper for writing a formal letter.

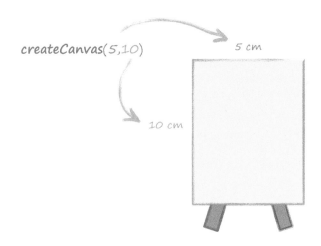

What about the next bit of **code**?

```
createCanvas(800,600);
```

The numbers here are much bigger. Are they too big? Did those numbers mean centimetres, or metres, or kilometres? The answer is none of these. Those numbers are **pixels**.

Pixels? If you look very closely at your computer or smartphone screen, you might be able to see tiny little squares. Everything on your screen is made up of pixels - lots of tiny little coloured squares that create the illusion of an image on your screen.

The following shows how an image of an apple on a computer screen is made of tiny coloured square pixels.

You'll see similar dots if you use a magnifying glass to look at printed newspapers or magazines. These days, the pixels are so small they are really hard to see, and this makes for a much smoother display for images and text. In the 1980s, home computers and video games had screens where the pixels were quite large and actually visible. Today, some computer artists deliberately create designs that mimic that 1980's vintage feel by using large square pixels!

So are **800** pixels too many for an art canvas? Now that we know the number means pixels, and that pixels are actually quite tiny, we can guess that **800** pixels isn't actually very big. Your laptop screen is very likely to be **1280** pixels wide. Recent laptops squeeze even more pixels into the display area. That means an **800** by **600** canvas probably fills about a quarter of your screen size, so not that big really.

You've probably had enough of the theory now and want to crack on and create a canvas. We're nearly there, just one more new concept to think about - colour.

Canvas Colour

We talked about creating a canvas, or asking a friend to buy one, but we forgot to mention what colour the canvas should be. I guess we just assumed it is going to be white, or some kind of off-white pale colour, because that's what most canvases are. What if we had asked for watercolour paper, or card for charcoals? We might want a work area that's a specific colour. Myself, I like doing charcoal life drawing on a mid-grey paper, or ink drawings on pastel coloured card.

How do we ask the computer to create a canvas with a specific colour? Well, we know the instruction should be intuitive, the word or words used should be a good clue about what it does.

Here it is:

```
background('pink');
```

That shouldn't surprise us at all. The instruction is **background**, because we're setting the background colour that will sit behind any shapes or strokes we might apply later. That was really rather easy!

You can see brackets after the **background** instruction, and we know from before that these are used to pass additional information to the instruction. In this case we're passing the colour we want for the background. Even the code for the colour is intuitive, **'pink'** is pink! Don't worry about the quotation marks around the word pink for now, we'll look at that later.

How would we choose a different background colour? It's not hard to guess that we change that **'pink'** for another colour. The following shows what happens if we chose **'yellow'** or **'lightgreen'** instead of **'pink'**. The results aren't surprising, and that's a good thing.

background('pink'); background('yellow'); background('lightgreen');

You've probably spotted another bit of grammar - the **semicolon ;** at the end of both the **createCanvas** and the **background** instructions. They're needed to signal the end of a single instruction, after which there may be more. They're just like full-stops in English, placed at the end of sentences, and helping us keep separate sentences apart. That's what the semicolons do - they mark the end of an instruction, and help our computer keep different instructions separate from each other.

What We've Learned

That was quite a lot of discussion about creating a canvas. We needed to have that because we learned about some important basic concepts that we'll use again and again as we progress.

In the next section we'll actually make a canvas, not just talk about it.

Here's a reminder of the key points we've learned so far:

Key Points

- We need to communicate with computers using special languages called **computer programming languages**. Unlike human languages, like English or German, these are very strict in their grammar, and very precise, unambiguous and consistent in their meaning. **Processing** is the name of the programming language designed for creating algorithmic art.

- **Processing** instructions are usually words, or combined words, chosen to give us a big clue about what they do. So **createCanvas** .. creates a canvas, and **background**, sets the background colour, neither of which is a surprise.

- We sometimes need to pass additional information to a processing instruction, like the width and height of a canvas we want to create. These are passed to the instructions by placing them in round brackets () attached to the instruction.

- Computer displays are made up of a grid of small coloured squares, called **pixels**. This is true of big monitors, laptop screens, smartphones and tablet displays too.

Creating A Canvas With Code

We've talk a lot about how we might create a canvas, ready for making marks on. We talked about how to make sure it was the right size and shape, and also the right background colour. Let's now stop talking about it and actually make one.

Log into **openprocessing** and create a new sketch like we did before. You'll see sample code already created for you. If you remember running this code, it created white circles that followed the mouse pointer around.

Use your pointer and keyboard to change the existing code so it is like the following. You'll need to type this carefully so it is exactly as it is here. Even the capital letters must be correct. Notice how **createCanvas** has only one capital letter **C** and it is in the middle, not at the beginning.

```
function setup() {
  createCanvas(800, 600);
  background('pink');
}

function draw() {
}
```

You could copy and paste the code, but honestly, you won't learn as effectively. Typing in code when we're beginning to code helps us learn because it is a physical activity, and it is slow enough for us to consider what we're typing, and to see patterns in the code.

You should be seeing something like this:

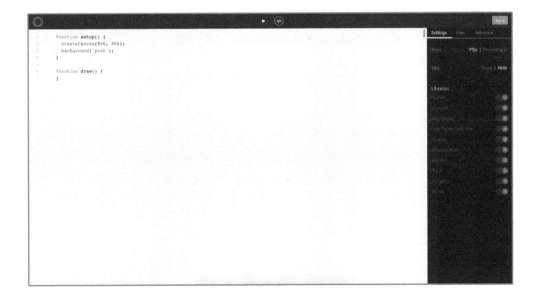

If you click the run button, the one that looks like a music play button, to execute all the instructions, you should see a blank pink canvas. Here's what mine looks like.

Yippee! We ran our first code … and we created a real canvas. It's even got the correct colour!

I've shared my copy of this code on **openprocessing** so anyone can see the code, the resulting canvas, and have a play with the code themselves. Openprocessing calls these saved works **sketches**. This sketch is here: https://www.openprocessing.org/sketch/445984.

Pat yourself on the back, because you've worked hard through quite a bit of reading to get to this important point. It wasn't that hard was it? Your first real code has just been executed, a moment to remember!

Once you've had a moment to breathe and calm down, click the code button to go back to the instructions again. Let's look more closely at that code. What do we see?

The first thing I noticed is that the text is coloured in the **openprocessing** web page. That's to help us understand the code better. As you learn more about Processing you'll see why different bits of text are coloured differently. And the colouring will help you see things quicker, or spot errors too. We can see the **createCanvas** and **background** instructions are coloured green. That helps us recognise these and similar instructions when we're looking at a lot of code. If the colour wasn't green, that might be because there was a typo which we need to correct. Look again and you'll see the width and height information **(800,600)** is coloured purple. That's to help us recognise numbers. The other bit of information was the canvas colour, and this time it is coloured a kind of light brown. It's not purple because **'pink'** is not a number, it's a bit of text.

Another way to think about this colouring, is to imagine that in a piece of normal English text, the words are coloured according to whether they are nouns, verbs, proper names, and so on. The colouring would help you visually and quickly start to understand the sentences.

That helpful colouring is called **syntax highlighting**. You don't need to know that, but it's a cool phrase to throw into a conversation!

What else do we see in that code?

Well, we see two sections. The first section at the top starts with **function setup()** and the next one starts with **function draw()**. The following picture shows these two sections of code.

```
1  function setup() {
2    createCanvas(800, 600);
3    background('pink');
4  }
5
6  function draw() {
7  }
```

What are these things? Every Processing program to create art will have these two sections at minimum, so they're kind of important. So let's talk about each one in turn.

The setup() Section

What do you think the **setup()** section of code does? As we saw before, the name of the instructions often gives us a clue. If we look inside that section of code we see the familiar **createCanvas()** and **background()** instructions. These instructions create a canvas of the right size, shape and colour. So you can imagine that **setup()** is how we set up our environment ready for creating art.

In fact you'd be right. That section of code named **setup()** is called once, at the start, and gets everything ready before any marks or colours are applied. Sections of code that can be referred to by a name are called **functions**. You can see how the code has the word **function** before the name of the function **setup()**. There's a bit more to functions, which we'll come back to later, but this simple explanation will do for now - it's a name for a section of code.

Although we don't do it now, we might set up other things in **setup()**, like pencil thickness, or whether shapes like circles and rectangles should be filled with colour or not.

So to recap, we already saw instructions like **createCanvas()** and **background()**, but now we know that they should be sitting inside the **setup()** function because that's where Processing expects to see instructions for preparing the work environment.

The draw() Section

What does the **draw()** function do? The clue is in the name again. We just saw how **setup()** prepares the work area ready for us to do some drawing. So it's not a massive surprise that **draw()** is a function that contains instructions that do the actual drawing of lines, shapes, dots and other things we can place on our canvas.

But the function looks empty? We haven't learned about making marks on our canvas yet. We'll do that soon.

Hang On! That Canvas Is The Wrong Size?

If you've had your coffee you might have noticed that the code we just ran did indeed create a pink canvas, but it didn't seem to be a quarter of the screen in size. We said before that a size of **(800, 600)** would be about a quarter of the size of most modern displays.

Our pink canvas seems to fill the entire browser window. What's going on? Is Processing ignoring our polite but clear instructions?

Here's the explanation. In normal Processing, a canvas of the right size is indeed created. Here's a sneak peak of the same code running with plain simple Processing, not at **openprocessing**. You can see that the pink canvas is indeed about a quarter of the screen size.

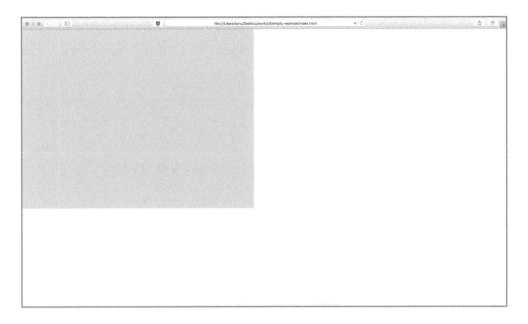

So **openprocessing** is doing something different. Well, it's trying to be extra helpful, by moving the smaller canvas to the middle of the web page, and colouring in the extra surrounding space with the same background colour of the proper canvas.

To show this is really happening, I've placed a white rectangle, the exact same size as the canvas, onto that canvas. You can now see how **openprocessing** has centred the canvas and filled in the extra space on the web page with the same pink background colour.

What We've Learned

We wrote our first code, a special moment on our journey. As we did that we also learned about the structure of all Processing programs.

Key Points

- All Processing programs have two sections, **setup()** and **draw()**.

- **setup()** contains instructions for setting up the work environment, like the canvas size and background colour.

- **draw()** contains instructions for creating the marks that make the actual artwork. These could be lines, shapes or dots.

Our First Shape - A Circle

Now that we have a canvas created, let's create our first shape. A **circle** sounds like a simple enough shape, and is certainly one of the more beautiful of simple shapes.

What do we need to think about before we dive into trying to write code? If we look back to the canvas, we thought about size, shape and colour. That all applies to a circle too. If I asked you to draw a circle for me, I'd need to tell you where I want it to be placed, and how big it should be. I might even tell you how I'd like it to be coloured, and I might even choose a different colour for the outline of the circle.

Let's not get too bogged down by all these options right now, and just look at the very basics. What's the most important thing we need to describe a circle? It's probably how big it is. The following shows three circles of different sizes.

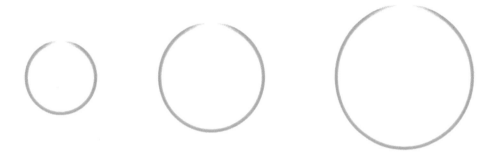

You might remember from school that a good way to describe the size of a circle is to use the distance across the circle through the centre, called the **diameter**. Here are the same circles with the diameter marked for each one. The smallest circle has a diameter of **4**. The largest one has a diameter of **8**. The medium sized circle has a diameter of **6**.

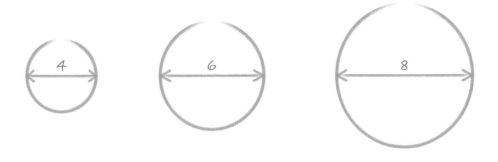

That seems easy enough. The diameter is clearly an important bit of information that we need to tell Processing when we ask it to draw a circle for us. But how do we do that? Remember when we defined the size of the canvas, we included the information inside brackets next to the **createCanvas** command. The same idea applies again.

Do we need to be specific about anything else, other than the diameter? Thinking about it, we realise that we need to say exactly where on the canvas the circle needs to be drawn!

So how do we specify a location? We need to be able to pin the circle to a particular part of the canvas. The easiest, and most common, way is to say where on the canvas the centre of the circle is pinned to. The following picture shows a great big metal pin fixing the circle to the very centre of the canvas we created earlier.

We've been able to define the size of the circle precisely with the diameter. How do we precisely define the location on the canvas where we pin the centre of the circle?

Believe it or not, you probably already know how to specify a precise location on a flat surface:

- You may be familiar with map grid references which specify a location using longitude and latitude. For example **51.509116N, -0.128036E** points to a gallery in London.

- You may be a chess player and know how to specify a square on a chess board using its row and column notation. A popular starting move is moving a pawn to **e4**.

- Perhaps you're more familiar with spreadsheets in your office, where each cell is referred to by a column letter and a row number. You may have calculated a sum to go into a cell called **B5**, for example.

- Most of us used graph or squared paper at school to learn about coordinates, where points were defined by how far along the horizontal and vertical axes they were. You may remember coordinates looking like **(3,4)** or **(1,3)**.

That last method, using graph coordinates, is how Processing works too. Let's remind ourselves what these coordinates are. The following shows our canvas overlaid with a grid of squares. It looks just the squared paper we used in school. You can see how the rows and columns are numbered, with columns being counted along the horizontal direction, and rows being counted along the vertical direction.

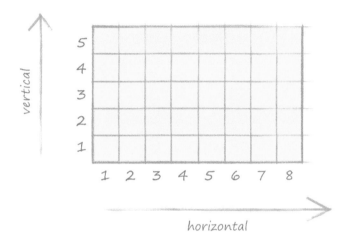

That numbering scheme helps us to easily refer to individual squares. The following shows the same canvas with a red, green and yellow square. You can see that the red square is **3** along and **4** up, or **(3,4)**. Similarly, the green square is **6** along and **3** up, or **(6,3)**.

That's easy enough, but it's good to have a refresher.

If we had a canvas of width **800** and height **600**, like the one we created earlier, then the middle of the canvas should be at **400** across and **300** up, or **(400, 300)**. That is correct but there is a slightly annoying difference with Processing. Instead of starting at the bottom left, like most of us are used to, Processing starts at the top left. It's a hangover from ancient computer systems. The following diagram illustrates this difference.

You can see that the red square is now at **(3,2)** because we're now counting the rows from the top, not the bottom. It's still **3** across.

Let's get back to drawing that circle in the middle of a canvas. We now know that we need to pin the centre at **(400, 300)**, which is the centre even after we start to count pixels from the top left.

So we have all the information we need to precisely instruct our computer to draw that circle for us:

- the horizontal position of the circle centre (from the left, rightwards)

- the vertical position of the circle centre (from the top, downwards)

- the diameter of the circle

See if you can make sense of the following code?

```
ellipse(400,300,200);
```

The first thing we do when we see unfamiliar code is to see if the name of the instruction gives us a clue. We expected a circle but the code says **ellipse**. That's ok, because circles are a special type of ellipse. Ellipses can be squashed or stretched, like a tomato that's been sat on, but a circle is the same size in all directions. It would be nice if Processing had a special

instruction for circles, but its makers stuck with **ellipse**, because circles are a kind of ellipse, just like squares are a special kind of rectangle.

The numbers inside the brackets are the information we have passed to the **ellipse** instruction to describe the circle. The first number, **400**, is the location of the circle's centre along the horizontal direction. The second number, **300**, is the location of the circle's centre along the vertical direction. Remember we're counting down from the top in Processing, not up from the bottom. What's that last number, **200**? That must be the **diameter**.

We've just learned to code our first shape. But before we celebrate, we need to think about where in the code we put that instruction. Does it go in the **setup()** function or does it go in the **draw()** section? You'll remember that the **setup()** function was only to be used for preparing the work environment, the canvas for example, before we did any drawing. The **draw()** function was where the real drawing happens. So let's put it in the previously empty **draw()** section. Your Processing code should now look like this:

```
function setup() {
  createCanvas(800, 600);
  background('pink');
}

function draw() {
  ellipse(400, 300, 200);
}
```

Change your openprocessing code to look like this exactly. When you run it, you should see a circle in the middle of the canvas.

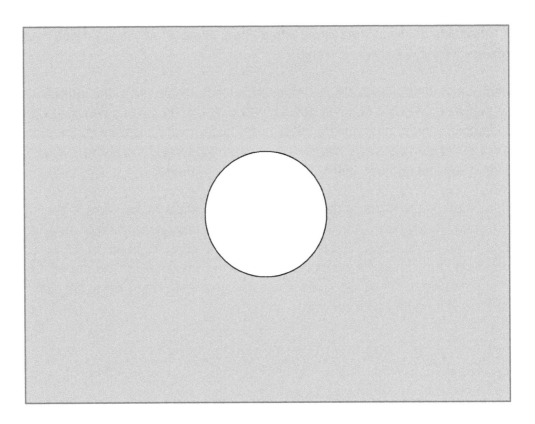

We've just created our first shape, let's celebrate! A beautiful perfectly formed circle of diameter **200** pixels precisely placed in the middle of our canvas.

The sketch for this first shape is here: https://www.openprocessing.org/sketch/445972.

The great thing about code is that once you've done the hard work to create something interesting, you can very easily create more with almost no additional effort. If we copy and paste that **ellipse** instruction a few times, and then change the location and size of each of the circles, we might get code that looks like this:

```
function setup() {
  createCanvas(800, 600);
  background('pink');
}

function draw() {
  ellipse(500, 400, 100);
  ellipse(300, 300, 300);
  ellipse(500, 200, 50);
  ellipse(600, 250, 20);
}
```

The result looks like the following:

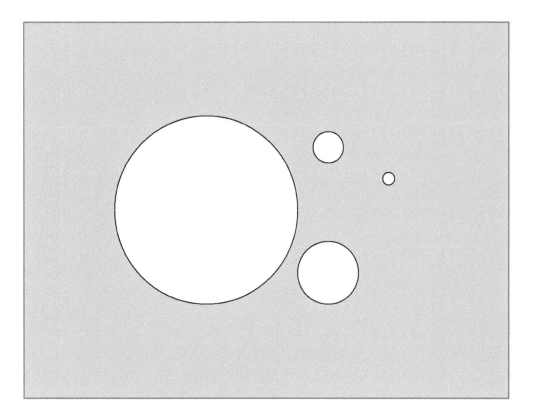

How exciting! With almost no extra effort, and a few well-chosen numbers for the location and size, we've created a rather nice composition!

This is an initial glimpse into the power of using computers to create art. The ease of replicating our initial effort is just the start of the amazing things we'll see on our journey.

The sketch for these circles is here: https://www.openprocessing.org/sketch/445969.

Have A Go, Play!
Have a go yourself.

Use the **openprocessing** editor to change the location and diameter of the circles. Create even more circles by adding more **ellipse** instructions, using copy and paste if you like.

Don't be cautious about playing around, there's no harm possible, and you can always undo any changes you've made to the code.

You'll learn the most about coding and creating art by playing and experimenting, much more than you can by just reading a textbook. I really can't stress this enough. Most of what

experienced coders, and experienced artists have learned, they have done through experimenting, exploring and playing.

What We've Learned

Before we go on ahead, let's pause and reflect on what we've learned.

Key Points

- The instruction to create a circle in Processing, is **ellipse()**. A circle is just an ellipse that hasn't been squashed.

- We use **(x,y) coordinates** to describe locations on a canvas. These are just like the graph coordinates we are familiar with, except the origin is at the top left of the canvas, not the bottom left. This means the y-coordinate is counted down from the top, not up from the bottom.

- Making copies of code, and modifying small elements of each copy, is an easy way to create interesting compositions. The extra code takes almost no additional effort. Painting ten circles with real paint, takes ten times the effort of painting one - not so with code. This is an early glimpse into the power of using code to create art, power that isn't possible using traditional methods like pen and ink.

Fill Colour

What else can we do with these circles? The first question that jumps up at me is how we can have different coloured circles. That is, circles filled, not in white, but another colour of our choice.

If I told you the instruction for telling Processing what colour to fill our shapes is **fill()**, you probably won't be surprised. The name makes sense because we're telling Processing how we want to fill any shapes it might draw later. Again, we've seen how the names of instructions give us a good clue about what they do.

To illustrate this, let's go back to our earlier code that just drew a single circle in the middle of the canvas, but this time add the **fill()** instruction.

```
function setup() {
  createCanvas(800, 600);
  background('pink');
}

function draw() {
  fill('lightgreen');
  ellipse(400, 300, 200);
}
```

All the code is the same as before, except you can see that immediately before the instruction to draw the circle we have a **fill('lightgreen')** instruction. No prizes for guessing it fills the circle with a light green colour. Let's try it and see.

Create a new sketch with the above code, or modify your previous code, and run it. You should see a light-green circle.

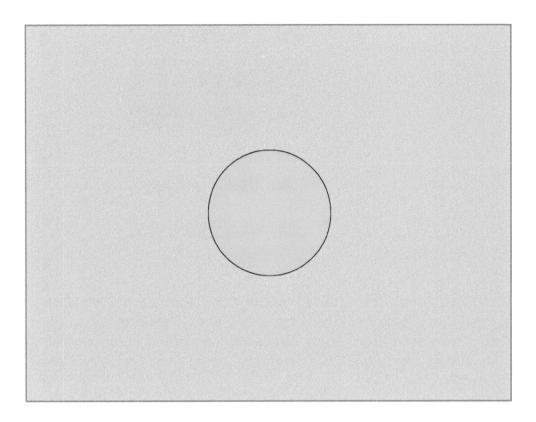

That wasn't too difficult at all. The sketch for this coloured circle is always available online at https://www.openprocessing.org/sketch/447018.

What happens if you change **fill('lightgreen')** with say .. **fill('purple')** or **fill('black')**? Have a play with these suggestions, and your own ideas for fill colours. The more you play, the more familiar coding will become.

You'll soon find that not every colour you choose will work, and that's because Processing only recognises colours from a special list. You can see that list here:

- web colour names: https://www.w3schools.com/cssref/css_colors.asp.

The following shows a section of the list, including the name of the colour, and a rectangle showing what that colour looks like. You can ignore the other stuff on that web page.

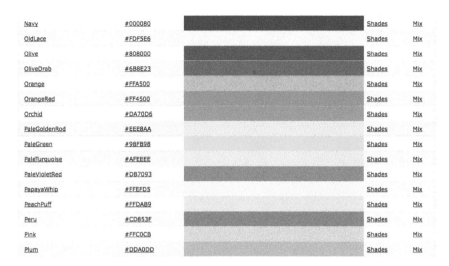

Navy	#000080		Shades	Mix
OldLace	#FDF5E6		Shades	Mix
Olive	#808000		Shades	Mix
OliveDrab	#6B8E23		Shades	Mix
Orange	#FFA500		Shades	Mix
OrangeRed	#FF4500		Shades	Mix
Orchid	#DA70D6		Shades	Mix
PaleGoldenRod	#EEE8AA		Shades	Mix
PaleGreen	#98FB98		Shades	Mix
PaleTurquoise	#AFEEEE		Shades	Mix
PaleVioletRed	#DB7093		Shades	Mix
PapayaWhip	#FFEFD5		Shades	Mix
PeachPuff	#FFDAB9		Shades	Mix
Peru	#CD853F		Shades	Mix
Pink	#FFC0CB		Shades	Mix
Plum	#DDA0DD		Shades	Mix

On that list you'll see named colours like **AliceBlue**, **Coral**, **Fuchsia**, **LightSkyBlue**, and **Tomato**. If I tried to invent a colour name yourself, like **ReallyDarkBlue**, that wouldn't work because it isn't on that list of known colour names. We'll come back to colours later and look at them properly as there are many ways of choosing or mixing them. For now we can carry on using these friendly colour names.

Outline Stroke

That circle we drew and filled with a colour has a black outline. That might be fine for our compositions, but most probably we'll want to try different outline colours.

The instruction to tell Processing which colour to use for the outline stroke of any shape we might draw is **stroke()**, with the colour we want passed inside the brackets. Let's take the code we've just been working on and add this new instruction before the instruction to draw a circle.

```
function setup() {
  createCanvas(800, 600);
  background('pink');
}

function draw() {
  stroke('red');
  fill('lightgreen');
  ellipse(400, 300, 200);
}
```

You can see we've passed the colour **red** to the stroke instruction. The results look like this:

If you look very carefully, you'll notice the circle has a very thin outline that's no longer black, but red. That's what we expected because that's what we told Processing to do using **stroke('red')**. Again, have a play with other colours yourself.

If you're like me, you're probably thinking that the outline is too thin to make the colour change meaningful. We need to make that outline stroke thicker. Processing has an answer for that too!

The command for setting the width, or **weight**, of the outline stroke is **strokeWeight()**. We need to tell Processing how thick that outline needs to be, so we pass a number inside those brackets. You're probably bored now of me telling you that. The more you learn about Processing, and coding in general, the less surprised you become, which shows you're becoming familiar with how computer programming works at a deeper level.

Let's try a weight of **10**. The code should look like the following, with this new instruction added.

```
function setup() {
  createCanvas(800, 600);
  background('pink');
}

function draw() {
```

```
    stroke('red');
    strokeWeight(10);
    fill('lightgreen');
    ellipse(400, 300, 200);
}
```

We've been adding new instructions one by one over the last few pages, so let's just summarise what this code does as a reminder. The **setup()** function sets up the working environment, which is the canvas. Here we set the size of the canvas to have a width of **800** pixels and a height of **600** pixels. We also set the canvas background colour to be **pink**. The **draw()** function contains the instructions for actually creating the artwork. Here we set the shape outline to be **red**, and have a thickness of **10** pixels. We also set the fill colour of any shape to be **lightgreen**, and the finally we draw a circle centred in the middle of the canvas at **(400, 300)** with a diameter of **200**.

The result looks like the following:

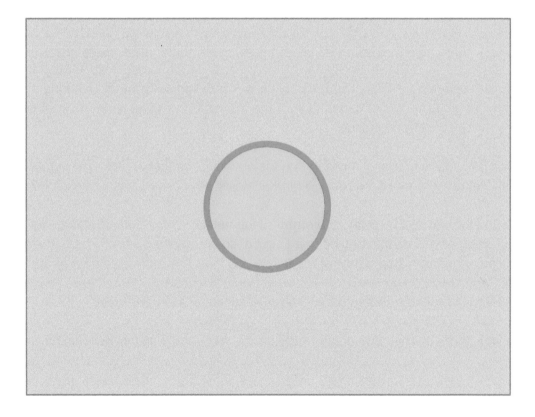

Again, try different colours and thicknesses for the outline stroke yourself.

Here's one of my own experiments that I quite like.

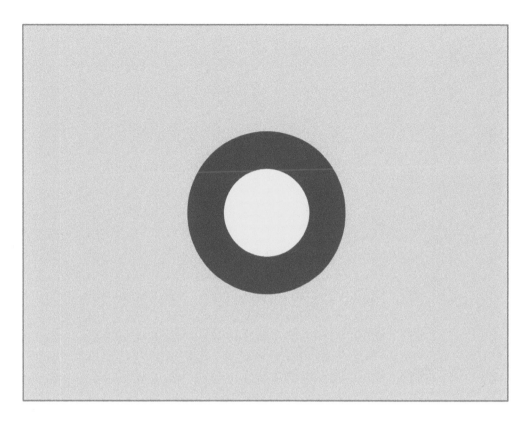

What if we don't want an outline? What if we simply want a coloured shape with no coloured stroke marking the outline?

We could set the stroke weight to zero. That would work. But a simpler way is to simply use the **noStroke()** instruction, like the following code shows.

```
function setup() {
  createCanvas(800, 600);
  background('pink');
}

function draw() {
  noStroke();
  fill('RoyalBlue');
  ellipse(400, 300, 200);
}
```

The result is as we'd expect, a nice blue circle with no coloured outline.

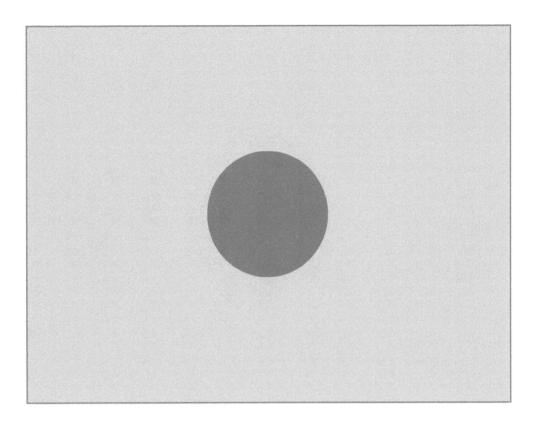

You can find the sketch online at https://www.openprocessing.org/sketch/447283.

If **noStroke()** means no stroke, what does **noFill()** mean? No prizes for getting that right! We'll use **noFill()** later.

Saving And Sharing Our Sketches

Now is a good time to see how we can save our work, so you can work on it in phases, coming back to a work in progress.

We'll also see how we can share our work with others. This is particularly valuable as art is much more powerful if others can see and experience it. For us, as algorithmic artists, it's also exciting that we can easily share the **code** that created the art, not just the image that the code makes.

Openprocessing calls our work **sketches**. A **sketch** means both the code and the image created by that code.

It is these **sketches** that we can save, so we can come back to them later, perhaps to continue working on them. They're just like word processing or spreadsheet documents which we work on, save, and come back to later to continue working on them.

You may have noticed, as you created code and viewed the resulting drawings, there was a big red **Save** button on the top right of the openprocessing web page.

To save our sketch, click that button. You'll be taken to a new page, asking you to fill in a few details in a form, to give a title to your work, and optionally a description. Initially it will have a temporary title "My Sketch" and no description, like the following shows.

To give your work a title, change that "My Sketch" to what you want it to be. You could call your work "**My Balloon**", or "**Abstract Blue Circle**", or even "**Untitled (2018)**" if you really feel that way.

Here I've filled the form in with my own title and description. We only really have to fill the title in, everything else can be left blank or unchanged. You can see I've called this work "**Blue and Pink Abstract**".

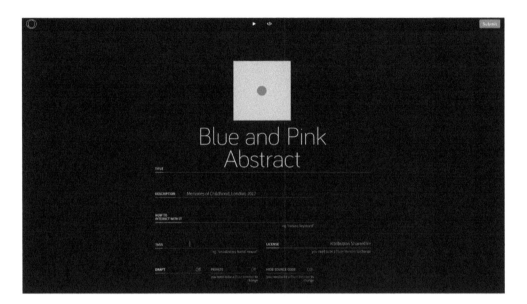

Once you're happy with the title and description, click the big red button at the top right, which now says **Submit**. The **openprocessing** service may take a few moments to save your work, but once it's done it'll return you to the view of your art. You can then carry on coding if you wanted to.

If we wanted to come back to our sketch later, we'd hover our pointer over the openprocessing logo at the top left, which will reveal more options, as shown here.

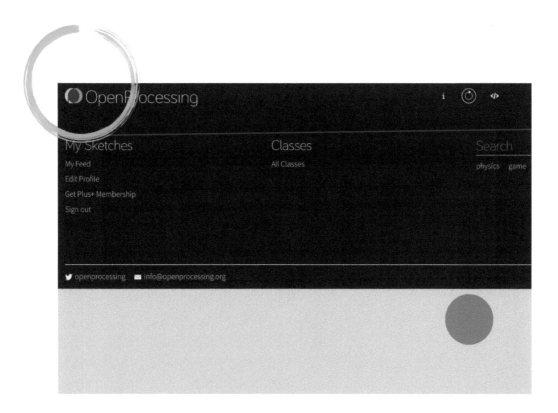

You'll see **My Sketches** as a prominent option. That's what we click to see all of our saved sketches. My list of sketches at this point look like the following.

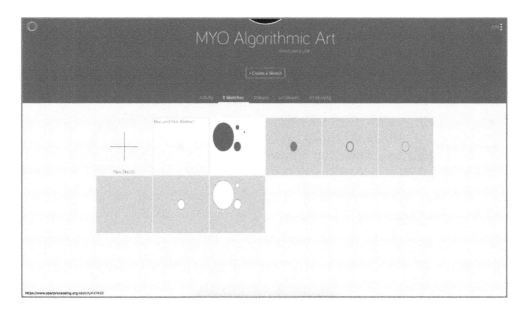

This is just a menu made out of our sketches, with each item showing a small preview of the image created by the code in each sketch. Hovering over a sketch shows the title. You can see above, the title "**Blue and Pink Abstract**" for the first sketch in the menu.

Click that sketch from the menu, and it opens. We're back at the familiar, code and drawing view again. For a short moment, the title is displayed over the image, but this fades away soon enough.

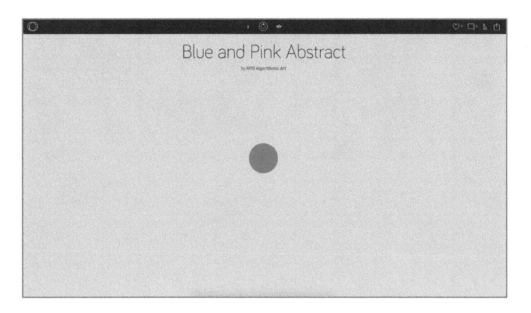

So what we've just done is **saved** and **retrieved** a sketch. That's an important thing to be able to do, because we might work on a sketch over a long time, coming back to it after taking breaks or time away.

So, how do we share our sketches? You've probably guessed correctly that the first step is to actually save the work. We've just done that.

When we reopen the sketch, the web browser shows the sketch's unique location on **openprocessing** in the web address bar. The address bar is where we sometimes type the name of the website we want to go to, like www.bbc.co.uk or www.amazon.com. The following shows the address at the top of the web browser, in case you're not familiar with it.

Sketch Web Address

Blue and Pink Abstract

by MYD Algorithmic Art

That web address for this sketch is unique to this sketch. It's also viewable by anyone on the internet. That means anyone with a smartphone, laptop or tablet can see your sketch from anywhere in the world, as long as they can access the internet. That's a potential audience of about three billion people. All they need is that web address to point their web browsers to.

That's pretty amazing.

To share your work, simply copy the sketch's web address and share it however you like - handwritten post-it notes, email or on social media.

The web address for this sketch is https://www.openprocessing.org/sketch/447450 - try it. I just shared my work with you!

What We've Learned

Before we go on ahead, let's pause and reflect on what we've learned.

Key Points

- The colour of shapes is defined using the **fill()** instruction. The outline stroke colour and thickness are defined by **stroke()** and **strokeWeight()**.

- **noStroke()** removes the outline stroke of shapes. **noFill()** removes the fill colour, making shapes transparent.

- **Openprocessing** can save our **sketches**, to be returned to later, or shared over the global internet. A **sketch** includes both the **p5js** code, and the image the code creates.

- Sharing **openprocessing** sketches is as simple as sharing the **web address**.

Worked Example: Ripples

Let's create an interesting composition using only the ideas we've covered up to this point.

That means we'll only be using the idea of a canvas, coloured circles of different sizes and outlines, and also the idea of repeating code but changing each copy in a small way to create some variation.

Let's start with the code we created earlier that drew 4 circles.

```
function setup() {
  createCanvas(800, 600);
  background('pink');
}

function draw() {
  ellipse(400,300,100);
  ellipse(200,200,300);
  ellipse(400,100,50);
  ellipse(500,150,20);
}
```

We'll change the canvas background from **pink** to pure **white**, using **background('white')**. Let's also remove the outlines from the circles using **noStroke()**.

We can also start by setting a fill colour just so we can see the circles, and think about how we might change them. We can do this using **fill('grey')** to set the circles to a neutral grey colour.

The code should now look like the following.

```
function setup() {
  createCanvas(800, 600);
  background('white');
}

function draw() {
  noStroke();
  fill('grey');

  ellipse(500, 400, 100);
  ellipse(300, 300, 300);
```

```
  ellipse(500, 200, 50);
  ellipse(600, 250, 20);
}
```

Here's what the results look like so far.

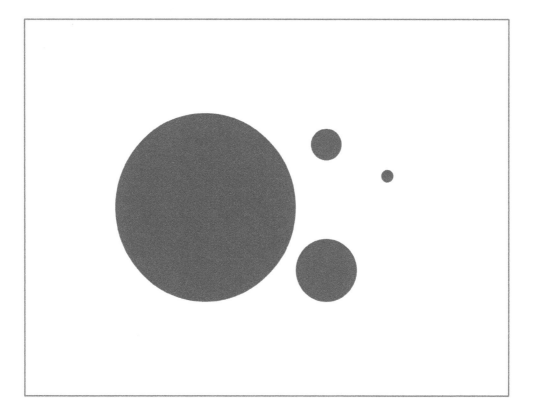

Remember, nothing we do is permanent. Any code we write can be changed easily, which makes the act of creating art with code very agile - we can chop and change ideas quickly and with almost no cost. Those circles don't need to remain grey for long!

Let's try making these circles transparent, but with a thick outline. We can use the **noFill()** instruction to make them transparent. We've already seen how the **stroke()** and **strokeWeight()** instructions control the circle outlines.

```
function setup() {
  createCanvas(800, 600);
  background('white');
}

function draw() {
  stroke('blue');
```

```
    strokeWeight(20);
    noFill();

    ellipse(500, 400, 100);
    ellipse(300, 300, 300);
    ellipse(500, 200, 50);
    ellipse(600, 250, 20);
}
```

We've chosen **blue** as a stroke colour, with a thickness of **20** pixels. We've not really thought about this, we're just doing it to see what happens. Perhaps it'll look like something we can work on and refine.

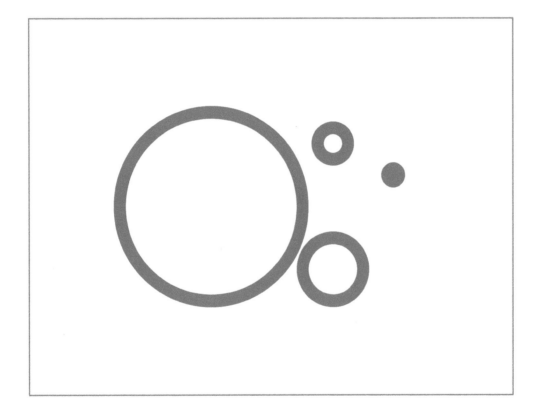

So what do we think? Do we prefer the filled circles with no outline, or these outline circles? What could we work with?

It is a deeply personal thing with no right or wrong answer. And my own answer is that I'm not sure yet. So let's experiment a bit more.

Let's soften the very striking blue to a softer colour like **pink**. Let's also add some more circles. My code looks like the following now, with the changes highlighted here to make them easier to see.

```
function setup() {
  createCanvas(800, 600);
  background('white');
}

function draw() {
  stroke('pink');
  strokeWeight(10);
  noFill();

  ellipse(500, 400, 100);
  ellipse(300, 300, 300);
  ellipse(500, 200, 50);
  ellipse(600, 250, 20);

  ellipse(600, 500, 100);
  ellipse(300, 400, 200);
  ellipse(400, 500, 300);
}
```

The resulting image is starting to look nicer, and more interesting too.

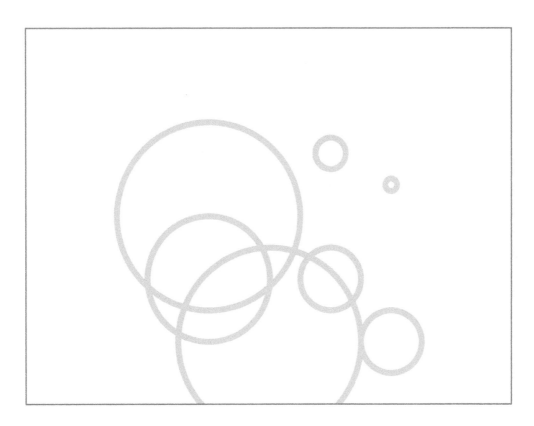

What do we want to do now? The image overall is not very balanced, with much of the action in the middle and bottom. Let's move the first four circles up and left by **100** pixels.

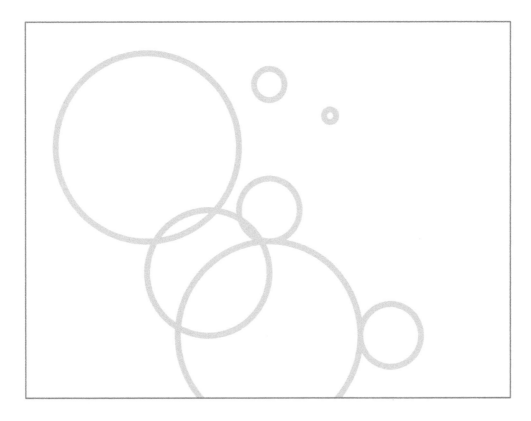

That looks better. I quite like the empty space towards the top right. It gives the overall composition a little bit of dynamism, as if the image was falling or moving. If the composition was totally balanced and centred, it wouldn't have this feel. The uniformity of the circle outline colour and weight nudges me, the viewer, to engage the composition as if it were a puzzle, and try to make sense of it. I personally like that in art.

Let's just see what happens if we break that and add some colour variation, and also vary the outline thickness too. We'll do it to the newest circles we added. You can see the two very simple code changes, setting the outline colour to **hotpink**, and the outline thickness to **5**.

```
function setup() {
  createCanvas(800, 600);
  background('white');
}

function draw() {
  stroke('pink');
  strokeWeight(10);
  noFill();

  ellipse(400,300,100);
  ellipse(200,200,300);
  ellipse(400,100,50);
  ellipse(500,150,20);

  stroke('hotpink');
  strokeWeight(5);
  ellipse(600,500,100);
  ellipse(300,400,200);
  ellipse(400,500,300);
}
```

The resulting image has a very different in feel now.

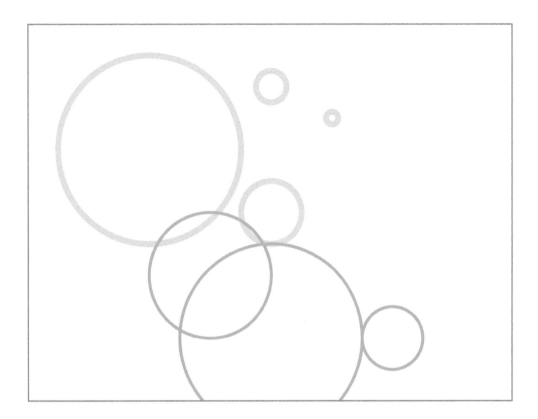

The more intense pink circles give the image an additional dimension, as if these circles were created with more force, or more recently than the lighter pink circles which look like they've started to dissipate.

In fact, those circles look like ripples, moving and dissipating out across a pool of water.

If you had never coded before, you've now created a proper piece of art made by code. That's not a small achievement at all. Well done!

Before we finish this section, it's worth thinking about how simple the ideas were that went into creating this image. Circles are not a difficult concept, and thinking about colour and line thickness isn't too difficult either. Placing the circles, and choosing the size takes a bit more judgement, trial and error, and that's where our artistic eye is at work.

This particular piece is always on the web at https://www.openprocessing.org/sketch/447312.

Do share your own versions online. Tweet me at @algorithmic_art.

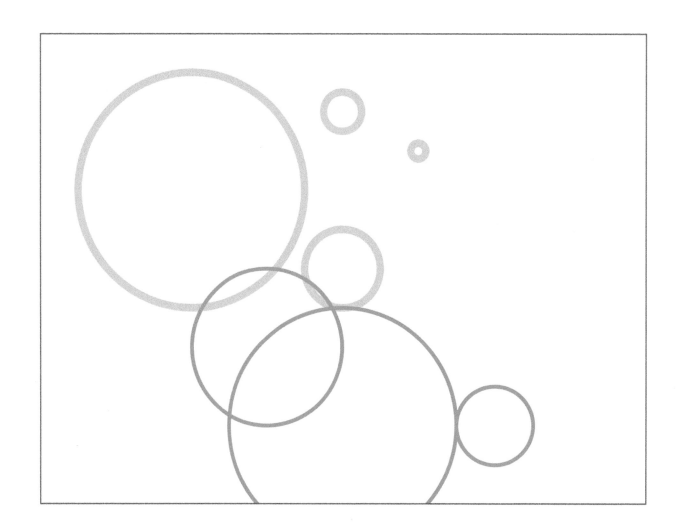

Ripples

More Shapes - Rectangles, Lines

Now that we've had lots of practice with drawing circles, we can look at some other shapes and markings.

Because we've already done lots of work on things like **(x,y)** coordinates, fill colour and stroke thickness, we'll find that new shapes work in a very familiar way.

Let's look at drawing squares and rectangles. We've already said that squares are just rectangles, but with the width and height being the same **length**. For this reason Processing only has an instruction for rectangles, not a separate one for squares. It's the same reason Processing has an **ellipse** instruction and not a separate **circle** instruction too.

Let's imagine how we, or a computer, might draw a rectangle on a canvas.

You can see the main thing we need to describe is how wide and how tall the rectangle is. In technical lingo that's the **width** and the **height**. That gives us the size of the rectangle.

But like the circle, we need to know where on the canvas we pin the rectangle. In Processing, we pin the top left corner of the rectangle. The diagram above shows a rectangle of **width 5** and **height 3**, with its corner pinned to the location **(2,1)** on the canvas.

That was easy enough. You can see similar ideas across circles and rectangles. We'll keep seeing similar ideas again and again, the more we learn about Processing and coding. That's a good thing as it makes learning to code easier.

Enough discussion, let's code! The instruction for drawing a rectangle is **rect(x, y, width, height)**. The first two numbers **x** and **y** give the location of the top left corner, and the **width** and **height** are just that. The example rectangle above would be coded as follows:

```
rect(2, 1, 5, 3);
```

The following full Processing program creates the same canvas that we've used before, and draws a single rectangle near the top left of that canvas. The top left is pinned to the location with coordinates **(100,100)** and has a **width** of **200** and a **height** of **200**.

```
function setup() {
  createCanvas(800, 600);
  background('pink');
}

function draw() {
  rect(100, 100, 200, 200);
}
```

The result is a simple **square**, as we'd expect, because the **width** and **height** are the same.

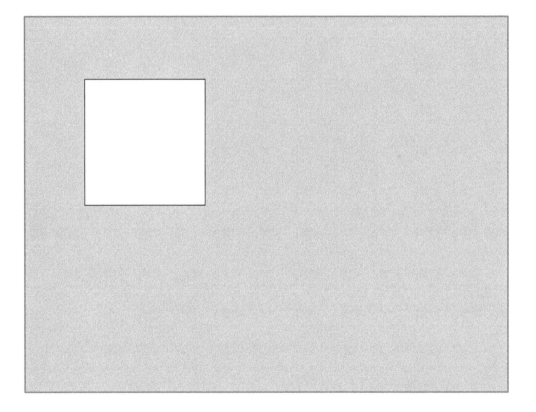

Remember all that work we did with fill colours, outline stroke colour and width? Let's apply it to rectangles now. It should all work in exactly the same way, with no surprises.

The following code, starts with a white canvas, and draws four rectangles with various colours and outline strokes. There's nothing new here at all. We're using **fill()**, **stroke()**, **noStroke()** and **strokeWeight()** just like before.

```
function setup() {
  createCanvas(800, 600);
  background('white');
}

function draw() {
  noStroke();
  fill('lightblue');
  rect(100, 100, 200, 200);

  noStroke();
  fill('aquamarine');
  rect(200, 200, 300, 200);

  stroke('red');
  fill('bisque');
  rect(400, 300, 200, 200);

  stroke('lightgrey');
  strokeWeight(10);
  noFill();
  rect(500, 100, 200, 300);
}
```

The resulting image is as follows.

I quite like the result! That composition didn't happen by luck, I did spend a few minutes experimenting with different colours, locations and sizes. The sketch for this experiment is always at https://www.openprocessing.org/sketch/448307. Have a go at experimenting with different kinds of rectangles yourself.

Let's look at an even simpler shape - the humble line. It's so humble, most people wouldn't even call it a shape!

How would we precisely describe a **line**? Well if you think about it, a line is the most direct path between two points. That's why the Romans liked to build very straight roads. For us, we need to pin these two points on a canvas so that we can draw a straight line between them. In other words, we need to know where we're starting from, and where we're going to, along that direct path. The following illustrates this idea.

You can see the **start** and **end** points at each end of the **line**. One is at **(2,1)** and the other is at **(6,4)**. It doesn't matter which one we start from, because the line will look the same either way.

We talked earlier about how coding in Processing, and indeed many other programming languages, should have recognisable patterns, to make learning it easier, and to avoid unexpected surprises. So without looking it up, can you guess what the instruction for drawing a line is?

You guessed it - the command is **line()**. How easy was that!

How do we pass this **line()** instruction the information it needs, the start and end points of the line? Just like with circles and rectangles, we should be able to pass the **(x,y)** coordinates inside brackets attached to the instruction. This is in fact correct.

The following shows an example which draws a line like the one in the previous picture:

```
line(2, 1, 6, 4);
```

We can see how simple and easy it is. We can also see the coordinates of the start **(2,1)** and end **(6,4)** points listed as numbers inside the brackets.

Let's create a sketch to draw a line. The following is very simple code, drawing a line from **(100,100)** to **(400,300)** on a **pink** canvas.

```
function setup() {
  createCanvas(800, 600);
  background('pink');
}
```

```
function draw() {
  line(100, 100, 400, 300);
}
```

Here's what the result looks like.

I'll admit, it's not as visually interesting as some of the other drawings we've created. But that's ok, because we're learning about building blocks, which we'll use to compose more interesting images later.

We can modify line colour and thickness, just like before, using **stroke()** and **strokeWeight()**. What we can't do is fill the shape with a colour. That's because a line isn't a shape which has an inside area for us to fill with colour. Let's draw a few lines with different colours and thicknesses. I've changed the background to **white** again, as it's easier to balance several colours on it.

```
function setup() {
  createCanvas(800, 600);
  background('white');
}

function draw() {
```

```
    stroke('red');
    strokeWeight(10);
    line(100, 100, 400, 300);

    stroke('green');
    strokeWeight(5);
    line(600, 100, 200, 400);

    stroke('darkgrey');
    strokeWeight(2);
    line(450,450, 600, 450);
    line(450,460, 600, 460);
    line(450,470, 600, 470);

    stroke('lightskyblue');
    strokeWeight(10);
    line(500, 100, 500, 400);
    line(520, 100, 520, 400);
    line(540, 100, 540, 400);
}
```

The results are rather good, given we've just used a few humble lines to create it.

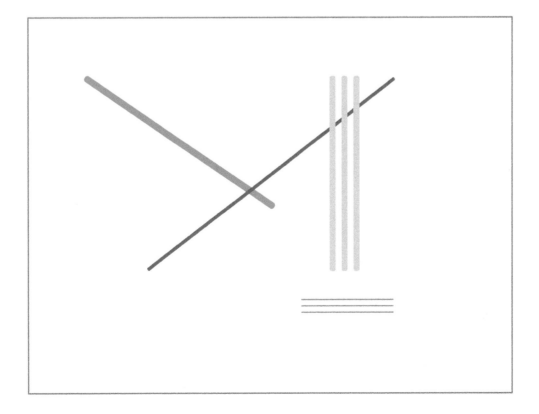

As an artist, you'll have seen how the repetition of similar lines, close to each other, is a strong pattern to use in compositions. Hang onto that thought, as we'll be using that idea quite a lot later, and we won't have to laboriously copy similar code to do it. Programming languages, including Processing, are designed to make such repetition easy and elegant.

Even More Shapes Are Possible

We've looked at circles, rectangles and lines. These are a good shapes to look at first as they're simple enough, and also really useful for composing our own work. You can achieve quite a lot with just circles, rectangles and lines, especially if you think about their colours and outline strokes.

There are more shapes possible with Processing, but we won't look at them right now. They include **triangles**, **ellipses** (squashed circles), **quadrilaterals** (squashed rectangles), **arcs** (parts of a circle) and the simplest shape of all, a **dot**.

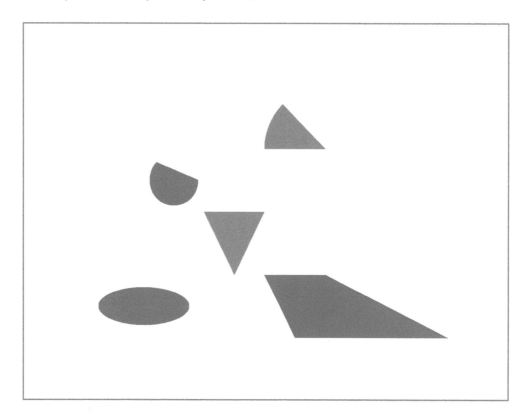

You'll find that as you become more familiar with Processing you can easily pick up new instructions, because the way they work is the same or very similar to what you already know. Take that triangle, for example, you won't be surprised that the instruction simply needs the location of the three corners, and that's it. If you want to jump ahead and see how these shapes work, have a look at the p5js reference at https://p5js.org/reference/ in the 2D shapes section.

If you're interested in having a look at the code that made these shapes, the sketch is online at https://www.openprocessing.org/sketch/451308.

If you don't feel ready to explore those new shapes right now, that's ok. We're going to continue our journey, gently and unrushed.

What We've Learned

Believe it not, we've covered enough of the basics to move straight onto real algorithmic art.

Things are about to get interesting very soon!

Key Points

- **rect()** is the instruction for drawing rectangles. It requires the location of the top left corner, as well as the width and height of the rectangle.

- **line()** is the instruction for drawing a simple line. It needs the start and end of the line to be passed to it.

- Like many shapes, both **rect()** and **line()** obey the **fill()**, **stroke()** and **strokeWeight()** instructions to specify how to colour them, and how to draw their outlines. The exception is that a line doesn't have an internal space to fill with colour.

- There are more shapes available in Processing, like triangles, arcs and quadrilaterals, and they work in ways that are already familiar.

Part 2 - Algorithmic Thinking

In Part 2 we'll explore how even simple mathematical ideas, randomness and repetition, can lead to intricate and beautiful forms.

Randomness

The first algorithmic idea we're going to explore is the easiest one. But just because it's easy, doesn't mean it's not interesting.

Up to now, we've been deciding where to place shapes on a canvas, and what size they should be. Sure, we might have changed our minds and refined those locations and sizes to make the compositions work better, but we still chose those numbers ourselves.

What if we didn't decide? What if we let our computer decide?

That's a very big change in how art is created. We'll have transferred some of the creative process from ourselves to our computers. It's easy to get sucked into the technical details of programming but we should always be conscious of the bigger picture - the dramatic shift of creative act from us, humans, to our computers, machines.

So how would a computer choose, say, where to pin a circle? One of the things computers can easily do is come up with randomly chosen numbers. We could ask our computer to pick a number at random between **1** and **6**. That would be just like rolling a six-sided die and picking the number facing up, just like we do in many board games.

We don't know which number between **1** and **6** our computer will come up with. And if we came back next week and asked it do to the same, it would very probably choose a different number. That's the magic of **random numbers** - they really are unpredictable.

Enough talk, let's bring this to life with an example. Let's start first with a simple circle in the middle of a canvas. This is really familiar to us now, we've done lots of circles earlier in this book.

```
function setup() {
  createCanvas(800, 600);
```

```
    background('white');
}

function draw() {
  noStroke();
  fill('pink');

  ellipse(400, 300, 100);
}
```

We know that this will draw a pink circle, in the very centre of the canvas, with a diameter of **100** pixels. The result looks like this:

Now, look at that code again for drawing the ellipse:

```
ellipse(400, 300, 100);
```

If we changed that diameter from **100** to **400**, we'd get a bigger circle.

```
ellipse(400, 300, 400);
```

Here's what changing it to **400** looks like:

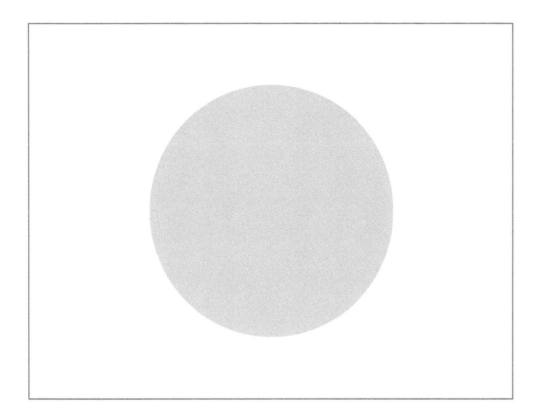

Let's get the computer to choose the diameter now. That means we need to replace that **100** or that **400** with something else.

What is that something else? We can't replace the diameter with **299**, or **13** or **234**, because that would be us choosing the diameter, not the computer.

Luckily there's a really convenient Processing instruction for coming up with randomly chosen numbers. You won't be surprised that it's called **random()**. What do you think the following code does?

```
random(6);
```

Let's think what we'd do if someone asked us to pick a random number. We'd want to know what the smallest and biggest numbers could possibly be. In other words, we'd want to know in what **range** we're supposed to pick a random number. So that **random()** instruction must need to know the range we want it to randomly choose a number from.

That **6** tells **random()** to pick a number between **0** and **6**. That was easy! Actually, there's a small subtlety here, which often doesn't matter, but is worth knowing. The instruction **random(6)** picks a number between **0** and **6** but not including **6**. That means the chosen number could be something like **1.5**, **3.2**, **5.99**, **0.001**, or **2.1212**, but not **6** itself.

Let's get back to that circle. If we replaced that diameter of **400** by **random(400)**, we should get a circle that's of a size anywhere between **0** and **400** (but not including **400**). Here's the code:

```
function setup() {
  createCanvas(800, 600);
  background('white');
  noLoop();
}

function draw() {
  noStroke();
  fill('pink');

  ellipse(400, 300, random(400));
}
```

You can see that **ellipse()** command now has **random(400)** where the diameter should be. We're also starting to see lots of brackets, but they're easy enough to keep track of. There's a closing bracket for the **random()** instruction and another one for the **ellipse()** instruction, which is why we see **));** at the end of that line.

You might have spotted another change to the code. I've put a strange-looking **noLoop()** instruction in the **setup()** function. What is that? Well, remember we use the **setup()** function to set up the environment, like the canvas size and the background colour. What we didn't talk about before is that the **draw()** function, which does the actual drawing of shapes on the canvas, is not run once but many times. In fact **draw()** is run again and again, and again, forever. We didn't notice this before because our drawings were overwritten again and again by exactly the same shapes and colours in exactly the same locations. The **noLoop()** instruction makes sure **draw()** is executed only once.

Here's what happens when we run the code.

That's a tiny circle! That **random(400)** must have picked a small number. You may get a large, or medium sized circle, because when your own code runs, the random number chosen for the size of the circle will very likely be different to mine.

Let's run that code again, using the re-run button. This time I get a larger circle.

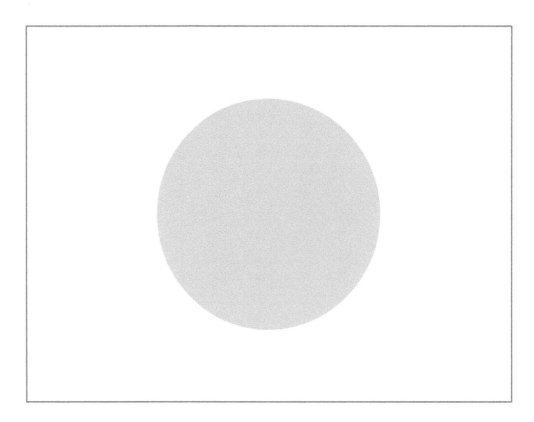

Take this moment to pause and think about the importance of what we've done. We've handed over responsibility for picking the size of a circle to our computer. We've given up a lot of creative control, and passed it to our computer. As a concept, that's pretty awesome!

This idea features a lot in algorithmic art made with a computer, and has since the earliest attempts in the 1960s. Even today, we play computer games with landscapes generated automatically and randomly by our computers. Of course we do set some constraints. Here we limit the range of numbers to be between **0** and **400**, and that becomes a new kind of creativity. It's a new kind of approach to design. We have moved our creative and thinking process up and above the small details of choosing a number, to the more interesting process of saying we want a random number, and setting the acceptable range, a range we know will be good for our composition as a whole. Of course, we'll probably have to experiment quite a bit to find these 'just right' number ranges.

Here's a collection showing the result of running that code six times.

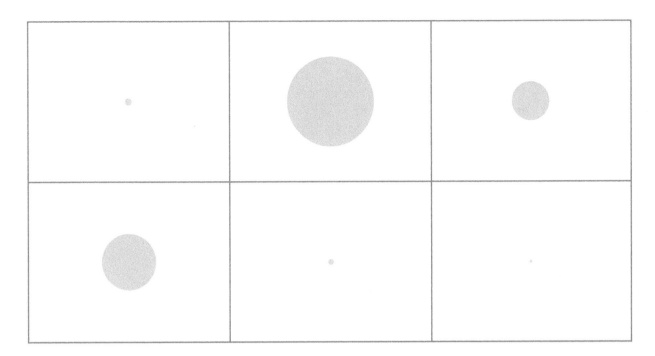

All this from a tiny change in the code. We're starting to see the power of code. Really simple ideas, and really simple code, that create a wonderfully rich and varied set of images. This is just the start!

What could we do next? Well maybe we can place many circles at random locations on the canvas. You can probably guess how we do that. We'd replace the **(x,y)** coordinate numbers with the **random()** instruction. That way the centre of the circle is located at a point where the distance along the horizontal direction is chosen at random, and so is the distance down the vertical direction too.

```
ellipse(random(800), random(600), 100);
```

You can see how the horizontal position has been constrained to be picked randomly from the range **0** to **800**. Similarly the vertical position is picked randomly from the range **0** to **600**. Because the canvas is **800** wide and **600** tall, that means the centre of the circle is always pinned to somewhere on the canvas. There is no way the random numbers will place the centre of the circle far away off the canvas. Let's repeat that circle drawing instruction five times. The diameter of the circle is set to **100** pixels for now as we focus on the location, not the size.

```
function setup() {
  createCanvas(800, 600);
  background('white');
  noLoop();
}
```

```
function draw() {
  noStroke();
  fill('pink');

  ellipse(random(800), random(600), 100);
  ellipse(random(800), random(600), 100);
  ellipse(random(800), random(600), 100);
  ellipse(random(800), random(600), 100);
  ellipse(random(800), random(600), 100);

}
```

Here's what it looks like for me. Yours will look different because your circles will have locations chosen by different random numbers.

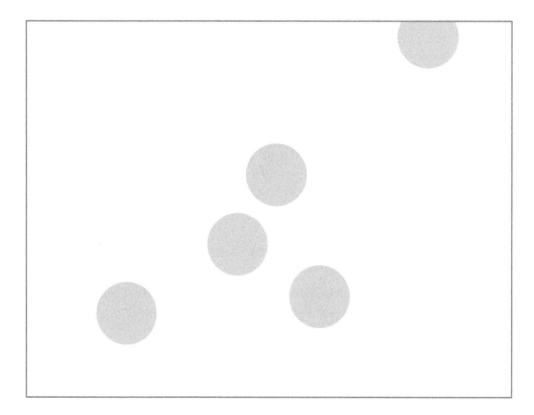

That's rather nice. Running the code again will give different compositions, some will work better than others. The element of chance is a key part of the creative process now.

Try it yourself, with different ranges for both the location and also the circle size.

Before we finish, let's talk about something that might have been bothering you. We know the **random()** produces numbers which have fractional bits, like **2.34** or **7.24**. We also know that the

location or size of a circle is in pixels, those tiny little squares that make up our display. We can have a diameter of **7** pixels, or a diameter of **8** pixels, but what on earth is does **7.24** pixels mean? Why doesn't Processing complain when we ask it to draw a circle with diameter **random(10)**, if that turns out to be **7.24**? The reason it doesn't is because in many places, Processing is forgiving, and rounds the number down to the nearest whole number. In this case, Processing would round **7.24** down to **7**, and draw a circle with a diameter of **7** pixels.

What We've Learned

We've learned about our first algorithmic art idea - randomness - a simple but powerful idea.

Key Points

- Instead of us manually choosing numbers to decide the location or size of shapes, we can ask our computer to pick numbers at random. This is a simple, but powerful, way of moving some of the creative process to the computer. The element of chance is then a key part of how the art is composed and arranged.

- **random(n)** is the instruction for picking a number in the range from **0** to **n**, but not including **n**. For example, **random(6)** might pick **1.323**, **0.237** or **5.232**. There's a very tiny chance it might pick **0**, but it will never pick **6**.

- The **setup()** function is only run once, at the start, to set up a sketch. The **draw()** function is run again and again, forever. This doesn't matter in many cases, but if it isn't what we want, we can ask Processing to only run it once, using the **noLoop()** instruction in **setup()**.

Worked Example: Paint Drops

Let's continue working on the code we just explored for drawing circles at random locations on the canvas.

Let's see what happens if we set the size of the circles to be randomly chosen too. We'll replace the diameter of **100** with the **random()** instruction. You can see we've set the circle size to be anything between **0** and **200** pixels in diameter.

```
ellipse(random(800), random(600), random(200));
```

The code should now look like this.

```
function setup() {
  createCanvas(800, 600);
  background('white');
  noLoop();
}

function draw() {
  noStroke();
  fill('pink');

  ellipse(random(800), random(600), random(200));
  ellipse(random(800), random(600), random(200));
  ellipse(random(800), random(600), random(200));
  ellipse(random(800), random(600), random(200));
  ellipse(random(800), random(600), random(200));

}
```

Let's see what the results look like.

That is an interesting arrangement, and running the code again and again, will show different compositions.

Myself I'm not sure that I like the circles going off the edges. That happens when the centre of the circle is too close to the edge. So let's tighten the constraints for choosing the circle centre locations. Instead of being anywhere on the **800** by **600** canvas, let's try limiting the circle centres to be inside a smaller imaginary box. The following shows this imaginary box, smaller than the canvas itself, and acting like a fence keeping the circle centres inside it.

If that fencing box is **200** pixels from the outer edges of the canvas, we can work out the horizontal and vertical ranges that the circle centres must fall inside. The following shows how we can work this out.

That looks complicated! It's not really, so let's talk about it, taking it slow.

We previously allowed the circle centres to be anywhere on the canvas. That meant the circle centres could lie anywhere between **0** and **800** along the horizontal direction. Looking at the diagram above, we can see that with the fence in place, the circle centres must now be between **200** and **600**. Similarly, we previously allowed the vertical location to fall anywhere between **0** and **600**, but now with the fence, it must fall between **200** and **400**.

Phew! That was a lot of words to explain a simple idea.

How do we change the code? This time we're asking the **random()** instruction to choose a number between a lower and upper limit. Before we had an upper limit and assumed the bottom was **0**. The answer is actually simple. The **random()** instruction can take two bits of information, and it will interpret them as the lower and upper limits. Here's an example:

```
random(5, 10);
```

That code **random(5, 10)** could pick any number between **5** and **10**, but not including **10**. That means our code changes as shown below:

```
function setup() {
  createCanvas(800, 600);
  background('white');
  noLoop();
}
```

```
function draw() {
  noStroke();
  fill('pink');

  ellipse(random(200, 600), random(200, 400), random(200));
  ellipse(random(200, 600), random(200, 400), random(200));
  ellipse(random(200, 600), random(200, 400), random(200));
  ellipse(random(200, 600), random(200, 400), random(200));
  ellipse(random(200, 600), random(200, 400), random(200));
}
```

Let's see what the results look like. Remember, yours will be different because the random numbers chosen by your computer will be different from mine.

That's much better. All of the objects are now nearer the centre of the canvas with a nice margin around the edge. If we re-run the code several times, this still works because the circles can't be outside the fence we've enforced.

That's a good step forward. What next? Well those circles, when they overlap, look like blobs of paint dropped accidentally on the floor. We could make them more distinct by giving them a dark outline stroke. Or we could give the circles different colours. Let's try this colour idea.

We could choose a fill colour for each of the five circles. We've seen how to do that with the **fill()** instruction. But let's continue the theme of using randomness and get our computer to choose a colour for us.

So how is this going to work? We want to pick a random colour from list of colours. That means we need the **random()** instruction to be even more talented and be able to pick randomly from a list, not just from a range of numbers. Can it do that? Yes, it can!

Look at the following for a moment.

```
random(['pink', 'lightpink', 'oldlace', plum]);
```

We can see the familiar **random()** instruction. Inside the brackets, we previously saw a number or two numbers. This time we see a list of colours, each one separated by commas. That looks like how we might write a list. My shopping list might be **coffee, flour, tomato, lemon**. But there's one more thing - the list is contained in square brackets **[]**. In Processing, lists are always enclosed inside square brackets. My shopping list should have square brackets around it too, **[coffee, flour, tomato, lemon]**.

So **random()** will pick any one of the items in the list. And this is perfect for us, because it will pick one of the colours at random. You can think of the list of colours as our colour palette, a small set of colours that we deliberately restrict ourselves to. Such big ideas from such simple code!

Here is the colour palette of **pink**, **lightpink**, **oldlace** and **plum**.

Before we change our sketch code, don't forget that our **random()** instruction needs to go inside the **fill()** instruction's brackets. That's because **fill()** expects a colour, and our **random()** instruction picks one from a list. You can see these ideas coming together in the code below.

```
function setup() {
  createCanvas(800, 600);
  background('white');
  noLoop();
```

```
}

function draw() {
  noStroke();

  fill(random(['pink', 'lightpink', 'oldlace', 'plum']));
  ellipse(random(200, 600), random(200, 400), random(200));

  fill(random(['pink', 'lightpink', 'oldlace', 'plum']));
  ellipse(random(200, 600), random(200, 400), random(200));

  fill(random(['pink', 'lightpink', 'oldlace', 'plum']));
  ellipse(random(200, 600), random(200, 400), random(200));

  fill(random(['pink', 'lightpink', 'oldlace', 'plum']));
  ellipse(random(200, 600), random(200, 400), random(200));

  fill(random(['pink', 'lightpink', 'oldlace', 'plum']));
  ellipse(random(200, 600), random(200, 400), random(200));

}
```

Let's what kind of result this gives. I tried running it a few times, until I found a fairly balanced image. Because they're random, not all the compositions will be nicely balanced.

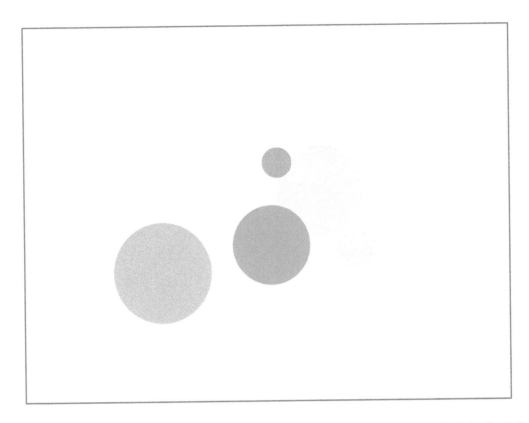

I don't think I like **lightpink**. It's actually muddier and darker than the normal **pink**. So let's replace it with another one, **bisque**. I'm also not so sure about **oldlace**, so let's just get rid of it completely.

I also don't like the very small circles, so let's set a lower limit to their size. We already know how to do this, by using two numbers with **random()**. Let's try a minimum size of **50**, and keep the maximum of **200**. Our code now looks like this.

```
function setup() {
  createCanvas(800, 600);
  background('white');
  noLoop();
}

function draw() {
  noStroke();

  fill(random(['pink', 'bisque', 'plum']));
  ellipse(random(200, 600), random(200, 400), random(50, 200));

  fill(random(['pink', 'bisque', 'plum']));
  ellipse(random(200, 600), random(200, 400), random(50, 200));
```

```
    fill(random(['pink', 'bisque', 'plum']));
    ellipse(random(200, 600), random(200, 400), random(50, 200));

    fill(random(['pink', 'bisque', 'plum']));
    ellipse(random(200, 600), random(200, 400), random(50, 200));

    fill(random(['pink', 'bisque', 'plum']));
    ellipse(random(200, 600), random(200, 400), random(50, 200));
}
```

The results are a little more balanced now.

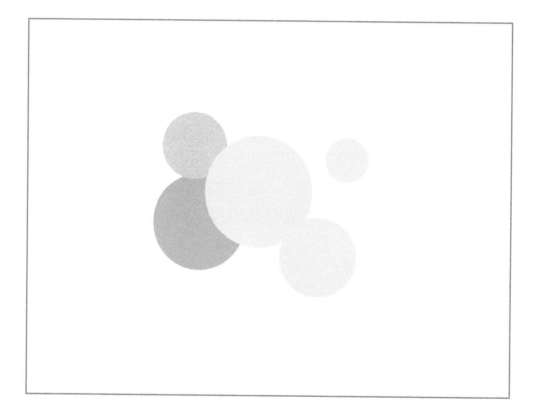

We could stop there. We can be proud of what we've done. We've used randomness to decide the location, size and colour of circles, which sometimes forms a nice composition.

But I think we can do better still.

Let's try doubling the number of circles from **5** to **10**. We simply copy and paste the code to do that. Because there will be more circles on the canvas, let's reduce the upper limit on their size, from **200** down to **100**. The code looks like this now:

```
function setup() {
  createCanvas(800, 600);
  background('white');
  noLoop();
}

function draw() {
  noStroke();

  fill(random(['pink', 'bisque', 'plum']));
  ellipse(random(200, 600), random(200, 400), random(50, 100));

  fill(random(['pink', 'bisque', 'plum']));
  ellipse(random(200, 600), random(200, 400), random(50, 100));

  fill(random(['pink', 'bisque', 'plum']));
  ellipse(random(200, 600), random(200, 400), random(50, 100));

  fill(random(['pink', 'bisque', 'plum']));
  ellipse(random(200, 600), random(200, 400), random(50, 100));

  fill(random(['pink', 'bisque', 'plum']));
  ellipse(random(200, 600), random(200, 400), random(50, 100));

  fill(random(['pink', 'bisque', 'plum']));
  ellipse(random(200, 600), random(200, 400), random(50, 100));

  fill(random(['pink', 'bisque', 'plum']));
  ellipse(random(200, 600), random(200, 400), random(50, 100));

  fill(random(['pink', 'bisque', 'plum']));
  ellipse(random(200, 600), random(200, 400), random(50, 100));

  fill(random(['pink', 'bisque', 'plum']));
  ellipse(random(200, 600), random(200, 400), random(50, 100));

  fill(random(['pink', 'bisque', 'plum']));
  ellipse(random(200, 600), random(200, 400), random(50, 100));
}
```

The results are much nicer. Some of the re-runs produce compositions that I'd be happy to print and frame. Here's one example.

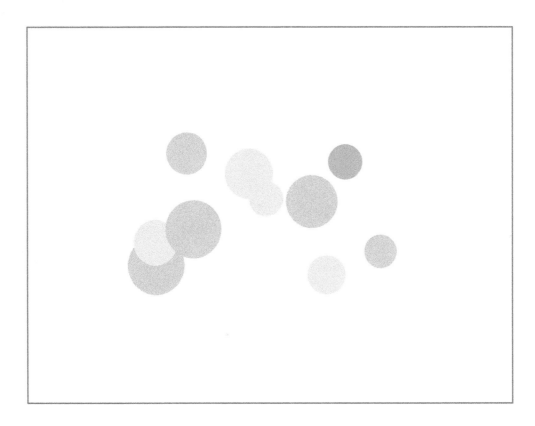

Try your own colour palette by choosing a list from the named colours at
https://www.w3schools.com/cssref/css_colors.asp. Try setting your own lower and upper sizes
for the circles.

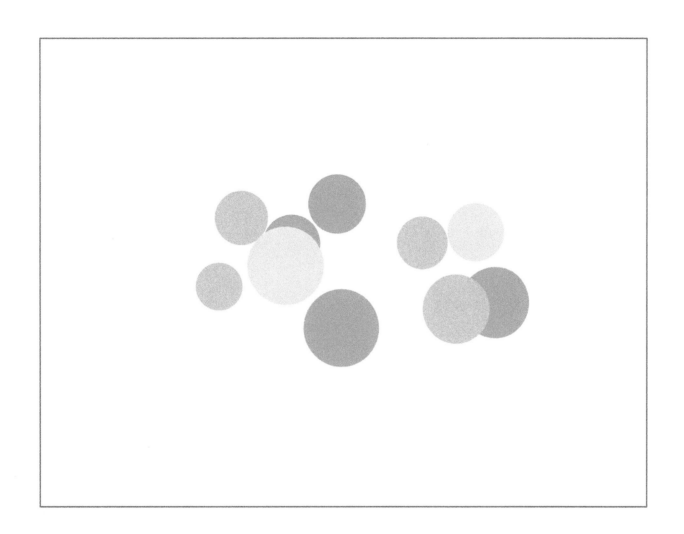

Paint Drops

Repetition

The next idea we'll look at is **repetition**. We saw earlier how repeating similar objects on a canvas is a visually powerful technique.

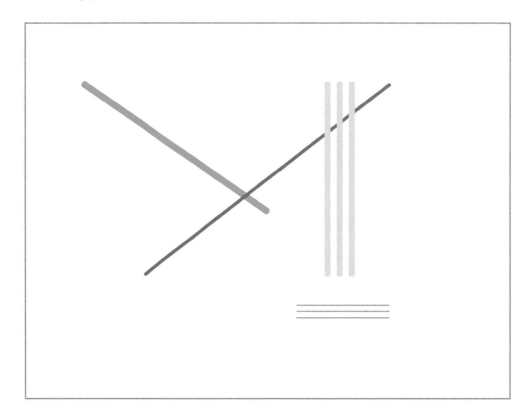

When we did that with lines, we copied the code for the shape and pasted it again, and then changed the location a little bit. When we did it with circles, we again copied and pasted the code, and used **random()** to vary things like location and size.

That's fine when we're repeating a shape a small number of times, like **3**, **4** or **5**. Any more, and it's going to get really boring and laborious. And it'll suck the joy out of creating art made by code. I did find it really boring to have ten copies of the **fill()** and **ellipse()** instructions.

Luckily, one of the things computer programming languages are good at, really really good at, is repeating instructions. Computers don't mind drawing a line **10** times, **100** times, or even **1,000,000** times. It's what they were designed to do all those decades ago.

Because the Processing instructions for repeating code aren't as simple as they could be, we'll start from very simple ideas and gradually build up from there. Processing isn't perfect, no programming language is, and how it does repetition is one of those bits that they could have made simpler.

So let's start by imagining how we might count to **5** if we were a computer. To do this we have to pretend we have very little intelligence, or even experience of counting. Remember,

computers don't have any real intelligence at all, and they need to be told exactly what to do, and how.

What's the first thing we need? Well, we need to know where we're starting the count from. When we say "count to 5", I assume we're starting from **1**. Maybe you assumed we're starting from **0**? While we're at it, perhaps you thought "counting to 5" meant up to, and including **5**? Some people might say that "up to" means not including **5**.

This all shows how human conversation is imprecise, ambiguous, and full of assumptions which may not be correct. We need to be totally unambiguous and precise when instructing a computer.

So we've already decided we need a clear starting number, and a clear ending number.

What do we do now? Well, we know our first number is going to be that starting number, which is **1** in the diagram above. How do we pick our next number? We add **1** to it, to get **2**. That gives us our next number. Let's picture it.

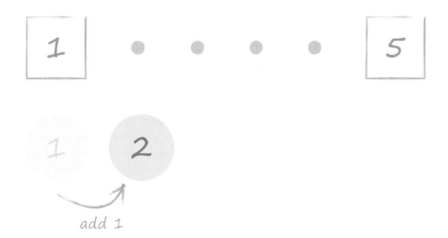

What next? You guessed it, we add **1** again to get **3**. You can see how our count is working. We started with **1**, which became **2**, and now we have **3**.

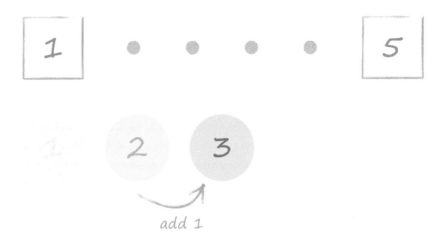

You can see how we keep going until our counter reaches the last ending number, **5**.

When our counter reaches that ending number, we stop.

Phew! That seemed like a lot of work just to count to **5**! We actually needed to talk through that detail because that's how we count things in Processing.

Have a look at the following code, and see if you can guess what each little bit of it does. Keep in mind how we just counted from **1** to **5**, using a **start** and **end** number.

```
for (var count = 1; count < 6; count = count + 1)
```

That looks like quite a lot of new code that we've never seen before. Don't worry, this is probably the most complicated code we'll ever see in Processing. I really mean that. All other code that I can think of is simpler than this, so if you can get through this, you can get through anything!

Let's see if we can understand that code by looking at smaller bits of it. Inside the brackets we can see three things, separated by semicolon. We already know that semicolons are used to separate different instructions, and here they play a similar separating role.

The first of those three things is **var count = 1**. Can you see how that's related to the counting example we just talked though? That **1** is the starting number, the one we count up from. So what is **count**? That is the number we're using as a counter. We can name it anything, like **dog** or **banana**, but it's good practice to use names that make sense, like **count**. The **var** simply tells Processing that we're about to create a new named thing, in this case **count**. Because we set it to **1**, that thing is a number, but you can create other kinds of things too, like a bit of text. The instruction is called **var** because these things are properly called **variables**.

Whenever we use the variable **count**, it will act as a number. Remember when we used numbers for the location or size of a circle? Instead of using an actual number like **20**, we could use **count**, and Processing will interpret it as the number that **count** is set to. For example, **count = 10**, sets **count** to **10**.

Let's jump past the middle bit, and look at the last bit, **count = count + 1**. Can you guess what that bit of code does? When we looked at counting from **1** to **5** earlier, we were increasing the counter by **1** at every step of the counting. That's what this does. It adds **1** to **count**, and sets **count** to the new number, replacing whatever it was before. So if **count** was **7**, **count + 1** is **8**, and so **count = count + 1**, sets **count** to be **8**, overwriting the previous **7**.

So what was that middle bit we skipped over? That middle bit says **count < 6**. This must be saying something about the last ending number, because we haven't done that yet, and we need to at some point. How is this saying the last number is **5**? Take a deep breath, pause, and the mystery will be solved! We started with **count** set to **1**. At every step of the counting, we increase **count** by **1**, so it goes to **2**, **3**, **4** and so on. Instead of saying directly that we stop when **count** is **5**, Processing wants to know when to keep going. And we keep going as long as **count** is less than **6**. You may recognise that symbol **<** meaning less than.

Phew! That was hard work.

I'm not going to pretend Processing does this in a nice way at all. The reason it's like that, is because Processing is descended from Java, once a very popular programming language, and the makers of Processing didn't take the opportunity to make counting and repetition simpler. Anyway, it's the most complicated bit of code we'll ever need to understand, everything else is simpler and nicer.

So what does that counting code have to do with repetition, which is what we wanted to do in the first place? Have a look again at the code, this time with a tiny bit added.

```
for (var count = 1; count < 6; count = count + 1) {
```

```
    ellipse(100, 100, 50);
}
```

We've added curly brackets after the code we just looked at, and inside these curly brackets we can see a very familiar friend, the instruction to draw a circle.

Now we hit the magic. That circle is going to be drawn **5** times. We don't need to write out the **ellipse()** instruction **5** times. That counting code starts the counter at **1**, and keeps increasing it, until it reaches **5**. And any code inside the brackets will be run at every step of that counting.

I was quite lost the first time I came across repetition done like this. So let's go through it one more time, but this time visually, step by step. The following shows what the code is doing at each repetition.

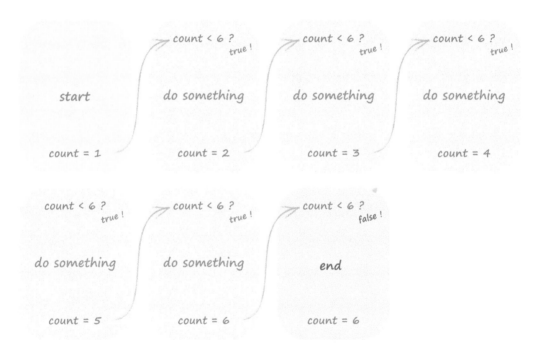

- To begin, **var count = 1**, creates the variable called **count** and sets it to the number **1**.

- Then the condition for continuing is tested. That condition is **count < 6**, which checks to see if **count** is less than **6**. If it is true, then whatever instructions are inside the curly brackets **{}** are carried out. For us, this is drawing a circle.

- Once those instructions are carried out, shown as **do something** above, then increase **count** by **1**. The code that does this is **count = count + 1**. That leaves **count** as **2**.

- Now we go back to that test to see if we should continue, **count < 6**. This is true again, because **count** is **2**. So the instructions inside the curly brackets, **do something**, are carried out again. Once that's done, increase **count** by **1**. That leaves count as **3**.

- Now we go back to that test to see if we should continue, **count < 6**. This is true again, because **count** is **3**. So the instructions inside the curly brackets, **do something**, are carried out again. Once that's done, increase **count** by **1**. That leaves count as **4**.

- Now we go back to that test to see if we should continue, **count < 6**. This is true again, because **count** is **4**. So the instructions inside the curly brackets, **do something**, are carried out again. Once that's done, increase **count** by **1**. That leaves count as **5**.

- Now we go back to that test to see if we should continue, **count < 6**. This is true again, because **count** is **5**. So the instructions inside the curly brackets, **do something**, are carried out again. Once that's done, increase **count** by **1**. That leaves count as **6**.

- Now we go back to that test to see if we should continue, **count < 6**. This is no longer true. That's because **count** is **6**, which is not less than **6**. The instructions inside the curly brackets, **do something**, are not carried out.

- We break free of this **for** loop, and Processing carries on with the rest of your program.

You can see why this is called a **loop**. It's because Processing will go round and round that code until it is allowed to break free and escape. In fact, this construct is called a **for loop** by experienced coders.

Enough talk, let's try this new magic. The following code draws five circles of size **50**, at a random location on the canvas.

```
function setup() {
  createCanvas(800, 600);
  background('white');
  noLoop();
}

function draw() {
  noStroke();
  fill('red');

  for (var count = 1; count < 6; count = count + 1) {
    ellipse(random(800), random(600), 50);
  }
```

```
}
```

You'll recognise the familiar use of **random()** to pick a random location on the canvas. You'll also see that **for** loop, with the **count** starting at **1**, and running as long as count is less than **6**. Here is the resulting image. Yours will be different because the circle locations are random.

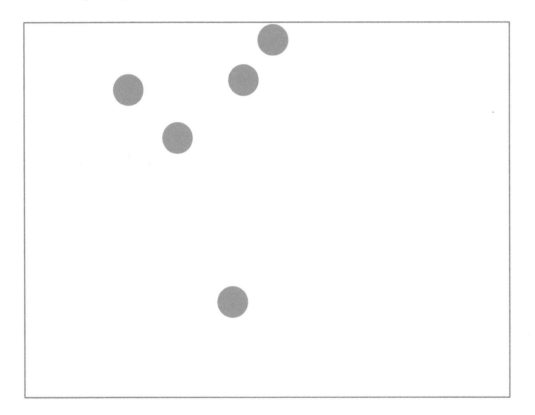

You may be thinking that all the effort trying to understand that **for** loop wasn't worth it. All we got was a canvas with five randomly placed circles, and we've done that before without loops.

But notice that we only typed the instruction for drawing a circle once. Not five times. Now if we changed that **count < 6** to **count < 51**, we should get **50** circles, without any further effort typing on our keyboard. That's **50** circles without having to type the **ellipse()** instruction **50** times!

You can see how this style of coding is very efficient.

What if we used **count < 101**? We'd get **100** circles. One hundred circles, with only a tiny change in the code. There's no way I was going to write the **ellipse()** instruction **100** times!

What if we used **count < 1001**? We'd get **1000** circles! You can see the huge power of code now.

Let's have a play, and modify that code to create **50** transparent circles, with a thin red outline. Let's also constrain the circles centres to not be too close to the edge. We created a fenced off box to do this before.

```
function setup() {
  createCanvas(800, 600);
  background('white');
  noLoop();
}

function draw() {
  stroke('red');
  noFill();

  for (var count = 1; count < 51; count = count + 1) {
    ellipse(random(100,700), random(100,500), 50);
  }

}
```

The results are really cool!

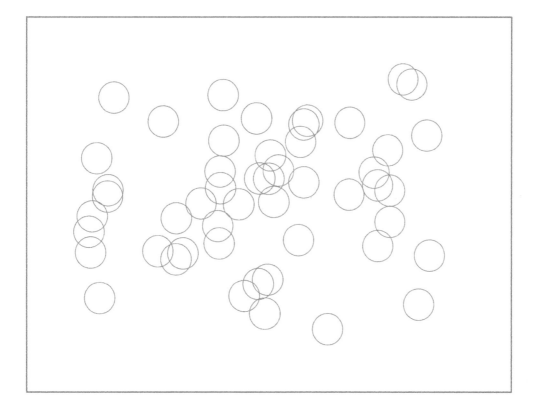

That's a nice composition. In fact, re-running the code several times seems to always result in a nice composition. It's also very satisfying knowing that we used the power of Processing to place the circles, and to draw **50** of them by repeating the drawing instruction.

Let's try **200** circles.

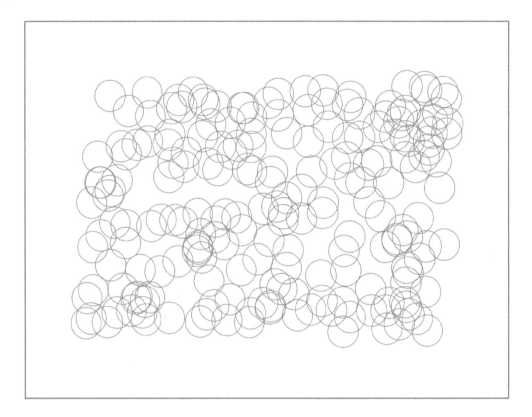

The composition is denser in parts, but not too dense. There's a nice balance of emptier parts and busier parts. I like it!

Why not try **1000** circles, especially as it is so easy!

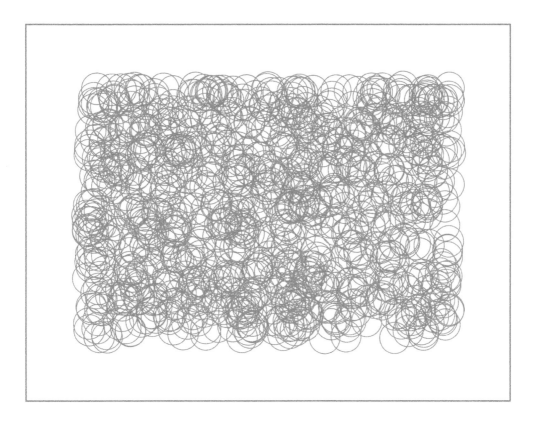

That's much busier, but I think still rather balanced, with just the right amount of variation from denser parts to less dense parts. It draws your eye into it, to explore for a few moments.

What We've Learned

That last section was quite hard work, but it was worth the effort for two reasons. Firstly, repetition is a powerful element of composition in art, and we've learned how to do it elegantly and efficiently. Secondly, repetition is the most common tool used in almost all algorithmic art, and indeed, in many other areas of computer science - you've learned something that will keep being useful for months and years ahead!

It can take some time to become comfortable with the way Processing does repetition and loops. Have a look at Appendix A which works through a few examples of repetition and loops, explaining each one step by step.

Key Points

- Repetition is a technique that can make very strong compositions.

- In Processing, repetition is achieved by **counting** from a **starting number** to an **ending number**. We can say which instructions are repeated for each count.

- In Processing code this is written as **for (var count = 5; count < 11; count = count + 1) { }** where **count** is the name we have chosen for the counter. In this example, we start from **5** and count up to **10**, by increasing **count** by **1** repeatedly. The middle bit **count < 11** is a **condition** which decides whether to keep going with the repetition or stop. The code we want to repeat is placed inside the curly brackets **{ }**.

- Computer programmers code which repeats a **loop**. The above code is often called a **for loop**, because there are other kinds of loops too.

Repetition - Using The Counter

In the last section we learned about **for loops** and how they are used to carry out instructions repeatedly.

All that stuff about counters, conditions and incrementing the counter, seems rather complicated if all we want to do is repeat some code, say, **5** times. We're now going to see how those counters can, in fact, be really very useful.

Previously we drew circles at random locations on the canvas. That worked well because every time the **for loop** was repeated the **random()** instruction gave a different number to use for the coordinates of the circle centres.

What if we want to draw several circles evenly spaced along the middle of the canvas. Like the following:

We could specify the locations of the circles, working out the coordinates ourselves. But that wouldn't be fun if we had, say, **10** circles. And totally impractical if we had **200** circles!

How does a loop counter help us? Have a look at the same arrangement of circles, but this time with some coordinates shown to see if we can spot it.

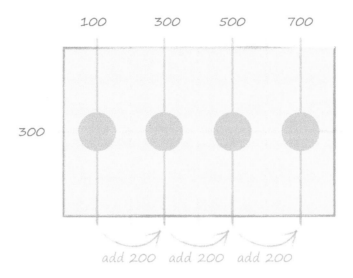

What can we see? We can see the circles are evenly spaced. That's what we wanted. We can see that the centres of the circles are **200** pixels apart along the horizontal axis. That's the spacing between the circle centres. The first circle is at horizontal position **100**. The next one is at horizontal position **300**. The next one **500**, and the final one at **700**.

To repeat that point, because it is important, to get from **100** to **300** we add **200**. To get to the next one we add **200** again, which gives us **500**. And to get to the final one, we add **200** again. That gives us the final **700**.

So the pattern is clear. We keep adding **200** to get to the next one.

Can you see how this relates to a **for loop**? We can start the counter at **100**, keep adding **200** until we get to the final number **700**. Let's see if we can try to write that in code:

```
for (var count = 100; count < 800; count = count + 200) {
    ellipse(count, 300, 50);
}
```

Let's talk through that **for loop** step by step to make sure we understand it. We know the first part of defining a **for loop** is to create a counter with a starting value. Here we've created a counter called **count**, and given it the value **100**. We also know that we need to increment the counter every time we go around the loop. Normally we'd increase a loop counter by **1**, but here we're increasing it by **200**. The other bit is the condition, which decides whether we continue going around the loop or whether we stop and bail out. That condition here says we keep going around as long as the counter is less than **800**, which is the full width of the canvas.

None of that is new, and we've practised these ideas before. Let's look inside the curly brackets. We expect to see an instruction for drawing a circle. That's the code that's repeated every time we go around the **for loop**. Again that's not new.

What is new, and rather magical, is that we're using the counter inside the code. Look again and you'll see it:

```
for (var count = 100; count < 800; count = count + 200) {
    ellipse(count, 300, 50);
}
```

We've used the variable **count**, as the horizontal location of the circle's centre. What does this do? Well, every time Processing executes that code, it will interpret the variable **count** as the number it has at the time. Let's talk that through, step by step:

- When we first go around that loop, **count** is **100**. That means the code **ellipse(count, 300, 50)** will be interpreted as **ellipse(100, 300, 50)**.

- That circle is drawn, and **count** is increased by **200**. It is now **300**.

- This time **ellipse(count, 300, 50)** will be interpreted as **ellipse(300, 300, 50)**.

- The circle is drawn, and **count** is increased by **200**. It is now **500**.

- This time **ellipse(count, 300, 50)** will be interpreted as **ellipse(500, 300, 50)**.

- The circle is drawn, and **count** is increased by **200**. It is now **700**.

- This time **ellipse(count, 300, 50)** will be interpreted as **ellipse(700, 300, 50)**.

- The circle is drawn, and **count** is increased by **200**. It is now **900**.

- Because **count** is **900**, and no longer less than **800**, Processing stops going around the loop.

The important point here is that the loop counter can be used inside the repeated code, and each time it is interpreted, its current value is used. That's very powerful concept that algorithmic artists really exploit.

Here's the code for the sketch.

```
function setup() {
  createCanvas(800, 600);
  background('white');
}
```

```
function draw() {

  noStroke();
  fill('violet');

  for (var count = 100; count < 800; count = count + 200) {
    ellipse(count, 300, 50);
  }

}
```

The results look like the following.

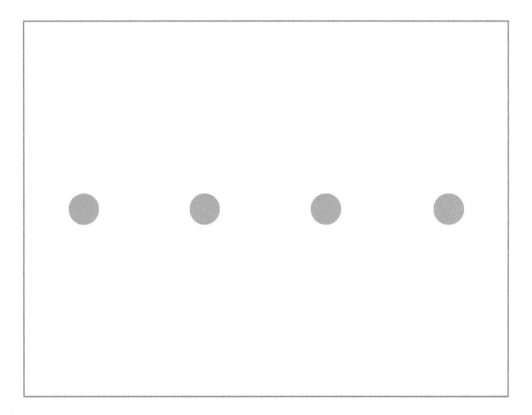

Now let's start to see the power of using loops and counters.

What if we increased the counter by a smaller amount, say **100**, not **200**. That's only a single small change to the code.

```
function setup() {
  createCanvas(800, 600);
  background('white');
```

```
}

function draw() {

  noStroke();
  fill('violet');

  for (var count = 100; count < 800; count = count + 100) {
    ellipse(count, 300, 50);
  }

}
```

What should we expect? Well, the count is being used as the horizontal coordinate of the circle centres. If we're increasing it by a smaller amount every time we go round the loop, the circles should be closer together.

So if the circles will be closer together, will there be more circles in total? The code only cares about repeatedly drawing circles until the count reaches **800**. If that means it draws more circles before that happens, so be it. So yes, more circles will get drawn, because we're moving to the **800** limit in smaller **100** pixel steps, drawing a circle as we go.

Here's the result.

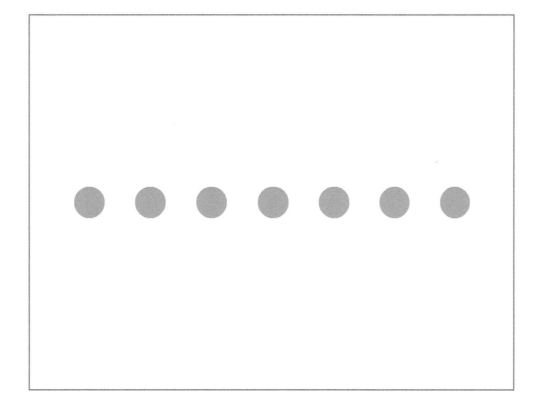

The following diagram shows why there are seven circles.

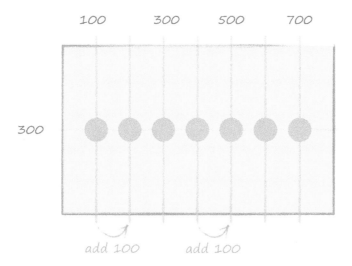

You can see that if we start at **100**, and keep adding **100**, our horizontal coordinate increases through **200**, **300**, **400**, **500**, **600** and **700**. There is no eighth circle because the code only loops while the counter is **less than 800**. That is actually what we want, because we don't want a circle on the edge of the canvas.

Let's do something different now. Let's start the counter at **0**, not **100**. Let's keep the loop going while the counter is **less than or equal to 800**, the right hand edge of the canvas. Let's also make the counter increase by an even smaller **50**. Here's the code.

```
function setup() {
  createCanvas(800, 600);
  background('white');
}

function draw() {

  noStroke();
  fill('violet');

  for (var count = 0; count <= 800; count = count + 50) {
    ellipse(count, 300, 50);
  }

}
```

Notice that strange **count <= 800** loop condition. That **<=** means **less than or equal to**. It's true if the count is less than or equal to **800**. Before we had **count < 800**, which would only be true if count was less than **800**, and not if **count** was exactly **800**. We've made this change because we're happy for the circles to reach the very right hand edge of the canvas.

Here are the results.

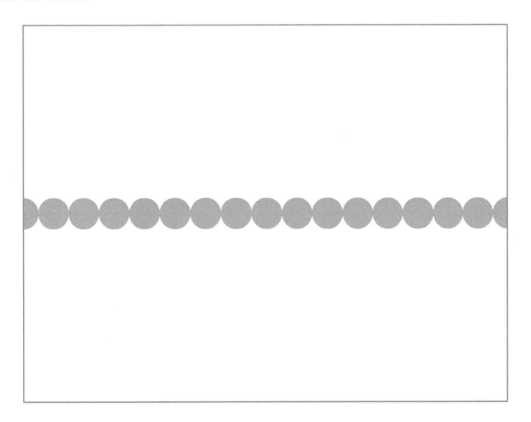

That's a nice design! And it beautifully illustrates the power of code to do repetition efficiently.

Let's keep going with the craziness. Let's make the circles, bigger, transparent but with a thin **violet** coloured outline stroke, and make the gap between them even smaller.

```
function setup() {
  createCanvas(800, 600);
  background('white');
}

function draw() {
  stroke('violet');
  noFill();

  for (var count = 0; count <= 800; count = count + 10) {
```

```
      ellipse(count, 300, 250);
  }

}
```

Here's what the code creates.

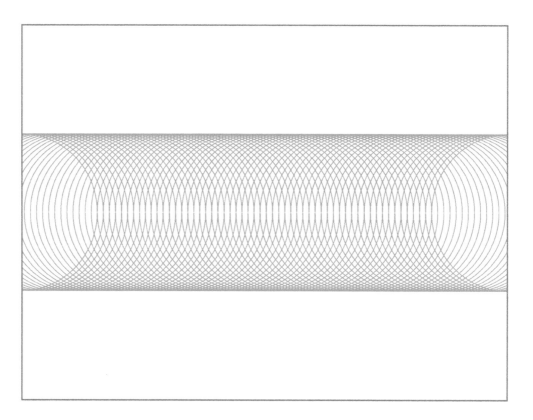

Woah - that's pretty cool! And all that from some very simple code. It really shows the power repetition made easy with code.

Have a play yourself, with different kinds of circle, and different sized steps for incrementing the counter. If you want to be even crazier, try using **count** to affect the size of the circle somehow.

Just because this is so fun, I couldn't resist having a go myself. Why should you have all the fun! The following experiments show the same code as above but with counter deciding the diameter of the circles. Can you see how this works?

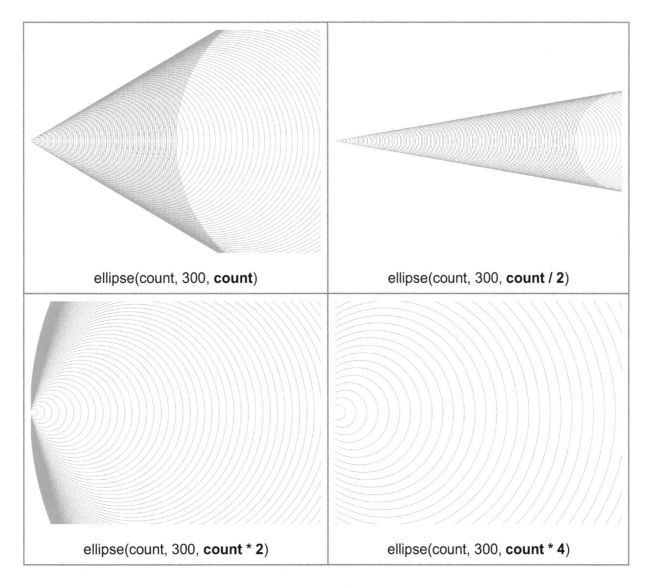

ellipse(count, 300, **count**) | ellipse(count, 300, **count / 2**)

ellipse(count, 300, **count * 2**) | ellipse(count, 300, **count * 4**)

The first experiment uses **count** as the diameter of the circle. As the **count** increases, and the circles are drawn further and further to the right, they are also drawn larger and larger.

The second experiment uses **count / 2** as the diameter. That simply tells **Processing** to take the value of **count** and divide it by **2**. This has the effect of making the circle sizes grow at a slower rate.

The last two experiments are the opposite of the second one. The **count * 2** means multiply **count** by **2**, and **count * 4** means multiply it by **4**. So these circles grow bigger at a faster rate.

Take a break before continuing - we're going to be bending our minds next.

A Loop Within a Loop

Before you call the police to have me locked up, have a think about this scenario. Imagine, you're lucky enough to have a large garden with many apple trees. One afternoon, when all the apples are ripe, you ask your robot to harvest them. How would you program your robot to do that?

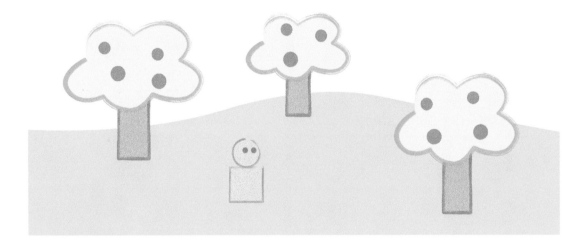

Well, however you do it, there will be two important loops in your code:

- **Loop 1 - go to every tree in the garden**. Visit the first one, then the next one, then the next one, then the next one … until the last one.

- **Loop 2 - pick every apple from the tree**. Pick the first one, then the next one, then the next one, … until the last apple.

But you can see that **loop 2**, picking every apple from a tree, must be done for every single tree that's visited, which is **loop 1**.

Another way of saying that is for every tree in **loop 1**, we run through all of **loop 2**, picking all the apples from that tree, before we move on to the next tree in **loop 1**. My brain is melting so let's draw a picture of this idea.

loop 1

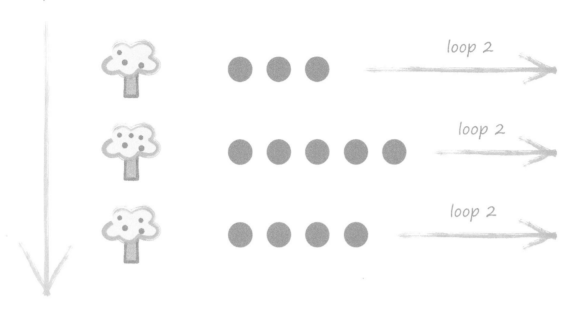

You can see that the first thing we do is start **loop 1**. That loop is about visiting every tree, but we do that one tree at a time. So we go to the first tree. Loops are about repeating instructions, and in this case, instead of drawing a circle or a line, the repeated instructions are another loop, **loop 2**.

We know **loop 2** is about going to every apple in a tree and picking it. That **loop 2** repeats instructions for every apple until it is done. The first tree has three apples, so **loop 2** repeats three times, and is then done. What happens next? We go to the next item in **loop 1**, which is the next tree.

What happens now? Well, we repeat the instructions that **loop 1** wants us to repeat for every tree. And that's **loop 2** again. So we visit all the apples in this second tree and pick all of them. The second tree has five apples, so **loop 2** runs five times.

And so on .. until we've visited all the trees, and picked all their apples.

Let's see if we can connect this idea of loops within loops to code and drawing shapes. If we look at that picture above, we can see how the apples are drawn as red circles horizontally for each tree. The rows are for separate trees. Maybe we can do something similar. Have a look at the following code:

```
for (var tree = 1; tree < 4; tree += 1) {
    for (var apple = 1; apple < 6; apple += 1) {
        ellipse(apple * 100, tree * 100, 50);
```

```
      }
    }
```

You can see the familiar **for loop** code on the first line. We're setting up a counter called **tree**, and starting from **1**, and incrementing it up to **3**. That **tree += 1** is shorthand for increasing **tree** by **1**, it's shorter to write than **tree = tree + 1**. So we have three trees.

The code inside the blue curly brackets is the code that's repeated for every **tree**. But here we have another **for loop**. It's a loop with a counter called **apple**, which starts at **1** and grows to **5**. Inside the green curly brackets is the code that's repeated for every **apple**, and here we finally do some drawing.

So this code is doing what we were doing in the garden scenario, visiting every tree, and then for every tree, visiting every apple.

So what do we do for every apple? The instruction we can see is the familiar **ellipse()** to draw a circle. Where are we drawing this circle? The vertical position is defined by the **tree** counter, just multiplied by **100**, to make it big enough to better match the size of our canvas. Remember that **tree** cycles through **1**, **2** and **3**. That means **tree * 100** is **100**, **200** and **300**.

So we expect the apples for each of the three trees to be drawn at different vertical heights on the canvas. Just like that picture we drew.

What about the horizontal position of the circles? That depends on the **apple** counter, and is set to **apple * 100**. The **apple** counter goes from **1** to **5**, so the horizontal location goes through **100**, **200**, **300**, **400**, and **500**.

That means the apples for each tree will be drawn as circles horizontally for each tree.

Here's the full code:

```
function setup() {
  createCanvas(800, 600);
  background('white');
}

function draw() {
  noStroke();
  fill('red');

  for (var tree = 1; tree < 4; tree += 1) {
    for (var apple = 1; apple < 6; apple += 1) {
      ellipse(apple * 100, tree * 100, 50);
```

```
      }
   }

}
```

You may have noticed that the repeated code inside the loops is indented. In fact you may have noticed even earlier in this book that the code inside the curly brackets **{ }** for the **setup()** and **draw()** functions is also indented. That's not strictly necessary in Processing but is a very useful style to adopt, because it helps us quickly and visually see the structure of the code. We can look and see very quickly where the loops and repeated code are. I can look at that code above and see that **ellipse()** is potentially repeated lots as it is inside two loops.

Intending is such a good idea that some other languages require it, it's not optional!

The **openprocessing** code editor will try to help you with this indenting style by automatically creating an indent when you press return after the first curly bracket, and then a bigger indent after the second curly bracket.

Here's what the code creates.

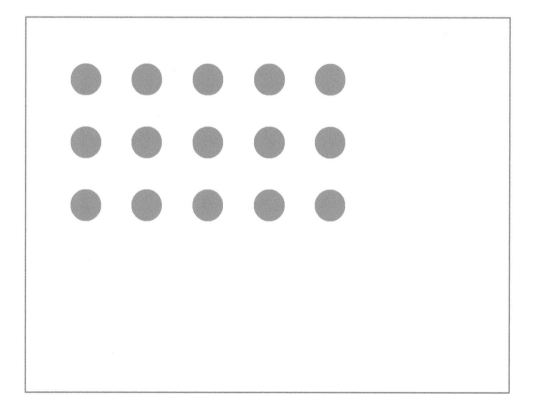

That worked! Each red circle along a row represents the five apples on a tree. And each row represents one of the three trees.

That image may look simple, but what we've actually done is started to use the power of loops within loops. Let's see what's possible.

Let's fill the canvas by having five trees, and seven apples for each tree. We just change the conditions in the for loop code to **tree < 6** and **apple < 8**. The result looks like this.

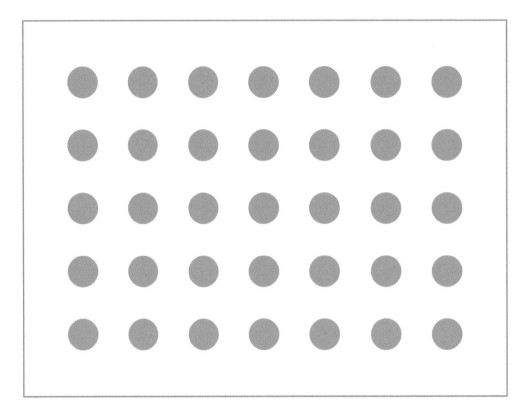

So loops within loops, or **nested loops** as some people call them, are great for filling the canvas, because it is easy to move along and down the canvas in steps. We don't need to do it manually, we just get the loop counters to do all the hard work for us. Doing it manually would mean working out the locations of all 35 circles individually.

Let's practice these ideas a bit more.

Let's draw a leaf for every apple. To keep things simple, we'll just draw a green triangle, and pretend it's a leaf. How would we do that? Well, again, we don't want to do it manually for every location that an apple might be. We want to exploit the power of the nested loops, and see if the counters can help us.

This kind of thinking, trying to get loop counters to help us, is the way an algorithmic artist thinks. Trying to harness the power of code, finding automated ways of working things out, and avoiding manually repetitive and boring ways of working. It's being lazy in a smart way.

Let's draw a picture to see how we might draw a leaf on every apple, in a way that makes use of the counters. Let's start with a red circle, showing its location worked out using the **tree** and **apple** counters.

You can see the horizontal coordinate of the circle centre is **apple * 100**. We've shortened this to just **x**, saving us from having to write out **apple * 100** every time. Similarly the vertical coordinate of the circle centre is **tree * 100**, which we'll call **y**. None of this is new, except perhaps using a shortcut like **x** and **y**. Remember that **x** will increase when the counter **apple** increases, and the same happens for **y** when **tree** increases.

Now let's draw a picture focussing on that green leaf triangle.

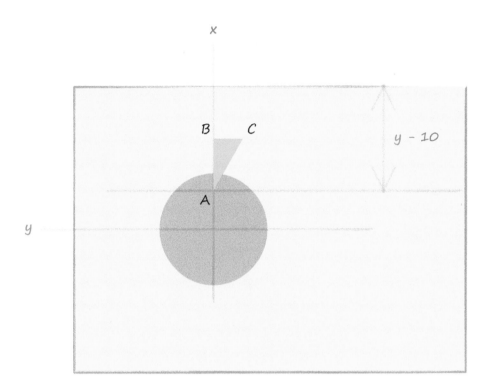

That looks complicated but it's not really. There are just a few things on that diagram, but each one is easy to understand, so let's take it step by step.

Let's first look at the bottom corner of the triangle, labelled **A**. The horizontal coordinate of that corner is the same as the circle centre. You can see that from the picture, as that corner **A** is directly upwards from the circle centre. It was a bit to the left or a bit to the right, the horizontal coordinate would be different. We know from the first picture that this horizontal coordinate is **x** or **apple * 100**. What about the vertical coordinate of **A**? Well it higher up compared to the centre of the circle, which was at **y**, so it will be a little less than **y**. Let's try ten pixels less, or **y - 10**. We don't want it too high, or it will be higher than the circle itself. You can see that height marked on the picture with a horizontal line which touches the **A** corner of the triangle. So that corner **A** has coordinates **(x, y - 10)**.

What about the corner labelled **B**? Let's do another picture with more lines marked on it to help us.

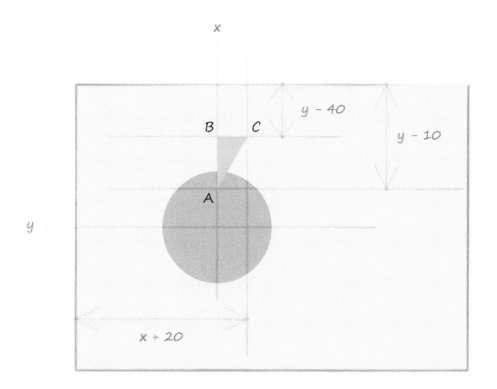

That corner is directly above **A** and also the circle centre. That means its horizontal coordinate is **x**, just like **A**. That was easy! What about its vertical coordinate? Well, we want it to be higher than the top of the circle. Remember the circle has a diameter of **50**, so it's radius is half that, **25** pixels. That means the top of the circle is at **y - 25**. So our triangle corner **B** must be higher than that. Let's try **y - 40**. We can always adjust these guesses later if we're not happy. So the coordinates of **B** are **(x, y - 40)**.

Hang in there .. only one more corner to go! That corner **C** isn't above the circle centre, but is a bit to the right of it. That means its horizontal coordinate must be more than **x**. Let's try **x + 20**. In the picture we've set that corner to be level with **B**, that is, the same height. So the vertical coordinate is decided for us at **y - 40**, just like **B**. The coordinates of **C** are **(x + 20, y - 40)**.

Here's a summary of what we've just worked out:

- corner **A** is at **(x, y - 10)**

- corner **B** is at **(x, y - 40)**

- corner **C** is at **(x + 20, y - 40)**

Phew! That was hard work. But we only have to do it once. And we've succeeded in defining the green leaf using the counters **apple** and **tree**, which means our computer can do all the hard work working out the coordinates for all the leaves on all of the **35** apples.

Let's add this green leaf to our code.

```
function setup() {
  createCanvas(800, 600);
  background('white');
}

function draw() {
  noStroke();

  for (var tree = 1; tree < 6; tree += 1) {
    for (var apple = 1; apple < 8; apple += 1) {

      // circle centre from counters
      var x = apple * 100;
      var y = tree * 100;

      // red circle for apple
      fill('red');
      ellipse(x, y, 50);

      // green triangle for leaf
      fill('green');
      triangle(x, y - 10, x, y - 40, x + 20, y - 40);

    }
  }

}
```

We can see the familiar loop for the trees, and the loop inside that one for the apples. But what's that next line beginning with the two forward slashes // ? Those special symbols // tell Processing to ignore the rest of that line. Why is that useful? It's not useful for our computer, but it is useful for us to be able to write **comments** to ourselves, or anyone else who might want to read our code. Such comments are good practice, and are especially helpful if it isn't obvious what the code is supposed to be doing. I use comments to help myself when I return to code days or weeks later.

So we've written a comment to ourselves that says // **circle centre from counters**. That helps us remember what the next bit of code is doing. We're using the **apple** counter and creating a new **variable** called **x**. That **x** will take the value of **apple * 100**, every time that code is repeated. When the counter **apple** grows, so does **x**. Have a look back at that picture we did above, to remind ourselves that **x** is a shortcut for the horizontal coordinate of the circle centre.

The same thinking applies to the variable **y**. It is the vertical coordinate of the circle centre, and is calculated from the **tree** counter, as **y = tree * 100**.

After that we see a comment **// red circle for apple**. That reminds us the next bit of code is for drawing a red circle centred at **(x,y)** and with a diameter of **50**.

The final comment **// green triangle for leaf**, helps us remember the next bit of code is drawing the green leaf. You can see the familiar **fill()** instruction to set the green fill colour. After that you can see a **triangle()** instruction for drawing the leaf. Inside the brackets are the coordinates of the three corners we just worked out, **A** at **(x, y - 10)**, **B** at **(x, y - 40)**, and **C** at **(x + 20, y - 40)**.

Let's see the results:

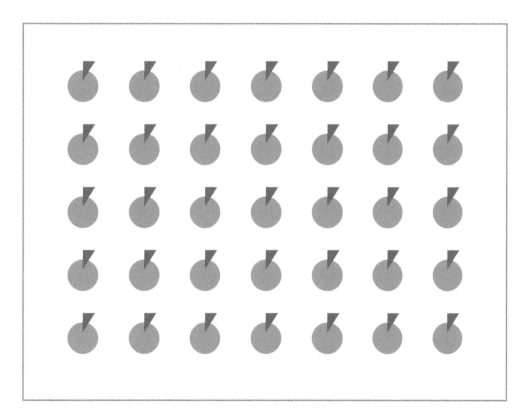

Nice!

I'll admit this art is probably not going to be hanging on my own wall, but the reason we did it was to work through how we can make use of the loop counters to create elements of our composition, like the leaf. This ability to spot how we might use loops, and loop counters, to make them work for us, is an important skill for an algorithmic artist. It comes with practice and seeing how other algorithmic artists create their own work.

Have a play, experiment with your own loops. Maybe you can have three levels of nested loops? A loop within a loop, which itself is within another loop!

Again, because it's so fun, I had a go too. My idea is to see if the colour of the apples could also be connected to the counters. That is, as the counters changed, the colour of the apples would change too.

This seems to be impossible. How can we use a counter, which goes from **1** to **7** like the **apple** counter for example, and use that to choose a colour? Turning counters into coordinates wasn't so difficult as they're both numbers. But colours, like **'red'** and **'white'** and **'yellow'** aren't numbers.

Actually, colours are defined by numbers, but we've avoided exploring that for now to keep things simple. Luckily, Processing has a nice instruction which takes two colours, and gives us a colour that's part way between the two colours. It uses a fraction, between **0** and **1**, to decide how far from the first colour, towards the second colour, its chosen colour is. This is best explained using pictures.

Here are two colours, **red** and **white**. The start colour is **red**, and the end colour is **white**. You can see underneath a colour scale that gradually changes from the start colour **red** to the end colour **white**. Along that scale you can see some nice pinks!

We want a way to say how far along this scale our chosen colour is. If we're **0** along, we're still at the start, so we keep **red**. If we're all the way along, at **1**, we end up at full **white**.

Have a look at the next picture.

start colour 0.5 end colour

You can see that half way along the scale, we have an intermediate **pink**. Halfway along is **0.5** along. That's the fraction we'd use if we wanted to pick a colour halfway between the start and end colours.

How about a colour that's three quarters of the way along? That's **0.75** along.

start colour 0.75 end colour

You can see this pink is much lighter, and is picked up from a point three quarters along the scale towards **white**.

This magic instruction has a weird name, **lerpColor()**. We don't need to know what **lerp** means, to know what it does. If you are interested, it's a geeky shorthand for **linear interpolation**, which is just a very fancy way of saying that we're connecting two things by a straight path, and picking a value along that path. Here's how it's used:

```
lerpColor(start_colour, end_colour, fraction);
```

The instruction **lerpColor()** takes three bits of information. These are just the ones we've talked about; the start colour **start_colour**, the end colour **end_colour**, and a **fraction** between **0** and **1** telling it how far along that colour scale to go and pick a colour from.

Notice that **lerpColor()** uses the American spelling, not the British spelling for colour.

Let's look at the full code for the sketch.

```
function setup() {
  createCanvas(800, 600);
  background('white');
}

function draw() {
  noStroke();

  for (var tree = 1; tree < 6; tree += 1) {
    for (var apple = 1; apple < 8; apple += 1) {

      // circle centre from counters
      var x = apple * 100;
      var y = tree * 100;

      // colour between red and yellow for apple
      var start_colour = color('red');
      var end_colour = color('yellow');
      var fraction = apple / 7;
      fill(lerpColor(start_colour, end_colour, fraction));
      ellipse(x, y, 50);

      // green triangle for leaf
      fill('green');
      triangle(x, y - 10, x, y - 40, x + 20, y - 40);

    }
  }

}
```

We've changed the comment to remind us we're picking a colour between **red** and **yellow**. We've also created a variable called **start_colour**. Its value is **color('red')** which is Processing's way of turning the shorthand **'red'** into numbers, which are how it prefers to think about colours, which we'll cover later in this book. The same is done for **end_colour**, which is

yellow. The **fraction** is set as the counter **apple** divided by **7**. Because the counter **apple** goes from **1** to **7**, the calculated variable **fraction** will go from **0.14286** to **1.0**, which is fine for us to get a nice spread of colours from the scale.

Notice how the **lerpColor()** sits inside **fill()**, because that's how we set the fill colour for our circles. Let's see the results.

Cool!

The reason the colours change along the horizontal direction is because we only used the **apple** counter to decide the colour, not the vertically changing **tree** counter. That's something to try for yourself.

You can find the sketch online at https://www.openprocessing.org/sketch/455263.

What We've Learned

We previously learned about repetition as a powerful technique for both design and for coding. We built on that by taking advantage of the **counters** in code **loops**.

Appendix A works through more examples of repetition and code loops, explaining each one step by step.

Key Points

- Repetition in computer programming is done with **loops**. These **loops** often have a **counter**, which keeps track of how often the loop code has been repeated.

- These **counters** are extremely useful inside the content of the repeated code.

- For example, **counters** can be used to calculate **locations** on the canvas. This can be used to easily cover the canvas with shapes. Another example is **counters** being used to calculate **colours** from a scale.

- **lerpColor(colour_1, colour_2, fraction)** picks a colour that is **fraction** along the colour scale from **colour_1** to **colour_2**.

Worked Example: Splatter!

In this worked example we're continuing with the theme of our previous worked example, **Paint Drops**, but now we're going to take advantage of the new techniques we've learned.

We'll use **repetition**, **loops** within loops, **randomness** and selecting **colours** from a palette too.

Let's start with the main idea, which is only an idea in our heads at this stage. The idea isn't about code or maths - yet. That's not a bad thing. Some of the best original ideas are things we first imagine, and have nothing to do with code or maths.

So the idea is that paint is thrown on the canvas, but importantly, it does not land completely randomly. We want to replicate what happens in the real world, where paint lands in clumps, with the drops grouped together in a loose way. The following picture shows this idea.

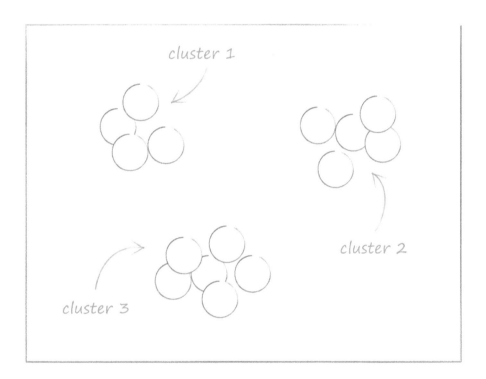

You can see three groups of paint drops. You can also start to see that the actual drops are randomly arranged but within that group, near the other drops in the same group. **Cluster** is just a fancy name for group.

Note that we're not throwing the blobs completely at random on the canvas. We did that before, and that's a nice effect, but means the blobs are roughly evenly spread over the canvas. We don't want that. We want to create these groups, these clusters of blobs.

How do we go about doing that?

It's a good idea to use a pencil and paper to start to plan out how more complex algorithmic art ideas might work. Almost all moderately complex works start as ideas then sketches with pen and paper. Pen and paper isn't something a digital algorithmic artists should avoid. There is an immediacy that helps the design and experimentation process, that computer tools just don't have yet.

The first thing that leaps out is that we need to decide where those clusters are before we can do anything else. We can't place those individual drops if we don't know which cluster they're in.

Can we use complete randomness to pick a location for the clusters? Perhaps an imaginary centre of the cluster? I think we can but let's try it. If it doesn't work, we'll try something else. That's how we should experiment as part of our creative process.

Let's use a loop to create **5** clusters, and keep them away from the edge of the canvas by using an imaginary fence that's **100** pixels away from the edge, just like we did before.

The code for deciding the centres of these clusters should be familiar:

```
// main clusters
for (var cluster = 0; cluster < 5; cluster += 1) {

  // location of splatter
```

```
    var x = random(100,700);
    var y = random(100,500);

  }
```

You can see // comments to help us remember what the code does. You may have spotted that the **for loop** goes from **0** to **< 5** and not **1** to **< 6** like we did before. The effect is the same **5** repetitions. Before we had the counter go through **1, 2, 3, 4, 5** and now we have it go through **0, 1, 2, 3, 4**. Some people prefer writing code one way, some the other way.

Inside the loop we create two named variables, **x** and **y**. These are the horizontal and vertical coordinates of the imaginary cluster centres, shown in the picture above. They are chosen randomly but from ranges which keep them away from the canvas edges.

For now, let's draw a small circle just to see where these cluster centres fall. Here is the code so far.

```
function setup() {
  createCanvas(800, 600);
  background('white');
  noLoop();
}

function draw() {

  noStroke();

  // main clusters
  for (var cluster = 0; cluster < 5; cluster += 1) {

    // location of splatter
    var x = random(100,700);
    var y = random(100,500);

    fill('blue');
    ellipse(x,y,10);

  }

}
```

Here are four runs of the code. Remember, yours will be different because the chosen locations are random.

Great - that looks like it is working.

By the way, this use of making marks on the canvas to see what the code is doing, even if they won't be part of the final work, is a useful technique that professional coders use. It's a way to check that the code is doing what we think it is doing, by making it show us visually. Here we've got the code to show us the locations of the imaginary clusters, and as we wanted, they're pretty randomly located but no too close to the edge.

It's easy to make an error in the code, a typo for example, or have the wrong idea completely, like using randomness when we shouldn't. Computer programmers call these **bugs**. That's a fun technical word to know! We sometimes spend ages trying to find these **bugs**, they can be quite elusive.

That's great. Now what?

Now that we've got the locations of the clusters, we can start thinking about splatting paint around those centres. An easy way to do this is to again choose random locations that are forced to stay within an imaginary fence around the cluster centres. A picture shows this familiar idea.

You can see how the blobs of paint don't fall outside that imaginary square fence that we've drawn around the cluster centre.

The way we code this is very similar to how we enforced a perimeter before to keep objects away from the canvas edge. We did that buy limiting the range of numbers that coordinates are randomly chosen from. We can do that here, but this time we use the coordinates of the circle centres, **x** and **y**, to work out what those lower and upper limits are.

Again, a picture helps. Have a look at the following showing a cluster centre at **(x,y)** and the imaginary fence around it.

You can see that the horizontal coordinates of the paint blobs must fall around **x**. The range is from a bit less than **x**, to a bit more than **x**. In the picture we've chosen **50** pixels less, and **50** pixels more. In code that means **random(x - 50, x + 50)**. The same idea applies to the vertical direction, so the paint blobs are located somewhere between **y - 50** and **y + 50**.

Let's update the code to create **5** paint blobs for each cluster centre. That means a loop within a loop. The main outer loop is the one we have already, which creates the **5** clusters. Then for each cluster, we have an inner loop which creates **5** paint blobs near the cluster centre. This is just like the apples and trees example we saw earlier, with the trees being the clusters, and the apples being the paint blobs. Here's the code, and for now we've left in drawing the cluster centres, and used a small pink circle to mark the paint blobs.

```
function setup() {
  createCanvas(800, 600);
  background('white');
  noLoop();
}

function draw() {
  noStroke();

  // main clusters
  for (var cluster = 0; cluster < 5; cluster += 1) {

    // location of splatter
    var x = random(100,700);
    var y = random(100,500);

    fill('blue');
    ellipse(x,y, 10);

    // smaller circles randomly placed around cluster centre
    for (var circle = 0; circle < 5; circle += 1) {

      var circle_x = random(x - 50, x + 50);
      var circle_y = random(y - 50, y + 50);

      fill('pink');
      ellipse(circle_x, circle_y, 10);
    }

  }

}
```

You can see the inner **for loop** creating **5** circles for each cluster, their centres chosen at random but within the imaginary fence around the cluster centre. Let's see what the result looks like.

That makes sense again. We can see the **pink** paint blobs thrown at random, but still close to the **blue** cluster centres. Let's run it again to check all this crazy use of randomness still works.

Yes, that still works. Notice how two clusters are quite close together, which means their **pink** paint blobs will also be close together.

Now that we're happy with the placement of paint drops in a cluster, we can start to think about how those drops look. That is, their shape and colour.

Let's keep going with our use of randomness and try having random sizes for those drops. We don't want very large drops, because they'd dominate the canvas and hide other drops. I think, and I might be wrong, that we don't need to have a minimum size for the drops. Very small drops will be just like very small dribbles of paint. The following code, removes the **blue** and **pink** markers, and now only draws the actual paint drops.

```
function setup() {
  createCanvas(800, 600);
  background('white');
  noLoop();
}

function draw() {

  noStroke();
```

```
// main clusters
for (var cluster = 0; cluster < 5; cluster += 1) {

  // location of splatter
  var x = random(100,700);
  var y = random(100,500);

  // smaller circles randomly placed around cluster centre
  for (var circle = 0; circle < 5; circle += 1) {

    var circle_x = random(x - 50, x + 50);
    var circle_y = random(y - 50, y + 50);
    var circle_size = random(50);

    fill('green');
    ellipse(circle_x, circle_y, circle_size);
  }

}

}
```

You can see the use of the **random(50)** instruction to pick a paint drop size between **0** and **50**, and assign it to a variable named **circle_size**.

Here's what the results from four runs look like.

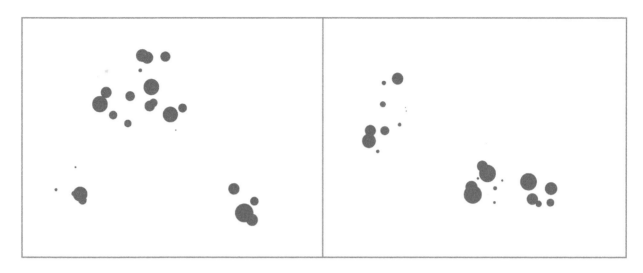

I'm quite pleased with that. As compositions these could stand on their own. Somehow, and I'm not entirely sure how, almost all of the results seem well balanced. There's a nice balance of larger and smaller blobs, and over the canvas they seem to be spread in a way that both balances the composition but with enough imperfection to add a pinch of dynamism.

What I also like is that these images demand our eyes keep exploring them, like a good photograph. They are abstract and yet they tease us to image objects or a story in them.

We could stop there but let's experiment to see what happens if we change a few more things. Let's try changing the number of clusters. That's not the number of paint blobs in a cluster, but the number of clusters themselves. That means changing the condition that keeps the outer loop repeating, **cluster <5**. Have a go yourself with a few different numbers.

For me, **2** clusters is too few.

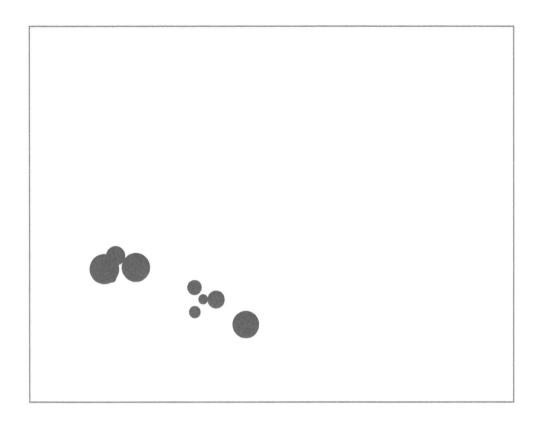

And **20** clusters is too many.

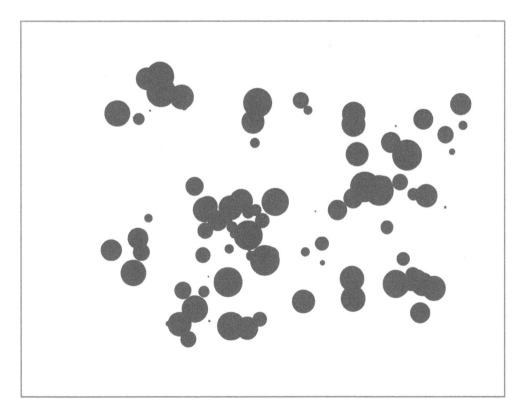

And **10** is about right.

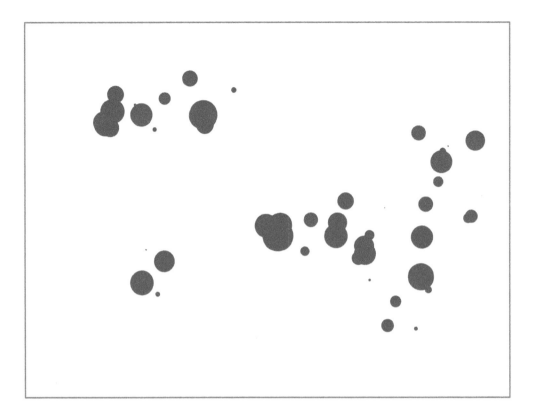

Let's see if colouring the paint blobs adds anything to the composition. Let's try that technique we used before, where we randomly pick two colours from a list, and then use another random number to pick an intermediate colour along the colour scale between these two chosen colours. We used the special instruction **lerpColor()** to **interpolate** between two colours.

I suspect the results might be too harsh, but let's try doing this from a list of primary colours **red**, **green**, **blue** and **yellow**. We create a list of colours using the square brackets **[]**, like we did before.

```
// colour palette
var list_of_colours = ['red', 'green', 'blue', 'yellow'];
```

We do that outside the loops, at the top of the **draw()** function. The reason this is outside the loops is because there is no need for this code to be repeated for every cluster or blob.

Then inside the outer **loop**, the one that repeats code for every cluster, we need to pick two colours from the list. That will set the colour scale for that cluster, and every blob associated with that cluster. That's what we want. We want all the blobs in the same cluster to have colours that are taken from the same colour scale, so they appear related.

```
// pick two colours to create a gradient
var colour_1 = random(list_of_colours);
```

```
var colour_2 = random(list_of_colours);
```

Then inside the inner loop, the one that repeats for every blob around a cluster centre, we pick a colour at a random point along that colour scale.

```
var circle_colour = lerpColor(color(colour_1), color(colour_2),
random());
fill(circle_colour);
```

We haven't introduced anything new here at all. We've practised all these ideas before.

Let's see what the results from four runs look like.

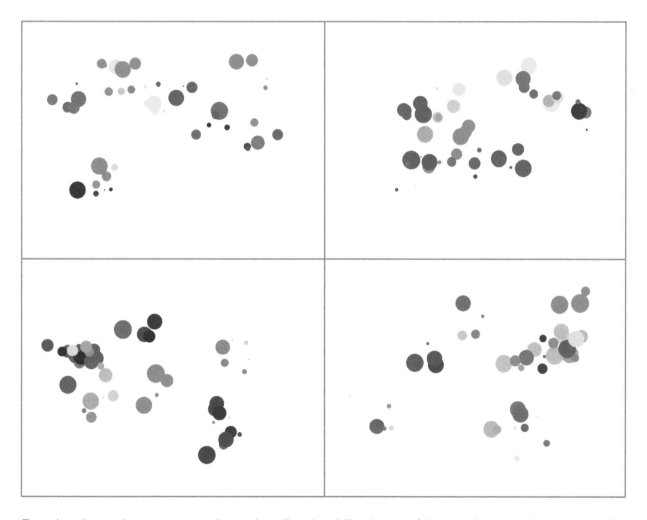

Running the code many more times, I realise that I like some of the results more than others. So let's have a think about why that is, and what we can do to improve the algorithm to make more of the compositions that I do like.

The first thing I notice is that I like those regions where the colours seem to be gently related to each other and no so strongly contrasting. Perhaps our original palette of primary colours was too strong? Let's try it with a gentler set of lighter colours.

```
var list_of_colours = ['pink', 'lightgreen', 'lightblue',
'yellow'];
```

Here's the result.

That's quite nice. A nice calming composition of pastel colours. Let's see what happens if we take out all of the contrasting colours and leave only **violet**, **yellow** and **pink**. This palette has no opposite colours, like **red** is opposite to **green**, and **blue** is opposite to **yellow**. Here's what happens.

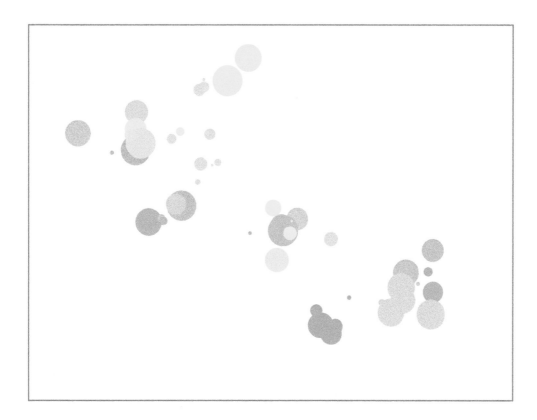

I really like that. It's very calming and relaxing. It's not as dynamic as the previous results, and I'm not sure which one to keep. Like so many works of art, it depends on your mood at the time.

We can keep useful colour combinations by including them in our code but commenting all but one of them out. That way we don't lose useful combinations, and can easily swap them in and out by commenting and uncommenting the code. The following shows this.

```
// colour palette
//var list_of_colours = ['red', 'green', 'blue', 'yellow'];
//var list_of_colours = ['pink', 'lightgreen', 'lightblue',
'yellow'];
var list_of_colours = ['violet', 'yellow', 'pink'];
```

You can see that we have three versions of the code that creates the list of colours, but the first two are commented out using the special double forward slashes //. If wanted to try the middle one, we'd comment out the last one by putting // before it, and remove them from the middle one.

One last thing to try. After running the code many times now, it seems that the best compositions have visible small paint spots. They seem to add both balance to the larger blobs, but also add a sense of realistic splatter. How about adding **5** smaller paint spots in addition to the **5** already coded? We can use **random(10)** to make sure their size is small. This doesn't

mean the existing circles can't be small, it's just that chances are they will be bigger because their size is chosen from the range **0** to **50**.

Where in the code we add these new small spots? A picture will help us more than words.

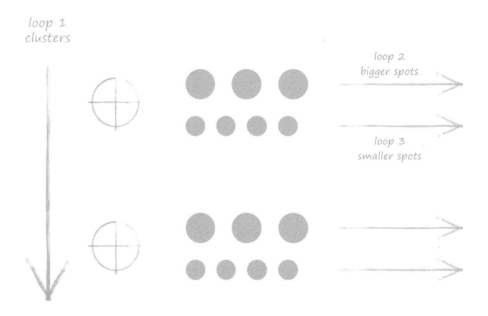

These new smaller spots still need to be centred around the imaginary cluster centres. That means they need to be inside the outer cluster loop, just like the existing one for drawing paint spots. Does it go inside the inner loop? No, because these new small drops are in addition to the existing ones. They go alongside the existing ones. We're not drawing **5** small drops for every one of the **5** larger drops. That means we create a new **for loop** for the smaller circles to go before or after the existing loop. The picture above makes clear that the two loops for larger and smaller circles are both equal, and both fall inside the cluster loop.

Here's the code so far.

```
function setup() {
  createCanvas(800, 600);
  background('white');
  noLoop();
}

function draw() {
  noStroke();

  // colour palette
  //var list_of_colours = ['red', 'green', 'blue', 'yellow'];
  //var list_of_colours = ['pink', 'lightgreen', 'lightblue',
```

```
'yellow'];
  var list_of_colours = ['violet', 'yellow', 'pink'];

  // main clusters
  for (var cluster = 0; cluster < 10; cluster += 1) {

    // location of splatter
    var x = random(100,700);
    var y = random(100,500);

    // pick two colours to create a gradient
    var colour_1 = random(list_of_colours);
    var colour_2 = random(list_of_colours);

    // smaller circles randomly placed around cluster centre
    for (var circle = 0; circle < 5; circle += 1) {

      var circle_x = random(x - 50, x + 50);
      var circle_y = random(y - 50, y + 50);
      var circle_size = random(50);

      // circle colour is between the two randomly chosen colours
from the list
      var circle_colour = lerpColor(color(colour_1), color(colour_2),
random());
      fill(circle_colour);

      ellipse(circle_x, circle_y, circle_size);
    }

    // even smaller circles randomly placed around cluster centre
    for (var circle = 0; circle < 5; circle += 1) {

      var circle_x = random(x - 50, x + 50);
      var circle_y = random(y - 50, y + 50);
      var circle_size = random(10);

      // circle colour is between the two randomly chosen colours
from the list
      var circle_colour = lerpColor(color(colour_1), color(colour_2),
random());
      fill(circle_colour);

      ellipse(circle_x, circle_y, circle_size);
    }
```

```
        }

    }
```

You might have spotted that we have two sections of code that are almost the same. The **for loop** for drawing the **5** larger and **5** smaller circles are exactly the same except for a one tiny change in the **random()** instruction. That suggests we should have used a loop to repeat this almost identical code. We could have, and probably should have, but we won't right now as we'll get a headache from all these loops!

You can find the sketch online at https://www.openprocessing.org/sketch/456906.

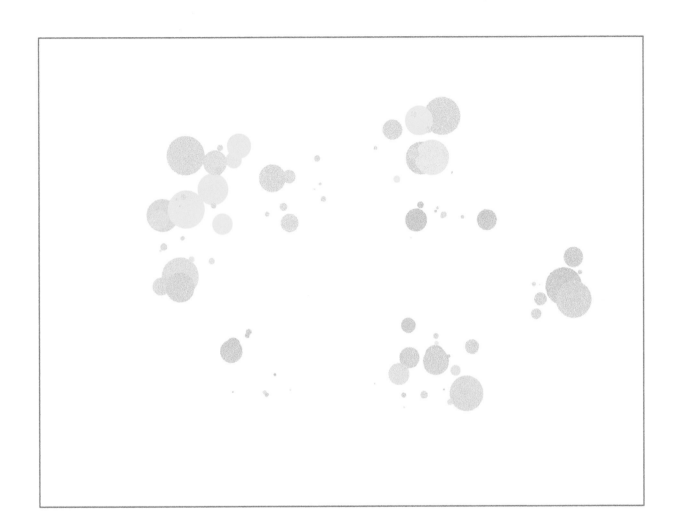

Splatter !

Part 3 - More Building Blocks

In Part 3 we'll learn about more building blocks - mixing colour, reusable code, and artistically useful maths - that we can use to elegantly design more sophisticated creations.

Mixing Colours

Colour is a fundamental element of composition. Up to this point, we've actually avoided exploring it, believe it or not. We've used named colours like **pink** and **blue**, and only looked at the **lerpColor()** instruction to create colours that are somewhere between two named colours. There is so much more we can do with colours, so let's explore them a little bit more.

Let's go back to our earliest experiences of colour, when we were very young and had pots of paint to play with. What happened when we mixed **yellow** and **blue** paint?

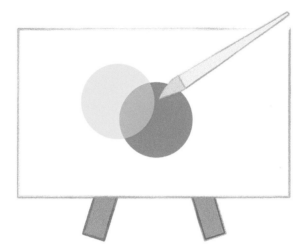

When we mixed **yellow** and **blue** paint, we got a kind of **green**. Many artists are familiar with mixing paint colours, though it is a skill that takes time to develop. You may already be familiar with **primary colours** which are mixed to make other colours.

When computers create colours, they also mix primary colours. But there is an important difference we need to be aware of.

When we mix paint, the resulting colours get **darker** and darker. Mixing in more and different paints, gives us darker and darker colours, until we almost have black. In real life, we often end up with a muddy dark brown.

When we mix coloured light, the resulting colours get **lighter** and lighter. If we mix more and different coloured lights, the results will be lighter and lighter colours, until we get to white. Here's a picture showing coloured **red** and **green** torches, not paint, being mixed.

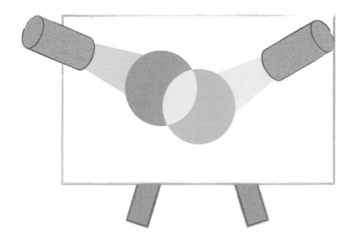

You can see that when the lights overlap, we have **yellow**, a lighter colour than **red** or **green**.

So we've just seen two different ways in which colours combine. Mixing paint results in darker and darker colours, but mixing light results in lighter and lighter colours.

You don't have to know why this is but it is interesting. White light is made of a mixture of purer colours. You will have seen them separated out with a prism, or a rainbow in the sky, where raindrops act like prisms. Paint, pigments and dyes work by **absorbing** some of these parts of white light, leaving the remainder to be reflected back. Adding more, and different, paints means more of the elements of white light are absorbed, leaving less and less to be reflected. That's why the results get darker. This is why mixing paints is called **subtractive** colour mixing.

The **subtractive primary colours** are **cyan**, **magenta** and **yellow**. You may have noticed your colour printer mixes colours from inks of these primary colours.

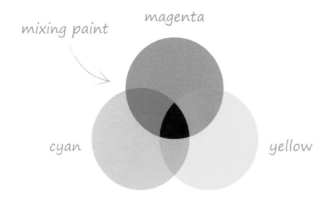

Mixing coloured light is just that, adding together different parts of white light. Mixing different colours means adding more and more of the elements of white light. If we added together all the elements of white light, ... we'd end up with white light. This is like the opposite of a prism or a rainbow. Instead of separating out the rainbow colours, we'd be adding them back together. That's why mixing light is called **additive** colour mixing.

The **additive primary colours** are **red**, **green** and **blue**.

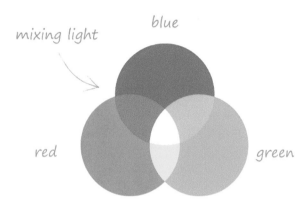

We didn't need to know any of that, so don't worry if it doesn't make perfect sense right now.

What is important for us, is to know that computer screens, like a laptop display, a smartphone or tablet screen, make colours by mixing **red**, **green** and **blue** light.

Remember those screen pixels we talked about at the start of this book? Those pixels are actually made of 3 smaller bits, which are teeny weeny **red**, **green** and **blue** lights. By turning on each of these three colours by different amounts, the pixel takes on different colours. So to make **yellow**, a pixel will have the teeny weeny **red** and **green** lights turned on, but not the **blue** light.

With Processing, we can mix these primary colours to make our own colours too. We can have very fine control over the exact colour we want. We're not limited to the list of named colours that we saw before.

So let's look at some examples of mixing **red**, **green** and **blue** light to get a feel for how it works.

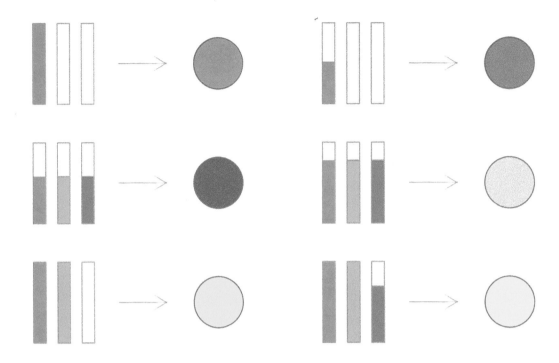

Let's start at the top left. The first example shows only **red** light switched on. There is no **green** or **blue** light in the mix. You won't be surprised that makes a **red** pixel! The next example along, is the same but this time the **red** light has been turned down to about half strength. This makes the resulting colour darker, not lighter, because there is less light overall. If we turned down the **red** to zero, we'd have no light contributing to the mix at all, and we'd end up with **black**.

The next row shows all three **red**, **green** and **blue** turned on at about half strength. The important point here is that they are all turned on at an equal level. This gives us a mid **grey**. The next example is the same but this time the amount that all three **red**, **green** and **blue** are turned on is a bit higher, about three quarters of the way up. The result is a lighter grey. That's because there is more light contributing to the mix. If we turned the levels up to the max, we'd get **white**.

The last row is more interesting. Here we show how light mixing creates different colours. Mixing **red** and **green** light makes **yellow**. How do we make it darker? Well, we've just seen how reducing the amount of light being mixed makes the result darker. So having levels of **50%** **red** and **green** would create a darker **yellow**. That's not a surprise, the first two rows show this happening. So here's a more interesting question - how do we make the **yellow** lighter? Hmm. Well, we know we need to add more light somehow. We can't add more **red** or **green** as those are already at the maximum level. The only option left to us is to add more **blue** light. It works! Think of it like this - **red** and **green** but no **blue** makes **yellow**, but an equal amount of all three makes a neutral **grey**. So we've just taken a light **grey** and added some **yellow** to it, to make a light **yellow**.

Don't worry about being able to predict what colours will result from mixing **red**, **green** and **blue** light. You develop a feel for it over time, and even professionals don't need to be able to do it without help. You can find many tools on the web, or in your favourite photo editing software.

Here's a good tool for mixing **red**, **green** and **blue**, or just **RGB**, to make colours:

- W3Schools RGB calculator: https://www.w3schools.com/colors/colors_rgb.asp.

Here is the tool being used to make the darker yellow.

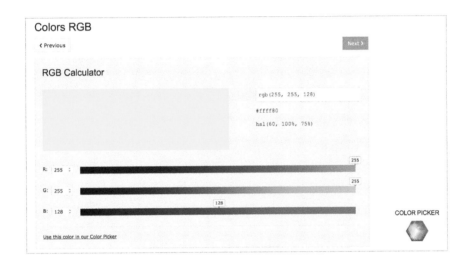

Have a play yourself, moving the sliders to add more or less **red**, **green** and **blue** elements. It's quite fun mixing light to create colours. I really encourage you to do this, as this is the only way to start to get a feel for what combinations make which colours, and how light or dark they are.

Did you notice that the tool shows the sliders going from a low of **0** all the up to a maximum of **255**? Why isn't this **0** to **100%**, or maybe **0** to **1**? Those would make sense. What sense does a top level of **255** make?

You don't need to know the reason, but if you're interested, here it is. That **255** is an antique from history. When I was little, in the 1980s, computers were much less powerful than they are today. The numbers they could easily store in their memory maxed out at **255**. To have bigger numbers, they had to do complicated things joining bits of memory together. You may know that computers store only **1**s and **0**s, and eight of these can represent numbers from **0** to **255**. Eight bits was the size of a piece of memory. That's where the phrase **8-bit** comes from. The **red**, **green** and **blue** colour levels were stored in memory that could only go from **0 to 255**.

So RGB values going from **0** to **255** have stayed with us. Today, you'll see this in your favourite photo and image editing software, tools like Photoshop, Krita, Gimp and many more. The following shows the colour mixer from Affinity Photo. You can see the sliders and RGB values

going up to **255**. You can also see I've made a light yellow and used the paintbrush to make a light yellow mark.

Enough talk, let's code! Have a look at the follow code.

```
fill(255, 0, 0);
ellipse(400, 300, 200);
```

It's that familiar **fill()** instruction again. Earlier, we used to give it colour names like **fill('red')** or **fill('yellow')**. Now we seem to be passing three numbers to it. You've guess it - they're the **red**, **green** and **blue** levels for that colour. What colour is **(255, 0, 0)**? Well, by strict convention, the order is always **red**, then **green**, then **blue**. Here we have a maximum level for **red**, and no amount of **green** or **blue**, so the result must be a bright pure **red**. The next line of code just draws a circle in the middle of the canvas, something we'd done so many times now. Let's see it in action. Here's the full code:

```
function setup() {
  createCanvas(800, 600);
  background('white');
  noLoop();
}

function draw() {
  noStroke();

  // fill colour using RGB levels
  fill(255, 0, 0);
  ellipse(400, 300, 200);
}
```

And here's the result, a bright red joyous circle.

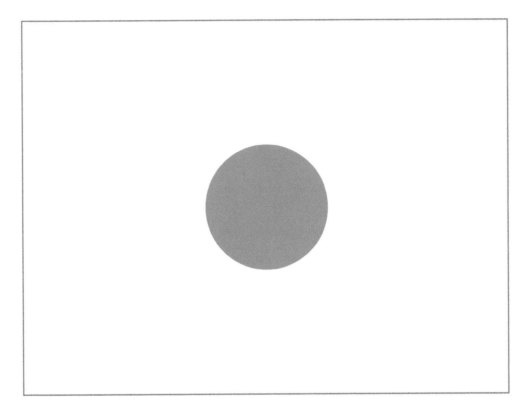

Have a go yourself. Play with different numbers for the **red**, **green** and **blue** levels. Try mixing a colour using the online tool and read off the RGB values and put them into your code to create a circle of that colour. Here's me mixing a nice darker pink.

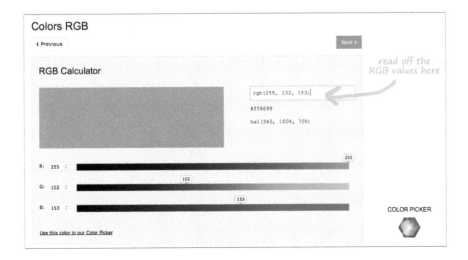

You can see the **RGB** values are **(255, 102, 153)**. I can change the **fill()** instruction to have these levels.

```
fill(255, 102, 153);
ellipse(400, 300, 200);
```

And here's the result. It works!

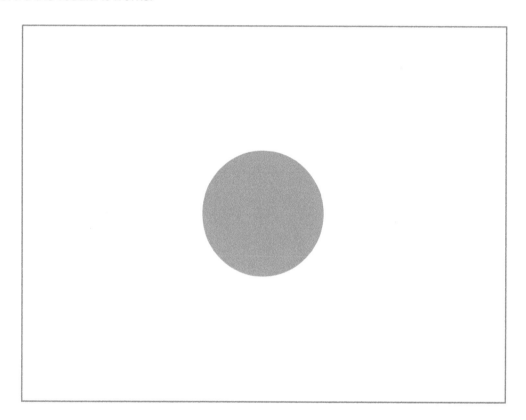

An algorithmic artist would see all this and spot that we can use code to choose those levels, instead of having to manually pick them. We've already used randomness to get our computers to pick random numbers for locations and sizes. Why not use randomness for colour too?

Let's try it. We can use **random(255)** to pick a number at random between **0** and **255**, which is what we want for the **RGB** levels. Our **fill()** instruction should now look like the following.

```
fill(random(255), random(255), random(255));
```

We've probably had an overdose of circles, so let's try coloured lines instead. How about a series of thick lines, each with line colours chosen at random? Here's the code.

```
function setup() {
  createCanvas(800,600);
```

```
    background('white');
    noLoop();
}

function draw() {

    strokeWeight(20);

    for (var x = 200; x <= 600; x += 50) {

        // random line stroke colour
        stroke(random(255), random(255), random(255));

        // draw the vertical line
        line(x, 200, x, 400);
    }

}
```

You can see the familiar **for loop** which uses a counter **x**, starting at **200**, and going up by **50** every loop until it reaches **600**.

Inside the loop is the interesting stuff. We've used **stroke()** to set the line colour. Remember that **fill()** doesn't make sense for a line, only closed shapes like circles and rectangles. Previously we used named colours like **violet** or **pink** inside the **stroke()** brackets but now we're using three numbers to define the **red**, **green** and **blue** levels. We just happen to use **random(255)** to pick these at numbers.

The rest of the code takes the counter **x**, and uses it as a horizontal location to draw a vertical line. Here's the result.

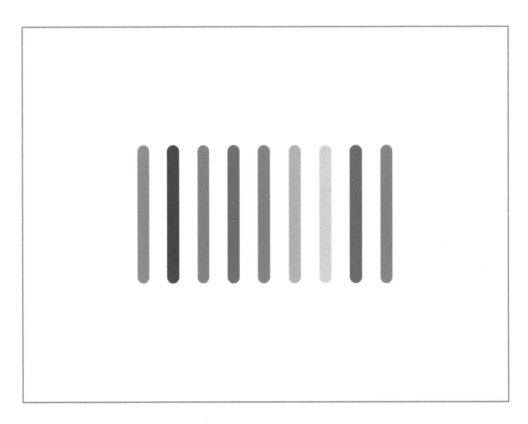

I think that's pretty amazing. Simple, powerful composition, where even the randomly mixed colours seem to make sense, with just enough playful interaction between them, but enough balance to keep the work grounded. You can tell I like it!

And all that from four simple, easy lines of code. Look again at the code, and you can see there really are only four relevant instructions - setting the stroke weight, the for loop, setting the stroke colour, and drawing the line itself.

One of the things algorithmic artists sometimes try to achieve is powerful or sophisticated art from the smallest simplest ideas and code. For some, it is a measure of how good an algorithmic artist they are, for others it is just a way to marvel at the power and beauty of what is really just mathematics. You read that right - mathematics can be beautiful! We'll see lots more later than will convince even a hardened disbeliever.

Not every run of this code creates a nice image, because the colours are chosen completely at random. Here are some more examples, just to show the range.

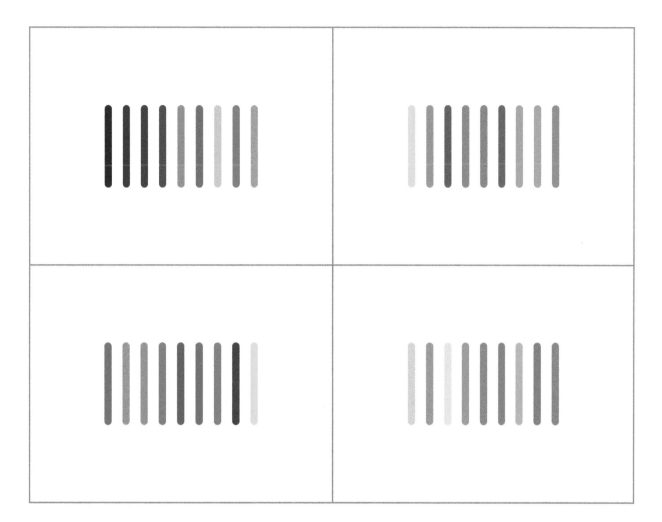

Running the code lots of times, reinforces what artists have known for a long time, that artistic constraints lead to stronger compositions. How could we apply this idea here? One way is to limit the freedom of choosing RGB levels for the colours. Maybe we should force the **blue** level to be chosen at random from a fairly high range, between **200** and **255**. The code to pick the stroke colour becomes:

```
stroke(random(255), random(255), random(200, 255));
```

You can see that the red and green levels are still free to pick any number from the full range **0** to **255**. Let's see what that does.

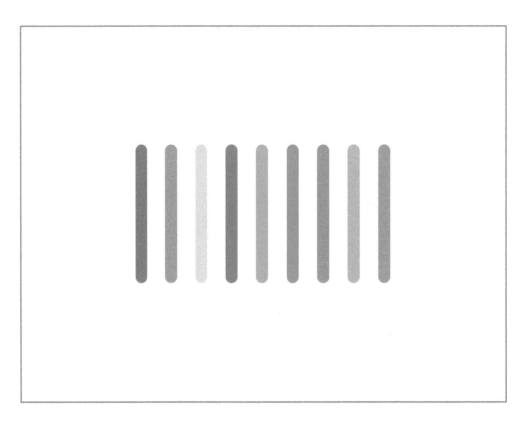

Nice! It's as if the artist has been very intentional and careful about the colour palette. And that's because we have, but using code and not real paint. You can find the sketch online at https://www.openprocessing.org/sketch/459522.

Have a play yourself constraining the **red**, **green** and **blue** levels used to mix the line colour. Perhaps you want to force picking numbers from a smaller range for the **red** level? Maybe you just want pin it to a specific number like **50**?

Here are some of my own experiments.

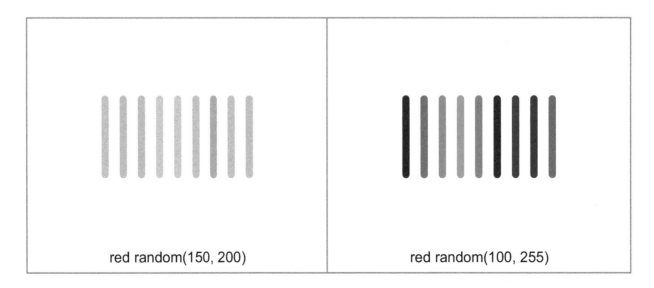

red random(150, 200) red random(100, 255)

green random(150, 200) blue random(200, 255)	green 0 blue 0
y random(200, 235) red y green y + 20 blue y	y random(255) red y green 255 - y blue 0

The first example constrains the **red** and **green** levels to be picked from a fairly narrow and intermediate range, **150** to **200**. The **blue** level is picked from another narrow range but from a larger set of numbers, **200** to **255**. That should give the results an overall cold wintery feel, because the **blue** level dominates. But at the same time, the **red** and **green** are not too small, nor too large, and so the result is a muted grey, but coloured towards shades of **blue**. It's my favourite so far.

The second example eliminates any **green** or **blue** from the colour mixing. The **red** level is chosen from a bigger range, **100** to **255**, which ensures it is not too small. That gives a good range of fire-like **red** colours.

The third example continues the idea of setting the levels to be similar to each other to create grey-like tones. Here we actually create a new variable, **y**, picked at random from the very narrow and high range, **200** to **235**. The **red** and **blue** levels are both set to **y**, so they both have this same randomly chosen number. The **green** level is also set to **y** but with an additional **20** added. Without the additional **20** added, we'd simply have levels of grey. Adding **20** to the **green** level means we have subtly green greys.

Why did we need to create that new variable **y**? Because we wanted the **red** and **blue** levels to have the same number, and using **random()** separately would have given different numbers to each of the three levels. By creating **y** once, we can use its value as many times as we want. Here we use it for the **red**, **blue** and also the **green** levels.

The last example also creates a variable **y**, assigning a random number between **0** and **255** to it. The **red** level is set to **y** in the same way as the previous example. But this time the **blue** level is set to **0**. We're not going to use any **blue** light in mixing the colours. The green level is set to **255 - y**. That means when the **red** level is high, the **green** is low. It also means that when the **red** level is low, the **green** level is high. In this way, the colours should sometimes be very opposing, either very red or very green. We're using that **255 - y** to create an unsubtle colour scheme. That's the opposite of what we were doing before, when very similar levels created subtle greyish colours.

We've learned a lot, take a break!

What We've Learned

We've made a huge leap in our understanding of how computers mix and create colours. At first we simply used pre-mixed colours that were given names. Now we can mix our own colours with a very fine level of control over the exact shade.

Key Points

- Digital displays, like a laptop or television screen, create coloured **pixels** by mixing **red**, **green** and **blue** light.

- Historically, the amount of **red**, **green** and **blue** light mixed to create colours is measured on a scale from **0** to **255**.

- Because these are numbers, we can use any method we like to choose these numbers. That can include **fixed** numbers, **loop counters**, **random** numbers or numbers **calculated** in different ways.

Translucent Shades

There's one more thing that's really worth learning about colour. And the best way to learn about it is to see an example first before we talk more about it.

Let's draw two overlapping circles. There's nothing special about the code here, we've drawn lots of circles already.

```
function setup() {
  createCanvas(800,600);
  background('white');
  noLoop();
}

function draw() {

  noStroke();

  // circle fill colour
  fill(255, 0, 0);

  // two overlapping circles
  ellipse(300, 300, 400);
  ellipse(500, 300, 400);

}
```

The colour is set using the **fill()** instruction as usual. You can tell the colour will be a bright **red** because the RGB **red** level is at maximum, while the **green** and **blue** levels are zero.

```
fill(255, 0, 0);
```

Here's the result, and it's just as we expected. If you think it looks like something rude, go see a doctor!

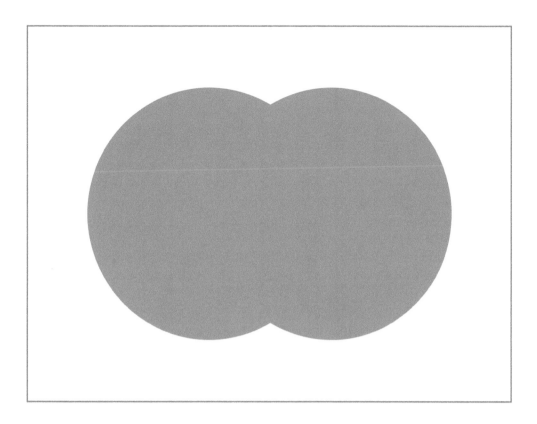

Now try this. Change the fill colour to add an extra number at the end, like this:

```
fill(255, 0, 0, 100);
```

The resulting image is quite different.

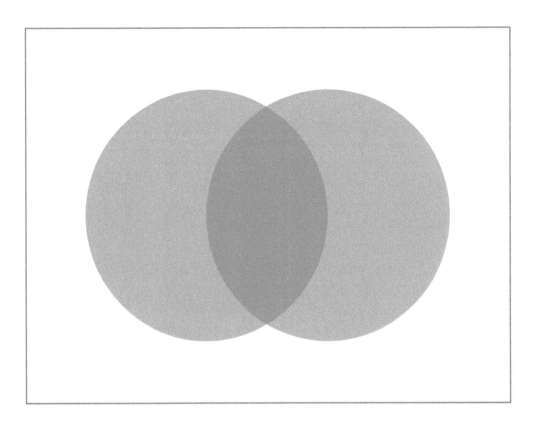

What's happened? Let's try to work it out. The circles are no longer as deep **red** as they were before. They're now lighter, pinker. Did that extra number somehow make the color lighter? Maybe it's a control for how light or dark colours should be, a bit like the brightness controls you sometimes see on televisions? That's not a bad idea, but it's wrong. It wouldn't make sense anyway, because we can create all the colours, including lighter and pinker shades using the RGB levels already. There wouldn't be a need for another control number. So it must be something else.

Well, where the circles overlap, the colour is darker but not fully deep **red** like before. There must be a clue in here somewhere. If two objects overlap then the result is darker. It's almost as if the circles are made of coloured clear plastic that you can partially see through. That would seem to make sense. Through one circle we can see the **white** background, and it makes the **red** circle look **pink**. And where the circles overlap, we can still see through them to the background, but less so because now there are two layers of plastic to see through. So maybe the additional number controls how see-through an object is?

That's actually correct. That extra number controls how **translucent**, or see-through, a colour is. When it comes to defining colours, this number is called the **alpha** value. A high **alpha** value means the colour is not very translucent and you can't see through it very much. A low **alpha** value means the colour is very see through. And the range is again between **0** and **255**. An **alpha** of **255** means completely **opaque**, and an **alpha** of **0** means completely see through with none of the object's colour visible at all.

Here's a picture showing how **alpha** values work.

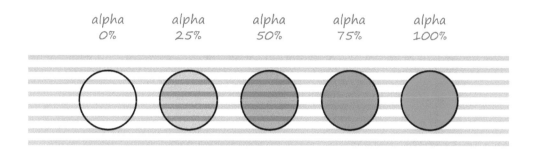

alpha 0% alpha 25% alpha 50% alpha 75% alpha 100%

We can see how an **alpha** of **100%**, or **255**, makes for a completely opaque object. We can't see through the deep **red** circle at all. Turning down the **alpha** value gradually, we can see more and more of the background stripes. When we reach an **alpha** of **0**, we can see right through the object, and it completely loses any colour it had.

By the way, it's worth sorting out the precise difference between **transparent** and **translucent**, because they are often used as if they were same thing.

- **Transparent** objects are completely see through, like the circle above with alpha **0%**, and none of their own colour is apparent.

- **Translucent** objects are partially see-through and their own colour is apparent as well as what's behind the object.

Having **translucent** objects suddenly enables us to have compositions that work where they wouldn't work with opaque objects. Let's see this with a simple example of a canvas covered with random circles.

Here is a canvas filled with **200** opaque circles, located at random locations, of random sizes, and filled with a mid grey using the following **fill()** instruction.

```
fill(128, 128, 128);
```

That **128** is half of the maximum **255**, which is why it's a mid-grey.

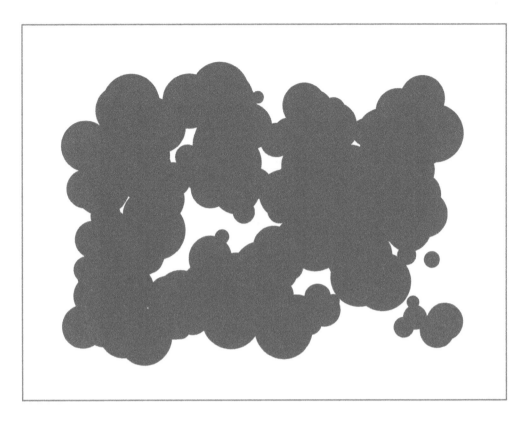

It's not a terrible composition, but it's close! Now see what happens if we only change the translucency of the circles using a fairly low alpha value to make the circles very see-through.

```
fill(128, 128, 128, 60);
```

Here's the result.

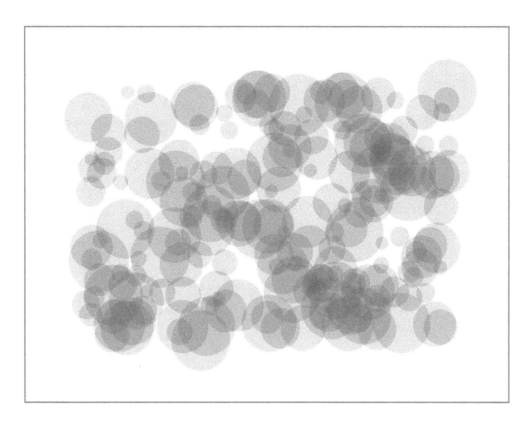

Wow! What a difference translucency makes. The composition is much less brutal and much more interesting in its detail too. You can see darker areas where many circles overlap, and light areas where there only a few.

Translucency is a powerful tool, and helps make images which have lots of elements and detail possible, when otherwise they would be to too saturated and overwhelming. We'll see more of this later.

Just for fun, we can add randomly chosen colour to the circles. Here we've deliberately chosen RGB levels that are high, between **150** and **255**, to give us subtle pastel shades. The **green** level is chosen between **200** and **255** to give an overall **green** theme. Here's the code.

```
function setup() {
  createCanvas(800,600);
  background('white');
  noLoop();
}

function draw() {

  noStroke();
```

```
// create 200 circles
for (count = 0; count < 200; count += 1) {

  // random location on canvas away from edge
  var x = random(100, 700);
  var y = random(100, 500);
  var size = random(20, 100);

  // random but high RGB for pastel colours
  var red = random(150, 255);
  var green = random(200, 255);
  var blue = random(150, 255);

  // make circles translucent
  fill(red, green, blue, 100);
  ellipse(x, y, size);

}

}
```

And the results look like this.

Subtle colours and gently vibrant! Translucency really creates a lot of interesting detail for our eyes to explore, but at the same time doesn't make it overwhelming or brutal. The code for this sketch is at https://www.openprocessing.org/sketch/460178.

Have a go yourself, try different alpha levels, and even apply it to different shapes and even outline strokes too. Yes, transparency can be used whenever we use **stroke()** for the outline stroke of shape, or the colour of simple lines.

Worked Example: Metropolis

We saw earlier how **translucent** objects allow for more objects to be placed onto a composition without it becoming overly saturated and brutal. The overlapping of translucent objects creates new detail and colour, which can have great meaning in a work of art.

So let's create a composition that is about these themes - lots of activity, congestion, urban living, traffic, lights, sophistication and productivity. My initial idea is to create lines representing roads, and somehow light them with lots of translucent circles, often overlapping, to give a sense of an urban network, with signs of busy life.

I don't like living in an urban environment as much as I did 20 years ago. But that doesn't mean I'm not romantic about the urban aesthetic. If you think the words **romantic** and **urban** don't go together, watch this sequence from the 1995 version of Ghost In The Shell, a beautifully animated Japanese film, with breathtaking music that still gives me the tingles:

- Ghost In The Shell urban montage: https://www.youtube.com/watch?v=ARTLckN9e7I

That sequence itself literally shaped the next 15 years of my artistic life!

So let's start our experiments by creating some test marks for this network. We've talked about drawing lines before, but here's a reminder. The following picture shows how a line is defined by its start and end points.

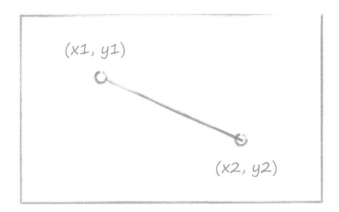

(x1, y1)

(x2, y2)

An easy way to create lots of lines quickly and easily is to create random lines. It's a good way of starting an experiment, even if we decide later that pure randomness isn't right. The following code shows how we use **random()** to pick random horizontal and vertical coordinates for the **start** and **end** points of a line. You'll recognise that we've chosen number ranges to keep the lines away from the canvas edge.

```
var x1 = random(100, 700);
var y1 = random(100, 500);
var x2 = random(100, 700);
var y2 = random(100, 500);
```

We've created **variables** to represent the horizontal and vertical coordinates of the line start and end points. These are **(x1, y1)** and **(x2, y2)**.

Let's use a loop to create **20** lines and draw them, just to see what they look like. We don't have to keep these marks if we decide later that we don't want them. Here's the initial code.

```
function setup() {
  createCanvas(800,600);
  background('white');
  noLoop();
}

function draw() {

  // 20 network lines
  for(var count = 0; count < 20; count += 1) {

    // random start and end points line
```

```
    var x1 = random(100, 700);
    var y1 = random(100, 500);
    var x2 = random(100, 700);
    var y2 = random(100, 500);

    // draw line
    stroke(0, 0, 255, 100);
    line(x1, y1, x2, y2);

  }

}
```

Here's what the result looks like.

Well the code does produce random lines, which could form a structure or skeleton for our lights. They have the right amount of cross-cutting too, which I think is important to reflect urban traffic and intersecting lives. But the network here isn't busy enough. We need more lines. Let's try increasing the **20** to **40**.

That's much better. We'll leave that for now, and tweak it later if we feel it needs more or less skeleton.

Now we need to think about how we add the main content to this supporting architecture. A very simple thing to do is to add coloured circles at the start and end of the lines. But doing this wouldn't suggest the underlying lines, the avenues of urban life. We wouldn't even need lines to do that, we'd simply throw circles at random locations. So we need to follow the lines in some way.

One way to follow those lines is to place circles at regular intervals along those lines. Let's draw a picture to help us see how we'd do this.

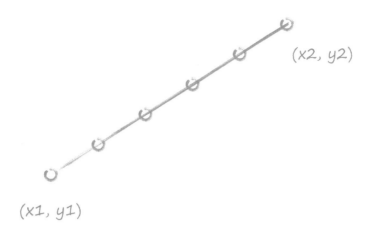

We can see a simple line, with a starting point at **(x1, y1)** and end point at **(x2, y2)**. That's simple enough. We can also see steps along the line, which divide the line into **5** equal pieces. We could have chosen to divide the line into **10**, **50** or **100** pieces, but we'll go with **5** for now.

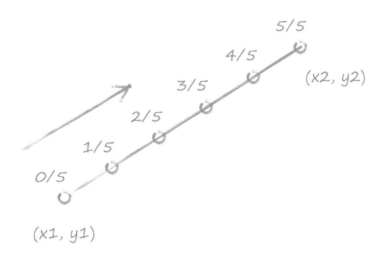

Here we simply show how far along the line each of those steps is. The first step is one fifth of the way along, the second step is two fifths of the way, and so on. We can use fractions to say the same thing, **1/5**, **2/5**, **3/5**, **4/5**, and the last step **5/5** which is just the whole distance.

Let's remember what we're trying to do. We want to work out the locations of each of these evenly spaced steps. That means the horizontal and vertical positions, or coordinates of each step. It will help us to know the full distance we move vertically and horizontally as we journey from the beginning of the line to the end. The next picture shows this.

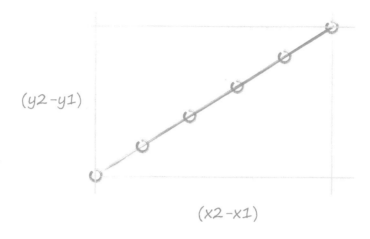

It's actually really easy to work out. If we journey from the start of the line to the end, we have moved horizontally from **x1** to **x2**. That means the horizontal journey is the difference, **(x2 - x1)**. The same works vertically. The journey takes us from **y1** to **y2**, so the vertical journey is **(y2 - y1)**.

The key realisation is that each of the equal steps also divide these horizontal and vertical distances too. So the first step, which was a fifth of the journey along the line, is located a fifth of the way along the horizontal journey. Similarly, that step is also a fifth of the way along the vertical change too. The next picture shows this idea for the second step.

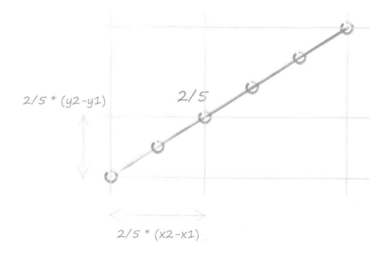

This picture looks a bit complicated, but it's just saying the same thing. As we take equal sized steps on our journey along the line, our horizontal and vertical positions also grow in steps. If we're on our second step out of five, then the horizontal shift is **2/5** of the total horizontal change **(x2 - x1)**. Which is **2/5 * (x2 - x1)**. The horizontal coordinate of the second step is this change added to the original position. That's **x1 + 2/5 (x2 - x1)**. The same applies vertically, so the vertical coordinate of the second step is **y1 + 2/5 (y2 - y1)**.

It's worth reading that several times and trying it out, if it feels like new mathematics. It's not hard, it just looks it.

What if we didn't want to just think about the second step, but any step? What does that calculation look like for other steps? Let's draw another picture.

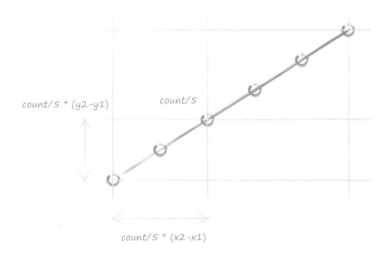

All we've done is replace the **2** for the second step with **count** for any step. The same thinking still applies. The horizontal coordinate of the **count**-th step is **x1 + count/5 (x2 - x1)**, and the vertical coordinate is **y1 + count/5 (y2 - y1)**.

Phew, that was hard work! Let's code this up, and draw simple circles just to mark these steps, and make sure our calculations were right.

```
function setup() {
  createCanvas(800,600);
  background('white');
  noLoop();
}

function draw() {

  // 20 network lines
  for(var count = 0; count < 20; count += 1) {

    // random start and end points line
    var x1 = random(100, 700);
    var y1 = random(100, 500);
    var x2 = random(100, 700);
```

```
    var y2 = random(100, 500);

    // draw line
    stroke(0, 0, 255, 100);
    line(x1, y1, x2, y2);

    // move along line in equal steps
    for (step = 0; step <= 5; step += 1) {
      // coordinates of point along line
      var x = x1 + ((x2 - x1) * step / 5);
      var y = y1 + ((y2 - y1) * step / 5);

      // draw circle
      noStroke();
      fill(255, 0, 0);
      ellipse(x, y, 10);
    }

  }

}
```

You can see the code that calculates the positions of the steps along the line. We simply draw a small red circle at each step. Here's what the results look like.

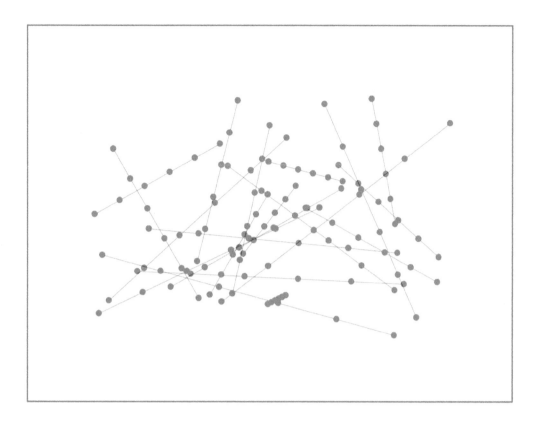

I really like this! What a nice surprise. There's a lovely interplay between the dots and the lines, and between the regularity of the dots and the randomness of the intersecting lines. It reminds me of those aerial photographs of city lights at night.

Because the algorithm for creating these lines is random, we'll get different results every time. Here are four more runs of the code.

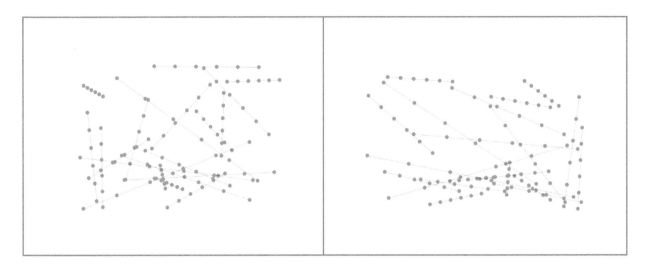

I'm pretty satisfied by the structure that the random lines create. I had thought we'd have to put some effort into constraining the randomness somehow to make the networks more realistically metropolitan, but enough of the random compositions work well as it is.

I had thought we'd be focussing on the circles, and removing the blue lines from the final composition but I like how they add a certain filament-like feel to the results. Just as an experiment, let's see what happens if we do the opposite of our initial intentions, and emphasise the lines more but making them thicker with **strokeWeight(20)** and the colour a lighter translucent blue, with **stroke(100, 100, 255, 100)** so they're not too dominant.

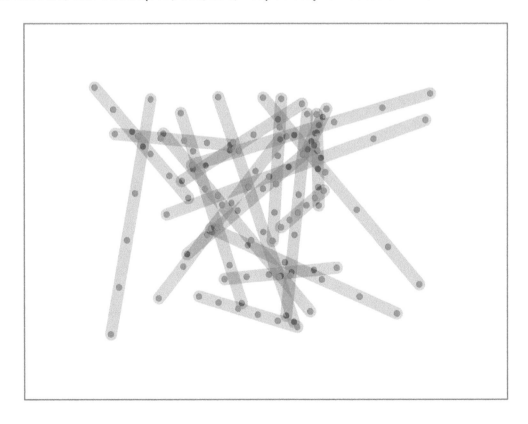

Again, a really nice effect. And we could go further down this avenue with the lines being a major feature of our composition. It's nice to discover something like this just by experimenting. It's very much encouraged!

For now, let's put this idea our back pocket, and continue with the circles. We might add lines back into our work later.

We wanted those circles to have different sizes, and also to make them translucent so we could have them overlapping, to create more interesting detail and interaction between shapes. Let's try what's most familiar to us, picking a random size between a lower and upper limit, say between **5** and **20** pixels in diameter. Let's try an **alpha** value of **50**, just to get started. Here's the code so far.

```
function setup() {
  createCanvas(800,600);
  background('white');
  noLoop();
}

function draw() {

  // 20 network lines
  for(var count = 0; count < 20; count += 1) {

    // random start and end points line
    var x1 = random(100, 700);
    var y1 = random(100, 500);
    var x2 = random(100, 700);
    var y2 = random(100, 500);

    // draw line
    stroke(0, 0, 255, 100);
    line(x1, y1, x2, y2);

    // move along line in equal steps
    for (step = 0; step <= 5; step += 1) {
      // coordinates of point along line
      var x = x1 + ((x2 - x1) * step / 5);
      var y = y1 + ((y2 - y1) * step / 5);
      var size = random(5, 20);

      // draw circle
      noStroke();
      fill(255, 0, 0, 50);
```

```
        ellipse(x, y, size);
    }

  }

}
```

You can see we've created a new variable **size** for the randomly chosen circle size. You can also see we've used **random(5, 20)** to ensure the random size of between **5** and **20**. We use the variable **size** in the **ellipse()** instruction to replace the fixed number **10**. We've also added an alpha value of **50** to the circle fill colour.

Here's what the results looks like.

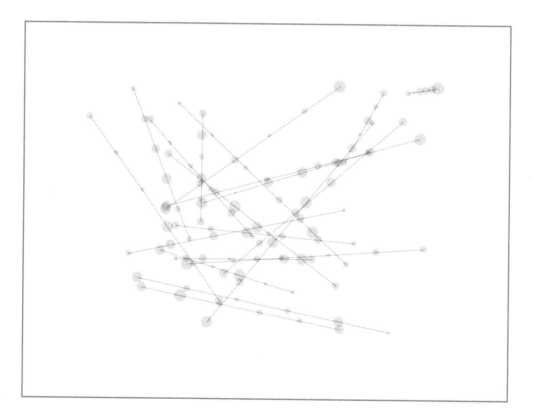

That's a nice image on its own, but not quite the effect we were looking for. We wanted the circles to be busy, overlapping, congested, treading on each other's toes. We need more circles on a line!

How do we make each line have more circles? Well if you look back at our discussion, we always assumed the lines were divided into **5** equal pieces, which meant **6** circles per line. Look at the images we've created already and you'll see this. We need to divide the lines into more steps, so there are more smaller pieces, and so more circles at each step. Rather than pick a

number and change the code to use this number, we should always try to write code that is as general as possible. That's something that experienced coders and mathematicians try to do - to solve problems as **generally** as they can, so the answer works in more cases than just the one they're thinking about this minute. For us, that means code that will work for any number of pieces, not just **5**, or **6**, or **10**.

Here, we can create a variable which holds the number of pieces the line is divided into, and we can use that variable to calculate the positions of the circles. We can then experiment with different numbers for how many pieces the lines are divided into really easily, by just changing the value of one variable.

Let's do this step by step, as it's the first time we've taken some code and tried to make it more general.

At the top of the code, we'll create our variable, and use a comment to remind us of what it does.

```
// number of pieces a line is split into
var pieces = 10;
```

It's good practice and style to declare such important **parameters**, near the top of any relevant code, and not hide it somewhere deep and further down. A **parameter** is just another name for a **variable** but we tend to say **parameter** when it's about something that we want to change, and that will affect the resulting image. Remember how we pass location and size information to the **ellipse()** instruction? We call them **parameters** too, because they affect the appearance of the circle.

So instead of chopping the line into **5** pieces, we have the parameter **pieces** and it is set to **10**. We now need to use this variable wherever we assumed **5** pieces. The first place this happens is the **for loop**. We use the loop to count up to the number of pieces, which was set to **5**, but we can now replace it with the variable **pieces**.

```
// move along line in equal steps
    for (step = 0; step <= pieces; step += 1) {
```

You can see that if **pieces** is set to **10**, the loop will count to **10**. If **pieces** is set to **20**, the loop will count to **20**.

The next place we used the number of pieces is in the calculation of the location of the circles. Again, we can simply swap out the reference to **5** pieces and use the variable **pieces**.

```
// coordinates of point along line
var x = x1 + ((x2 - x1) * step / pieces);
var y = y1 + ((y2 - y1) * step / pieces);
```

That wasn't so hard. Now, we only need to change one **parameter** to change how many circles are drawn on every line.

Let's see what the results look like.

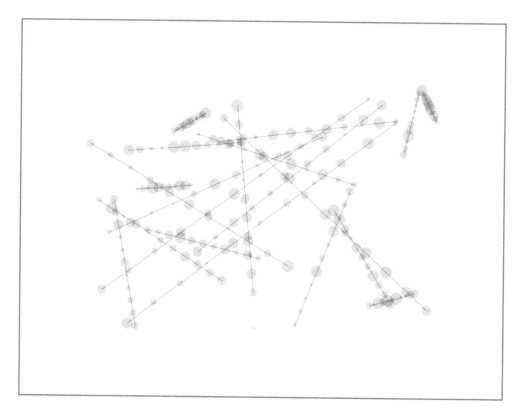

Still not enough density. Let's increase **pieces** to **20**.

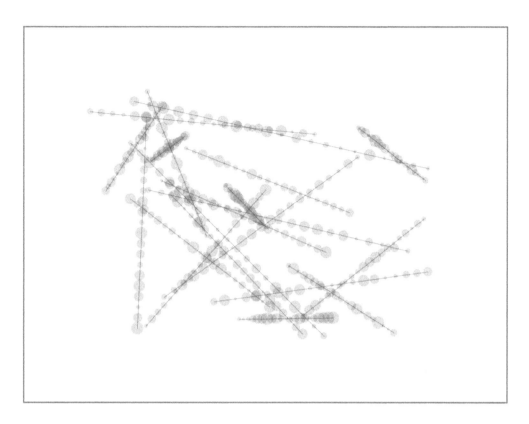

That's better. The overall composition still feels too sparse. Maybe we could try making the circles larger, by increasing the range from which their sizes are randomly picked, using **random(5, 40)**.

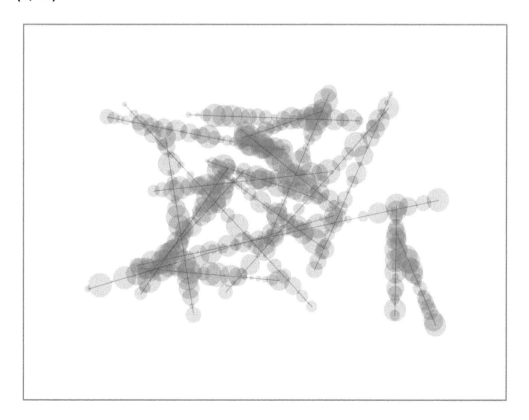

We're now starting to show congestion and activity, but the image is too blunt and simplistic. So let's reduce the maximum circle size down to **20** again, but this time increase the number of lines to **40**, to strengthen the sense of a busy network.

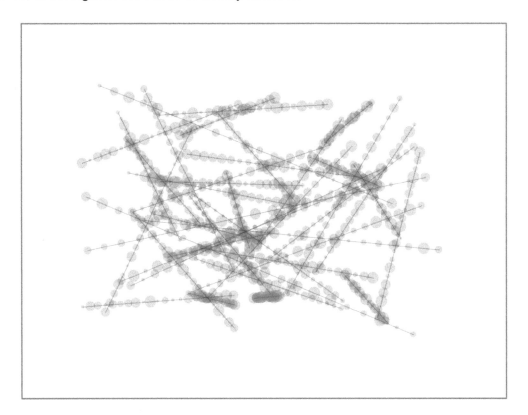

That's the best one yet. Still, it's not easy to get that balance right between complexity and overbearing.

Let's try a new idea that makes use of translucency to solve this very problem. Whenever we draw a circle, why don't we add an additional circle at the same location, but a bigger circle which is also much more see-through. The code for this is simple.

```
// first circle
fill(255, 0, 0, 40);
ellipse(x, y, size);

// second larger, more translucent circle
fill(255, 0, 0, 10);
ellipse(x, y, size*3);
```

You can see that second circle is the same red colour, but with an even smaller **alpha** value of **10**, making it very see-through. The **diameter** of the circle is now **size*3**. That means it is three times whatever random size was picked for the first circle. This is a neat way of keeping the two

circles in proportion. It doesn't matter what the size of the first circle was, the second one will always be three times larger.

Here's the code so far.

```
function setup() {
  createCanvas(800,600);
  background('white');
  noLoop();
}

function draw() {

  // number of pieces a line is split into
  var pieces = 20;

  // 40 network lines
  for(var count = 0; count < 40; count += 1) {

    // random start and end points line
    var x1 = random(100, 700);
    var y1 = random(100, 500);
    var x2 = random(100, 700);
    var y2 = random(100, 500);

    // draw line
    stroke(0, 0, 255, 50);
    line(x1, y1, x2, y2);

    // move along line in equal steps
    for (step = 0; step <= pieces; step += 1) {
      // coordinates of point along line
      var x = x1 + ((x2 - x1) * step / pieces);
      var y = y1 + ((y2 - y1) * step / pieces);
      var size = random(5, 20);

      // draw circles
      noStroke();

      // first circle
      fill(255, 0, 0, 40);
      ellipse(x, y, size);

      // second larger, more translucent circle
```

```
        fill(255, 0, 0, 10);
        ellipse(x, y, size*3);
    }

  }

}
```

We've also reduced the alpha value of the blue lines as I now think we'll keep them, but reduce their prominence. Here are the results of this code.

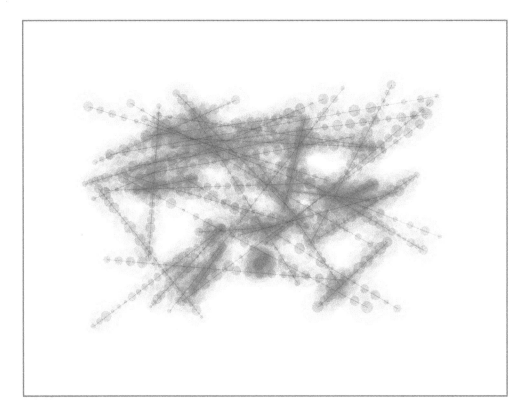

Getting there! I love the effect of the overlaid larger but more translucent circles. It gives a sense of pulsating rhythm and adds gently to the complexity. But we have lost some clarity around the area where lots of circles overlap. In some way, this now looks more like background and not foreground. We need to emphasise some objects to make them feel like the foreground.

One way to do this is to darken the smaller circles. We can easily link the size of a circle to its alpha value by using any calculation that makes the alpha smaller as the size grows. Given that the size of the circle is chosen randomly from a range between **5** and **20**, if we divide **1000** by the **size** variable, we should get answers between **200** and **50**. That looks a good range for alpha values. The following code shows how we replace the **alpha** value of the inner circle with **1000/size**.

```
// first circle
fill(255, 0, 0, 1000/size);
ellipse(x, y, size);
```

Let's see the results.

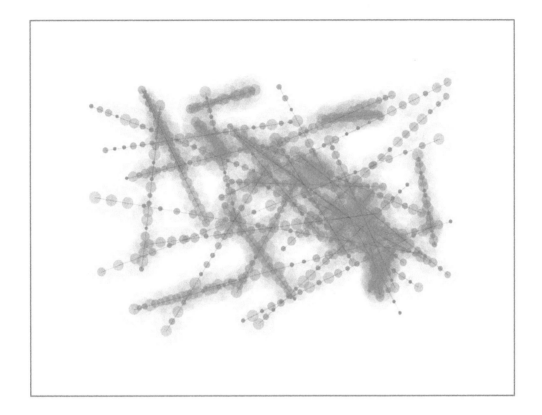

That is much much better. The smaller circles are emphasised, and definitely look like they're marking the network of lines.

One last thing to try is colour. Adding lots of colour to this is difficult to get right. But why don't we try picking a small number of circles and making them pop out by giving them a strong contrasting colour? That way we add some sparkle to the image, but avoid over complicating it with too many colours.

How do we pick a small number of circles to give this special colour treatment to? Randomness comes to the rescue again. We can use **random()** to, in effect, roll some dice.

We know that **random()** picks numbers randomly from a range of numbers. If we say this range is the numbers **1** to **6**, then **random()** works like a six-sided die, by picking one of those six possible numbers. If we wanted a smaller chance of picking, say **1**, we'd increase the range of numbers to choose from. The chance of picking **1** from the range **1** to **1000**, is much smaller than picking from the range **1** to **5**.

Let's show this idea as a picture, as it will help us understand what's going on. We're using spinning roulette wheels which stop on a random number.

chance of picking 1 $\quad \dfrac{1}{2}$

chance of picking 1 $\quad \dfrac{1}{6}$

chance of picking 1 $\quad \dfrac{1}{8}$

That first example shows us randomly picking a number in the range **1** to **2**. The chance of getting a **1** is a half, **1/2**. That's because there are only two possibilities. That is just like throwing a coin to see if we get a head or a tail. The chance of a head is the also a half, because there are only two possibilities.

The next example shows us picking a random number from the range **1** to **6**. The chance of picking a **1** is now a sixth, **1/6**. This **chance**, or **probability**, is smaller as there are more possibilities besides picking a **1**. This is just like throwing a six-sided die.

If we make the range bigger, from **1** to **8**, then the chance of picking a **1** gets even smaller. It's an eighth, **1/8**, because there are eight possibilities.

You can see that if we picked randomly from a range **1** to **1000**, the chance of getting a **1** is tiny, a thousandth, **1/1000**.

So we can use this idea to effectively throw a die and if the result is a **1**, we can make that circle a bright colour. Have a look at the following code snippet.

```
// first circle
fill(255, 0, 0, 1000/size);

// random small change circle is brightly coloured
if (int(random(50)) == 1) {
```

```
    fill(0, 0, 255, 200);
}

ellipse(x, y, size);
```

We can see the code at the top setting the colour of the inner circle to red, with a translucency that depends on **size**. That's just what we did before. At the bottom you can see the familiar instruction to draw the circle. But in the middle we have some new code. Let's talk about it.

We've not seen this **if** instruction. It seems to be similar to the **for loop** because it seems to have a condition inside some brackets (), and then some code inside curly brackets {}. This is actually much simpler than a **for loop**. Remember I promised you that **for loops** are probably the most complicated thing we'd ever see, and everything else would be easier?

This **if** instruction is easy. All it does is run the code inside the curly brackets, if and only if the condition inside the round brackets is true. That's why it is called an **if**. The names of Processing instructions are usually helpfully named. Here the code tests whether a number, chosen randomly between **0** and **50**, is equal to **1**. If it is, then the code inside the curly brackets {} is executed. In this case it sets the fill colour to a pure **blue**, with a high **alpha** value of **200**. That's what the **double equals ==** does, it tests whether whatever is on the left of it, is the same as whatever is on the right of it. If the two sides are the same, the result is true, and **if** can be happy.

Let's take a step back from all that. The chances of the fill colour being set to that not-so-see-through **blue** is quite low. One in fifty, **1/50**, in fact. That's the same idea as rolling a die and getting a **1**, but this die has **50** sides! On the rare chance this does happen, the inner circle is filled in with a deep blue colour.

Hang on! What's that **int()** instruction that's sitting around the **random(50)**? Well, we've talked before about how **random()** picks numbers that aren't necessarily whole numbers like **1**, **3**, **7**, **21**, but picks numbers with fractional bits, like **1.231**, **3.212**, **7.011**, **21.338431**, and so on. This didn't matter to us before because when we used it to pick colour **RGB** levels, or locations and sizes of objects, inside Processing these numbers with decimal fraction bits were rounded to a whole number.

We assumed that our random numbers were whole numbers when we designed our dice rolling idea. That means we need to round those numbers picked by **random()** down to the nearest whole number. For example, **1.57** is rounded down to **1**, and **0.89** is rounded down to **0**. That's what the **int()** does, it rounds numbers downwards to the nearest whole number. The name for **int()** comes from **integer**, which is a mathematical way of saying whole number.

Enough talk, let's see what the results look like.

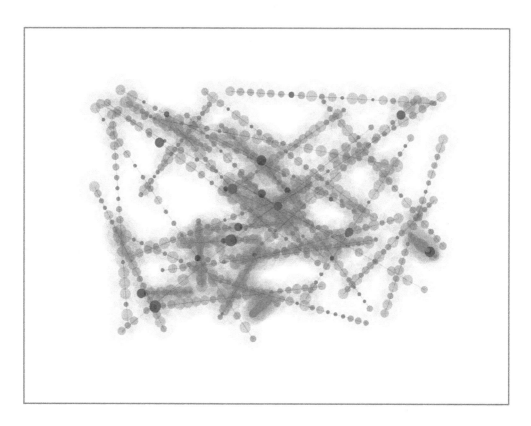

That's much more interesting. We now have an interplay between some highlights against a more ambient pulsing background.

The idea of adding a sprinkling of colour worked, and we need a little more of it, perhaps some more circles of a third colour. Have a look at the following code, which again introduces a new instruction.

```
// first circle
fill(255, 0, 0, 1000/size);

// small chance of brightly coloured circles
    if (int(random(50)) == 1) {
        fill(0, 0, 255, 200);
    } else if (int(random(10)) == 1) {
        fill(255, 255, 0, 200);
    }

ellipse(x, y, size);
```

You can easily guess what **else if** does. If the condition in the first **if()** isn't true then the second **if()** is tested. It almost reads like everyday English. If the first roll of the **50** sided die doesn't

produce a **1**, then we get a second go on a **10** sided die. If that second die produces a **1**, we paint a **yellow** circle with a fixed **alpha** value of **200**. I experimented a few times to arrive at these values.

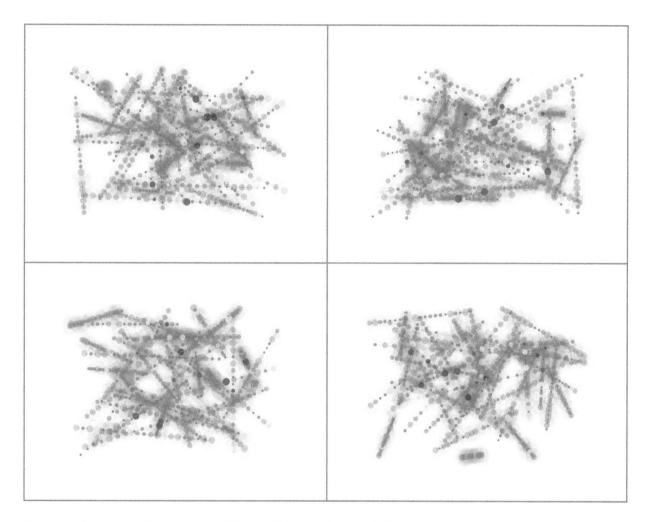

The results are really amazing. A beautiful symphony of dancing highlights against a pulsing rhythm of busy urban networks.

Amazing also because we've only used simple ideas like randomness, coordinates, fractions and simple shapes like lines and translucent circles.

The final sketch is online at https://www.openprocessing.org/sketch/460914.

Well done!

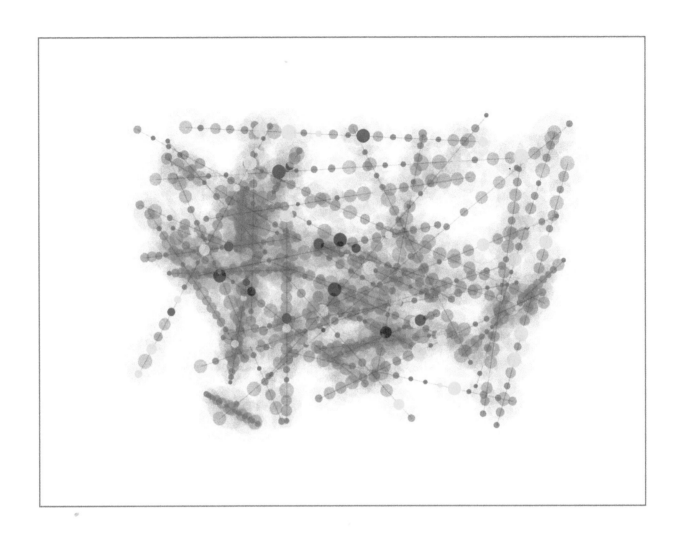

Metropolis

Functions - Reusable Code

In this section we're going to learn about packaging up useful code so we can use it again and again, without having to type it all out again and again.

It's like having a really great recipe for pizza dough. You'd want to keep it safe, and use again and again, as a base for different kinds of pizzas. It's the same idea with code, keeping interesting and useful bits of code to be used easily as part of a bigger project.

It's easiest to see all this in action than to explain the theory first. So let's dive in, starting from a simple bit of code, and seeing the idea of reusable code emerge naturally.

Let's draw a flower. The following shows how we can make one out of a **yellow** circle for the centre of the flower, and four **red** circles around the flower for the petals. It's a simple flower, nothing fancy.

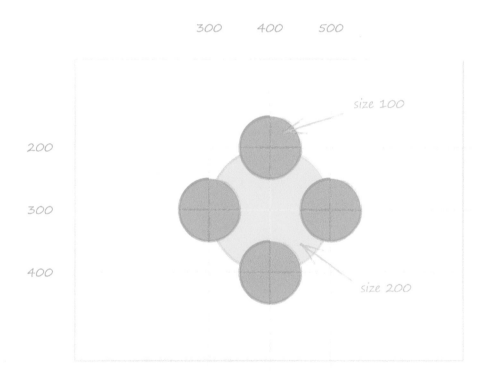

The **yellow** circle is right in the middle of the canvas, and has a diameter of **200**. The other **red** circles are smaller with diameter **100**, and they're placed directly above, below, to the left and to the right of the main circle. That picture helps us work out the coordinates of the red circle centres.

Here's the code. Nothing in there is new, we've done circles and working out coordinates many times before.

```
function setup() {
  createCanvas(800, 600);
  background('white');
  noLoop();
}

function draw() {
  noStroke();

  // yellow flower centre
  fill('yellow');
  ellipse(400, 300, 200);

  // four red petals
  fill('red');
  ellipse(500, 300, 100);
  ellipse(300, 300, 100);
  ellipse(400, 200, 100);
  ellipse(400, 400, 100);
}
```

The result is a flower, as we'd expect.

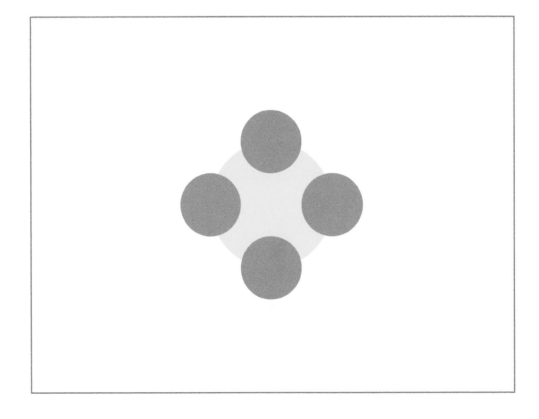

Now, imagine we like this flower so much, that we want to package up the code so that we can reuse it later. How do we do that?

The answer is something we've already seen - **functions**. If you remember, we talked earlier about the **setup()** and **draw()** functions, and how Processing calls **setup()** once, but calls **draw()** repeatedly. We're going to create our own function. Here's what the basic code for creating our own function looks like.

```
function my_function() {
  // the reusable code goes inside the curly brackets
}
```

It really is as simple as that. We start with the **function** instruction to tell Processing we're about to create our own function. We then give it a name. In this example we've used **my_function** as the name. In real code, it's always a good idea to use a meaningful name that helps other readers of our code understand what the function is for. We put our useful code inside the curly brackets **{ }**.

Let's package up our flower code into a function called **my_flower**.

```
function my_flower() {
  noStroke();

  // yellow flower centre
  fill('yellow');
  ellipse(400, 300, 200);

  // four red petals
  fill('red');
  ellipse(500, 300, 100);
  ellipse(300, 300, 100);
  ellipse(400, 200, 100);
  ellipse(400, 400, 100);
}
```

You can see the **function** instruction telling Processing we're about to create a new function called **my_flower**. Inside the curly brackets, we've placed exactly the same code we had before for drawing the flower.

That's great, but how do we actually use this packaged up code? We simply use the name of our new function as if it was a Processing instruction. It couldn't be simpler.

```
my_flower();
```

It's as if we invented our own new Processing instruction to sit alongside others like **ellipse()** and **fill()** as equals.

You may be wondering why we have empty brackets after **my_flower**. They were there when we defined the function too, if you have a look back. We'll talk about what they're for very soon, but for now just include them.

Let's write a whole program that draws the same flower, but this time uses that **my_flower()** function we created.

```
function setup() {
  createCanvas(800, 600);
  background('white');
  noLoop();
}

function draw() {
  // call our function my_flower()
  my_flower();
}

function my_flower() {
  noStroke();

  // yellow flower centre
  fill('yellow');
  ellipse(400, 300, 200);

  // four red petals
  fill('red');
  ellipse(500, 300, 100);
  ellipse(300, 300, 100);
  ellipse(400, 200, 100);
  ellipse(400, 400, 100);
}
```

You can see that the **draw()** function is now very empty! All it has is a single instruction, which is a call to our new function **my_flower()**. And that function is defined further down the code just as we talked about above.

Notice that our new function is not inside the **draw()** function's curly brackets like the code we've written before. Our new **my_flower()** stands on its own and separate from **draw()**.

If you run the code, the result should be exactly the same as before.

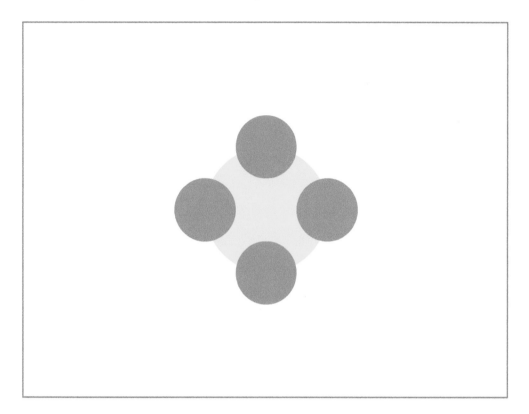

Great! It's worth taking a moment to appreciate how simple that was. To package up some code so that it can be reused very simply by its name was almost too easy.

We haven't yet gained much from doing this. So let's have a look at how functions can be very powerful friends. Instead of **my_flower()** always drawing the flower at the centre of the canvas, let's have the function draw the flower at any location we tell it. This is where those brackets we mentioned before come in. Remember how we regularly use brackets to pass information to Processing instructions? For example, we pass a location and a diameter to the **ellipse()** instruction to tell it where to draw a circle, and at what size. Another familiar example is **fill()**, where we tell it what colour to fill any shape we then draw. We pass this information through those brackets **()**. We can do the same for our own **my_flower()**.

To do this, we need to adjust our definition of **my_flower()** so that it actually expects that information to be passed to it. You may remember we called that information the **parameters**.

```
function my_function(parameter_1, parameter_2, ...) {
    // the reusable code goes inside the curly brackets
}
```

You can see that we have the same **function** instruction to tell Processing we're about to create a new function named **my_function()**. But now we have a list of parameters inside the brackets (). That's the information that our function should expect every time it is used.

If we expect to pass it just one item of information, then we'd only have one parameter listed, like the following.

```
function my_function(parameter_1) {
    // the reusable code goes inside the curly brackets
}
```

If we expect to pass two bits of information, then we'd have two parameters, like the following.

```
function my_function(parameter_1, parameter_2) {
    // the reusable code goes inside the curly brackets
}
```

If we expect to pass three bits of information, we'd list three parameters, and so on.

In our case, we want to tell **my_flower()** where to draw the flower. That requires two bits of information, the **horizontal** and **vertical** coordinates of the centre of the flower. So our **my_flower()** definition could look like this.

```
function my_flower(x, y) {
    // inside the code, we can use parameters x and y
    // the reusable code goes inside the curly brackets
}
```

We've named the parameters **x** and **y**. That makes sense, as they give us, and anyone else reading our code, a big clue about what they're for. Inside the function code, we will magically have that **x** and **y** available for us to use. We don't need to create those variables, they're automatically created for us, and their values are what we pass to **my_flower()** through its brackets. Here's how we'd pass a location of **(200, 300)** to **my_flower()**.

```
my_flower(200, 300);
```

That's just like how we pass information to other Processing instructions. That familiarity and consistency is good. It helps make learning easier, avoids surprises, and also helps others to use our **my_flower()** function too, because it behaves just like everything else in Processing.

Let's adjust the flower drawing code to use these parameters, and calculate the location of the yellow and red circles from the given location **(x,y)**. The following picture helps us work out what those coordinates should to be.

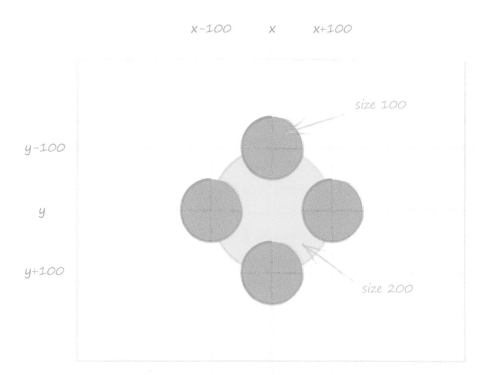

The big yellow circle is at **(x,y)**. That's the centre of the whole flower. Starting from the top and going round clockwise, the locations of the smaller red circles are **(x, y - 100)**, **(x + 100, y)**, **(x, y + 100)**, and **(x - 100, y)**. You can follow the light blue guiding lines to see this for yourself.

Here's the full code.

```
function setup() {
  createCanvas(800, 600);
  background('white');
  noLoop();
}

function draw() {
  // call our function my_flower()
  // passing it the location of the flower
  my_flower(400, 300);
}

function my_flower(x, y) {
```

```
  noStroke();

  // yellow flower centre
  fill('yellow');
  ellipse(x, y, 200);

  // four red petals
  fill('red');
  ellipse(x + 100, y, 100);
  ellipse(x - 100, y, 100);
  ellipse(x, y - 100, 100);
  ellipse(x, y + 100, 100);
}
```

You can see inside the **draw()** function our call to **my_flower()** now has the location of the flower passed as two numbers inside the brackets, **my_flower(400,300)**.

You can also see the definition of **my_flower()** now shows two parameters that it should expect, and names them **x** and **y**. Inside the curly brackets you can see the big yellow circle being drawn at **(x,y)** and the other smaller red circles at the coordinates we worked out above. The resulting image is exactly the same as before, which is what we expect because we've just told **my_function()** to draw the flower at **(400, 300)**, the very centre of the canvas.

The sketch is online at https://www.openprocessing.org/sketch/469021.

Now the magic happens! Let's change how we call our function from **my_flower(400, 300)** to **my_flower(200, 200)**. We've changed the location we pass to our function to **(200, 200)**. The result looks like this.

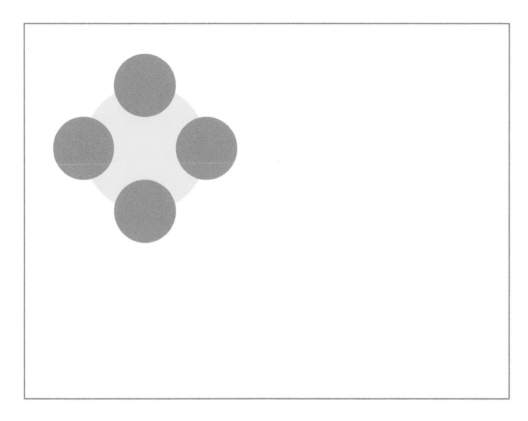

The whole flower has moved! Not just a circle, but the whole arrangement. That's because we made the effort to work out the locations of the yellow and red circles based on the chosen **x** and **y** coordinates. This proves our working out was correct.

But the really important point is that we now have a function that can draw a flower anywhere we want. And we can use that function **my_flower()** as many times as we want. Let's try it. The following shows our **draw()** function with two more calls to **my_flower()** added.

```
function draw() {
  // call our function my_flower()
  // passing it the location of the flower
  my_flower(200, 200);
  my_flower(400, 400);
  my_flower(600, 200);
}
```

The results show three flowers, each at three different locations **(200, 200)**, **(400, 400)** and **(600, 200)**.

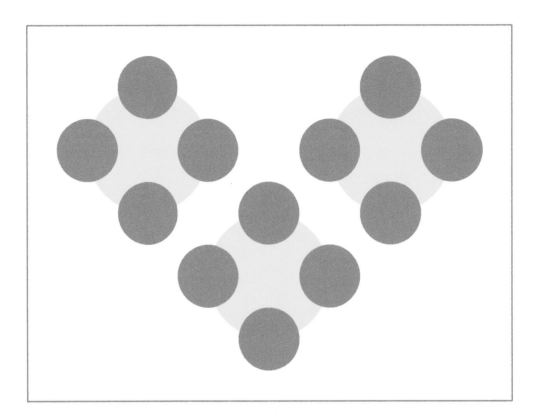

Let's pause and think about what we've achieved. We've packaged up code into a reusable form. That saves us from having to type out the code again and again. That whole flower arrangement is now called by a very simple **my_flower()** instruction.

We have also done something very powerful. We've changed the function to expect some information, and act according to that information. That opens up huge possibilities, and is a technique which coders and algorithmic artist use frequently. This is the **generalisation** we talked about before. We've taken something specific, and made it work in a more general way. Here we took code that drew a flower at a specific location, and made it able to draw a flower at any location. Using parameters, like **x** and **y**, which can be chosen when we call the function, and not decided beforehand and set in stone, is called **parameterisation**. Don't worry if you don't feel comfortable with these fancy words yet, they're just words computer scientists use to show off!

We've covered all we need to about functions, so let's have some fun. Not only because it is fun, but because we'll also see these ideas illustrated in different ways, which helps us understand them more deeply.

We've parameterised the location of the flower, but the size of the flower is still fixed, decided when we first wrote the code. Let's change the definition of **my_flower()** to accept not just the location of the flowers, but also its size.

```
function my_flower(x, y, size) {
```

```
    // inside the code, we can use parameters x, y and size
    // the reusable code goes inside the curly brackets
}
```

We'll need to change the code that draws the circles to take account of this **size** parameter.

```
// yellow flower centre
fill('yellow');
ellipse(x, y, size);

// four red petals
fill('red');
ellipse(x + (size * 0.6), y, size * 0.8);
ellipse(x - (size * 0.6), y, size * 0.8);
ellipse(x, y - (size * 0.6), size * 0.8);
ellipse(x, y + (size * 0.6), size * 0.8);
```

The big yellow circle now has a diameter of **size** instead of **100**. That was easy enough. The smaller red circles seem more complicated, so let's take it step by step. The diameter is **size * 0.8**, which makes these red circles a bit smaller than the yellow circle. The locations of these red circles was previous shifted away from the centre of the yellow circle by **100** pixels. Now they're shifted by **size * 0.6**, which reduces **size** to just over half.

Here's the full code showing the new **my_flower()** function being used three times with three different **size** parameters, **100**, **150** and **50**.

```
function setup() {
  createCanvas(800, 600);
  background('white');
  noLoop();
}

function draw() {
  // call our function my_flower()
  // passing it the location of the flower
  my_flower(200, 200, 100);
  my_flower(400, 400, 150);
  my_flower(600, 200, 50);
}

function my_flower(x, y, size) {
  noStroke();
```

```
  // yellow flower centre
  fill('yellow');
  ellipse(x, y, size);

  // four red petals
  fill('red');
  ellipse(x + (size * 0.6), y, size * 0.8);
  ellipse(x - (size * 0.6), y, size * 0.8);
  ellipse(x, y - (size * 0.6), size * 0.8);
  ellipse(x, y + (size * 0.6), size * 0.8);
}
```

The results show this worked.

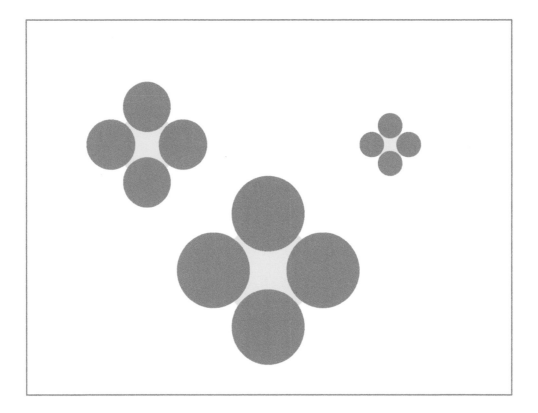

The flowers are all scaled properly.

The reason this works is that both the size of the circles, and the positions of the petals away from the flower centre, are directly proportional to the **size** parameter. If **size** doubles, so do the sizes of the circles, and the distance of the petals from the centre. This way, everything scales in **proportion**.

Our choice of fractions **0.8** for how much smaller the red circle is than the yellow circle, and **0.6** for the shift away from the centre, decides the overall look of the flower. Have a play with different fractions to see this for yourself. Here's one of my own experiments. Yes, it's a bit silly!

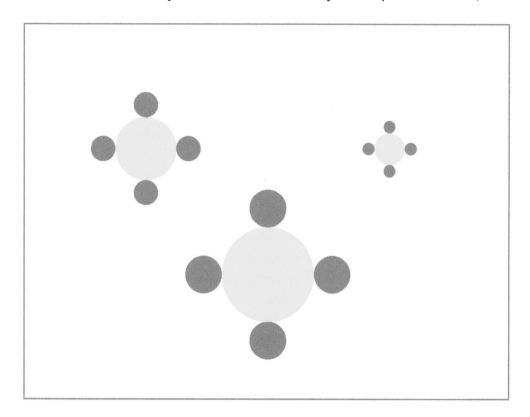

Now let's go flower crazy and draw lots of them. We can use a **loop** to call **my_flower()** as many times as we like. We can use **randomness** to pick locations all over the canvas. Here's how we'd do this in code.

```
// fifty flowers of random location and size
for (var count = 0; count < 50; count += 1) {
    my_flower(random(100, 700), random(100, 500), random(10, 30));
}
```

There's nothing new in that code. We've already seen loops, and using **random()** to pick locations at random, but away from the canvas edge. The **size** parameter is constrained to be chosen between **10** and **30**, so we're going to draw **50** small flowers.

Let's also change the colours to be translucent. The yellow circle can be a **yellow** mixed using RGB values with an **alpha** of **100** so mildly translucent. The petals can be a **red** and also with an **alpha** of **100**. Here's the full code.

```
function setup() {
  createCanvas(800, 600);
  background('white');
  noLoop();
}

function draw() {
  // fifty flowers of random location and size
  for (var count = 0; count < 50; count += 1) {
    my_flower(random(100, 700), random(100, 500), random(10, 30));
  }
}

function my_flower(x, y, size) {
  noStroke();

  // translucent yellow flower centre
  fill(255, 255, 0, 100);
  ellipse(x, y, size);

  // four  translucent red petals
  fill(255, 0, 0, 100);
  ellipse(x + (size * 0.6), y, size * 0.8);
  ellipse(x - (size * 0.6), y, size * 0.8);
  ellipse(x, y - (size * 0.6), size * 0.8);
  ellipse(x, y + (size * 0.6), size * 0.8);
}
```

And here's the result.

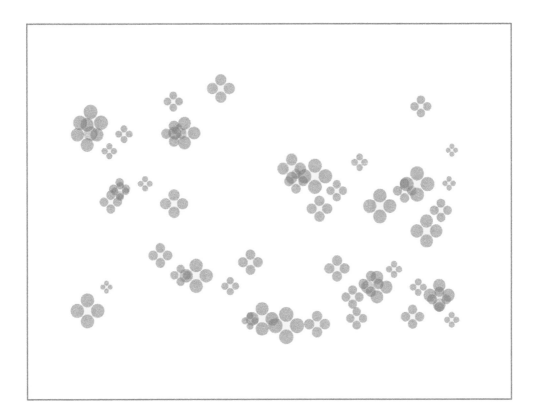

What a nice result! Remember every run will produce different compositions because the location and size of the flowers is chosen randomly.

This sketch is online at https://www.openprocessing.org/sketch/469279.

What We've Learned

We've learned about packaging up code to make it reusable. That's a key skill that every programmer learns, not only to make their own code reusable, but also learn how to use other people's code.

The **setup()** and **draw()** functions are not the only ones we've seen. Almost every Processing instruction is actually a function that someone else wrote for us to use. Instructions like **ellipse()**, **line()**, **fill()** are in fact functions, packaged code, made it easy for us to use. Mind blowing!

Key Points

- Useful code can be packaged as a named **function** to make it easier to reuse.

- A function is created using **function function_name() {}**, where **function_name** is the name we've chosen for this function. The code itself is placed inside the curly brackets.

- We can pass information to a function through brackets after its name, for example **my_function(100, 200)**. These bits of information are called **parameters**. The function must be defined to expect these parameters. These parameters automatically become **variables** inside the function code. For example **function my_function(x, y) {}** expects two parameters, which will be called **x** and **y** inside the curly brackets.

- Changing code which does a specific thing, to make it more general is a very useful habit for both computer scientists and algorithmic artists. **Generalisation** means the code becomes even more useful. For example, code which draws a flower at a specific location is more useful if it can take parameters telling it where to draw a flower. The location of the flower has been **parameterised**.

Functions Made of Functions

Imagine we're making a lovely pizza. We break the task down into smaller ones:

- preparing the dough

- preparing the toppings

- cooking it in an oven

To make the dough we use flour that someone else has prepared so that our job is easier. The same with mozzarella cheese for the topping, a specialist made that cheese ready for us to use. In turn, the cheesemaker will break down the task of making mozzarella cheese into several smaller jobs, which might include using the work of others, like the dairy that collects the milk to make the cheese.

This approach of breaking down a more complex task into smaller ones is a good mindset to develop for two reasons.

First, breaking things down into smaller pieces makes them more manageable, easier to create, and with less chance of error. It's a fact that our brains prefer to work on several smaller simpler tasks, making less errors, than on one large complicated task.

Second, we get the chance to create reusable bits of more general code, those **functions** we talked about, which makes for efficient coding. Some algorithmic artists take great pride in the elegance and efficiency of their code.

So let's apply these grand ideas, but in a simple way, to make it easier to see how they work.

Let's make something that's not too complex, but a bit more complex than the flower we made before. How about a plant, made of several flowers? The following is a rough idea of how this plant could be made. We have three of our previous flowers joined together by three green stalks. Simple!

It would be useful to have the code for a whole plant packaged up neatly so it was reusable. We could use it repeatedly in loops, or to draw plants at random locations, just like our **my_flower()** function. So let's create a **my_plant()** function. It clearly needs parameters to tell it where to draw the plant. That means the definition should look something like this:

```
function my_plant(x, y) {
// code to draw a whole plant at (x,y) goes here
}
```

You can see the name of this function is **my_plant**, and it expects to take two parameters. These will be the coordinates of the point at which the plant is drawn.

Let's draw another picture to plan out how we're going to draw the flowers and the stalks. It's always helpful to sketch things out with a pen and paper before we dive into coding.

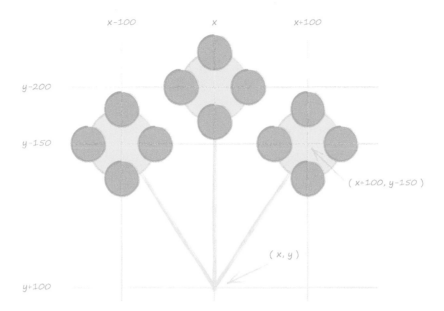

Here we've made the bottom of the flower, where the three stalks join together, the reference point. When we say that the flower is located at **(x, y)**, we mean the point at the bottom, where the **green** stalks join together, is at **(x, y)**.

That means the flowers are not at **(x, y)**, but shifted up, and to the left and right of this point. Looking at the picture above, we can see the middle flower is centred at **(x, y - 200)**. We can simply read that off using the guide lines we've drawn. By the way, this is just an initial sketch, there's no real reason that should be **y - 200**. We're know it has to be above the bottom of the stalks. The distances can be adjusted later. Looking again at the other two flowers, we can again read off their centres. The left flower is at **(x - 100, y - 150)**, and the right flower is at **(x + 100, y - 150)**. The reason these are shifted up by **150** is that they need to be lower than the middle flower which we've shifted up by **200**.

A nice thing about our arrangement is that the green lines, which represent the flower stalks, also have endpoints at the centres of the flowers so we don't need to calculate these points again.

This is good progress. We can now start to flesh out the **my_plant()** function with these coordinates.

```
function my_plant(x, y) {
  // middle flower
  var x1 = x;
  var y1 = y - 200;

  // left flower
  var x2 = x - 100;
```

```
    var y2 = y - 150;

    // right flower
    var x3 = x + 100;
    var y3 = y - 150;
}
```

Here we've simply created new variables which are the horizontal and vertical coordinates of the centres of the flowers, calculated from the bottom of the plant at **(x, y)**. The middle flower is centred at **(x1, y1)**, the left flower at **(x2, y2)** and the right flower at **(x3, y3)**.

That's all we need to call the flower functions, because we know their locations. For now we can keep their size at **100**.

```
// draw middle flower
my_flower(x1, y1, 100);

// draw left flower
my_flower(x2, y2, 100);

// draw right flower
my_flower(x3, y3, 100);
```

Let's code up what we have so far, and see what the results look like.

```
function setup() {
  createCanvas(800, 600);
  background('white');
  noLoop();
}

function draw() {
  // draw a plant
  my_plant(400, 500);
}

function my_plant(x, y) {
  // the centres of the three flowers

  // middle flower
  var x1 = x;
  var y1 = y - 200;
```

```
  // left flower
  var x2 = x - 100;
  var y2 = y - 150;

  // right flower
  var x3 = x + 100;
  var y3 = y - 150;

  // draw the flowers
  // draw middle flower
  my_flower(x1, y1, 100);

  // draw left flower
  my_flower(x2, y2, 100);

  // draw right flower
  my_flower(x3, y3, 100);
}

function my_flower(x, y, size) {
  noStroke();

  // translucent yellow flower centre
  fill(255, 255, 0, 100);
  ellipse(x, y, size);

  // four  translucent red petals
  fill(255, 0, 0, 100);
  ellipse(x + (size * 0.6), y, size * 0.8);
  ellipse(x - (size * 0.6), y, size * 0.8);
  ellipse(x, y - (size * 0.6), size * 0.8);
  ellipse(x, y + (size * 0.6), size * 0.8);
}
```

You can see the main **draw()** function only has a single instruction, the call to **my_plant()**. The function **my_plant()** is defined just as we talked about, and that in turn makes use of the function **my_flower()** which we made earlier.

The next picture shows this hierarchy of functions made of functions. The function **my_plant()** is made with **my_flower()**, which is made using the **ellipse()** function built into Processing.

ellipse() my_flower() my_plant()

Here are the results.

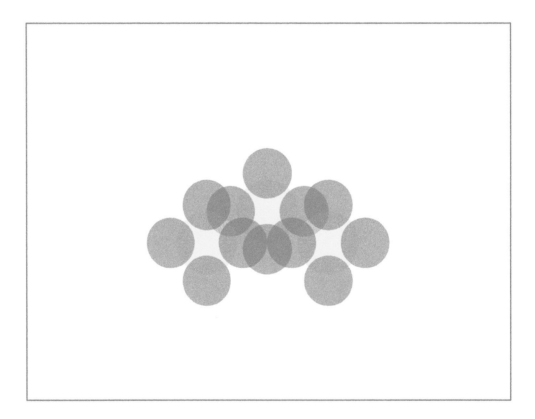

Something is not quite right. The three flowers are there but they're overlapping. The size of **100** that we used is too large, let's try **50** instead.

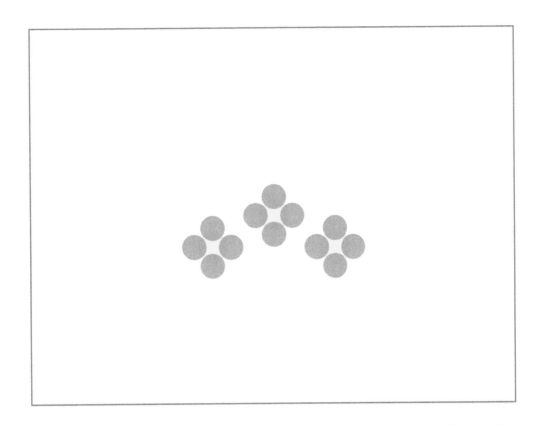

That's much better. Let's add in the green stalks. They're really easy as they're just thick **green** lines from the bottom of the plant at **(x, y)** to each of the flower centres. We must remember to draw them before the flowers, so they appear behind them. The code should look something like this.

```
// set line colour and thickness
stroke(0, 255, 0, 100);
strokeWeight(2);
// draw middle stalk
line(x, y, x1, y1);
// draw left stalk
line(x, y, x2, y2);
// draw right stalk
line(x, y, x3, y3);
```

Let's update our code.

```
function setup() {
  createCanvas(800, 600);
  background('white');
  noLoop();
```

```
}

function draw() {
  // draw a plant
  my_plant(400, 500);
}

function my_plant(x, y) {
  // the centres of the three flowers
  // middle flower
  var x1 = x;
  var y1 = y - 200;
  // left flower
  var x2 = x - 100;
  var y2 = y - 150;
  // right flower
  var x3 = x + 100;
  var y3 = y - 150;

  // draw the stalks
  // set line colour and thickness
  stroke(0, 255, 0, 100);
  strokeWeight(2);
  // draw middle stalk
  line(x, y, x1, y1);
  // draw left stalk
  line(x, y, x2, y2);
  // draw right stalk
  line(x, y, x3, y3);

  // draw the flowers
  // draw middle flower
  my_flower(x1, y1, 50);
  // draw left flower
  my_flower(x2, y2, 50);
  // draw right flower
  my_flower(x3, y3, 50);
}

function my_flower(x, y, size) {
  noStroke();

  // translucent yellow flower centre
  fill(255, 255, 0, 100);
```

```
  ellipse(x, y, size);

  // four  translucent red petals
  fill(255, 0, 0, 100);
  ellipse(x + (size * 0.6), y, size * 0.8);
  ellipse(x - (size * 0.6), y, size * 0.8);
  ellipse(x, y - (size * 0.6), size * 0.8);
  ellipse(x, y + (size * 0.6), size * 0.8);
}
```

And the results are as expected.

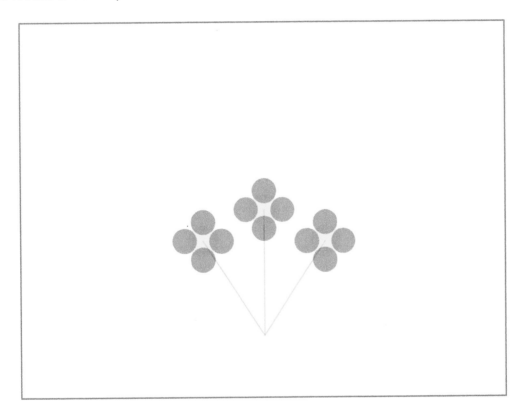

Great! We now have a function which can draw plants anywhere.

Let's try using **my_plant()** to draw three plants.

```
// draw three plants
my_plant(200, 500);
my_plant(400, 300);
my_plant(600, 500);
```

The result is pretty cool.

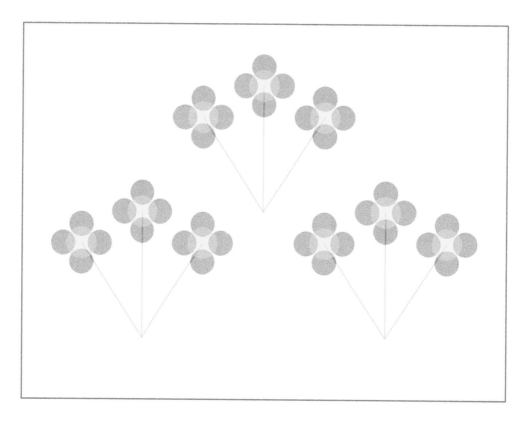

Let's pause and digest what we've achieved. We have created a new function **my_plant()**, which draws a moderately complex object - a plant with **3** flowers. It relies on another function **my_flower()** to do the job of drawing the flower made of **5** circles. To draw this plant, all we need to do is simply use one call to **my_plant()**. That composition above only took **3** lines of code in **draw()**. That's the power of **functions**, and functions made of other functions.

The code for this composition is online at https://www.openprocessing.org/sketch/469497.

Have some fun by making a change in **my_flower()** to see what effect it has on **my_plant()**. My own experiment was to make a single change to the colour of the petals to be **blue** using **fill(0, 0, 255, 100)**, and the result affects the whole plant.

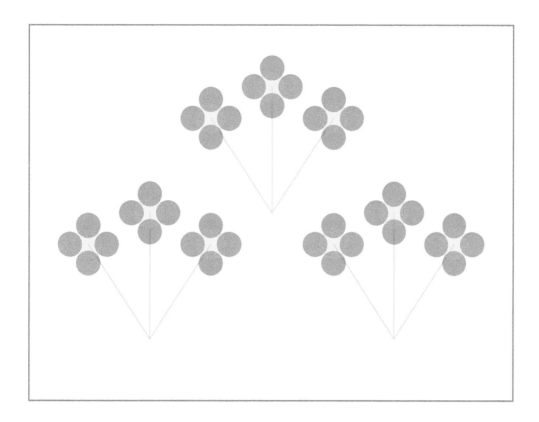

That is fun, but it also illustrates how powerful this idea of breaking a bigger task into smaller functions really is. We can make improvements to smaller more manageable functions, and the benefits immediately appear in any function that uses those functions. If we didn't break our project into smaller reusable functions, we'd have to hunt down and modify any code that draws a flower petal, which for the above composition could be **36** times for **36** petals!

Enough on functions for now.

What We've Learned

We've not learned any new Processing instructions in this section. Instead we learned about the benefits of breaking more complicated projects into smaller tasks.

Key Points

- Breaking more complicated projects into **smaller tasks** makes them easier. Our brains prefer to work on smaller simpler tasks, making fewer errors when we do.

- A very common way of doing this in code is to use simpler smaller **functions** to make slightly more complex functions, which in turn can be used to make sophisticated compositions.

- Making a single improvement to a smaller building-block function immediately improves any function that makes use of it. This is a very efficient way of coding because we only need to fix code once, in one place.

The Sinuous Sine Wave

Mathematics contains many treasures that we can use to elegantly create really sophisticated, beautiful and intricate art.

I know that can be a hard thing to believe, and I won't try to convince you in one go. We have the rest of this journey to discover some of those jewels.

For now, we're going to dip our toe into some simple bits of maths, and show how they can be really useful for creating art. None of what we'll cover is beyond what we would have done at secondary school. Even so, we'll take it easy, step by step, because too often this cool maths wasn't explained in a fun engaging way at school.

Do you remember drawing graphs of mathematical equations like $y = x + 1$, or $y = 2x$? We did that by working out the value of **y** for several values of **x**, drawing these points on a graph, and then joining up the dots to see what the graph of these equations looked like.

Here's an example of **y** worked out for a few values of **x**, for the really simple equation $y = x + 1$.

x	y = x + 1
0	1
1	2
2	3
3	4
4	5

You can see that when **x** is **0**, **y** is **1**, because **y** is **x** with **1** added to it, just as the equation **y = x + 1** says it is. Similarly, when **x** is **1**, **y** is **2**, and when **x** is **4**, **y** is **5**. Let's draw pairs of **x** and **y** as dots with coordinates **(x,y)** on a graph and see what it looks like.

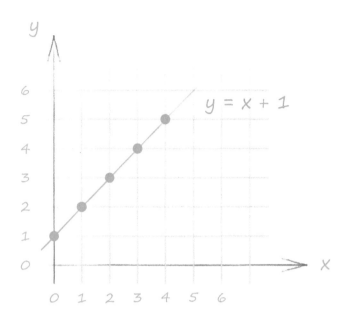

You can see I've drawn little red dots for every **(x, y)** pair that we worked out for **y = x + 1**. I've joined the dots too. It's clear to see that joining up the dots gives us a straight line. If we used different values of **x** to work out **y**, the **(x, y)** pairs would still fall on that line.

That equation **y = x + 1** is one of many equations that gives a straight line when drawn in this way. The fancy word for them is **linear function**. Linear for straight line, and function because just like a code **function**, it takes a value and does something with it, in our case takes an **x** and gives us back **x + 1**. The similarities between mathematical functions and functions in code are not accidental, but we can explore them another time, on a very rainy day.

You might have terrible memories of plotting such graphs of equations at school, memories of boredom and tedium. I promise our use of these equations will be much more fun.

Let's turn up the complexity a little bit. Let's try **y = x²**. That little **2** above the **x** means **x** is **squared**, or **x** multiplied by **x**. Let's work out **y** for some values of **x**, just like before.

x	y = x^2
-3	9
-2	4
-1	1
0	0
1	1

2	4
3	9

The easiest one is when **x** is **0**. In that case, **y** is also **0** because **0** times **0** is **0**. Similarly when **x** is **1**, **y** is **1**, because **1** times **1** is **1**. What about when **x** is **3**? In that case, **y** is **9**, because **3** times **3** is **9**. Easy enough. What about when **x** is less than **0**? Well, you may remember from school that a negative number times a negative number is a positive number. So when **x** is **-3**, **y** is **-3** times **-3**, which is **9**, not **-9**.

Let's plot those pairs for this equation and see what shape they make.

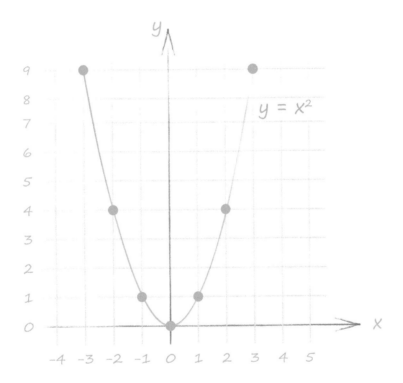

That's definitely more interesting. What's going on?

Well, the squared function, **y = x²**, gets bigger much more quickly than the linear one we just looked at. We're no longer adding a constant number to the **x** values. We're now multiplying that number by itself, and so the bigger the **x**, the much bigger its square. Because the square of a negative number is a positive number, the results are the same on the left hand side of that graph as they are on the right hand side. In other words, that graph is **symmetrical**.

Joining up the dots gives us an interesting curve, not a straight line. This function, **y = x²**, is not a linear function because that line is not straight. If you want to know, and you don't need to know it, that curve is called a **parabola**. I don't think I've used that word in polite conversation in over 20 years!

Let's step up the complexity a little bit again. Remember **trigonometry** from school? Don't run away! Yes, I know it was an extremely boring and excruciating time for many people, myself included. The crazy thing is, the maths in trigonometry can create really beautiful forms. Why they didn't show that, I don't know. Maybe more people would be interested in mathematics and algorithmic art today if maths was taught better in schools.

Anyway, let's look at one of those functions we came across in trigonometry classes. You may remember the **sine** function. Don't worry if you don't remember, or even know what it is. We'll uncover its nice side here, and not get bogged down in unnecessary equations.

Most calculators have a button with **sin** written on it, which is the common abbreviation for **sine**. Let's try working out a few values of **sin(x)** for some **x** just to get a feel for how it behaves. Try it yourself for some values of **x**. If you don't have a calculator, you've probably got one on your smartphone or computer. You can even type something like **sin(3)** into Google's search box and it will become a calculator for you.

x	y = sin(x)
-3	-0.1411
-2	-0.9093
-1	-0.8415
0	0.0000
1	0.8415
2	0.9093
3	0.1411

Something interesting is going on here. Let's uncover it. When **x** is **-3**, the value of **sin(x)** is **-0.1411**. For **x = -2**, the value of **sin(x)** falls down to **-0.9093**. But then for **x = -1**, it rises again to **-0.8415**. Then as **x** gets larger, we see **sin(x)** rising then falling in a similar way.

The values of **sin(x)** seem to be rising and falling - that's kinda weird!

It's always a good idea to visualise mathematical functions to get a better feel for what they do. We could do this by hand but that will get boring very quickly. I've used a spreadsheet with a column of numbers for **x**, another column for **sin(x)**, and then used the charting tool to plot these pairs as points, joined by a line. You can use your favourite spreadsheet, most can do this easily.

You can now see much more easily the fall and rise, and fall again, of **sin(x)** as **x** goes from **-3** to **+3**. This is actually very exciting! Most mathematical functions we learn about at school are boring in comparison. Most of them are straight lines, some might be curves. This one seems to be a **wave**. Let's add more detail to that graph by working out **sin(x)** for even more values of **x**, this time going from **-10** up to **+10**. I won't show the working out, as it is just like what we did before, and we can get our spreadsheets or calculators to do the hard work for us.

That seems to confirm that **sin(x)** just keeps going up and down. But the precise pattern isn't clear. Yes, those values seem to rise and fall, but it's hard to predict exactly what the pattern will be after **x** gets larger than **10**. It's not even obvious what the value of **sin(x)** when **x** is **1** should be, just from looking at the graph.

Maybe we're not plotting enough detail. Let's try plotting the graph for the same range of **x**, from **-10** to **+10**, but this time calculate **sin(x)** every **0.5**. That is for **x = -10, -9.5, -9.0. -8.5, -8.0,** .. and so on.

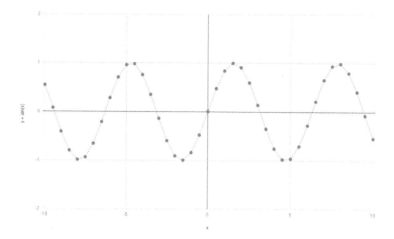

The pattern has revealed itself! It really is a beautiful sinuous wave. This is a really important discovery for us. We've found a function which rises and falls with a very natural movement. It's not like those boring cold straight lines. I would even say this is a happy function!

If we look closely, we can see that **sin(x)** rises to **+1**, and falls to **-1**, but never goes above **+1** or below **-1**. There are many more interesting features to be found in the **sine wave**, as it's called, but for now, noticing this fact will be very useful to us.

So how is this **sine wave** useful for us? Well, we can use a **sin()** function whenever we need something that varies up and down in a smooth organic way. Previously, we've used a counter that rises steadily to calculate things like circle sizes. That's the equivalent of a linear function, because it rises in a steady constant way. The possibilities for a sinuous undulating wavy function are endless, and algorithmic artists find all kinds of interesting uses for it. We'll explore a few ourselves.

You may be wondering why I used a spreadsheet to work out **sin(x)** and plot a graph. Good challenge! Let's use Processing to plot a sine wave. We'll need a loop to count up the values of **x** over a chosen range. The code should be something like the following.

```
// x ranges from 0 to 800
for (var x = 0; x <= 800; count += 1) {
  // calculate sin(x)
  var y = sin(x);
  // draw point on graph
  ellipse(x, y + 300, 2);
}
```

The value of **x** will go from **0** to **800**, increasing by one at every repetition of the loop. That matches the width of the canvas nicely. You've probably already spotted the Processing **sin()** instruction for calculating the **sine** of a number.

We place the calculated **sin(x)** into a new variable **y**. We then plot a very small circle of diameter **2** pixels at **(x, y + 300)**. We're adding **300** to the vertical coordinate because we noted above that the sine of anything is always between **-1** and **+1**. If we didn't add **300** then the points would be plotted along the very top of the canvas, and would fall off the edge of the canvas when **sin(x)** was less than **0**. This way, the wave should appear half way down the canvas.

Here's the full program code.

```
function setup() {
  createCanvas(800, 600);
  background('white');

}

function draw() {

  noStroke();
  fill('red');

  // x ranges from 0 to 800
  for (var x = 0; x < 800; x += 1) {
    // calculate sin(x)
    var y = sin(x);
    // draw point on graph
    ellipse(x, y + 300, 2);
  }

}
```

And here's the result.

That's not what I expected. There is a curvy wave if you look very very closely at that pink line. What happened?

If you look back at our previous nicer plot of **sin(x)**, the values of **x** between **-10** and **+10**. In that range we had about **3** peaks. Also the vertical limits of **sin(x)** were between **-1** and **+1**. Our canvas here goes from **0** to **800** horizontally, and from **0** to **600** vertically. That's a huge mismatch to the scale where we could see the sine wave clearly.

We can fix this mismatch of scale by simply rescaling the values of **x**. That is, for every **x** that we count in the loop, we can divide it by **100** before we calculate the sine value. That means the effective range will go from **0** to **8**, because **800** divided by **100** is **8**. That should sort it out horizontally. What about vertically? Well we know that **sin(x)** is always between **-1** and **+1**, so if we multiply the answer we get from **sin()** by **100**, we should be able to more easily see peaks going from **-100** to **+100**.

All that sounds complicated but the changes are really simple.

```
// calculate scaled sine
var y = sin(x / 100) * 100;
```

You can see we've divided the **x** by **100**, and the multiplied the result of the **sin()** function by **100**. Here's the result.

Much better.

If you've got a brain like Einstein, you may have spotted this curve starts to fall first as **x** grows from **0**, but when we used our spreadsheet the wave rose up as **x** grew from **0**. The reason is that the Processing canvas has the vertical coordinates going down, not up. That's why it looks upside down. We could have fixed that with some calculation, but it would only have distracted from the main idea.

Let's try to make this into something that we might want to print and hang on our wall. Repetition is a powerful visual technique, so let's try it. Let's repeat that sine wave several times, but shifted up and down a little bit. We can use another loop for these vertical offsets.

```
// calculate scaled sine
var y = sin(x/100) * 100;

// draw several points at offsets
  for (var offset = -100; offset <= 100; offset += 10) {
    ellipse(x, y + 300 + offset, 2);
  }
```

You can see that every time the sine is calculated, we have a new loop which creates an **offset** counter, going from **-100** up to **+100** in increments of **10**. Instead of plotting just one circle at **(x, y + 300)**, we're going to be plotting them at **(x, y + 300 + offset)** for every value that **offset**

takes. That is, at **(x, y + 300 - 100), (x, y + 300 - 90)**, and so on .. up to **(x, y + 300 + 90)** and **(x, y + 300 + 100)**.

This is a loop within a loop, like we've seen before with the trees and apples example. The outer loop counts **x**, and the inner loop counts the **offsets**.

Let's see the result.

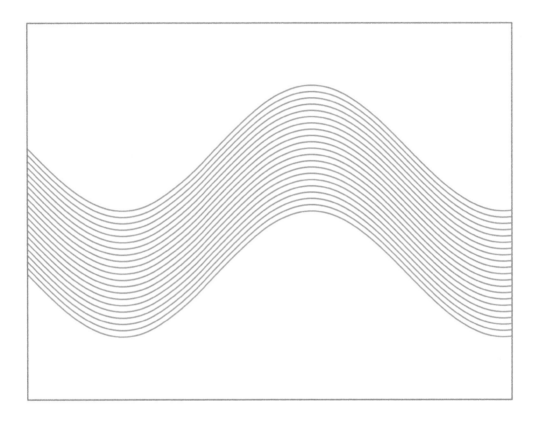

Funky! But let's not stop there. We've used the **offset** to draw each small pink circle above and below the original curve by shifting the vertical location of the pink circles. Why not use it to offset the horizontal coordinate too? There's no real thought process behind this idea other than experimentation - which is a perfectly valid reason in algorithmic art!

That should mean the pink circles will be plotted at **(x + offset, y + 300 + offset)**. Because offset ranges from **-100** to **+100**, that does mean some of the points will go off the canvas but let's see what we get anyway.

Here's the full code.

```
function setup() {
  createCanvas(800, 600);
  background('white');
```

```
}

function draw() {

  noStroke();
  fill('red');

  // x ranges from 0 to 800
  for (var x = 0; x < 800; x += 1) {
    // calculate scaled sine
    var y = sin(x/100) * 100;

    // draw several points at offsets
    for (var offset = -100; offset <= 100; offset += 10) {
      ellipse(x + offset, y + 300 + offset, 2);
    }

  }

}
```

And here's what it makes.

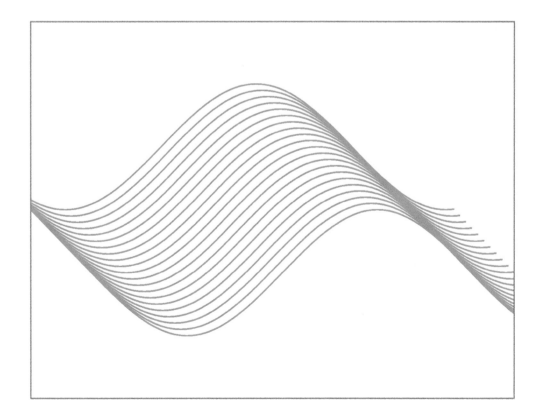

It reminds me of Bridget Riley's art, but with more of a sci-fi feel. Who would have thought that a deadly boring trigonometric function from school classes could produce such cool images!

The sketch is online at https://www.openprocessing.org/sketch/471602.

Because the **sin()** function varies smoothly it's also useful for mixing colours that vary smoothly. Let's see how this could work.

Let's draw coloured squares across the canvas, from left to right. Here's the basic code which draws squares of size **20**, moving along the horizontal axis by **20** units with every loop repetition, so the squares touch each other.

```
// x ranges from 0 to 800
  for (var x = 0; x < 800; x += 20) {
    rect(x, 200, 20, 20);
  }
```

Let's use the horizontal position **x** to calculate a smoothly varying colour. We've already seen how **sin(x)** is a smoothly varying function, but it varies between **-1** and **+1**. For mixing colour, we need RGB values between **0** and **255**. We can do this by first adding **1** to **sin(x)** to make the range go from **0** to **+2**, then multiplying by **127.5** to make the range go from **0** to **255**. We could try doing this just to the **green** channel, like the following code shows.

```
var red = 255;
var green = (sin(x/100) + 1) * 127.5;
var blue = 255;
```

We've divided **x** by **100** to give us the right range for **x** as it varies from **0** to **800**, just like we did before. The **red** and **blue** levels are fixed at **255** for now.

Here's the full code.

```
function setup() {
  createCanvas(800, 600);
  background('white');
  noLoop();
}

function draw() {

  // x ranges from 0 to 800
```

```
for (var x = 0; x < 800; x += 20) {
    // for every point calculate a colour
    var red = 255;
    var green = (sin(x/100) + 1) * 127.5;
    var blue = 255;

    // draw coloured square
    fill(red, green, blue);
    rect(x, 200, 20, 20);
  }

}
```

Before we look at the results, what should we expect? We know we're mixing the fill colour of squares drawn horizontally along the canvas. The **red** and **blue** levels are fixed at the maximum **255** so it should be a fairly light colour. The **green** level is the only one that varies at all. And it varies according to a square's horizontal position at **x**. The calculation takes the **sine** of **x/100** which should be a smoothly varying number between **-1** and **+1**. We rescale that to be between **0** and **255**. That means we should have a smoothly varying **green** channel. When it is at **255**, at the peaks of those **sine** waves, we have all the RGB levels at maximum, which gives us white. When it is at its minimum **0**, at the bottom trough of those waves, we only have **red** and **blue** levels which gives us a nice **magenta**.

Let's see.

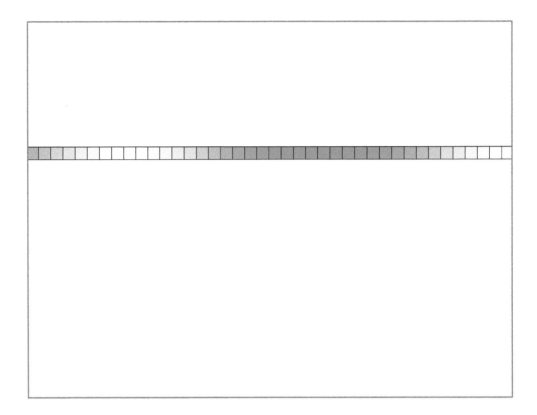

That worked. We've successfully used the smoothly varying mathematical function **sin()** to mix colours so they too vary smoothly across the canvas.

When we divided **x** by **100**, in **sin(x/100)**, we shrunk it quite a bit. If we don't shrink it quite so much with, **sin(x/25)** for example, we should get more of those sine waves peaks and troughs coming into range.

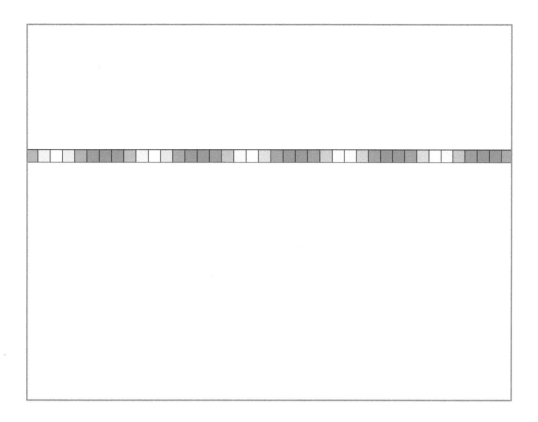

Yes, that worked too.

Let's remind ourselves why this works. If you look back to when we drew our first since wave, we saw two peaks in the range **0** to **10**. If our **x** goes from **0** to **800**, we'd see roughly **80** times as many peaks, that's **160** peaks, all squashed together! If we divide **x** by **100**, we bring the range back down to **0** to **8**, which is about one and half peaks. If we divide **x** by **25**, we bring the range down to **0** to **32**, which gives us about **5** peaks.

Count them yourself in the following graph showing **x** ranging from **0** to **32**. The peaks and troughs correspond to the white and deep magenta squares.

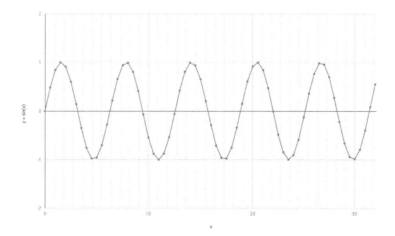

We don't have to use just one variable to calculate colour levels. Let's try adding a second variable **y**, from the vertical location on the canvas, to include in the calculation of the RGB colour levels. We'll have our very familiar **loop within a loop** to count along the horizontal and vertical directions so we can cover the canvas in coloured squares. The code to calculate the RGB colour levels could be something like the following.

```
// for every location calculate a colour
var red = 255;
var green = 255 - ((sin(x/100) + 1) * 100);
var blue = 255 - ((sin(y/100) + 1) * 100);

fill(red, green, blue);
rect(x, y, 10, 10);
```

We're leaving the **red** channel at the maximum **255** again. The calculations for the **green** and **blue** levels are exactly the same, except where **x** is used in one, and **y** in the other. We see the familiar **sin(x/100)**, which gives us a sine wave varying between **-1** and **+1**. We also see the familiar rescaling of this to **0** to **200**, achieved by adding **1**, then multiplying by **100**. The answer is then subtracted from **255**, so the overall range of the **green** and **blue** levels is from **55** to **255**.

Here's the full code.

```
function setup() {
  createCanvas(800, 600);
  background('white');
  noLoop();
}

function draw() {
  noStroke();

  // x ranges from 0 to 800
  for (var x = 0; x < 800; x += 10) {
    // y ranges from 0 to 600
    for (var y = 0; y < 600; y += 10) {

      // for every location calculate a colour
      var red = 255;
      var green = 255 - ((sin(x/100) + 1) * 100);
      var blue = 255 - ((sin(y/100) + 1) * 100);

      fill(red, green, blue);
```

```
        rect(x, y, 10, 10);

    }
  }

}
```

And the results.

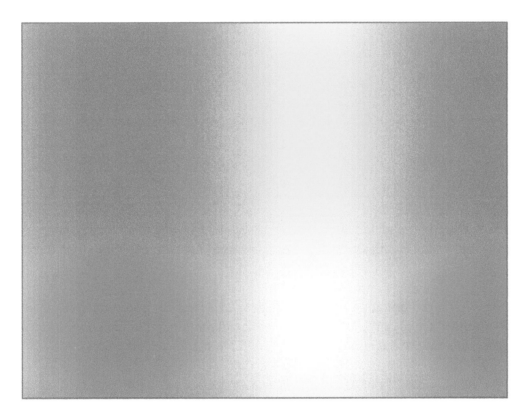

This image is really rather nice. You can see the smoothly varying colours as the mixing is governed by the sinuously smooth wavy sine function.

The sketch is online at https://www.openprocessing.org/sketch/471694.

There is a lot of fun to be had experimenting with different calculations for working out RGB colour levels. Here is one of my own experiments, achieved using nothing beyond using the variables **x** and **y**, and calculations including the **sin()** function.

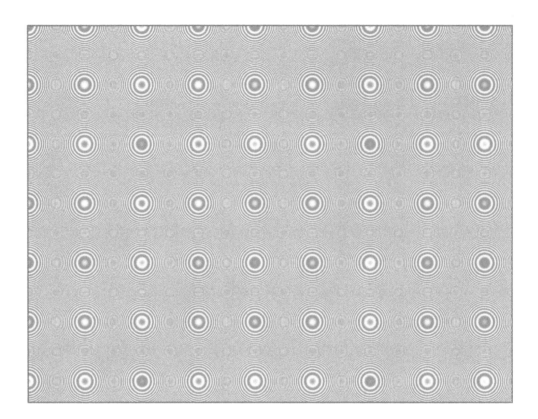

I did reduce the size of the squares to a single pixel, which is why this image is more detailed. What's really interesting is that calculations with the **sin()** function can often lead to circles and ripples.

How did I do it? The **red** and **blue** levels were set to **255**, and the **green** channel was calculated using **255 - ((sin((x*x + y*y)/30) + 1) * 100)**. That looks more horrible than it really is. All it's doing is taking the **sine** of the sum of x^2 and y^2, and the rest is just scaling.

The code for these ripples is online at https://www.openprocessing.org/sketch/521820.

Have a go yourself!

Before we move onto another useful mathematical function, it's worth looking at another Processing instruction to help with all that rescaling we've been doing. Just look back at that last calculation **255 - ((sin((x*x + y*y)/100) + 1) * 100)**. Yuk! All we wanted to do was map the **sine** range of **-1** to **+1**, to a new range **255** to **55**. Surely there must be a nicer way to do it.

Imagine we want to rescale **sine** values from their range **-1** to **+1**, to new range **0** to **255**, which is useful for RGB colour values, for example. It would be really convenient if we could do something like this:

```
map(my_value, -1, 1, 0, 255);
```

In fact we can. That **map()** is a real Processing instruction. We can call it a **function**, now that we know what functions are.

Let's look at what it does. The **0** and **255** are the target range we are interested in. The **-1** and **1** are the actual range of the value we're mapping. That value here is **my_value**. Here are some examples to help us understand how **map()** works.

- If **my_value** was **-1**, at the bottom of its range, then it would be mapped to **0**, the bottom of the target range.
- If **my_value** was **1**, at the top of its range, then it would be mapped to **255**, the top of the target range.
- If **my_value** was **0**, in the middle of its range, then it would be mapped to **127.5**, the middle of the target range.
- If **my_value** was **0.5**, three quarters along its range, then it would be mapped to **191.25**, also three quarters along the target range.

A picture actually explains all this much better.

You can see how **map()** takes a value **x**, which lives in its own range **[a,b]** and maps it to the target range **[c,d]**. The following shows this same picture but with a real example.

$$y = map (x, -1, 1, 0, 255)$$

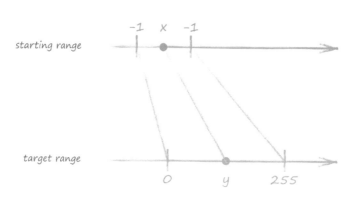

We can see now how **map(x, -1, 1, 0, 255)** can be used to take the results of a **sin()** function, which are always in the range **[-1, 1]**, and map them to the range **[0, 255]** which is useful for RGB levels.

By the way, that use of square brackets **[a,b]** is a convention in mathematics to mean a range from **a** to **b**, including **a** and **b**. It's shorter than saying all those words. Mathematicians are a very lazy bunch - lazy in a good way!

Our previous code did mapping like this:

```
var green = 255 - ((sin(x/100) + 1) * 100);
```

We can simplify it now that we know about **map()**.

```
var green = map(sin(x/100), -1, 1, 255, 55);
```

It's much easier to see what the intent is when we use **map()**, which helps anyone reading our code. Here you can see the target range actually goes backwards from **255** down to **55**, which matches what happens as **sin(x/100)** goes from **-1** to **+1**.

Next time we need to do any scaling or mapping, we'll check to see if **map()** can help.

What We've Learned

We've seen how mathematical functions are not designed to punish school children with boredom and tedium. They can actually be beautiful elegant creative tools.

Key Points

- The **sine** function creates a smoothly varying wave with evenly spaced peaks and troughs.

- It can be very useful whenever a smoothly rising and falling value is required. It has a particularly natural feel to the way it changes, which can be an important requirement for some projects.

- Processing's **sin(x)** takes a parameter **x**, and returns its **sine**, which is always in the range **[-1,1]**.

- As **x** varies from **0** to **10**, **sin(x)** has **2** peaks. That parameter **x** can be rescaled to have fewer or more frequent peaks. Similarly, the size of the peaks can be scaled up, or down, from the **[-1,1]** range.

- Processing has a convenience function **map(x, a, b, c, d)**, which scales **x** from its own range **[a,b]** to another range **[c,d]**. This can be useful for transforming sine values **[-1,1]** to RGB colour levels **[0,255]**, for example.

Natural Decay

Let's look at one more mathematical function which is really useful when we need something to decay away, to fade away in a smooth natural way.

But before we do that, let's first explore how some real world effects inspired the creation of this mathematical function.

Imagine you've bought a pack of coloured pencils for your next art project. You know the ones which are water soluble, so you can blend colours with a wet paintbrush, just like watercolours. Anyway, there are **100** pencils in this pack. They are all supposed to be the same length of **10 cm**. If we measured them, we'd find that, yes, most of them are pretty close to **10 cm**, but some are a bit more, and some a bit less. And in the pack, there might be a rare pencil which is really not close to **10 cm** at all. If we counted how many pencils were what length, we might get a table like the following.

Pencil length	number of pencils
8.0 - 8.5 cm	0
8.5 - 9.0 cm	1
9.0 - 9.5 cm	8
9.5 - 10.0 cm	40
10.0 - 10.5 cm	41
10.5 cm - 11.0 cm	10
11.0 - 11.5 cm	0
11.5 - 12.0 cm	0

You can see that there are **40** pencils between **9.5** and **10.0 cm**. There are **41** between **10.0** and **10.5 cm**. That's a very tiny bias towards pencil being longer than the advertised **10 cm**, which is fine. If there was a bias to be shorter there might be complaints! Overall that's **81** out of **100** pencils between **9.5** and **10.5 cm**, which is okay. There are **8** pencils between **9.0** and **9.5 cm**, and **10** between **10.5** and **11.0 cm**. We expect that number to be smaller, because we do expect most pencils will be close to the advertised **10 cm**. There is only one bad pencil which is between **8.5** and **9.0** cm, and none much shorter than that.

Let's turn that into a picture, so we can get a visual feel for what's going on.

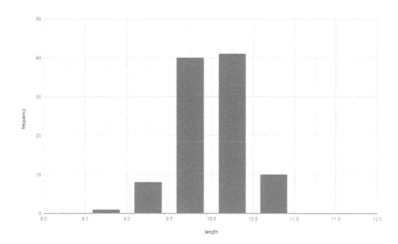

That's a good chart. It quickly shows us that most pencils are around 10 cm, with the frequency of unusual pencils tailing off.

If we take a step back from that chart, we might be able to see that there is a kind of bell shape. You may be familiar with the expression **bell curve**. It just means what we've seen with the pencils, that most things behave as we expect them to, and the unusual cases get rarer the more extreme they get. Let's draw a bell curve over that chart to see it.

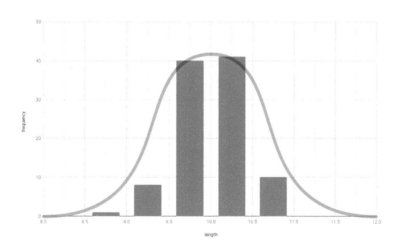

That curve has a very natural decay, starting hesitantly, then falling more rapidly before easing off into a very slow and gentle descent. In fact, nature is full of things which follow this bell-shaped curve. That's a good enough reason to try to capture that descent in a mathematical function.

There are lots of deep textbooks covering how such mathematical functions can be worked out, based on statistics, probability and even physics. But we won't do that. We'll just jump to the good bit.

Let's plot a chart of the function $y = 2^{-x}$. That's just taking the negative of **x**, and raising **2** to that number. Squaring numbers x^2 is familiar, so is taking the cube x^3. It might seem unfamiliar to raise **2** by another number which might be negative, and even worse, might not even be a whole number. Don't worry, we're only interested in how these functions behave, not in the deep algebra of how they work. Most calculators have a button for raising a number by another number, often labelled x^y. We can use a spreadsheet to do the calculations and plot a chart for us. You can even use the Google search box to do this by typing **2 ^ -1.5**, to raise **2** to the power of **-1.5** for example. You should get **0.35355**.

Well, we can see that the function $y = 2^{-x}$ does decay in a smooth way, starting from **1** and falling every closer to **0** as **x** gets larger and larger. It never actually gets to **0**, it just gets ever closer to it - that's a fun mathematical curiosity.

That's a nice curve, but it doesn't actually have the bell shape we wanted. The bell shape has a nice bulge in the middle, which means the decay starts off slowly before gathering pace. This curve starts falling fast and then slows its descent. It's worth being picky when chasing a particular aesthetic!

We can achieve that bell shape by slightly changing this function to $y = 2^{-x^2}$. The only change we've made is is to square that **x**. Let's see the effect.

That looks much better. This curve has all the characteristics we wanted. A slow unsure descent at first, speeding up to a faster fall, before slowing down into an eternal slow descent. It looks like it reaches zero, but it actually never does, it just keeps getting closer.

As it happens, this isn't the function that is used most often by mathematicians when they need a bell shaped decay. The one they actually use is $y = e^{-x^2}$. The only change here is that the **2** has become an **e**. What's an **e**? Well, you don't need to know this to create algorithmic art, but **e** is a number that is so special in mathematics that it is given its own name, **e**. I know, it's not a very imaginative name. That **e** is approximately **2.71828**, so it's not too far from the **2** we were using.

The following graph compares $y = 2^{-x^2}$ with $y = e^{-x^2}$, just to show they behave very similarly.

Enough theory! Let's see how we can use this nice gentle decay function.

Let's take inspiration from the world of physics, indeed nuclear physics, where similar decaying functions govern the behaviour of atoms and how they behave with each other. Don't worry we won't be doing a session on nuclear physics and advanced maths, we're just using the idea as creative inspiration.

Let's imagine we have tiny subatomic particles which are somehow stronger or more energised the closer they are to the centre of an atom. We can represent this by making them bigger the closer they are to the centre. We can use that bell curve to decide the size of these subatomic particles.

We can use randomness to create these subatomic particles, something we're now very practised at. The following code will get us started by drawing **5000** small pink circles on the canvas, keeping away from edge.

```
// 5000 subatomic particles
for (count = 0; count < 5000; count += 1) {
  var x = random(100, 700);
  var y = random(100, 500);

  // draw subatomic particle
  ellipse(x,y,5);
}
```

Here's what this looks like.

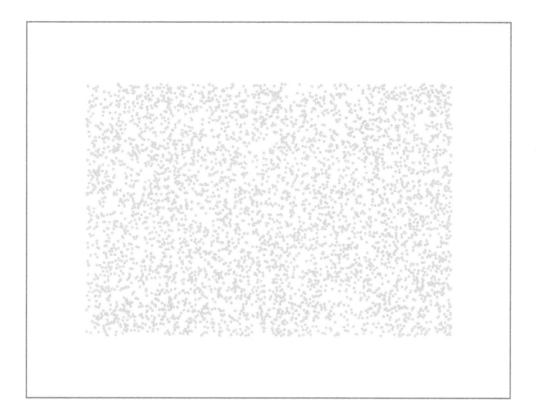

That's an even spread of particles over the canvas. Those particles are all the same size too.

If we want to make those particles near the centre of the atom somehow stronger or bigger, we need to know where the centre of the atom is, and then know how far each of those **5000** particles is from that centre. Let's make the centre of the canvas the centre of the atom.

How do we work out how far each of those particles is from the centre? Well, we could regurgitate our secondary school maths and Pythagoras' Theorem to work out the direct distance between two points. Luckily, we don't need to because Processing has a convenient function **dist()** which will do that calculation for us. The **dist()** function takes the coordinates of two points and returns the distance between them. If we had two points at **(0, 0)** and **(5, 0)**, then **dist(0, 0, 5, 0)** would give us the correct distance of **5**.

We can apply that bell shaped decay function to this distance to give us the size of the particle. Those particles close to the centre, that is, those a small distance from the centre, will be larger circles. The larger the distance, the smaller the size, but the change will happen smoothly. That hump in the middle of the bell curve will ensure that there is a nice clump in the middle of the atom, because the particles there won't have their sizes diminish too quickly.

Let's code this idea.

```
// 5000 subatomic particles
for (count = 0; count < 5000; count += 1) {
```

```
  var x = random(100, 700);
  var y = random(100, 500);

  // distance from the centre
  var d = dist(400, 300, x, y);

  // bell curve decay function
  var decay = exp(-pow(d/100, 2));

  // draw subatomic particle
  ellipse(x,y, decay * 10);
}
```

We can see **dist()** being used to work out the distance of the particle from the centre, with the answer being placed in a variable **d**.

The next bit of code needs a bit of explanation, but not much. The Processing function **pow()** is used to raise one number to the power of another number. So **pow(3,2)** is the same as 3^2, which is **9**. And **pow(d,2)** would be d^2. We have actually divided the distance **d** by **100** so the scale better matches our bell curve function. So far we have $(d/100)^2$.

Next we have a new Processing function, **exp()**. It simply raises that special mathematical number **e** to whatever is inside the brackets. So **exp(2)** is e^2, and **exp(-2)** would be e^{-2}. You can see now that **exp(-pow(d/100, 2))** is our bell shaped decay function e^{-x^2}, but with **d/100** instead of **x**. The result is placed in a variable named **decay**.

The larger the distance of a particle from the centre of the canvas, the smaller the value of **decay**. For very small distances, this will be very close to **1**. For very large distances, this will be almost **0**.

We then draw our particles as pink circles, but of size **decay * 10**, to scale up from a bell curve maximum of **1** to a maximum of **10**.

Here's the result.

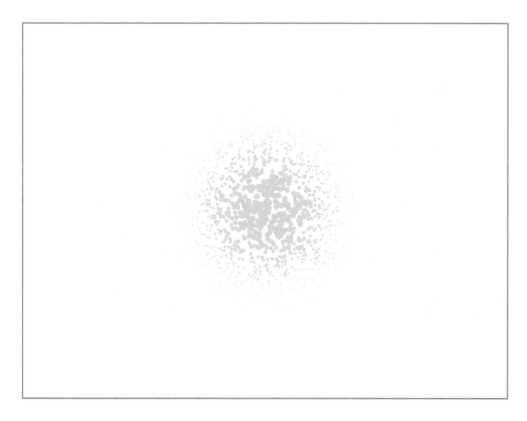

That's really very effective. It definitely looks like something from the largest expanses of space, or the tiniest clump of subatomic particles. Making the central particles larger, with their size gradually falling off smoothly works really well. It's actually rather haunting!

Let's see if we can use the bell curve to influence the colour of these particles. We can use the **decay** variable to influence the RGB levels.

```
// colour is based on bell decay curve too
fill(255, 255 - (100 * decay), 100 * decay);
```

Here we're leaving the **red** level at **255**, and having the **blue** level grow with the **decay** value. That means, for particles close to the centre, the **decay** variable will be closer to its maximum of **1**, and so the **blue** level will be closer to a maximum of **100**. The green level does the opposite because it falls as **decay** grows. There's no real rationale for this idea, other than experimentation and wanting to see one level go in the opposite direction of another.

Here's the full code.

```
function setup() {
  createCanvas(800, 600);
  background('white');
  noLoop();
```

```
}

function draw() {
  noStroke();

  // 5000 subatomic particles
  for (count = 0; count < 5000; count += 1) {
    var x = random(100, 700);
    var y = random(100, 500);

    // distance from the centre
    var d = dist(400, 300, x, y);

    // bell curve function
    var decay = exp(-pow(d/100, 2));

    // colour is based on bell curve too
    fill(255, 255 - (100 * decay), 100 * decay);

    // draw subatomic particle
    ellipse(x,y, decay * 10);
  }

}
```

Here's the result.

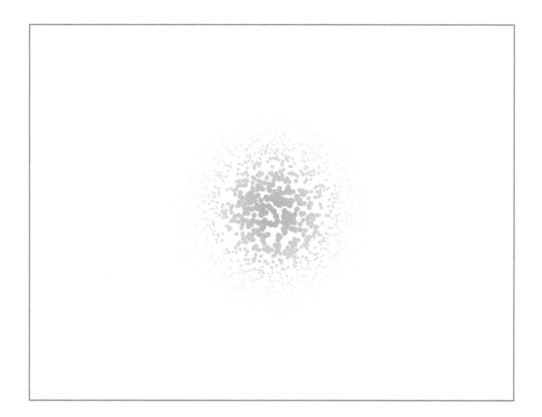

That's really very effective, given the simplicity of the idea and the code that created it. If you look back at that code, there really are only about seven lines of code that actually do the drawing.

The composition really does look like we're peering into a microscopic world of tiny particles, interacting with the heat and strength of hot lava. I'm really happy that the bell shaped decay has given us a solid middle clump, with activity falling away smoothly, and not being cut off suddenly.

The sketch is online at https://www.openprocessing.org/sketch/473264.

Have a play yourself with the scaling, and colour level calculations too.

Here's my own experiment adding a **red** stroke colour to the circles, which have also been doubled in size.

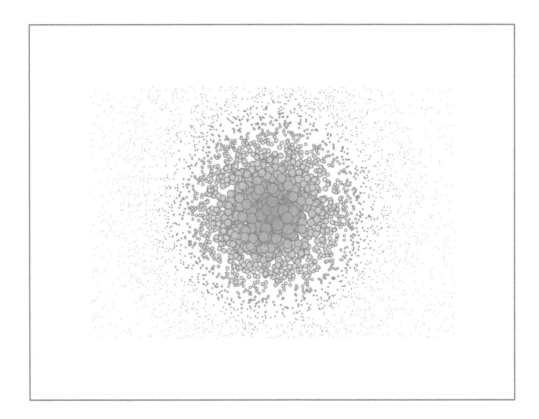

Here's another experiment where the outline stroke is not fixed as **red**, but calculated from the variable **decay**. The stroke thickness is also controlled by the **decay** variable. The stroke RGB levels are **(255, 255 * decay, 255 * decay)** so the stroke should start white and get darker further away from the centre. The stroke weight is **(2 * decay)** so should be about **2** pixels thick at the centre and get thinner further away.

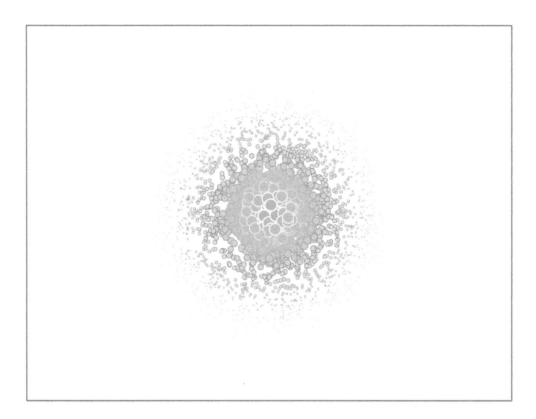

The colours are really interesting, and the image now looks more like a beautiful but dangerous virus. The sketch is online https://www.openprocessing.org/sketch/472937.

That's an amazing image from about 10 lines of code. Professional algorithmic artists would be proud!

Just when you think there can't be any more interesting variations, have a look at the following, and try to work out what simple change created it?

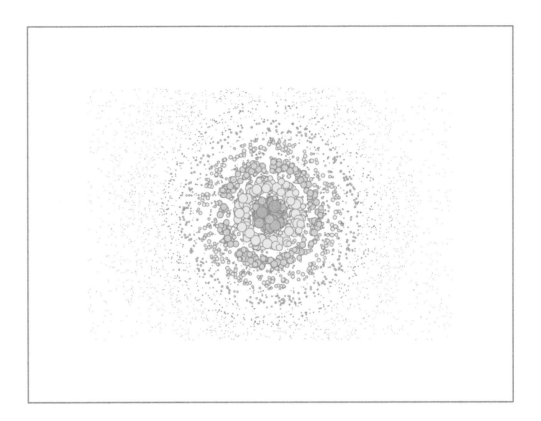

There are now definite rings of particles around that central cluster, which is a really interesting effect.

Remember the **sine** function, which rises and falls as a smooth wave? Well, if we look at that image above with the rings, we can see that as we move further away from the centre, the size of the particles rises and falls, and this works in any direction out from the centre. At the same time, overall the size of the particles falls. It's as if we're combining both the smooth descent of the **bell curve** and the sinuous waves of the **sine function**.

Let's draw a graph of the two functions multiplied together, $y = e^{-x^2} \cdot sin(5x)$. That **5** multiplying the **x** in **sin(5x)** is just to ensure we bring more peaks into the visible range.

You can see that multiplying the two functions creates the combined behaviour we wanted, the rise and fall of the sine wave, but with an overall decay in the size of the peaks. Those peaks never grow larger than the bell curve itself, and you can see that on the graph too.

Combining the behaviour of two mathematical functions idea is easy and allows us to create some really sophisticated effects.

The sketch for that composition is at https://www.openprocessing.org/sketch/473626.

More Functions To Play With

There are many more mathematical functions that you can play with, and Processing has convenient instructions for a good number of them. Have a look at the trigonometry section of the **p5js** reference online at https://p5js.org/reference/.

In addition to the **sine** function, it's really worth having a look at the **cosine** and **tangent** functions, which Processing makes available as **cos()** and **tan()**.

Experimenting with them to visualise their behaviour is the best approach to getting familiar with them. For many of us, that works better than trying to understand their origins and behaviour in a purely mathematical way using only algebra and equations.

Online graph plotters are also really useful to quickly see what equations and functions look like, without having to create a spreadsheet. This one is particularly easy to use:

- Desmos graphing calculator: https://www.desmos.com/calculator

Here is the tool being used to plot the same combination of a bell curve decay function and a wave function.

This time it's not the **sine** function but the **cosine** function. If you've had a play, you'll have found the **cosine** is the same as the **sine** but starts at a peak not at zero. Why not try using the tool to plot **sine** and **cosine** to compare them.

Here's another interesting effect of combining several functions.

Here we've combined the waves of a cosine function, with the waves of a slower cosine function to create little packets of waves, and then combined that with a bell curve decay function to make them gradually diminish.

The possibilities are endless, and fun to explore. Have a go!

What We've Learned

There are many functions that get smaller, but not all of them have a pleasing natural descent. We learned about one that is very popular, and even has some basis in the real world of physics and statistics.

Key Points

- The function **e⁻ˣ**, falls from **1** down towards **0**, but never gets to zero. It happens to be an example of an **exponential decay** function.

- A variation of that exponential decay function, $y = e^{-x^2}$, starts falling slowly, increases its rate of descent, and then slows down into an ever gradual fall towards **0**, without ever getting to **0**. This kind of shape is called a **bell curve**.

- The behaviour of different functions can be **combined** into a new function, most often achieved by **multiplying** the functions together.

Worked Example: Spirograph

This project is inspired by a drawing my young daughter and I came up with as we were messing about with pens and paper.

The idea was to start with a circle and mark out points around the edge of the circle spaced evenly apart. Then lines are drawn between these points, but skipping every other mark. You can see we've done that here with the **blue** pen. We've also drawn **yellow** lines skipping two marks at a time.

Let's use this idea of going around a circle. We've travelled along a line in steps before, with the **Metropolis** worked example, but how do we go around a circle? This will require a teeny bit of maths, but not much. Have a look at the following diagram.

It's a really simple picture of a circle, with a line drawn from the centre to the edge. The length of the line is called the **radius**. We'll call that radius **R** as it's easier to write. That point on the edge, we'll call point **P**.

That was easy enough. Now look at the following diagram.

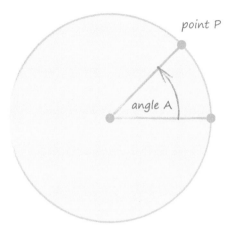

We can see the same point **P** again. The diagram also shows an angle **A**. That's the amount a point would have to turn **anticlockwise** around the centre of the circle to reach point **P**, having started on the edge directly to the right of the centre.

You may remember angles from school. Here are some examples just to remind us.

45 degrees 90 degrees 180 degrees 360 degrees

A quarter turn, from east to north for example, is **90 degrees**. A half turn, so we're facing the opposite direction, is **180 degrees**. A full turn, so we end up facing back where we started, is **360 degrees**.

Now have a look at the following diagram which links both these ideas of a **radius R** and the **angle A**.

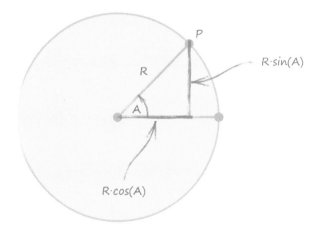

If we know the angle **A**, can we work out the horizontal and vertical location of that point **P**? The diagram shows us that we can. You can simply read off the vertical distance as **R sin(A)**, which is simply the **radius R** multiplied by the **sine** of the **angle A**. Similarly the horizontal distance is **R cos(A)**, where we use the **cosine** and not the **sine** function.

If we think of the point **P** in terms of its coordinates **(x,y)** then:

- x = R cos(A)

- y = R sin(A)

Take all the time you need to digest that. What we've just said looks simple but is quite powerful. If we only know the **angle** and **radius**, we can work out the **horizontal** and **vertical** locations of the point **P**.

Another way of saying that is, if we want to go around a circle, we can do that by counting up the angle, and when we need to draw something on the circle, we can use those mathematical statements to work out the **(x,y)** coordinates.

By the way, what we've just done is the very heart of **trigonometry**. Easy as that! If you need more time to get familiar with those **trigonometric** statements, there's a fuller discussion in **Appendix B**, including some worked examples of how we can use them.

Let's do some coding to bring this to life. Let's use a loop with a counter that starts at **0** and grows to **90**, in steps of **10**. If we think of this counter as an angle, we'll have counted up to a quarter turn. Let's use that trigonometry to calculate the location of a point on a circle of radius **100**, and mark those points with a small red dot.

The full code should look something like this.

```
function setup() {
  createCanvas(800, 600);
  background('white');
  noLoop();
}

function draw() {
  noStroke();
  fill('red');

  // set angles to be in degrees (not radians)
  angleMode(DEGREES);

  // circle radius
  var radius = 100;

  // loop to count angle
  for (var angle = 0; angle <= 90; angle += 10) {
    // calculate the x and y coordinates
    var x = radius * cos(angle);
    var y = radius * sin(angle);

    // small circle at (400 + x, 300 - y) because
    // processing canvas has y downwards, and
    // we want to centre at (400, 300)
    ellipse(400 + x, 300 - y, 5);
  }
}
```

Let's talk about that code. The first unfamiliar thing we see is **angleMode(DEGREES)**. That simply tells Processing we want to count angles in **degrees**. That's what we're most familiar with from school. That way, when we say an angle is **90**, Processing knows we mean **90 degrees**, or a quarter of a turn. There are other ways of counting angles, just like some people use **inches** and not **centimetres** for measuring length.

We set a variable **radius** to be **100**, which we'll use whenever we need to use the radius of the circle in a calculation.

We then have a familiar loop, this one using **angle** as a counter, going from **0** to **90**, in steps of **10**. Inside the loop, we use that magic trigonometry to calculate the horizontal **x** and vertical **y**

coordinates of the point on the circle that has moved around by **angle** degrees. We then draw a small red dot at that point.

Those coordinates **(400 + x, 300 - y)** given to the **ellipse()** function may look wonky, but what they're doing is two things.

- **400** is added to the horizontal coordinate **x** so that when **x** is **0**, the result is the centre of the canvas. In effect it's shifting **x** along by **400** to the centre. If **x** gets bigger than **0** then **400 + x** moves to the right, from the canvas centre.

- The vertical coordinate **y** is taken from **300**, so that when **y** is **0**, the result is the centre of the canvas. The reason **y** is subtracted from, and not added to, **300** is that Processing counts **y** down the canvas, not up the canvas. As **y** grows above **0**, **300 - y** gets smaller from **300**, which we see as going up from the middle of the canvas.

That is a lot of words for something that isn't really that complicated. A picture will help explain it better.

We want to pretend that the origin is at the centre of the canvas. We know it's not really, because **(0,0)** is at the top left of the canvas. That red dot is at **(x, y)** from the centre of the canvas. It's now easy to see why, from Processing's perspective, the red dot is at **(400 + x, 300 - y)**.

Here's the result of that code.

We can see that our little dots do indeed work their way around the edge of a circle with radius **100**. We can also see that the turn completed is a quarter of a turn, or **90 degrees**.

That's our first actual proof that the trigonometric maths linking the **angle** to the **horizontal** and **vertical** coordinates actually does work.

That image may look simple, but it is an important first step. Being able to go around a circle is a very useful skill, on which we can build more interesting ideas.

Let's change that loop to count up to the full **360 degrees**, that is, go all the way around the circle. The code change is simple.

```
// loop to count angle
for (var angle = 0; angle <= 360; angle += 10) {
```

Yes, that worked.

You may have spotted that as the angle turns beyond **90 degrees**, the **x** coordinate becomes less than **0**, and the little red dots are plotted to the left of the canvas centre. Do we have to do anything extra to make sure this happens correctly? We don't. The trigonometric functions automatically do that for us. When the angle is just passing **90 degrees**, the **cosine** of that angle falls below zero. If you remember the wavy of graph of **cos(x)**, this is when the wave starts to fall towards its first trough. The **cosine** becoming negative turns the **x** coordinate negative, that is, to the left of the canvas centre. The same happens to the **y** coordinate, which becomes less than **0** when the angle grows larger than **180 degrees**, so that the dots are drawn below the middle of the canvas.

What would happen if, instead of small little red dots, we draw transparent circles with a red outline of diameter **100** at those locations **(x,y)**? That's an easy change to make.

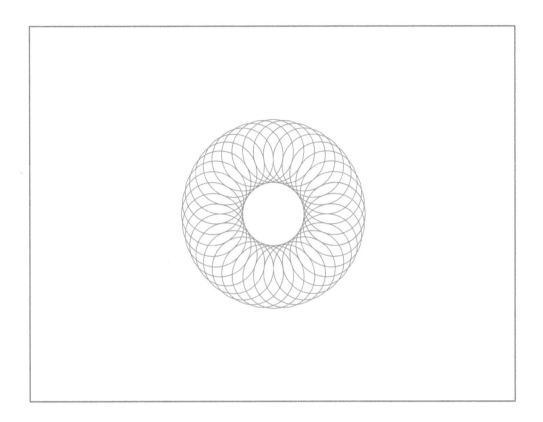

That's pretty amazing! Such an intricate pattern from such a simple idea of drawing a circle at evenly spaced points around an imaginary larger circle. That is the essence of algorithmic art, a simple idea creating beautiful forms.

Even changing those circles to filled translucent circles with a slightly less translucent outline stroke works really well.

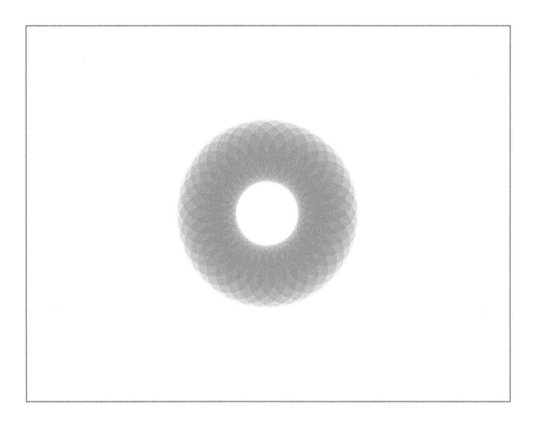

The sketch is online at https://www.openprocessing.org/sketch/473743.

Let's go back to the idea of drawing lines between those evenly spaced marks, like the doodle I did with my daughter.

Have a look at the following diagram.

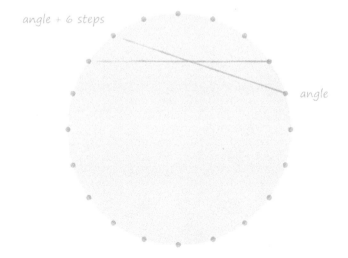

angle + 6 steps

angle

Our imaginary circle has evenly spaced red dots drawn around it. We've already coded this using a loop to count up the angle around the circle in equal steps, and calculated where the

points are. What's new here is a line from a point to another point which is **6** steps ahead. We want to do that for every point we visit.

We already visit every point with the code we've already written. The point **6** steps ahead is just **6** angle increments ahead. If we're counting up in increments of **10** degrees, and the current point is at **20** degrees, then the point **6** steps ahead is **6** lots of **10** degrees, or **60** degrees ahead, which comes to **80** degrees. We can calculate its **(x, y)** coordinates in the same way we do for any point, using those trigonometric functions. Let's see what kind of code will do this.

```
// increment step for angle
step = 10;

// loop to count angle
for (var angle = 0; angle < 360; angle += step) {

  // calculate (x,y) for the current point
  var x1 = radius * cos(angle);
  var y1 = radius * sin(angle);

  // calculate (x,y) for the next point
  var x2 = radius * cos(angle + (6*step));
  var y2 = radius * sin(angle + (6*step));

  // (400 + x, 300 - y) for origin at (400, 300)
  line(400 + x1, 300 - y1, 400 + x2, 300 - y2);
}
```

Most of the code is the same as before but there are some differences. We now set a **step** variable which is the amount the **angle** is increased by at every loop repetition. We still calculate the **(x,y)** coordinates for the point at the current **angle** around the circle, except this time we call the coordinates **x1** and **y1**.

We now also calculate the coordinates **(x2, y2)** of the point **6** steps ahead. The only difference in the calculation is that the angle now has **6** lots of **step** added to it **(angle + (6 * step))**. If it isn't clear why, think about this:

- The current point is an angle held by the variable **angle**.
- To get to the next point we add **step** to the **angle**. That's why the next point is at **(angle + step)**.
- To get to the point after that we add another **step** to the angle. So that point, two ahead of the current one, is at **angle + (2 * step)**.
- We can keep following this logic until we get to the point six ahead. It has an angle which is six lots of step ahead, or **angle + (6 * step)**.

A line is drawn from **(x1, y1)** to the point **6** steps ahead **(x2, y2)**. The line instruction takes into account the shifting we need for the origin to be at the centre of the canvas.

Here's what the results look like.

That looks promising. We are starting to see the **spirograph** effect we initially set out to achieve. It's interesting that the straight lines trace out another circle within our imaginary one.

Let's try drawing a line between a point and the point that's **15** steps ahead. The change to the code is really easy. The coordinates **(x2, y2)** are calculated from an angle which is **(angle + (15 * step))**.

The results are rather pleasing.

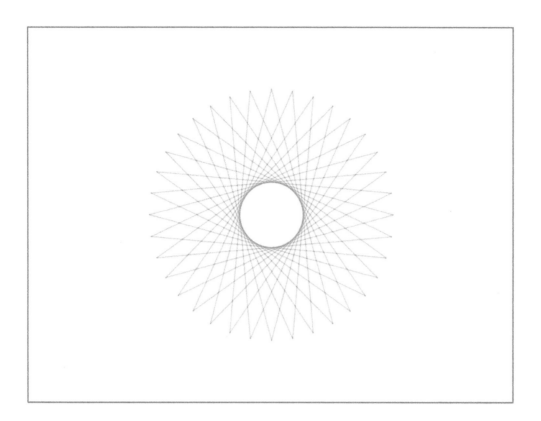

I think that's a perfectly balanced beautiful form just as it is.

We can easily add another set of lines, drawn from the same **(x1, y1)** but to a new point **(x3, y3)** which is a different number of steps ahead. The following shows the additional lines to **(x3, y3)** calculated at **17** steps ahead, with a yellow stroke colour.

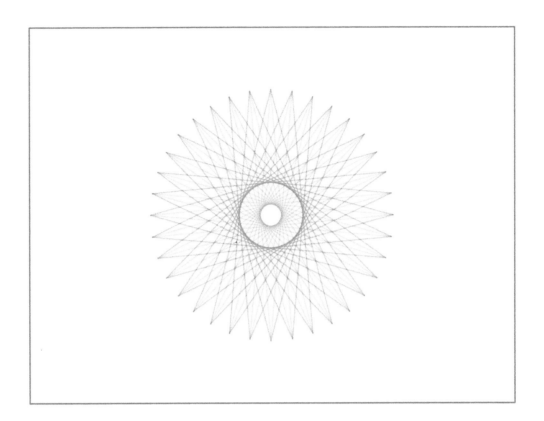

It's easy to create intricate forms and patterns in this way. Have a play yourself, varying the number of steps ahead that the line endpoints **(x2, y2)** and **(x3, y3)** are calculated at.

The sketch, including the code, is online at https://www.openprocessing.org/sketch/473794.

Another simple variation on this idea is to use filled translucent triangles with the corners at the **(x1, y1)**, **(x2, y2)** and **(x3, y3)** we just calculated. The following diagram shows this idea.

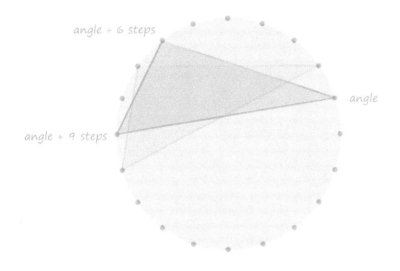

Just as the lines built up to create an intricate pattern, so should these triangles. Let' see if it does. The following result has the second point **(x2, y2)** at **15** steps ahead, and the third point **(x3, y3)** at **17** steps ahead.

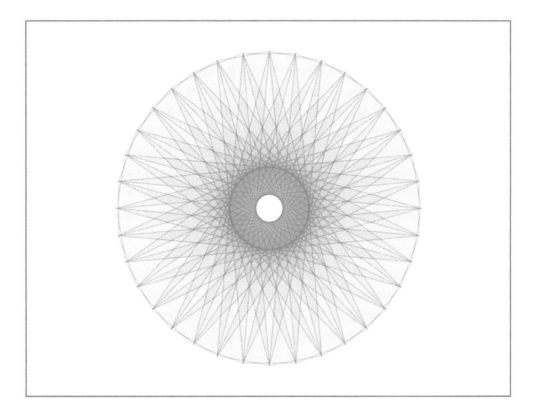

The results again are really effective, especially if we think about how simple the idea is - just triangles drawn with their corners moving around a circle.

The sketch is online at https://www.openprocessing.org/sketch/473998.

Let's shift up a gear now and try something a bit more ambitious. Have a look at the following picture.

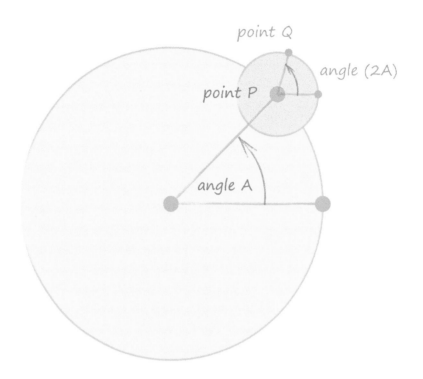

You can see the same point **P** which we follow around the main circle as we increase the angle **A**. We've already plotted that point **P** as we increased **A** in steps of **10 degrees**.

This time we're going to do something different. Instead of drawing a small dot at that point **P**, we're going use that point **P** as the centre of another imaginary circle, shown in the diagram above with a green colour. With that new smaller circle, we can follow a point, which we've named **Q**, around its edge in the same way we did with the big imaginary circle.

For now, let's link the angle of point **Q** around the small circle to the angle **A** around the large circle. Let's make it double whatever the angle **A** is. You can see that angle **2A** marked on the green circle.

Making the angle on the smaller circle **2A**, twice **A**, means the point **Q** is going around the smaller circle twice as fast as point **P** is going around the bigger circle. This might remind you of a gear system, where a smaller gear is connected to a larger gear, and the smaller gear turns faster than the bigger one. It might also remind you of a child's **spirograph** toy, which also uses gears of different sizes.

If we're going to code this idea we need to work out the horizontal and vertical coordinates of the point **Q**. How do we do that? It looks like a particularly horrible trigonometry puzzle designed to punish school children! It's actually really easy. Have a look at the following diagram.

What we've done is taken those points **P** and **Q** and shown where they are vertically and horizontally. Point **P** is at **(x1, y1)** from the centre of the big circle, and we've already seen how to work out what **x1** and **y1** are using that magic trigonometry.

- **x1 = R cos(A)**

- **y1 = R sin(A)**

Point **Q** is near point **P**, and is **x2** along, and **y2** upwards from it. You can see this in the diagram above. That means point **Q** is at **x1 + x2** horizontally, and **y1 + y2** vertically. That is, **Q** is at **(x1 + x2, y1 + y2)**.

But how do we work out **x2** and **y2**? Easy - in the same way we did with **x1** and **y2**. We'll need the radius of the small circle, which we drew in the diagram as a third of the big circle's radius, or **R/3**. We know the angle of **Q**, we've already said it's **2A**. So we have all we need.

- **x2 = R/3 cos(2A)**

- **y2 = R/3 sin(2A)**

Let's code this idea to see what it looks like.

```
function setup() {
  createCanvas(800, 600);
  background('white');
  noLoop();
}

function draw() {

  // set angles to be in degrees (not radians)
  angleMode(DEGREES);

  fill(255, 0, 0);
  noStroke();

  // circle radius
  var radius = 200;

  // loop to count angle
  for (var angle = 0; angle < 360; angle += 1) {

    // calculate (x,y) for point P
    var x1 = radius * cos(angle);
    var y1 = radius * sin(angle);

    // calculate how far point Q is from P
    var x2 = radius / 3 * cos(2 * angle);
    var y2 = radius / 3 * sin(2 * angle);

    // point Q is at (x1 + x2, y1 + y2)
    var x = x1 + x2;
    var y = y1 + y2;
    ellipse(400 + x, 300 - y, 4);

  }
}
```

There's nothing in the code that we haven't seen before. You can see how **x2** and **y2** are calculated using the smaller radius, a third of the main circle's radius, and with double the angle of **P**.

Let's see the results of this more ambitious, more complex idea. Should be good!

That's not quite the sophisticated intricate pattern we were expecting. It seems point **Q** traces out a bean or apple shape as it goes around the smaller imaginary circle at twice the **angular speed** of point **P**.

Let's see what happens if we increase the angular speed of **Q** from **2** times **A**, to **5** times **A**. The only code changes we make are to the multiplication of the angle in the calculation of **x2** and **y2**.

```
// calculate how far point Q is from P
var x2 = radius / 3 * cos(5 * angle);
var y2 = radius / 3 * sin(5 * angle);
```

Let's see if that makes the result more interesting.

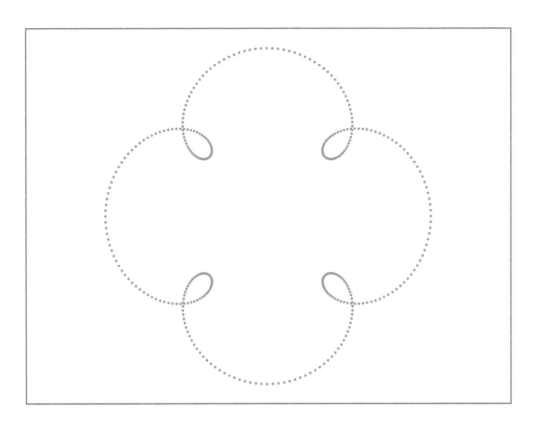

That's starting to get more interesting. We could increase that angular speed from **5A** to **10A** just to see what happens.

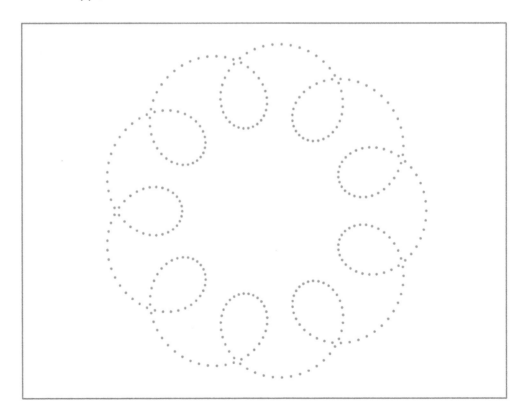

We can guess that increasing the speed at which point **Q** goes around the smaller circle, makes for more loopy results. Have a play with different speeds yourself.

Let's continue being ambitious, and add yet another even smaller circle around the little green one, in the same way we added that green one to the main central circle. This is a bit like adding a third gear to the green gear which itself is connected to the main gear. The following picture makes this clear.

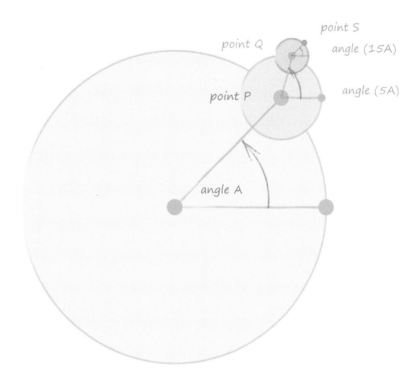

Yes, that does look crazy! Only a truly dangerous mind would even attempt such a thing.

You can see the new even smaller circle, shown red, has a point **S** on its edge. We've not called it **R** as we're already using that for the radius of the main central circle. We've set the angle of **S** to be **15A**, that is, fifteen times the angle **A**.

Let's say that small red circle has a radius which is a sixth of **R**, or **R/6**. This isn't shown on the diagram as it's getting crowded as it is!

We can calculate the horizontal and vertical coordinates of **S** in the same way we did for **Q**. This new point **S** is **x3** along and **y3** upwards from **Q**. We can use the same trigonometry to calculate these:

- **x3 = R/6 cos(15A)**

- **y3 = R/6 sin(15A)**

So the point **S** is at **(x1 + x2 + x3, y1 + y2 + y3)**. The following shows how our code changes.

```
// calculate (x,y) for point P
var x1 = radius * cos(angle);
var y1 = radius * sin(angle);

// calculate how far point Q is from P
var x2 = radius / 3 * cos(10 * angle);
var y2 = radius / 3 * sin(10 * angle);

// calculate how far point S is from Q
var x3 = radius / 6 * cos(15 * angle);
var y3 = radius / 6 * sin(15 * angle);

// point S is at (x1 + x2 + x3, y1 + y2 + x3)
var x = x1 + x2 + x3;
var y = y1 + y2 + x3;
ellipse(400 + x, 300 - y, 4);
```

You can see that we first calculate the location of point **P** at **(x1, y1)** just like before. We then calculate how far point **Q** is from **P**, which is **(x2, y2)**, just like before. And finally we calculate how far point **S** is from point **Q**, which is **(x3, y3)**. We've used an angular speed of **10** for **Q**, and **15** for **S**, chosen at random and not with any real reasoning.

Let's see what happens.

That's rather interesting. The trail loops in on itself, with some small tight loops and some bigger looser loops. Isn't it amazing that from rather regular mathematical functions, we seem to have created something that isn't very regular at all?

There is more detail in that image but it is harder to see because the gaps between the red dots are too big. How do we increase the detail?. Well, the point **S** is calculated from **Q**, which itself is calculated from point **P**. And if you remember, that point **P** is calculated from the angle **A**. Our loop starts with **A** at **0**, and increases it by **1**, until it gets to **360**. If we increase the angle in even smaller steps, then we calculate even more points. If we increment the angle **A** by **0.5**, we double the number of points calculated, and we draw twice as many red dots. If we increment **A** by **0.1**, we end up drawing ten times as many dots.

Here's the code change.

```
// loop to count angle
for (var angle = 0; angle < 360; angle += 0.1) {
```

Let's try it. The following shows the pattern where the angular speed of **Q** is **5A** and **S** is **20A**.

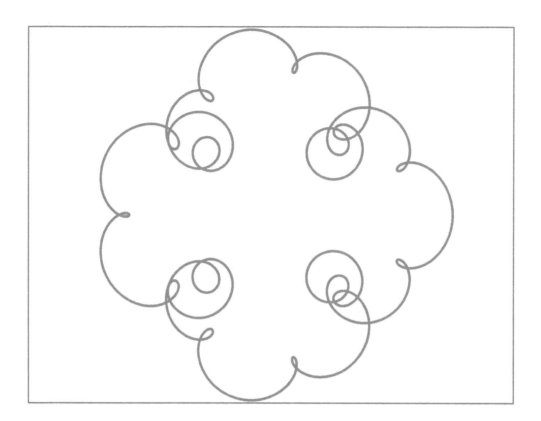

That does fill in the detail but saturates it too. If some of the dots are closer together than others, we no longer see it. We know translucency can help when we want to see detail and not be overwhelmed when there is a lot to be drawn.

So let's try the fill colour with a low alpha level of **20**, that is **fill(255, 0, 0, 20)**.

That worked. We can see parts of the trail that are denser because the dots are being drawn closer, and also less dark areas where the dots are not so tightly packed. In some sense, we can now see how fast or slow that point **S** is moving.

That's a nice pattern but it feels a little sparse. To enhance an image, to make it both richer, and more powerful as a composition, a technique we've used before is **visual repetition**. We could do that again, and write code to repeat this curly pattern several times.

Let's try drawing the same pattern but repeated **10** times and shifted along horizontally by **5** pixels each time. It's an easy idea to code. Every time **(x, y)** is calculated so that a red dot can be drawn, we use a new loop to repeat that dot **10** times, using a counter to shift it along the horizontal direction.

Here's the code change, around the code that draws the red dots..

```
for (var i = 0; i < 50; i += 1) {
    ellipse(400 + x + i, 300 - y, 4);
}
```

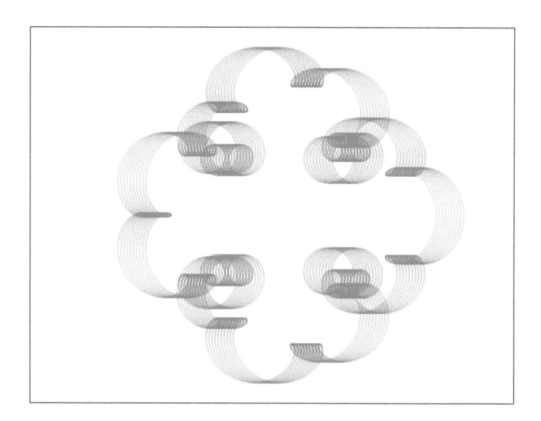

That's cool but we're trying to be really ambitious for this project. So let's try something even cooler.

The coordinates of the red dots **(x,y)** are the result of a chain of calculations. From the angle **A**, we calculate the location of point **P**, and from that point **Q**, and finally point **S** at **(x, y)**, which is where we draw the red dots. And now we've just applied visual repetition to the end result of this chain, by adding **variation** to the **(x, y)** coordinates by shifting them along in **10** steps of **5** pixels.

Instead of applying **variation** at the end of that chain, why don't we find a way to apply it to the start of the chain. Instead of having **10** versions of the outcome of that chain, we'll have **10** versions of the **angle** parameter at the start of that chain.

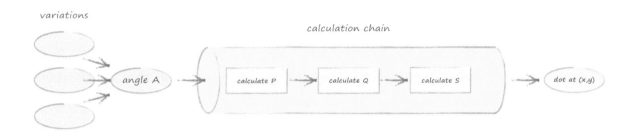

We can use a simple loop to do this, creating a whole series of angles to feed into that calculation chain. Let's try something like the following:

```
// loop to count angle
for (var angle = 0.0; angle < 360; angle += 0.1) {

    // loop to create a factor for varying angle
    for (var t = 0; t < 50; t += 10) {

        // inside the code, use (angle + t) instead of angle
```

You can see we now have a new loop, inside the loop that counts the **angle**. This loop uses a counter **t**, which starts at **0** and goes up in steps of **10**, until it is no longer less than **50**. Inside the code whenever we used **angle**, we can now use **(angle + t)**.

For example, the point **P** is now calculated using **(angle + t)**, not just **angle**.

```
// calculate (x,y) for point P
var x1 = radius * cos(angle + t);
var y1 = radius * sin(angle + t);
```

When **t** is **0**, the effective angle isn't changed, and everything should carry on as before. The same pattern should be drawn, as we haven't changed the angle **A** that starts off that calculation chain.

But when **t** grows above **0**, angle **A** changes too. So we've created a new set of angles which will feed the calculation chain, and hopefully create a set of varying patterns. In this case, the loop counts **t** as **0**, **10**, **20**, **30** and **40**, which is **5** repetitions of the loop. That means for every **angle**, we create **5** variations of that angle.

That may result in **5** patterns which vary slightly, or it might create **5** very different patterns. Let's see the results!

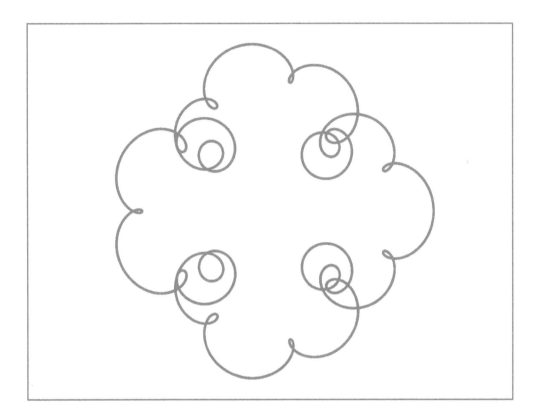

Oh … that doesn't seem right. It's the same pattern drawn over itself again and again, **5** times in fact.

There wasn't any variation in the pattern caused by varying the angle **A** that fed that chain of calculations.

Learning something by experimenting and failing is not only okay, it's good and necessary. If we don't allow ourselves to try things and fail, we can't learn.

Can you see what happened? It's not so obvious and took me three days to work it out. Three days of thinking about it over breakfast, pondering it during my walks, and even mulling over it in the shower!

The best way to understand why this failed is to go back to a simple circle. If we count up an angle from **0 degrees**, going up in steps all the way to **360 degrees**, and draw a dot at radius **100**, we'll trace out a circle. In fact we did this right at the start of this project. But what happens

if we don't start at **0 degrees**, but start at **20 degrees**, for example? You can see that even if we start at **20 degrees**, we still trace out a circle.

The pattern is still the same, no matter which angle we start drawing it from.

That's why our pattern didn't change. By shifting the **angle** up by **t**, all we did was shift the starting point on the pattern. The following shows the starting points shifted along by **t**.

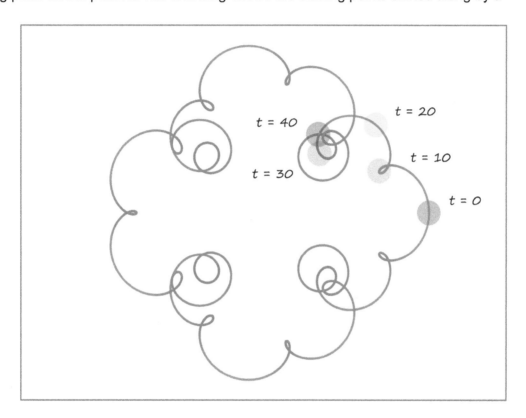

Let's not admit defeat just yet.

Why don't we use that **t** to vary the angles of the three points **P**, **Q** and **S** individually? That is, each of those angles could vary in their own way. This should fix the problem we just hit, because each point now has an angular speed that isn't entirely set by the angle **A**. Instead, each of the three points can now, **independently**, have their own angular speeds.

The following diagram shows this idea.

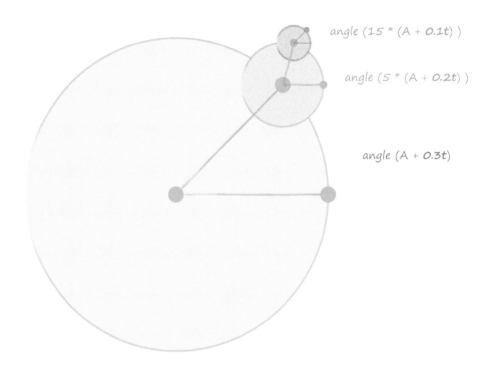

angle (15 * (A + 0.1t))

angle (5 * (A + 0.2t))

angle (A + 0.3t)

We've set point **P** in the big circle to have an angle **A + 0.3t**, that is, **A** with **0.3** of **t** added. The point **Q** on the medium circle has an angle **5(A + 0.2t)**, which is different to that of **P**. The point **S** on the small circle has an angle **15(A + 0.1t)**.

There are two main sets of parameters here. The ones that we initially used to create a pattern are **A**, **5A** and **15A**. We've now added a new variation by adding bits of **t** too, **0.1t**, **0.2t** and **0.3t**.

Let's see the result.

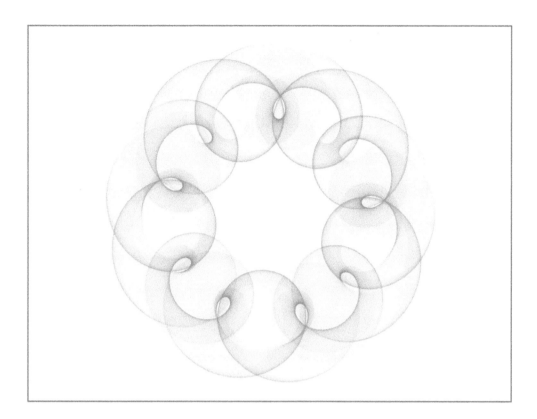

Wow! That's really is beautiful.

It's intricate, delicate, smoothly varying, and I love how there are dense areas and very subtle lightly coloured areas. The image itself, for me, evokes a forbidden glimpse into the beauty and raw power of mathematics. I'm getting tingles just talking about it.

We did it! Our perseverance paid off. Take a break and enjoy a chocolate.

The code was changed to make the little red dots even more translucent with an alpha of **5**, and also smaller with a diameter of **2** pixels. The inner loop was changed to count **t** up to **100**, where it was up to **50** before.

You can find the code online at https://www.openprocessing.org/sketch/474017.

You really should experiment with this one. You can vary the first set of parameters which decide the basic pattern, and then you can vary the way in which **t** is used to vary the angular speeds, **variations** which expand the basic pattern into a fuller form like the one above. Here are some of my own experiments.

P: **A**
Q: **5(A + 0.1t)**
S: **20A**

P: **5(A + 0.4t)**
Q: **5(A + 0.2t)**
S: **20(A + 0.4t)**

P: **A + 0.6t**
Q: **5(A + 0.2t)**
S: **15(A + 0.4t)**

P: **A + 0.1t**
Q: **16(A + 0.3t)**
S: **2(A + 0.1t)**

After lots of experimentation, the final form for this worked example was created with angular speed for **P** as **A + 0.1t**, for **Q** as **12(A + 0.4t)**, and for **S** as **11(A + 0.5t)**.

I love how this very natural looking form is not entirely symmetric, and looks like some kind of sea shell creature.

The sketch, including the code, is at https://www.openprocessing.org/sketch/476269.

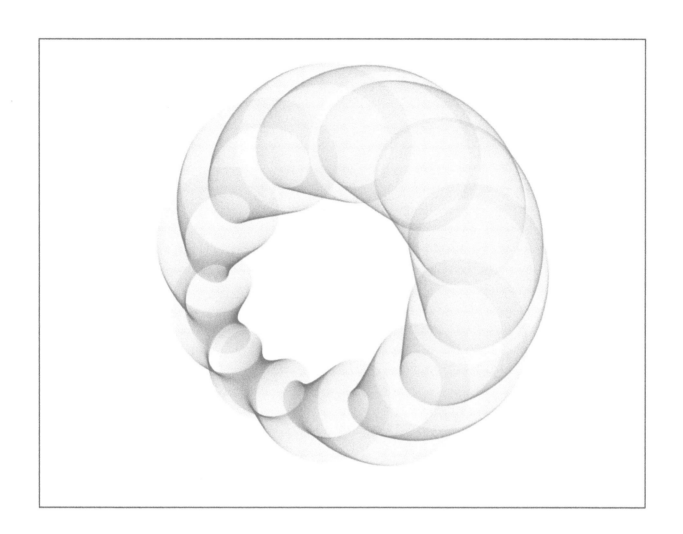

Spirograph

Part 4 - More Algorithmic Fun

In Part 4 we'll explore even more interesting algorithmic ideas - simple but powerful recursion, and the unexpected intricacy of chaos.

An Apparently Unhelpful Definition

We're going to look at a really powerful idea that is actually very simple but can be hard to grasp when we first see it.

So to get started, let's have a look at the following funny conversation.

The lady on the left asks what **3** is. The lady in the middle with the rose, answers that it is **"1 more than 2"**. That doesn't seem like the most helpful answer. So the first lady asks what **2** is. Again, the middle lady gives what seems like an unhelpful answer, **"1 more than 1"**. So finally, the first lady asks what **1** is. The lady with the rose is finally forced to explain what **1** is. Just be grateful the original question didn't start at **100**!

Yes it's a silly chat, but it actually contains an important idea. The rose lady kept using **"1 more than"** to explain what a number is. It might seem to us that she's being rather obtuse, but if she was an algorithmic artist, she'd be admired for the concise simplicity of her definitions.

So the definition of a **number** is **"1 more than"** another **number**. And we only define **1** when we really have to.

What we've done here is define a **number** in terms of a **number**. That sounds wonky. But it actually works, for all numbers that we might ask about, like **3**, or **7**, or even **182**. It might be a very long and boring conversation if we asked what **182** is .. but the explanation wouldn't be

wrong. The fancy term for this way of describing something is **recursive definition**. **Recursive** just means using itself to explain or do the next bit.

So we can define a big number like **182** in an algorithmically simple way. A good question to ask is whether we can define more complex patterns in such a simple way?

Let's take it slow and easy to start with, and ask ourselves, **"what is a circle of size 3?"**. In fact, why don't we ask the ladies to explain it.

So a circle of size **3** is defined as the circle that's **one size bigger than** a circle of size **2**. And a circle of size **2** is **one size bigger than** a circle of size **1**. And finally, a circle of size **1** is explained by drawing it.

Again, this way of looking at things might seem unhelpful and obtuse, but hang in there. The rewards will be plenty!

The Mysterious Holocrux

Let's try to bring this idea to life with a more interesting example. Let's imagine there exists an intricate and mysterious shape called a **holocrux**. Yes, that's a completely made up name. What is a **holocrux**? Let the ladies explain.

So the lady with the rose is explaining that a **holocrux** of size **200** is just a simple circle of size **200**, but with a **holocrux** of size **100** either side of it. Like before, this kind of explanation only partially explains what a **holocrux** is. So she explains further, that a **holocrux** of size **100** is just a circle of size **100** with a **holocrux** of size **0** either side of it. She finally completes the definition by stating that a **holocrux** of size **0** is **nothing**.

Before we turn this idea into code, let's try to figure out what this shape might be without using a computer. Let's start with a **holocrux** of size **300**.

We know it's a circle of size **300** with a smaller holocrux of size **200** on each side of it. We still don't know what a **holocrux** is completely, so let's just draw each **holocrux** of size **200** as empty squares which we can fill in as we continue.

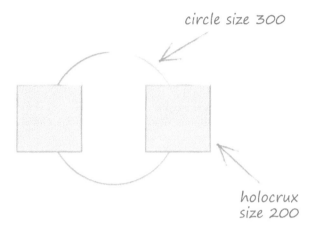

circle size 300

holocrux
size 200

We also know that a **holocrux** of size **200** is a circle of size **200**, with a **holocrux** of size **100** each side of it. So we can start to fill in both of those unknown squares.

circle size 200

holocrux
size 100

The mysterious **holocrux** is beginning to reveal itself!

Let's continue and try to add some detail to those smaller empty squares. We know the **holocrux** of size **100** is a circle of size **100**, with a **holocrux** of size **0** either side of it. So let's fill in those four squares using this knowledge.

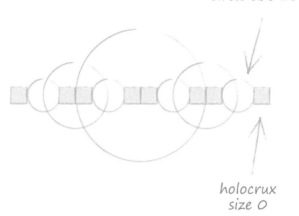

circle size 100

*holocrux
size 0*

Curiouser and curiouser! We've now reached the limit where all we have left are the unknown squares representing a **holocrux** of size **0**. Well, the lady told us that it was **nothing**. So we're left with a nice pattern of circles.

Let's code this **holocrux**. First we'll need a new **function** that defines the **holocrux** in the **recursive** way that the rose lady did. Let's make a start.

```
// holocrux function takes location (x,y) and size s
function holocrux(x, y, s) {
  // a holocrux of size s is a circle at (x,y) of size s
  ellipse(x, y, s);
}
```

Just like all the functions we've defined before, we've given it a name and made clear what parameters it takes. Here the function is called **holocrux()** and it takes the horizontal **x** and vertical **y** coordinates of the **holocrux**, as well as the size **s**.

Inside the function we have started to flesh out what a **holocrux** actually is. We know a **holocrux** of size **s** is a circle at **(x, y)**, with a smaller **holocrux** either side of it.

Here's the code so far.

```
function setup() {
  createCanvas(800, 600);
  background('white');
  noLoop();
}
```

```
function draw() {
  stroke('red');
  strokeWeight(2);

  holocrux(400, 300, 300);
}

// holocrux function takes location (x,y) and size s
function holocrux(x, y, s) {

  // a holocrux of size s is a circle at (x,y) of size s
  ellipse(x, y, s);

}
```

Running this code draws a circle of size **300** at **(400, 300)**, and nothing more. That's because the **holocrux()** function not fully defined yet.

How do we code the bit about the circle having a smaller **holocrux** either side of it? If it was a triangle or rectangle either side of the circle, we'd know how to code that. But how can we define something that depends on something we're still trying to define?

Can we really just tell Processing that the definition of a **holocrux** .. is another **holocrux**?

Yes we can. And that's a mind-blowing concept.

We're defining a **function** in terms of itself. You might think that was some kind of unnatural crime against coding, a sinister affront to logic, but it's not.

Let's try it. The **holocrux()** function should look something like this now.

```
// holocrux function takes location (x,y) and size s
function holocrux(x, y, s) {
  // a holocrux of size s is a circle at (x,y) of size s
  ellipse(x, y, s);
  // and a holocrux of size (s - 100) either side of the circle
  holocrux(x + (s/2), y, s - 100);
  holocrux(x - (s/2), y, s - 100);
}
```

We've added calls to **holocrux()** inside the definition of **holocrux()**. Well, it was how the rose lady defined it. You can see these new calls to **holocrux()** with parameters which shift them to each side of the circle, and also give them a smaller size of **(s - 100)**.

If we run the code again, we should see these new smaller **holocrux** patterns. Let's see what happens if we do.

```
mySketch, Line 23: Maximum call stack size exceeded.
```

At the bottom of the **openprocessing** page, we get a message telling us something has gone wrong. It's a bit of a cryptic message, and we won't try too hard to decipher it. Sadly, even in the 21st century, most programming languages produce terribly unhelpful error messages.

What went wrong? Well, if you pause with a well brewed coffee and ponder it for a while, you'll realise that when **holocrux()** is first called with size **300**, the function itself calls **holocrux()** again with size **200**, which in turn calls **holocrux()** with size **100**, and that one calls **holocrux()** with size **0**. So far so good.

But it doesn't stop there. That last call to **holocrux()** with size **0** calls **holocrux()** again with size **-100**. And again with size **-200**, then **-300**, and then **-400**, and so on .. forever. It doesn't stop.

And that's the problem. Processing can't keep track of which **holocrux()** called which **holocrux()**. The memory it uses to keep track gets filled up, and that's when it throws its hands in the air, let's out a deep sigh, and gives us that error message. That call stack, if you're curious, is the memory for keeping track.

How can we fix this? Well, we forgot something important that the rose lady said. She finally defined a **holocrux** of size **0** as nothing. In other words, we can stop when the size gets to zero. This will stop **holocrux()** calling **holocrux()** endlessly.

In code, we can check that the size **s** is more than **0** before drawing the circle and calling **holocrux()** again. If **s** isn't more than **0**, we do nothing.

```
// holocrux function takes location (x,y) and size s
function holocrux(x, y, s) {
  // ensure size s is more than zero
  if (s > 0) {
    // a holocrux of size s is a circle at (x,y) of size s
    ellipse(x, y, s);
    // and a holocrux of size (s - 100) either side of the circle
    holocrux(x + (s/2), y, s - 100);
    holocrux(x - (s/2), y, s - 100);
  }
}
```

You can see we've simply placed the existing code inside the curly brackets of an **if (s > 0)** instruction, so it only gets executed if the size parameter **s** is indeed more than **0**.

Let's run it again. Here's the full code so far.

```
function setup() {
  createCanvas(800, 600);
  background('white');
  noLoop();
}

function draw() {
  stroke('red');
  strokeWeight(2);

  holocrux(400, 300, 300);
}

// holocrux function takes location (x,y) and size s
function holocrux(x, y, s) {

  // ensure size s is more than zero
  if (s > 0) {
    // a holocrux of size s is a circle at (x,y) of size s
    ellipse(x, y, s);

    // and a holocrux of size (s - 100) either side of the circle
    holocrux(x + (s/2), y, s - 100);
    holocrux(x - (s/2), y, s - 100);
  }

}
```

And the result.

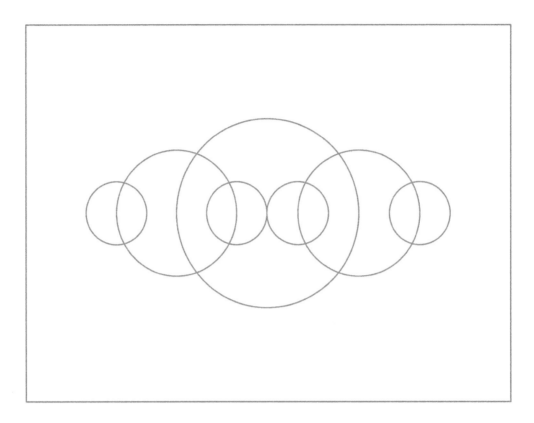

That worked. But was it worth all that effort of defining this pattern, this **holocrux**, in such an obtuse way? After all, we could easily have just drawn seven circles.

Let's see why it is worth the effort. The size of the **holocrux** is reduced by **100** every time it is called from **holocrux()**. Let's make it go down in smaller steps, say **30**. So the calls to **holocrux()** inside the definition of **holocrux()** are changed as follows.

```
// and a holocrux of smaller size either side of the circle
holocrux(x + (s/2), y, s - 30);
holocrux(x - (s/2), y, s - 30);
```

That should result in more circles being drawn, so let's change the stroke to be a translucent red with **stroke(255, 0, 0, 50)**. Here's the result.

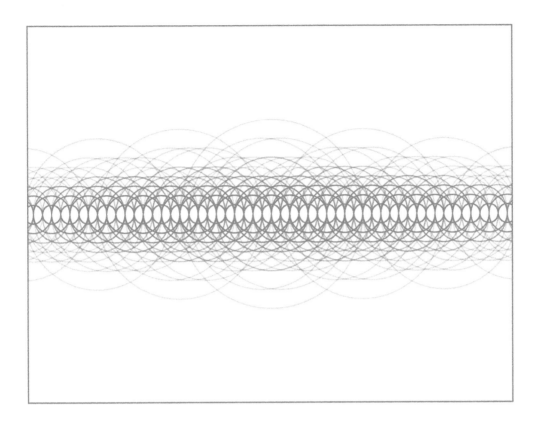

There's a lot more going on here, and some of the pattern is rather interesting. But it feels like we're not seeing the full pattern. Let's start with a smaller sized **holocrux** by changing the very first call inside **draw()** to **holocrux(400, 300, 200)**, so we're starting with a size of **200**, not **300**.

Let's see the results.

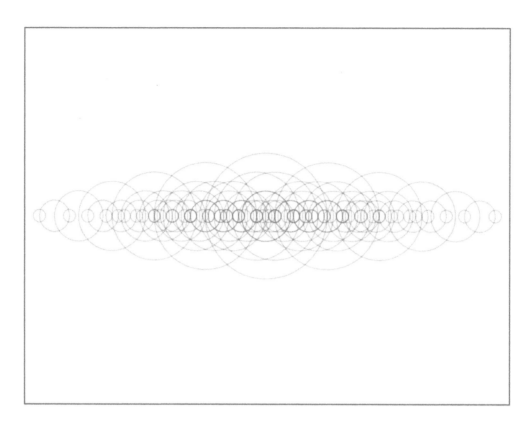

That is a rather intricate pattern. There are several levels of detail we can explore. If we fill the circles with a translucent red, and reduce the alpha value of the strokes, we can have an even more pleasing form.

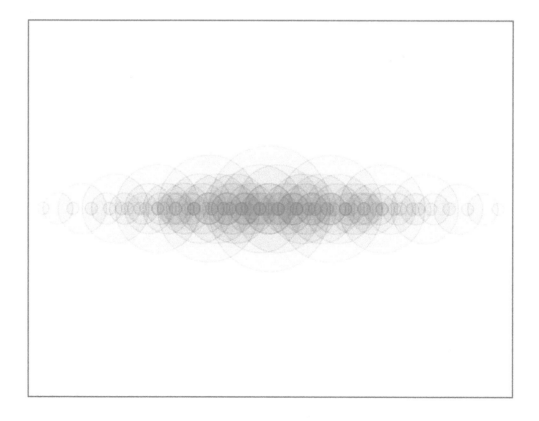

The sketch is online at https://www.openprocessing.org/sketch/477278.

Let's think about that question again. Was this intricate and detailed pattern, this **holocrux** as we called it, worth the effort of defining it in a **recursive** way, just like those ladies in the garden are fond of doing?

Although it takes a little bit of extra effort to think about, that **recursive** definition is extremely simple:

- A **holocrux** of size **s** is a circle of size **s**, with a smaller **holocrux** of size **(s - 30)** either side of this circle.

- A **holocrux** of size **0**, or less than **0**, is nothing.

That's just two short lines of definition that creates that previous image with many circles arranged in a rather sophisticated pattern. One rule is about continuing onto the next level of detail, and one rule is about when to stop adding more detail.

That's the power of **recursive** algorithms. They can be extremely simple, yet create rich intricate sophisticated forms.

If that pattern didn't convince you, let's demonstrate the power of **recursive** algorithms by making a tiny change to those rules to see that it creates an even more sophisticated pattern. Here are the tweaked rules:

- A **holocrux** of size **s** is a circle of size **s**, with a smaller **holocrux** of size **s/3** either side of this circle, and **above** and **below** too.

- A **holocrux** of size **6 or less** is nothing.

Here's a picture showing the idea.

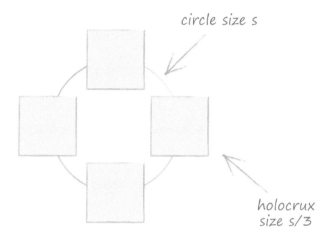

circle size s

holocrux size s/3

The most important change here is the additional smaller **holocrux above** and another **below** the circle. Before the next level of detail only extended horizontally, to the left and right. Now the detail should extend up and down too.

The other changes are not as important, they just refine the pattern created. Each smaller **holocrux** is now a **1/3** the size of the previous one, which means they should get smaller in a different way to simply taking a number off the size. The detail stops when a **holocrux** falls to **6** or below in size. This should prevent lots of really tiny detail being drawn, detail which could make the result too busy and overly saturated with detail.

The **holocrux()** algorithm now looks like this.

```
// holocrux function takes location (x,y) and size s
function holocrux(x, y, s) {

  // ensure size s is more than zero
  if (s > 6) {
    // a holocrux of size s is a circle at (x,y) of size s
    ellipse(x, y, s);

    // and a smaller holocrux to left, right, above and below
    holocrux(x + (s/2), y, s/3);
    holocrux(x - (s/2), y, s/3);
    holocrux(x, y + (s/2), s/3);
    holocrux(x, y - (s/2), s/3);
  }
```

That's not a big or complex change to the code by any means. Let's see the result.

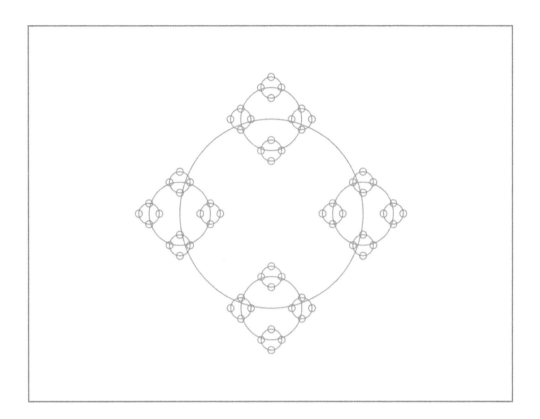

Wow! That's breathtaking - given how simple the defining rules were.

This the moment that convinces me of the power of recursive algorithms. Those two small rules gave us this beautiful form - a worthy **holocrux**!

The sketch, including the code, is online at https://www.openprocessing.org/sketch/478086.

This is addictive. Here's another experiment, this time having a smaller **holocrux** just touching the inside and outside of the circle, to the left, right, above and below, so there are **8** in total. Here's a picture to show the idea.

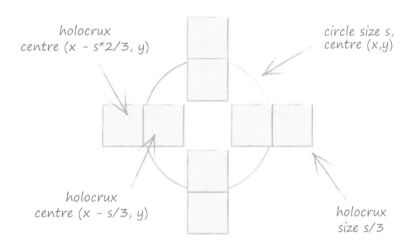

The code change to the **holocrux()** function is fairly simple.

```
// holocrux function takes location (x,y) and size s
function holocrux(x, y, s) {

  // ensure size s is more than zero
  if (s > 6) {
    // a holocrux of size s is a circle at (x,y) of size s
    ellipse(x, y, s);

    // smaller holocrux just inside the main circle
    holocrux(x + (s/3), y, s/3);
    holocrux(x - (s/3), y, s/3);
    holocrux(x, y + (s/3), s/3);
    holocrux(x, y - (s/3), s/3);

    // smaller holocrux just outside the main circle
    holocrux(x + (2*s/3), y, s/3);
    holocrux(x - (2*s/3), y, s/3);
    holocrux(x, y + (2*s/3), s/3);
    holocrux(x, y - (2*s/3), s/3);
  }
```

We can change the circles to have no stroke and be filled with a translucent red. Here are the results.

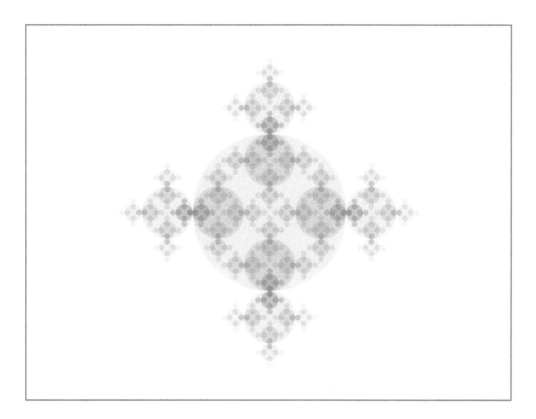

Nice! Again, the level of intricacy is impressive given the simplicity of the idea that created it. The power is in the **recursion**.

The sketch is at https://www.openprocessing.org/sketch/478216.

And just for fun, here's what happens if we only have the smaller **holocrux** on the inside, and not the outside of the circle.

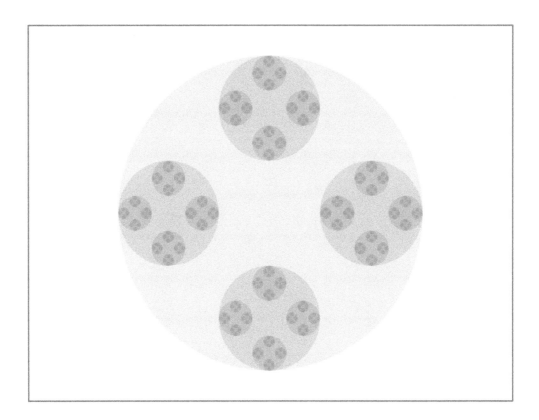

Random Recursion

Before we leave this topic, let's see if we can combine the powerful idea of **recursion** with another potent technique - **randomness**.

The rose lady is happy to explain the construction of another shape, the ancient, mystical and rather unpredictable **Jewel of Drax**.

She defines the jewel in the familiar way, explaining that it's a square with smaller jewels inside it, but this time there's a twist. The next level of detail depends on chance. Sometimes the next level of detail are two jewels in the top right and bottom left, but sometimes they're in the top left and bottom right.

Let's draw a picture to make her explanation clearer.

The code to do this shouldn't be difficult. It's the same code structure as before, but we use **randomness** to pick one of the two options, like rolling a die, something we've done before.

Let's name the recursive function **jewel_of_drax()**.

```
function jewel_of_drax(x, y, s) {

  // square at x,y of size s
  rect(x, y, s, s);

  // ensure size s is more than zero
  if (s > 20) {

    // pick a random number from 0 or 1
    var r = int(random(2));

    // 50% chance of jewel in top left and bottom right
    if (r == 0) {
      jewel_of_drax(x, y, s/2);
      jewel_of_drax(x+s/2, y+s/2, s/2);
    }
    // 50% chance of jewel in top right and bottom left
    else if (r == 1) {
      jewel_of_drax(x+s/2, y, s/2);
      jewel_of_drax(x, y+s/2, s/2);
    }

  }

}
```

You can see this **jewel_of_drax()** function takes a location **(x, y)** and a size **s**, just like our previous recursive functions. It draws a square at **(x,y)** of size **s** and then, as long as the size **s** is more than **20** it draws smaller jewels. This time, we can see how it picks a random number, which can be either **0** or **1**, and depending on which one it is, draws the smaller ones in the top left and bottom right, or in the top right and bottom left, of the square it just drew.

Here's what happens when we use this function, and draw translucent red squares, with slightly less translucent outlines.

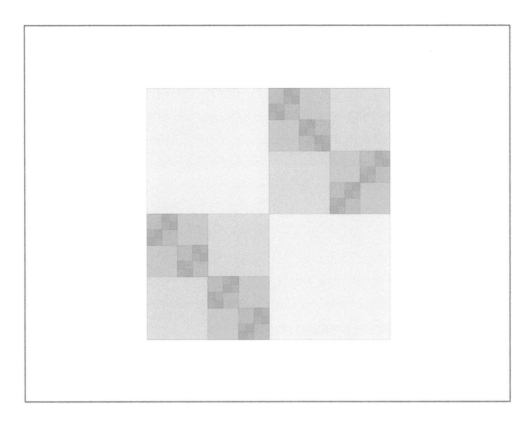

That's a rather pleasing, simple but powerful, composition. It has enough variety and detail, yet overall it remains very balanced, because of the equal chance of drawing smaller jewels in either of the two arrangements. I could definitely have a large print of that on my wall.

The results will be different every run because of the randomness built into how the smaller detail is arranged. Here are four more runs.

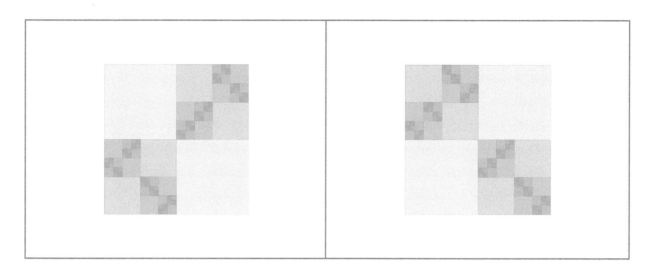

Understated sophistication!

The code for the **Jewel of Drax** is online at https://www.openprocessing.org/sketch/480802.

We're getting a good feel for how recursive definitions, or rules, work to create a pattern. We've even thrown in randomness to add some variety into the how the patterns are formed.

Recursive algorithms have huge potential for experimentation and the power to create really beautiful forms is sometimes breathtaking. Have a play, trying different rules yourself. Some will not go as expected, occasionally your program will crash because the recursion wasn't stopped in time, but sometimes you'll create some really mesmerising forms.

Here's one I made earlier using only things we have learned so far in this book. See if you can figure out how it was done.

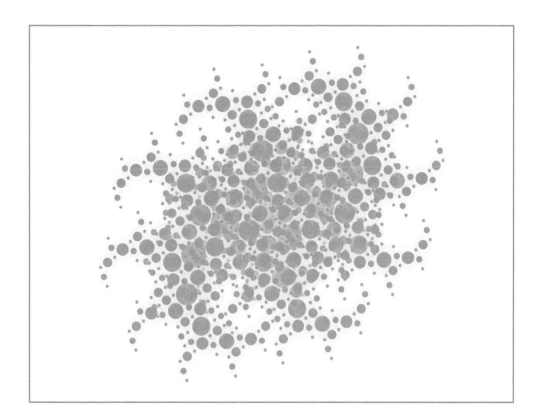

The secret ingredient is using angles to rotate and place the next level of detail. We'll look at using angles in recursive patterns in the next worked example.

The code for this intriguing form is online at https://www.openprocessing.org/sketch/480699.

Take a short break, because you've achieved a huge amount in this section. Too many people find **recursion** and **recursive functions** rather painful and some give up, sadly missing out on some amazing creative possibilities.

What We've Learned

Recursion is a really powerful technique, and isn't so difficult despite many of us finding it difficult to get our heads around the first time we encounter it.

Key Points

- A **recursive** function is one that refers to itself in its definition.

- Recursive functions can create extremely **intricate patterns**, even with very simple definition rules. This is the essential power of recursive functions.

- It is common to see two kinds of rules in the definition of recursive functions: a rule that defines the next level of detail, enabling the recursion to **continue**, and a rule that defines when the recursion must **stop**, preventing endless recursion.

- **Randomness** combined with recursion is a powerful technique for creating less predictable and regular patterns.

Worked Example: Tree Forms

This worked example is inspired by nature, and in particular, the way plants grow to make interesting patterns. Have a look at the following image of a **fern**.

Although it's a dead fern, because I didn't want to damage a living plant, you can still see it has a pleasing overall shape. But more interesting than that are the branches. Each branch looks like the whole fern, but shrunk to a smaller size. The next picture of three branches shows this more clearly - each one could have been a whole fern itself.

If we use a magnifying glass to look closely at those branches, we see they too have smaller branches which have the same kind of shape and pattern as the fern they came from.

This is called **self-similarity**, where you have the same, or similar, patterns repeated at different scales. Patterns that are self-similar are called **fractals**. That's a good word to know!

Look at the next picture of some clouds. We can't tell whether they are large clouds covering most of the sky, or a zoomed in section showing a small piece of the sky. That's because clouds look similar at large, medium and small scales. Or to use the technical term, clouds are **self-similar** at many scales.

Cloud patterns are rather **random**, but nature also creates fairly regular patterns too. The next picture shows Romanesco broccoli which has very geometric spiral patterns, similar at many scales. Looking at the picture, we can't tell if that's most of the broccoli, or an image of a very small part taken through a magnifying lens.

There are many examples of **self-similar fractals** in nature, from the pattern of streams and rivers as water carves its way to the sea, to the network of arteries and veins in a human body, from the peaks and troughs of mountain ranges, to the regular branching of miniscule snowflakes. Once you know what you're looking for, you'll notice fractals everywhere!

Looking at that fern again, the **self-similarity** reminds us of the patterns that we created using **recursive** algorithms earlier. In fact, those patterns were self-similar fractals, we just didn't call them that.

So for this worked example, let's try to recreate natural looking plant forms, which are **self-similar fractals**, using the power of **recursive algorithms**.

Let's start by having a closer look at a tree, this one from Richmond Park on the edges of London.

What do we see?

- We see a single main branch rising from the ground. Its direction isn't perfectly straight up, it's at a slight angle.

- The main branches seem to start around the same point, about a quarter of the way up the tree. Their directions have a larger angle away from straight up, in effect broadening out the tree.

- These branches spawn thinner branches, which vary even more in direction, further broadening out the tree.

- As we move from the main branches towards the edge branches, they get thinner and shorter.

Those are the main observations, enough to get us started. A good question to ask ourselves is do these ideas fit into a recursive approach? As always, using a pen and paper helps us think about how we might use a recursive algorithm. It's worth keeping in mind that the hardest part of developing a recursive pattern is planning out the algorithm rules, the coding is often really simple once that's done.

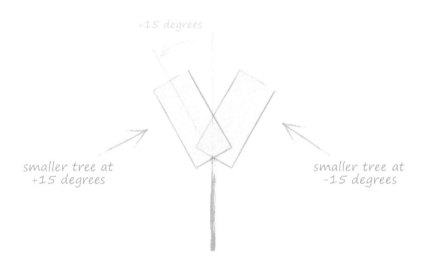

We can see the basic idea emerging. A **tree** is a branch with smaller **trees** attached. We've even drawn the idea that each of these smaller trees shoots off at a different angle to the branch they come from.

Just to get us started, we've set one of these trees to be at an angle of **-15 degrees** from the branch, and the other one at **+15 degrees** from the branch.

Let's use our pen and paper see what the next level of detail might be.

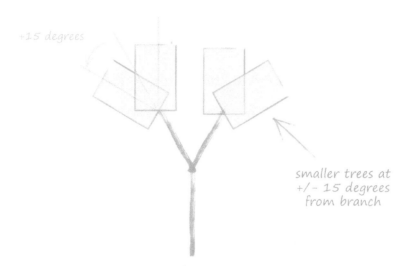

That seems to be working out rather well. We can see the second set of branches and how the even smaller trees would be attached to those. It does look like the tree will branch out nicely.

We need to think about how we keep track of the recursion so we can stop it at the right point. We've previously used a measure of size to keep track and stop when the size gets too small. Here we'll try a simpler idea of tree **depth**. The following picture illustrates this better than lots of words can.

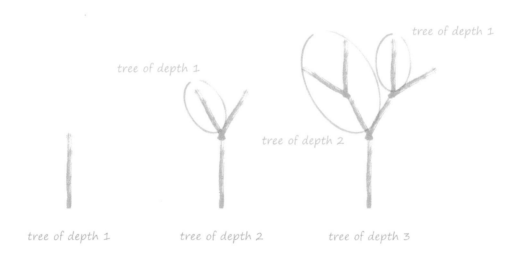

A tree of **depth 1** only has one branch, and no further detail. A tree of **depth 2** has a branch and one more level of detail, which are two trees of **depth 1** at an angle either side of the top of parent branch. A tree of **depth 3** is a branch with two trees of **depth 2** attached either side of it. Another way to think about **depth** is that it's the number of branches from the bottom of the tree trunk to the tip of the outermost branch.

This way of describing the trees leads us naturally to the **continue** and **stop** rules which define a recursive tree function.

- **Continue:** A tree of **depth n** is a branch with two smaller **trees** of **depth (n-1)** emerging from it, one pointing **15 degrees** anticlockwise, the other **15 degrees** clockwise, from this branch.

- **Stop:** A tree of **depth 1** is just a line, with no further detail.

The first of these rules defines how the tree keeps recursing to the next level of detail. The second rule stops the recursion when a **depth** of **1** has been reached.

Let's think about what a **tree()** function might look like in code.

```
// tree function takes coordinates of tree,
// angle, and current depth
function tree(x1, y1, angle, depth) {

    // use angle to calculate endpoint of branch
    line(x1, y1, x2, y2);

    // new trees at angle +/- 15 degrees
    // positioned at end of branch
    if (depth > 1) {
        tree(x2, y2, angle - 15, depth - 1);
        tree(x2, y2, angle + 15, depth - 1);
    }
}
```

Let's talk through this code piece by piece. We've created a new function called **tree()** in the usual way. It has a list of **parameters** it expects when it is used. The first two bits of information are the location of the tree **(x1, y1)**. We also need to include the **angle** of the tree, because we want the trees to change direction. Finally, we need to tell the **tree()** function what **depth** it is, so it can keep track and not go on recursing forever.

Inside the function, we start by drawing a branch from the tree location **(x1, y1)** to an endpoint **(x2, y2)** which we haven't calculated yet. Why do we need to calculate it? The end of the branch needs to follow the direction of the **angle** that this tree is set at, and that isn't trivial, but it's not difficult either.

After that, we have the very familiar calling of the **tree()** function again for the next level of detail. You can see the new trees start at the end of the current branch **(x2, y2)**. One of the calls to **tree()** has the angle set to **angle - 15**, and the other to **angle + 15**. Finally, the **depth** of the new trees is decreased by one. Notice the test to check that the **depth** is more than **1** before calling the **tree()** functions again.

Although the code we have so far is incomplete, it does contain all the main ideas.

So how do we calculate the endpoint of the branch **(x2, y2)**? A picture will help us.

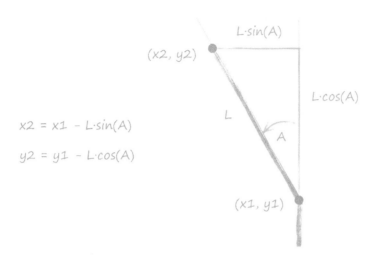

We're using **trigonometry** to work out the horizontal and vertical distances that the endpoint of the branch is away from its beginning. We've labelled the length of the branch **L**, and the angle from the straight up direction as **A**. The end of the line is shifted left by **L·sin(A)** and upwards by **L·cos(A)**. This is exactly the same trigonometry we learned about before. You can refresh your memory with **Appendix A** which gives a gentle introduction and works through some examples.

So, from that picture, we can see that **x2** is **x1 - L·sin(A)**. The reason **x1** is reduced is because a positive angle **A**, moves the end of the branch to the left. A negative angle **A**, would have a negative **sin(A)** and would, in effect, add to **x1**, shifting the endpoint to the right.

We can also see that **y2** is **y1 - L·cos(A)**. The reason for this subtraction is that Processing counts the vertical coordinates down the canvas, and so we need to reduce it if we want to move up canvas.

Phew! That took a bit of work. Let's update that function's code to include the calculation of the branch's endpoint **(x2, y2)**. For now, let's assume the length of the branch, **L**, is **100**.

```
// use angle to calculate endpoint of branch
var x2 = x1 - (100 * sin(angle));
var y2 = y1 - (100 * cos(angle));
line(x1, y1, x2, y2);
```

All that work, and we just added two small lines of code! That happens often in algorithmic art.

We have everything we need now to write a full program. Here it is.

```
function setup() {
  createCanvas(800, 600);
  background('white');
  noLoop();
  angleMode(DEGREES);
}

function draw() {
  stroke(0, 200, 0);
  strokeWeight(4);

  // start tree at (400, 500),
  // pointing straight up, with a depth of 3
  tree(400, 500, 0, 3);
}

// tree function takes coordinates of tree,
// angle, and current depth
function tree(x1, y1, angle, depth) {

  // use angle to calculate endpoint of branch
  var x2 = x1 - (100 * sin(angle));
  var y2 = y1 - (100 * cos(angle));
  line(x1, y1, x2, y2);

  // new trees at angle +/- 15 degrees
  // positioned at end of branch
  if (depth > 1) {
    tree(x2, y2, angle - 15, depth - 1);
    tree(x2, y2, angle + 15, depth - 1);
  }

}
```

Let's see the results.

That seems to have worked well. That's a rather nice simple tree which branches out in two directions at the end of each branch. It has the expected **depth** of **3**, that is, there are **3** branches from the very bottom to the tip of the outermost branch.

Let's see what happens if we increase the **depth** from **3** to **4** using **tree(400, 500, 0, 4)** in **draw()**.

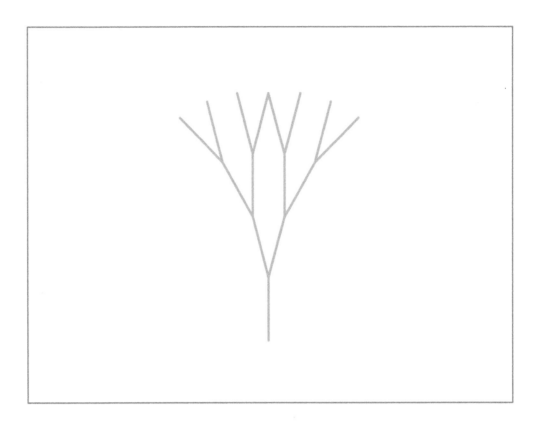

The recursive algorithm seems to be working. Good!

The code is online at https://www.openprocessing.org/sketch/485614.

Now that we have the basics working, let's start to think about making this tree more **natural**.

Branch Length

Let's start with an easy improvement. All our branches are the same length, but if we look at real trees and plants, the branches tend to get shorter and shorter, the further up the tree we go. If we want to do the same, we need to know where in the tree we are. We could try using the **depth** variable, because it does get smaller and smaller, the further away from the tree root we go.

If we're drawing a tree of total **depth 4**, then the first branch, the tree trunk, will be the longest. We could say that the **length** of a branch is always the **depth** multiplied by **20**, so we'd get **80**, a reasonable length. The next branch would have a **depth** of **3**, because it begins a new recursive tree of **depth 3**. Multiplying by **20**, would give us a **length** of **60**, and so on.

Let's see if we can use a smoother, more natural, function to take a **depth** and give us a **length**. This is just like the work we did earlier exploring mathematical functions that better represent smooth natural decay. Instead of a decay, here we want a function that starts small and smoothly rises, but doesn't keep rising. That's because, for a small **depth**, we want a small

length. And for a medium **depth**, we want a medium **length**. But for a large **depth**, we don't want a proportionately large **length**.

Why don't we want a proportionately large **length**? If we compare a tree of **depth 6** with a tree of **depth 3**, we want the tree of **depth 6** to be more detailed than the tree of **depth 3**, but we don't want it to twice as large on our canvas. That's why we want to dampen the growth of branch **length**.

Have a look at this graph of a mathematical function.

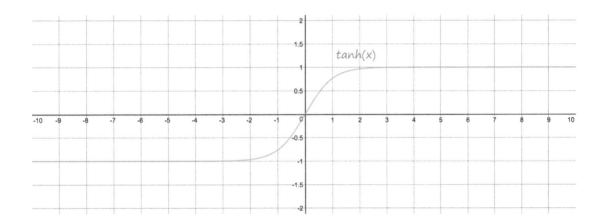

It seems to match what we want. It starts small, rises smoothly, but then stops rising, and flattens out.

This is a mathematical function called a **hyperbolic tangent**. Don't worry if you haven't come across it before. It comes up in conversation less often than the much more popular **sine** and **cosine** functions. The name itself, **hyperbolic tangent**, does sound very science fiction! It's often written as **tanh()** and you can find it on most calculators and in many programming languages. You can see that no matter how large **x** gets, **tanh(x)** never grows bigger than **1**. In fact it never reaches **1**, it just gets ever closer.

Another nice mathematical function to add out our algorithmic art tool box!

If we want to use this nicely shaped **tanh()** function to set the length of our tree branches at a given **depth**, we'll need to stretch the function so it has a slower rise. Here is a graph comparing **tanh(x)** and **tanh(x/4)**.

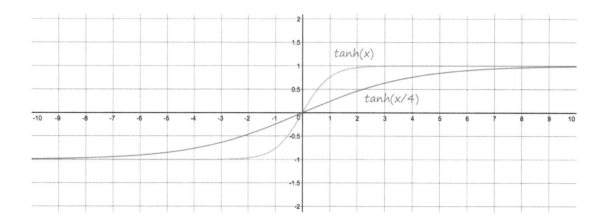

The rescaled **tanh(x/4)** better matches our needs. For depths of **6**, **7**, **8** or above, the function gives us roughly the same length. For **depths** of **5** and below, the functions starts to fall smoothly. The smallest **depth** we'd ever encounter is **1**, and here the function gives us a length that's about a quarter of the maximum. If we had stuck with the unscaled **tanh(x)** we'd have branch lengths all very close to the maximum from a **depth** of **2** upwards, which you can see from the graph.

Explore these functions yourself online https://www.desmos.com/calculator/epwslexdcr. Experiment with different scalings by changing the number which divides **x**.

Before we use this function, we need to rescale its value to better match the size of our canvas. The function **tanh(x/4)** never gets bigger than **1**. That would be a branch of less than a pixel in length! If we multiply it by **100**, that is **100 * tanh(x/4)**, we'd get a more reasonable range of branch lengths. For **depth 1**, this gives us **24.49** as the smallest branch length. For **depth 2**, this gives us **46.21**, which is reasonable. And larger depths give us branch lengths that get closer to **100**.

That all sounds good Let's try it. Here's the code we need to take the **depth** and calculate a branch **length** from it. After that we use this **length** in the calculations for the endpoint **(x2, y2)** of the line from its starting position **(x1,y1)**.

```
// length of branch
var length = 100 * Math.tanh(depth/4);

// use angle to calculate endpoint of branch
var x2 = x1 - (length * sin(angle));
var y2 = y1 - (length * cos(angle));
```

Again, the changes to the code are very simple, compared to the thinking that went into it. Here's the result.

The shorter branches at the top of the tree are give it a much more realistic look. Because the tree is getting busier, the line thickness was reduced from **4** to **2** using **strokeWeight(2)**.

What can we improve next?

Randomness

Looking back at our real trees again, we notice that the angle at which branches emerge isn't fixed at **15 degrees**. There's variation in those angles, and it appears to be rather **random**.

Looking more closely, we notice the branching angle isn't entirely random. Branches emerge without being too close to each other, and not too far apart either. So the randomness is constrained. We've dealt with constrained randomness before, for example, keeping randomly placed objects away from the canvas edge, or paint splashes not too far from a cluster centre.

We can constrain the randomness of the angles at which branches emerge. We can start by having the two branches at **+20** and **-20 degrees** from the branch they emerge from. We can then add or subtract a smaller random amount from these angles. Have a look at the following picture which illustrates the idea.

Let's look at the green branch at the very left. It emerges from its parent branch and would have been at an angle **20 degrees** further around. Instead we pick a random number in the range from **-15** to **+15**, and add this to that **20 degrees**. That means the angle of this new branch could be anywhere from **+35** to **+5 degrees** from the parent branch. That range is shown as a yellow segment in the picture. In this example, the chosen random number has reduced the branch's angle to almost the bottom of this range.

The next branch emerging from the same parent would have been at **-20 degrees**, but the random addition has pushed it anticlockwise to almost **-5 degrees**. So, by chance, these two branches are fairly close together. The other two branches happen to be further apart from each other, again by random chance.

Taking a step back, the yellow sectors show the potential directions that the branches could take, and it's easy to see that they can't be too close, because there is a gap between the two yellow segments coming from their parent branch. They can't be too far apart either, because the yellow segments don't spread over large angles.

How do we code this idea? Let's take a look.

```
// new angles for emerging trees
var angle1 = angle + 20 + random(-15, 15);
var angle2 = angle - 20 + random(-15, 15);
```

That code looks mildly complicated so let's break it down. We're first creating a new variable named **angle1**, which will be the angle of one of the two new trees at the next level of detail. That **angle1** is the same as the angle of parent branch, **angle**, but is rotated around by an additional **20 degrees**. That places it in the middle of one of the yellow sectors in our picture. Finally we add a bit of randomness by adding a number chosen from the range **-15** to **+15**. This puts **angle1** somewhere in the leftmost of the two yellow sectors. Similar logic applies to

angle2, where **20 degrees** are subtracted from **angle**, to place it in the other yellow sector, before it is varied by a small random amount.

Now that we have **angle1** and **angle2**, the angles of the new trees at **depth -1**, we simply change the calls to **tree()** to use these angles instead of the fixed **angle +15** and **angle -15**.

```
// new trees at next level of detail
if (depth > 1) {
     tree(x2, y2, angle1, depth - 1);
     tree(x2, y2, angle2, depth - 1);
}
```

Let's see the results.

The difference is drastic. Instead of a very regular structure we now have a form that looks much more organic in its growth.

Because the algorithm now incorporates randomness, each run of the code will give different results. Let's see a few.

These forms are quite mesmerising to look at. Each is unique, and yet still a recognisable tree. We've hit that magic balance where we can constrain randomness to give us, not total anarchy, and not boringly regular patterns, but organic natural looking structure.

This would be a perfectly respectable point to stop. We've achieved something very significant already. We've used simple mathematical ideas to create something that doesn't look like it came from a school maths book, but actually looks like it was created by nature itself. But let's keep going - because algorithmic art is far too fun and addictive!

The trees we've created are rather sparse. We can add more branching to these trees. We could do that by increasing the number of smaller trees that emerge from the end of a branch, from **2** to **4**, or maybe **6** or even **10**. That would be a good experiment to do, and you should definitely try it. But if we look back at the real trees again, we see that the branching doesn't always occur at the end of a branch. Sometimes branches emerge part way along a branch. Let's try this, more realistic, idea instead.

As always, a pen and paper sketch helps clarify what we want to do.

We can see the same branch as before, with the two smaller trees emerging from end of the branch, one at **angle1**, and the other at **angle2**. What's new are two new smaller trees emerging part way along the branch. One is shown **7/10** of the way up, and the other **4/10** of the way up. We could calculate new randomly chosen angles for these new trees, but for simplicity let's see if we can get away with using the same **angle1** and **angle2** again, one for each new smaller tree.

To create these new trees, we need to know their locations. That might seem like a complicated task, because the picture is starting to look more complex, but it's easy. We've already calculated the location **(x2, y2)** of the end of the parent branch using the **length** of the branch, and its **angle**. We can use the same approach for the locations of the new trees. Have a look at the next picture.

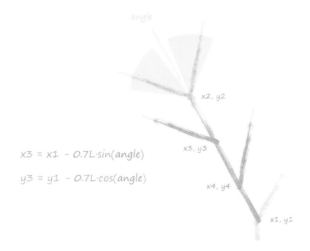

We've shown the location of the tree **0.7** along the parent branch at **(x3, y3)**. Working out **(x3, y3)** is easy. It's just like working out **(x2, y2)** except the radius, or distance from **(x1, y1)**, we use

is **0.7 * length**. The same thinking applies to working out the other tree's location at **(x4, y4)** where we use a distance of **0.4 * length**.

Here's the code.

```
// two more trees part way up the branch
var x3 = x1 - (0.7 * length * sin(angle));
var y3 = y1 - (0.7 * length * cos(angle));
var x4 = x1 - (0.4 * length * sin(angle));
var y4 = y1 - (0.4 * length * cos(angle));
```

And the code to create these two new trees is very similar to the previous two trees.

```
// new trees at angle +/- 15 degrees
// positioned at end of branch
if (depth > 1) {
  tree(x2, y2, angle1, depth - 1);
  tree(x2, y2, angle2, depth - 1);
  // part way up branch
  tree(x3, y3, angle1, depth -1);
  tree(x4, y4, angle2, depth -1);
}
```

You can see the new trees reuse **angle1** and **angle2**, but use the new locations **(x3, y3)** and **(x4, y4)**.

Let's see what this new code creates.

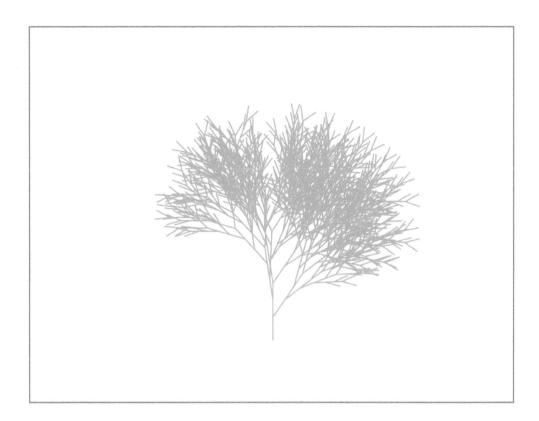

What a difference that makes! The tree has much more foliage, and again it looks surprisingly realistic. My mind is blown.

We can improve this tree even more. Looking at that image again, we've hit the same problem we often get when we have a lot of detail to be drawn in a small space. We get overcrowding and start to lose visible detail. We've previously used **translucency** to solve this problem, so let's try it again. Let's make the branches translucent and a darker, more pine, shade of green, using **stroke(0, 150, 0, 100)**.

Let's see the result.

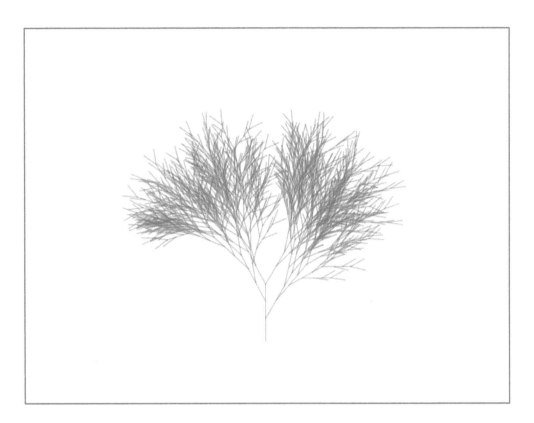

Translucency has given the tree another dimension, making the rendering richer, and even more realistic, with branches that appear to be in front of, or behind, other branches.

This is a good point to try different colours yourself. I can imagine a translucent red creating beautiful flame-like trees.

Our improvements seem to be refinements now. Looking critically at that last tree, we can see the branches are of the same thickness everywhere. We did make them get shorter the further up the tree they got, but we didn't change their thickness. We can again use the fact that **depth** gets smaller further up the tree to calculate thickness.

Let's try a simple calculation, where we simply halve the **depth** for the stroke weight, that is, in code **strokeWeight(depth/2)**. I experimented quite a bit and found that when the **depth** is small, the stroke gets too small. Dividing the **depth** by a smaller amount gives branches that are too thick. An easy solution to this is to simply add a small minimum amount, **0.2** for example, to **depth/2**, that is **strokeWeight(0.2 + depth/2)**.

Here's the result.

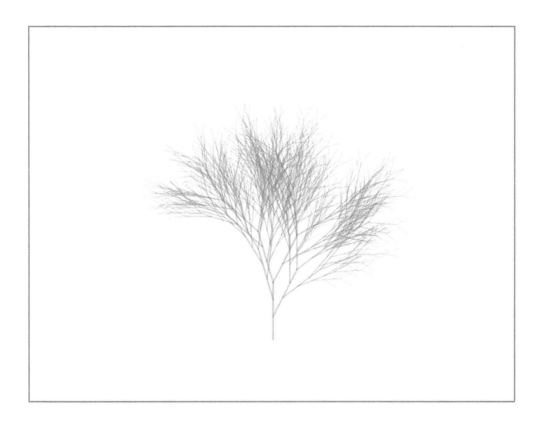

I really like that. It looks more like a fern, or a grass, than a tree, but it still looks beautifully balanced, with delicate natural detail to explore. I'm still surprised at how realistic this looks, given all we're using to create it is cold hard mathematics. Maybe mathematics isn't really cold and hard!

There are quite a few things you can experiment with. You can try different colours, different branching points for new smaller trees to emerge, and different ways to calculate the branch thickness. You can try trees with different depths, and perhaps try different constraints for the angle at which branches emerge. You can even try adding more branching by adding additional trees when the recursion happens.

You can spend hours exploring these variations. I did. Here's a tree that I'm very happy with. I've changed the branch **length** calculation which uses the **tanh()** function to scale from **110** not **100**, to better fill the canvas. I've also changed the starting angle of the tree trunk to **10 degrees**, by making the very first call **tree(400, 500, 10, 6)**. This makes the tree trunk lean over a little, something I find more realistic.

Here's the full code, including all the refinements we've made.

```
function setup() {
  createCanvas(800, 600);
  background('white');
```

```
  noLoop();
  angleMode(DEGREES);
}

function draw() {
  stroke(0); noFill(); rect(0,0,799,599);

  stroke(0, 150, 0, 100);

  // start tree at (400, 500),
  // pointing straight up, with a depth of 3
  tree(400, 500, 10, 6);

}

// tree function takes coordinates of tree,
// angle, and current depth
function tree(x1, y1, angle, depth) {

  // length of branch
  var length = 110 * Math.tanh(depth/4);

  // use angle to calculate endpoint of branch
  var x2 = x1 - (length * sin(angle));
  var y2 = y1 - (length * cos(angle));

  // calculate thickness and draw branch
  strokeWeight(0.2 + depth/2);
  line(x1, y1, x2, y2);

  // new angles for emerging trees
  var angle1 = angle + 20 + random(-15, 15);
  var angle2 = angle - 20 + random(-15, 15);

  // two more trees part way up the branch
  var x3 = x1 - (0.7 * length * sin(angle));
  var y3 = y1 - (0.7 * length * cos(angle));
  var x4 = x1 - (0.4 * length * sin(angle));
  var y4 = y1 - (0.4 * length * cos(angle));

  // new trees at next level of detail
  if (depth > 1) {
    tree(x2, y2, angle1, depth - 1);
    tree(x2, y2, angle2, depth - 1);
    // part way up branch
```

```
    tree(x3, y3, angle1, depth -1);
    tree(x4, y4, angle2, depth -1);
  }

}
```

And the result.

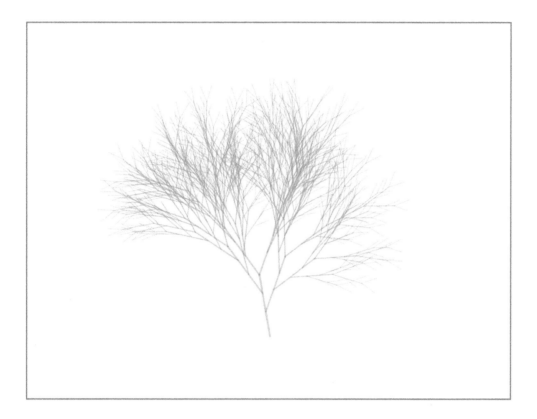

The code is online at https://www.openprocessing.org/sketch/486455.

It's a shame to have to choose just one of the many interesting tree forms that we can generate, so for the final piece let's place several trees in a grid. That way, we can explore and enjoy the variety of forms our algorithm creates in the same composition - a comparative study.

To fit more trees we can use a larger canvas of width **1200** and height **900**. Those numbers are chosen so the canvas has the shame shape as the **800** by **600** we normally use.

A familiar loop within a loop helps us place the trees in a grid. It took some experimenting to get right these loops right so that the overall grid was in the middle of the canvas. Actually, this grid is slightly lower down the canvas to balance the fact that the trees grow upwards and are busier upwards too.

```
/// create a 3 by 3 grid of trees
for (var x = 300; x <=1000; x+= 300) {
  for (var y = 280; y <= 800; y+= 250) {
      tree(x, y, random(-10, 10), 5);
  }
}
```

You can see from the code, that the call to **tree()** has an angle chosen randomly between **-10** and **+10**, to give some variety to the direction the trees start to grow.

The branch length calculation was tweaked to scale up to **60**, not the previous **100** or **100**, to better fit trees which might have a depth of **5** or **6**. The calculation is now **length = 60 * Math.tanh(depth/4)**.

Finally, the transparency of the branch colour was lowered a small amount just to increase the overall contrast with the white background of the canvas. The alpha value was bumped up from **100** to **120** with **stroke(0, 150, 0, 120)**.

The full code is online at https://www.openprocessing.org/sketch/488062.

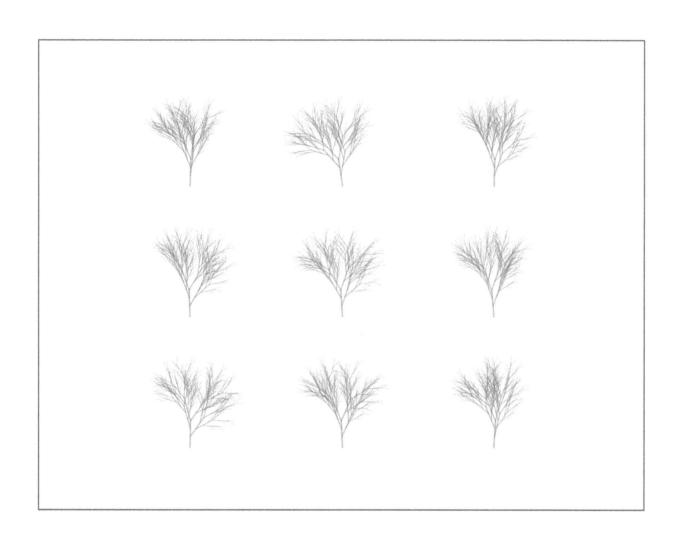

Tree Forms

Creative Chaos

In this section we'll to see how even very simple maths can cause numbers to behave in an unexpected and very unpredictable way, and yet out of this **chaos**, we'll see some extremely intricate patterns unveil themselves.

These will be some of the most detailed and beautiful patterns in mathematics! Keep that promise in mind as we work through the preparatory ideas. There a few new ideas to work through but it really will be worth the effort.

Let's start our journey with a very simple thought experiment. Have a look at the following.

In this thought experiment we take a number and feed it to a machine, which applies a mathematical function to it, and spits out the result. Here, we're feeding the machine the number **2**. The machine itself applies a function **"add 2"**, which just adds **2** to the number it eats. We can see the answer, **4**, spat out the other side of the machine. Simple.

Although that was indeed simple, it illustrates an important idea for us, that of a **function** which takes a number, called the **input**, does something to it, and gives us the answer, called the **output**. This is no different to other mathematical functions that we've seen, like **sin(x)** or **tanh(x)**, which also take a number and give us an answer.

Here's a picture making clear this idea of **input** to, and **output** from, a mathematical **function**.

Feedback

Now here's an interesting, perhaps subversive, idea. What if we take the answer the machine gives us .. and feed it back into the machine again? That is, we take the **output**, and put it back into the same function as a new **input**.

The next picture shows this happening to the **4** that popped out of the machine earlier.

If we put that **4** into the machine which applies an **"add 2"** function, it should give us a new output. It should be **6**, because **4 + 2** is **6**. And if we do it again, and put that **6** back into the machine, we get **8**. The following picture shows this whole process, starting with the first **2**, and repeating until we get to **8**.

$$2 \longrightarrow \boxed{\text{add } 2} \longrightarrow 4 \longrightarrow \boxed{\text{add } 2} \longrightarrow 6 \longrightarrow \boxed{\text{add } 2} \longrightarrow 8$$

Another way to look at that picture is that after **3** repetitions, the output value is **8**, if we started with **2**.

That wasn't too difficult, even if the idea of feeding back the **output** to become the new **input** is a little strange. I do worry about the warped mind that first thought of doing this!

It's no surprise this feeding back is called **feedback**. It's just like the **feedback** we sometimes get when a microphone is too close to a loudspeaker. The output of the speaker gets picked up by the microphone which passes it back to the speaker, which is picked up again by the microphone .. and so on, resulting in a rather unpleasant over-amplified screech.

Let's follow that microphone analogy a bit more. What happens if we allow this feedback to continue for more repetitions, or **iterations** as they're also called? The following table shows the output values after each **iteration**, going on for **10** iterations.

iteration	starting value 2 function "add 2"
0	2
1	4
2	6
3	8
4	10
5	12
6	14
7	16
8	18

9	20
10	22

We can see that after one pass through the machine, the starting value of **2** becomes **4**. Looking further down the table, we can see that after the **10** passes through the machine, the output value becomes **22**. Right at the top of the table we have iteration **0**, which just means that we haven't passed a value through the machine yet, so we just have the starting value of **2**.

Overall, we can see that the output values get bigger and bigger. Let's plot a graph to get a better feel for what happens to these output values. You might remember we visualised numbers before, when we were exploring interesting mathematical functions like **sine** and **cosine**.

We can see the values starting at **2**, and growing steadily. Because the increase is by **2** every iteration, the line is straight. If any of the increases were in steps bigger or smaller than **2**, then we'd see a line that wasn't straight.

That's not a very exciting graph, but we didn't really didn't expect it to be with such a simple function like **"add 2"**.

Let's try another function. How about **"divide by 2"**. If we start with a value of, say **4**, and push it through a machine which applies that function, we'd get **2** popping out. Easy enough. If we feed that **2** back into the machine again, we get **1** popping out. Doing another iteration gives us **0.5**, because that's what happens when we divide **1** by **2**. Here's a picture just to reinforce the idea.

Let's create another table with more iterations completed.

iteration	starting value 4 function "divide by 2"
0	4
1	2
2	1
3	0.5
4	0.25
5	0.125
6	0.0625
7	0.0313
8	0.0156
9	0.0078
10	0.0039

We can see the output values get smaller and smaller, which we should expect because that's what the function inside the machine does, it halves whatever it is fed. Let's plot a graph to see what this getting smaller looks like. By the way, we've rounded those numbers in the table to four decimal places, in case you're wondering why your own calculations look different.

That looks like one of the smooth decay functions we saw before! The line falls rapidly at first, then the fall slows to an ever smaller rate. If we think about it, that makes sense, because when we halve a big number, the drop is bigger than if we halve a tiny number. We saw **exponential decay** before, and this is actually another example of an exponential decay. The values get smaller and smaller, ever closer to **0**, but never actually reach it.

What about a function like **"multiply by 2"**, which is the opposite of the **"divide by 2"** we just looked at. If we start with a value of **2**, the first iteration through the machine gives us **4**. Doing it again, gives us **8**. Another iteration and we get **16**. We can see the values are getting bigger. Again, let's plot a graph to get a better feel for this growth.

That's a nice smooth growth, the opposite of a smooth decay.

So far we've seen output values that are either straight lines, or smooth curves that grow or decay. In fact, many of the functions we can think of behave in this way.

Starting Points Can Matter

Let's look at one more function, **"square it"**. Squaring a number just means taking a number and multiplying it by itself. So the square of **2** is **4**, and the square of **10** is **100**. Let's make a table with a few iterations, with a starting value of **2**.

iteration	starting value 2 function "square it"
0	2
1	4
2	16
3	256
4	65,536
5	4,294,967,296

The numbers get big very very quickly. We've had to stop after only **5** iterations, because the output value here is **4,294,967,296** or just over **four trillion**! Squaring that is a ridiculously huge number, **18,446,744,073,709,551,616**.

So the function **"square it"** causes the output values to get bigger much much faster than **"double it"** does. Let's change the starting value to **1.01**, which is a tiny bit more than **1**. Hopefully the numbers won't grow so fast.

iteration	starting value 1.01 function "square it"
0	1.01
1	1.0201
2	1.0406
3	1.0829
4	1.1726
5	1.3749

Starting from **1.01** results in the numbers growing, but they seem to grow at a slower rate. By iteration **5**, we've moved to **1.3749**, which is much more manageable than four trillion. Let's see what this looks like when plotted in a graph.

That is definitely a curve that grows, but because the starting point is so small, the growth seems slow too. Actually it isn't slow for very long. If we carried on with the iterations, by iteration **10** we'd have an output value of 26,612.56612 which is just over 26 thousand. Square that and we've got enormous numbers again.

So the **"square it"** function seems to lead to a runaway explosion, just like a runaway nuclear reaction. Let's invent our own mathematical phrase and say these numbers **explode**!

What if we start with a value of just **1**? Well, **1** squared is just **1**. And squaring it again gives us **1** again. That's interesting. No matter how many iterations we do, starting from **1**, the output values from function **"square it"** stay constant, at **1**.

So we've found a function that seems to display two kinds of behaviour. For most starting values, the output numbers explode upwards, except for a starting value of 1, where it just stays at 1.

Let's try a number just less than **1**, say **0.99**. If we square **0.99** we get **0.9801**, which is smaller than **0.99**. Squaring again, we get **0.9606**, which is smaller again. Let's make a table of **5** iterations.

iteration	starting value 0.99 function "square it"
0	0.99
1	0.9801

2	0.9606
3	0.9227
4	0.8515
5	0.7250

The output values do seem to be getting smaller, and getting smaller faster too.

Let's plot all that information on the same graph so we can compare them more easily.

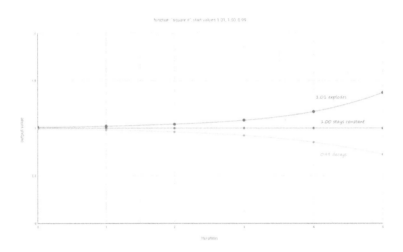

So we've seen three different kinds of behaviour from the same function, and the different behaviours depend on the starting value. That's an important point, worth pondering for a moment before we continue.

start value	behaviour
1.01	grows and explodes
1.00	stays constant
0.99	decays towards zero

What We've Learned

We're laying the foundations for exploring **chaos**, and the promise of intricate beautiful patterns that can emerge from it. We've picked up some simple ideas to prepare ourselves.

Key Points

- A mathematical **function** takes an **input** value, and gives an **output** value.

- Passing a function's output back to the function as new input is called **feedback**.

- Each repetition of the process of giving a function an input to create an output is called an **iteration**.

- The output values from a function can show three kinds of behaviour. They can get **larger**, or **smaller**, or **stay constant**. Often the behaviour depends on the **initial value** that is first fed into the function.

A Different Kind of Number

In the last section we used a function **"square it"**, and saw how its **output** values can either grow larger, get smaller, or stay the same, when these values are fed back as **input**.

The following diagram reminds us of the idea. Instead of **"square it"**, we're using the less wordy mathematical way of saying the same thing, x^2.

Let's do exactly the same thing again, but with one difference. Instead of normal numbers, we're going to use a new kind of number. The following diagram is exactly the same as the last one, but with the **x** replaced by a **z**, just to show that we're now using a different kind of number.

So what are these new kinds of numbers? Well, they're called **complex numbers**, and they're very common in science and mathematics. The name is a real tragedy because it just scares people away. They're really not complex at all. Let's have a look at one.

$$z = 2 + 3i$$

What we're looking at is a complex number which we've called **z**. It has two parts. The first part is just **2**, and that **2** is just the normal number that we've been used to since we were small children. The second part is **3i**. That's three lots of something called **i**. That's the new thing we haven't seen before.

These two parts have names. The first normal part is called the **real** part, and the second new part is called the **imaginary** part. What a cool name! The name **imaginary** originated in the 17th century as a way of insulting these numbers, suggesting they were useless or invalid. It's the same kind of opposition that crazy ideas like **negative numbers**, and even **zero**, received when they were trying to become useful.

Here's a picture showing how a **complex number** is made of a **real** part and an **imaginary** part.

complex number

$$z = 2 + 3i$$

real part *imaginary part*

The fact that this **complex number** has two parts shouldn't be too uncomfortable. We're used to two part things already, like coordinates **(x,y)**, chess board squares **(e5)**, or map locations **12.3E, 14.1N**.

Examples of **complex numbers** could be **(2 - 3i)**, or **(0.5 + 0.2i)**. Any of the two parts could be negative, or be fractions, just like normal numbers can.

Let's go back to what we were trying to do. We were going to push these **complex numbers** through a mathematical function to get an **output** value. That means we need to know how to do simple things like addition, subtraction and multiplication.

The good news is that these things are really easy with so-called **complex numbers**. Let's have a look at **adding** two of them together.

$$(2 + 3i) + (4 + 5i) = (6 + 8i)$$

You can see that we simply combine the real parts and the imaginary parts separately. If we imagined the **real** parts were **red apples**, and the **imaginary** parts were **green grapes**, we'd be adding **2 apples** to **4 apples** to get **6 apples** in total. Similarly, **3 grapes** and **5 grapes** make **8 grapes**. This is also just like normal school maths where we might add **(2x + 3y) + (4x + 5y)** to get **(6x + 8y)**.

Subtraction is no different because we combine the elements in the same way we're already used to.

$$(2 + 3i) - (4 + 5i) = (-2 - 2i)$$

What about **multiplying** two complex numbers together? Well, let's go with the idea that we do it just as we would with normal school maths. Here's an example.

$$(2 + 3i) * (4 + 5i)$$

$$= 2*4 + 2*5i + 3i*4 + 3i*5i$$

$$= 8 + 22i + 15i^2$$

You can see that we multiply out the brackets just like we would do **(2x + 3y) * (4x + 5y)**. Collecting the bits that are of the same kind, we're left with **8 real** parts and **22 imaginary** parts. But we have an extra bit, **15i²**, which happens when we multiply two imaginary parts together. What do we do with this? There is a simple new rule we can apply.

$$i^2 = -1$$

That's the only new rule we need to work with complex numbers. Everything else is just like normal school maths. This rule looks really simple, and it is simple. It tells us that **i²** simply

becomes **-1**. That means we can simplify the expression we had above because **15i^2** becomes just **-15**.

So we have real parts **8** and now also **-15,** leaving us with **-7**. Now we can finish the multiplication, leaving only **real** and **imaginary** parts.

$$(2 + 3i) * (4 + 5i)$$

$$= 8 + 22i + \cancel{15i^2} -15$$

$$= -7 + 22i$$

We're interested in squaring complex numbers because want to use them with the function **z^2 + c**. Let's see what happens if we square a complex number **(a + bi)**. Remember that squaring a number is just multiplying that number by itself, so **(a +bi)2** is just **(a +bi) * (a +bi)**, and we can multiply out those brackets as usual.

$$(a + bi) * (a + bi)$$

$$= a^2 + 2abi + b^2i^2$$

$$= (a^2 - b^2) + 2abi$$

That's a really useful generally result, which we can use again and again for squaring different complex numbers. For example, if we want to work out **(1 + 2i)2** we can use that general result, with **a = 1** and **b = 2**. The answer has real part **(1^2 - 2^2) = -3** and imaginary part **2*1*2 = 4**, so the answer is **(-3 + 4i)**.

Not every calculator can do complex number calculations, but if you type them into Google's search box, it will work out the answer for you.

Appendix C provides a gentler introduction to complex numbers, and also some worked examples of complex number calculations.

Iterating with Complex Numbers

Now that we know how to square a complex number, we can take a starting value of, say **(1 + 1i)** for example, and try repeatedly iterating the function **"square it"** to see what happens.

iteration	starting value (1 + 1i) function "square it"
0	1 + 1i
1	0 + 2i
2	-4 + 0i
3	16 + 0i
4	256 + 0i
5	65536 + 0i

The first output value is **(0 + 2i)** which is purely **imaginary**, there is no **real** part. Squaring that gives us **(-4 + 0i)** which is purely **real**, and has no **imaginary** part. That's interesting because we are now back in the world of normal numbers. After that, we have the familiar output values of **16**, **256** and **65536**. The output values will never become complex after that **-4**, because squaring **real**, normal, numbers only ever gives us **real**, normal, numbers.

What's the overall behaviour? The numbers seem to get bigger and bigger, or at least the real part of the output does. How could we visualise the behaviour of these output complex numbers on a graph? It's not immediately obvious because these complex numbers have two parts.

We could consider these two parts to be coordinates, with the **real** part describing the horizontal direction, and the **imaginary** part describing the vertical direction. So a complex number **(a + bi)** could be considered a point at the location **(a, b)**. In fact, this is a very common way of thinking about complex numbers. We could visualise the size of these complex numbers by working out the direct distance of the point from the origin at **(0, 0)**.

The distance of the point **(a, b)** from the origin is the square root of $a^2 + b^2$. You may remember this from school, where it was called **Pythagoras' Theorem**. Here's a picture to make it clearer.

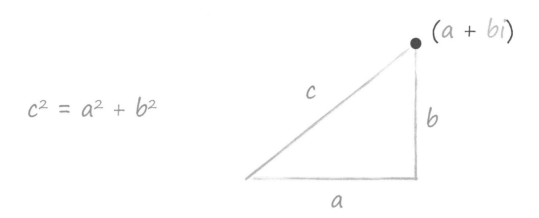

$$c^2 = a^2 + b^2$$

So, if we had an output complex number **(a + ib)** we can consider the square root of **a² +b²** to be the size of the complex number. In fact the word, **magnitude**, is more commonly used, and means the same thing. Let's use this magnitude to visualise what happens to the output values from the function.

Here's the same table as before, but this time we've also worked out the magnitude of the output complex numbers.

iteration	starting value (1 + 1i) function "square it"	magnitude
0	1 + 1i	1.4142
1	0 + 2i	2
2	-4 + 0i	4
3	16 + 0i	16
4	256 + 0i	256
5	65536 + 0i	65536

We can see the magnitude of the complex numbers popping out of the function getting larger and larger, just as we expected. Now we can draw a graph showing the magnitude of these complex numbers.

We can see the behaviour getting larger and **exploding**, one of the behaviours we've seen before.

Let's try starting with a different complex number **(0 + 1i)**. The square of **(0 + 1i)** is just **-1**. And the square of that is **+1**. And after that, we always get output values of **1**, because the square of **1** is always **1**. We don't need a table for this simple example, but it is useful to see how the output values change on a graph.

You can see the magnitude doesn't change. That's another one of the three behaviours we saw before.

Let's try a starting value of **(0.5 + 0.5i)**. Let's go straight to the graph showing how the output values behave.

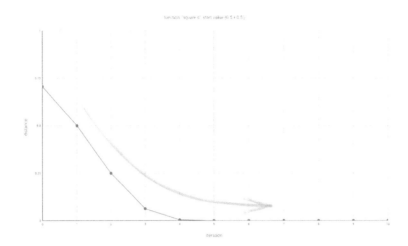

This time we see the size of the output complex numbers getting smaller and smaller. This is the last of the three behaviours we saw.

So after all that hard work using a new kind of number, we have only seen the three behaviours we saw using normal numbers - getting smaller, getting bigger, and approaching a constant number.

start value	magnitude behaviour
1 + 1i	grows and explodes
0 + 1i	stays constant
0.5 + 0.5i	decays towards zero

Let's try the whole thing again, but with a slightly different mathematical function. Instead of **"square it"**, or z^2, we'll add a complex number too, so our new function is $z^2 + c$. That **c** is just a complex number that we can chose to be anything, but once chosen, it stays the same through all the iterations. That's why it is called **c**, for constant.

Let's start with **z** at **(0 + 0i)**, and try **c = 0.33 + 0.577i**. Because this is a little different to what we've just done, let's write out the table of output values and their magnitudes for the first **10** iterations.

iteration	starting value (0 + 0i) function $z^2 + 0.33 + 0.577i$	magnitude
0	0 + 0i	0
1	0.33 + 0.577i	0.6647
2	0.1060 + 0.9578i	0.9637
3	-0.5762 + 0.7800i	0.9698
4	0.0536 + -0.3219i	0.3263
5	0.2293 + 0.5425i	0.5890
6	0.0883 + 0.8258i	0.8305
7	-0.3441 + 0.7228i	0.8005
8	-0.0740 + 0.0796i	0.1087
9	0.3291 + 0.5652i	0.6541
10	0.1189 + 0.9491i	0.9565

It's not clear at all how these output values are behaving. The numbers seem to be pretty random. Staring at them for ages doesn't seem to reveal any pattern. Maybe more iterations will make reveal a pattern. Let's plot a graph of the magnitude from the first **50** iterations.

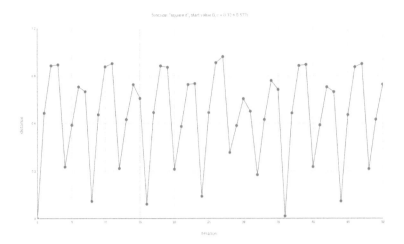

That is pretty random, but there seems to be a wave-like pattern in there too. That wave pattern is definitely not regular like the **sine wave** we saw earlier. Trying to predict future values based on this pattern seems impossible as any pattern isn't regular enough, whereas it was possible with the very regular **sine** wave.

This behaviour is not anything like the three we already know about. We've discovered a new behaviour!

Let's see what happens if we change the value of that constant **c** a very tiny amount to **c = 0.34 + 0.577i**. That's a change of only **0.01** to the **real** part. Such a tiny change shouldn't make a difference to the behaviour of the output values. Let's see.

This time the magnitude of the output complex values bounces around like before, before it finally breaks out and escapes, and explodes towards ever bigger values. This is a new behaviour again.

What if we changed **c** by a tiny amount in the other direction? Let's see what happens when **c = 0.32 + 0.577i**. Again this is only a change of **0.01** to the **real** part.

Again we're seeing the values bounce about irregularly and then suddenly escape. That's the same behaviour as when **c** was **0.34 + 0.577i**.

Let's summarise these last three experiments.

c	magnitude behaviour
0.32 + 0.577i	irregular then explodes
0.33 + 0.577i	irregular, does not explode
0.34 + 0.577i	irregular then explodes

Let's take a step back and think about what we've discovered.

We've found a new kind of behaviour, where the output values seem to bounce about in an irregular way. Let's be more precise about this. The magnitudes aren't totally random. The magnitudes seem to follow an irregular wave pattern. What makes them similar to totally random numbers is that it is not possible to observe the values and then use them to predict a value at a future iteration. The only feasible way to do that is to actually run the iterations.

We've also seen that even very small changes to the starting values can cause the behaviour of the output values to be drastically different. As the real part of **c** changes through **0.32**, **0.33** and **0.34** we see a complete switch in behaviour from exploding numbers, not exploding numbers, and back to exploding again. This really is an important point, and worth meditating on for a while. A tiny change in the starting conditions can lead to drastically different outcomes.

What we're seeing is something that goes by the name of **chaos**. Chaos is not total randomness. It is something much more interesting.

A system is chaotic if it behaves so irregularly that trying to predict its future is almost impossible, and where small changes can cause drastic changes to its behaviour. Nature is full of chaotic things. Mixing two liquids together is chaotic. It's almost impossible to predict where a drop of one liquid will end up when the mixing starts, and yet the mixing isn't entirely random. A nearby drop will end up somewhere totally different to the first one, showing that the mixing is very sensitive to the starting point.

Here's a picture of the chaotic mixing of clouds on Jupiter, originally taken by NASA.

What We've Learned

We've laid the final foundations for exploring **chaos**, learning about complex numbers and how they behave when fed back repeatedly into simple functions.

Key Points

- A **complex number** is simply a number with two parts - a **real** part, and an **imaginary** part.

- Complex numbers can be added and subtracted very simply:

 - **(a + bi) + (c + di) = (a + c) + (b + d)i**
 - **(a + bi) - (c + di) = (a - c) + (b - d)i**

- Multiplying complex numbers is also familiar, except the rule $i^2 = -1$ is applied:

 - **(a + bi) · (c + di) = (ac - bd) + (ad + bc)i**

- The size, or **magnitude**, of a complex number **(a + bi)** is the square root of **($a^2 + b^2$)**.

- The output values of simple functions, when using complex numbers, show the three behaviours we saw with normal numbers: they get ever smaller, they get ever larger, or they approach a constant. Complex numbers also show a new behaviour, which is **irregular** and **hard to predict**. Furthermore, **small changes to the starting conditions** can lead to **drastically different behaviour**. Together this is called **chaos**.

Making A Map of Chaos

We've seen how three complex numbers, very close together, can produce very different behaviour when repeatedly fed back into a simple function $z^2 + c$.

Because complex numbers have two parts like coordinates on a map, we could make a map showing how complex numbers behave.

Let's look at this idea of a map. The following picture shows examples of complex numbers acting like coordinates for points on a map.

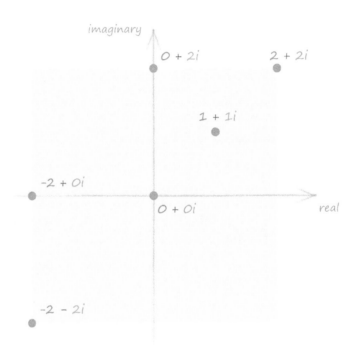

You can see how they work just like normal coordinates. This particular map is a square shape, and at the top right the point is at **(2, 2)** which corresponds to the complex number **(2 + 2i)**. You can see we're using the **real** part as the **horizontal** coordinate, and the **imaginary** part as the **vertical** coordinate.

Here's the big idea. Why don't we test many points on that map, taking the complex number corresponding to each point as **c**, and see how they behave when iterated through the function we've been experimenting with, $z^2 + c$? If the outputs explode, we can colour the point white, and if they don't explode we can colour the points black.

In effect, we're marking territory on this map to see if there are regions which behave one way or another.

Let's start thinking about code. It makes sense to use every pixel on our canvas for this coloured map. The following diagram shows how the canvas and this map are related.

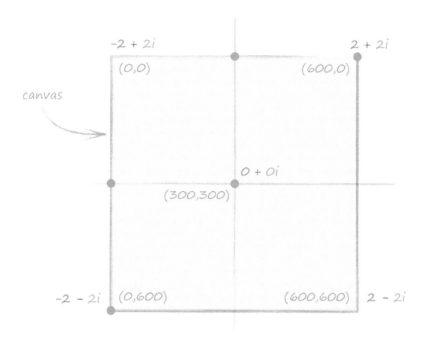

We can see this canvas has a width and a height of **600 pixels**. It's a square canvas, unlike the rectangular canvases we've used before. Remember how Processing starts its coordinates at the top left, which means the top left of the canvas is at **(0,0) pixels**, and the bottom right is at **(600, 600)**. The middle of the canvas is at **(300, 300)** pixels. This is all familiar stuff that we've done before.

The map of complex numbers, however, has a different set of coordinates. The top left corresponds to **(-2, 2)**, the bottom right **(2, -2)**, and the middle **(0,0)**. That sounds like it could be a terrible pain converting between canvas and map, but we've already seen the Processing **map()** function, which can translate from one range to another range.

If we have pixel coordinates **(x,y)**, then the complex number coordinates **(a,b)** will be:

```
var a = map(x, 0, 600, -2, 2);
var b = map(y, 0, 600, 2, -2);
```

It's as simple as that. As **x** goes from **0** to **600**, the real part of the complex number **c** goes from **-2** to **2**. As **y** goes from **0** to **600**, the imaginary part of the complex number **c** goes from **2** to **-2**. The reason this looks backwards is because Processing counts the vertical coordinate down the canvas. Looking at the diagram again makes this clear.

Let's start fleshing out some code. We can use the familiar loop within a loop to move across every pixel on the canvas.

```
// visit every pixel on the canvas
for (var x = 0; x < 600; x += 1) {
  for (var y = 0; y < 600; y += 1) {

    // convert canvas (x, y) to complex number c = a + bi
    var a = map(x, 0, 599, -2, 2);
    var b = map(y, 0, 599, 2, -2);

  }
}
```

Remember the **a** and **b** are the **real** and **imaginary** parts of the complex number **c** that we use in the function $z^2 + c$. That is, **c = a + bi**.

Now we need to start with **z = 0 + 0i** and apply the function $z^2 + c$, taking the output and feeding it back as input, repeating this until we know whether the output values grow ever larger and explode.

But we might have a problem. The behaviour of the output values can be irregular, bouncing about, almost randomly. We've seen behaviour where the values bounce about without getting too large, and then at some point, they suddenly escape and explode. We've already said we can't easily predict how a sequence of outputs will evolve, the very definition of chaotic behaviour. So how do we decide whether a particular **c** will cause the explosive behaviour or not? We can't run the iterations forever, just in case the outputs do eventually explode.

We can do two things:

- If we see the magnitude of the output complex value grow bigger than **2**, we can assume that it is already on the path to growing ever larger and exploding. If you're really interested, there is an easy mathematical proof of this which you can find on the blog accompanying this book:

 - http://makeyourownalgorithmicart.blogspot.co.uk/2017/12/escape-conditions-for-julia-and.html

- If we reach, say **50**, iterations, and the output values haven't escaped, we could assume they won't. If we're not very convinced, we can extend the limit to **100**, or even **500** iterations. This isn't a guarantee that the values won't escape, but should give us an approximately correct map.

Let's see what the code could look like.

```
// start with z=0+0i and c=a+bi
// iterate 50 times or until |z|>2
var z_real = 0;
var z_imag = 0;
for (var iteration = 1; iteration <= 50; iteration += 1) {
   // apply z^2 + c function
}
```

This is just the skeleton code which will need more adding to it, but it's useful to get started like this. We've created **z_real** and **z_imag** as the **real** and **imaginary** part of the complex number **z**, and set both parts to **0**. We then use a familiar loop to iterate the $z^2 + c$ function **50** times. That was easy enough.

The bit we haven't fleshed out is the actual application of the function, and then testing the output to see if its size has grown beyond **2**.

A neat way to stop the iterations if the size of **z** grows larger than **2** is to add it to the loop condition for continuing. It's easier to see it than talk about it.

```
for (var iteration = 1; (iteration <= 50) && (dist(0, 0, z_real,
z_imag) < 2); iteration += 1)
```

Previously the loop continued as long as the **iteration** counter was less than 50, but now we've added an additional condition. That additional condition is that the distance from the origin **(0,0)** to **(z_real, z_imag)** is less than 2. This is the same as saying the **magnitude** of **z** is less than 2. The Processing **dist()** function, which we've seen before, conveniently gives us the magnitude of **z**, which means we can avoid calculating it ourselves. The **&&** means **"and"**, which means both conditions have to be true for the loop to continue.

The code for calculating the next output of the $z^2 + c$ function makes use of the general result we worked out earlier for squaring complex numbers.

```
// apply z^2 + c function
var z_real_temp = (z_real * z_real) - (z_imag * z_imag) + a;
var z_imag_temp = (2 * z_real * z_imag) + b;
z_real = z_real_temp;
z_imag = z_imag_temp;
```

The real part of $z^2 + c$ is assigned to a temporary variable **z_real_temp**, and the imaginary part to **z_imag_temp**. Only after both of these calculations are complete, are the values re-assigned

to **z_real** and **z_imag**. The reason for this is that if we updated **z_real** straight away, we'd be using the new value prematurely for calculating the imaginary part.

After the iteration loop is done, we simply check whether we actually reached the limit of **50** iterations. If we did, that means the values of **z** didn't explode, so we can colour the pixel at **(x,y)** black. Processing has a **point()** instruction for colouring a single pixel.

```
// if we reached 50 iterations colour point
if (iteration == 51) {
  point(x, y);
}
```

The reason we check if the loop counter **iteration** is **51** is that after the loops have completed **iteration** is left at **51**, not **50**. The continue condition fails when **iteration** is no longer less than or equal to **50**, and the first time that happens is when **iteration** reaches **51**.

All this means that the regions where **c** leads to an explosion of **z** are left as the background **white**, and where there is no explosion they're coloured **black**.

Here's the full code so far. As usual, the code isn't very large at all, given how many ideas went into it.

```
function setup() {
  createCanvas(600, 600);
  background('white');
  noLoop();
}

function draw() {

  // visit every pixel on the canvas
  for (var x = 0; x < 600; x += 1) {
    for (var y = 0; y < 600; y += 1) {

      // convert canvas (x, y) to complex number c = a + bi
      var a = map(x, 0, 599, -2, 2);
      var b = map(y, 0, 599, 2, -2);

      // start with z=0+0i and c=a+bi
      // iterate 50 times or until |z|>2
      var z_real = 0;
      var z_imag = 0;
```

```
    for (var iteration = 1; (iteration <= 50) && (dist(0, 0,
z_real, z_imag) < 2); iteration += 1) {

        // apply z^2 + c function
        var z_real_temp = (z_real * z_real) - (z_imag * z_imag) + a;
        var z_imag_temp = (2 * z_real * z_imag) + b;
        z_real = z_real_temp;
        z_imag = z_imag_temp;

    }

    // if we reached 50 iterations colour point
    if (iteration == 51) {
      point(x, y);
    }

  }
 }

}
```

Before we run the code, let's try to predict what that map might look like. We can imagine that for small **c**, the output values of **z** get smaller and smaller, not exploding. We can imagine for large **c**, the values of **z** to get larger and larger, because at every iteration we're adding that large **c**, leading to an explosion. So we can expect the centre of the canvas, close to **c = 0 + 0i**, to be **black**, and the edges of the canvas to be left **white**. What about the boundary between these two regions? Is there a reason to think it wouldn't be a circle? Maybe a square? I can't imagine why it would be an elongated ellipse or a rectangle.

Let's run the code and see.

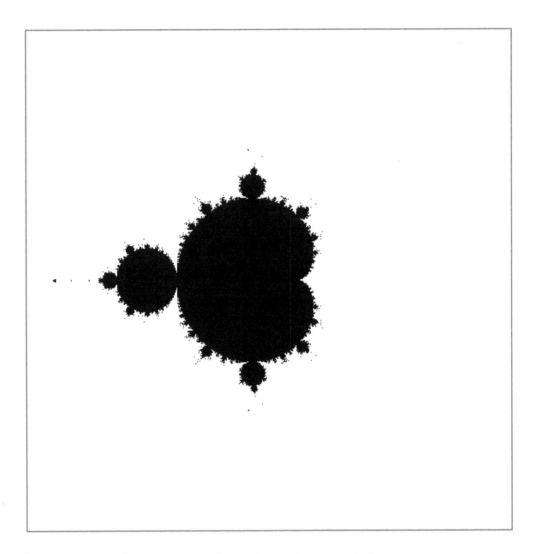

Boom! What is that thing? Have we made a mistake in our code?

We haven't made an error. That shape we've uncovered is a very famous pattern called the **Mandelbrot set**. It looks like some kind of insect, a beetle perhaps. It seems to have a head, arms, and what can only be described as its bottom! And if you look closely, there is fine grained detail around the edge of the shape. In fact that detail seems to be **self-similar**, meaning the pattern is a **fractal**.

That shape is certainly not the circle, ellipse, square or rectangle we expected. Remember, the dark bits represent the complex numbers **c** which don't explode when $z^2 + c$ is repeatedly applied, and the light bits are where they do explode.

Let's make sure we understand that because it's important. The boundary between the two behaviours is not a boring shape, but a rather interesting, and totally unexpected, fractal pattern. How deliciously odd!

All that detail from such a simple function $z^2 + c$ - this truly mind blowing!

Our canvas represented a square where the top left was **c = -2 + 2i**, and the bottom right was **2 - 2i**. That was a square with sides of length **4**. The classic view of this very popular fractal zooms in a little closer, with a square with sides of length **3**, and shifted long so the left hand side is at **-2.25**, the right at **0.75**, the bottom at **-1.5**, and the top at **1.5**. To do this we simply change the **map()** instructions that take the canvas locations and transform them into the real and imaginary part of **c**.

```
// convert canvas (x, y) to complex number c = a + bi
var a = map(x, 0, 599, -2.25, 0.75);
var b = map(y, 0, 599, 1.5, -1.5);
```

You can see how the left edge of the canvas is now mapped to **-2.25**, where previously it was **-2**. It's that easy to zoom into a closer view.

Let's see the results.

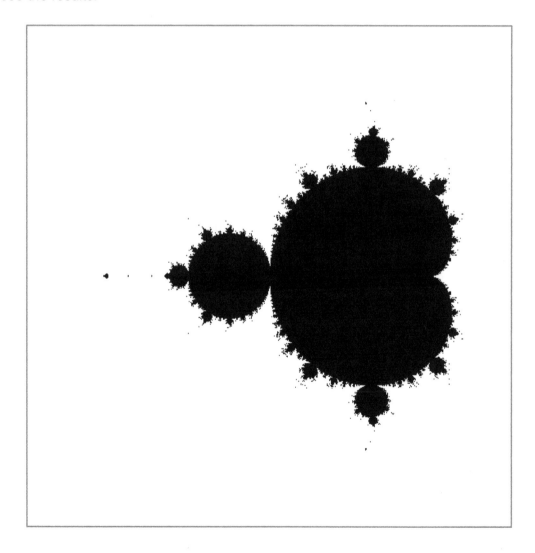

That is the traditional view of the Mandelbrot fractal. The code for this sketch is online at https://www.openprocessing.org/sketch/492545.

Let's pick some parts of the fractal to zoom in on and have a closer look at.

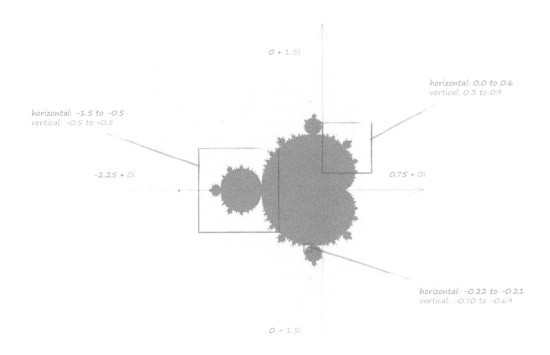

We've drawn smaller squares, or **viewports**, over the main canvas, and for each of them we've tried to estimate what the coordinates of the edges of the square are. We'll use the **map()** function again to convert the canvas pixel coordinates to complex numbers which lie within these viewports.

Let's take that biggest square on the left that covers the bug's head. That viewport runs from -**1.5** to **-0.5** horizontally, and from **-0.5** to **+0.5** vertically. So it's a square with sides of size **1.0**. The changes to **map()** are really simple, and nothing else needs to be changed for us to zoom into the Mandelbrot fractal.

```
// convert canvas (x, y) to complex number c = a + bi
var a = map(x, 0, 599, -1.5, -0.5);
var b = map(y, 0, 599, -0.5, 0.5);
```

And here's the result.

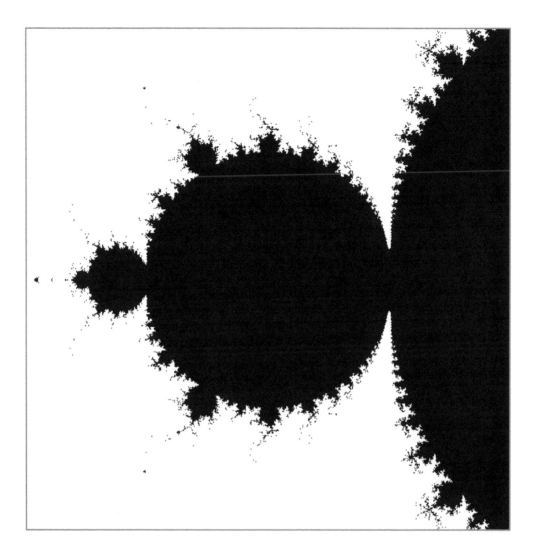

We can see that there definitely is a lot more detail, and lots of self-similar repetition of the main bulbous shape.

Colour

Before we look at the next viewport, let's try to add more information to these renderings. We know that the white area was left as the background colour because the complex number **z** exploded there. We actually cut short the **50** iterations when the size of **z** grew larger than **2**. If we look at how many iterations are completed when this happens, we'd have an idea of how fast that **z** grows. If all it takes are **3** iterations to grow beyond a size of **2**, that's a very quick explosion. If it takes **40** iterations then that's a slower growth. Why don't we use the iterations completed, given by the **iteration** loop counter, to colour the pixels. That way the colour will give us information about how fast the output values explode.

Have a look at the following code for choosing a colour.

```
// colour point
```

```
if (iteration == 51) {
  // black inside fractal
  stroke(0, 0, 0);
} else {
  // rate of explosion
  stroke(10*iteration, 0, 0);
}
point(x, y);
```

If all the iterations were completed, **iteration** is **51**, so we choose **black** using **stroke(0, 0, 0)**. It may seem odd but **stroke()**, **and** not **fill()**, is used to decide the colour of a **point()**. If **iteration** is not **51** then we choose a colour where the RGB values are **(10*iteration, 0, 0)**. We've multiplied **iteration** by **10** as an easy way to boost small values to something that fits the **0-255** colour range better.

Let's see what happens.

That is dramatic! The colour marks out filaments that emerge from the main body like electrical lightning. This adds a whole new dimension to the fractal pattern, both visually and in understanding what's happening mathematically as output values escape.

Let's have a look at the whole fractal again using this colouring scheme.

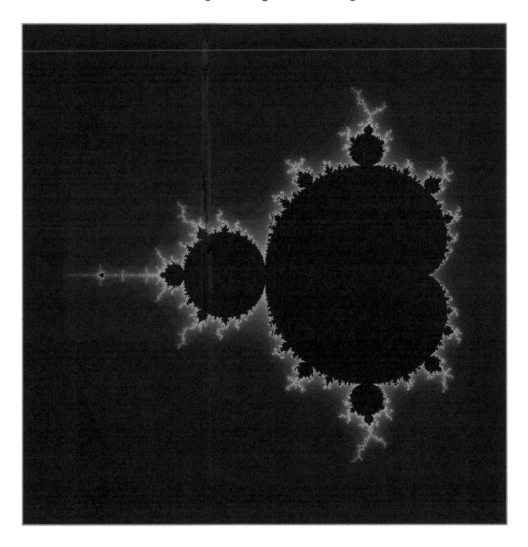

That is pretty striking. It's hard to believe it came from such a simple bit of maths, $z^2 + c$.

Let's see what happens when we zoom into the smaller viewport at the top right, which covered one of these bulbs on the main body. That viewport runs from **0.0** to **0.6** horizontally, and from **0.3** to **0.9** vertically. So it's an even smaller square with sides of size **0.6**.

That looks like a burning forest. Looking closer, the smaller blobs are definitely self-similar and we can even see what look like tiny beetles coming off the lightning filaments that emerge from the blobs. That sky definitely looks ominous!

Let's look at that final viewport. That one runs from **-0.22** to **-0.21** horizontally, and from **-0.70** to **-0.69** vertically. That's a tiny square with sides of length **0.01**. We're really zooming in now.

Hopefully we'll see lots of tiny detail.

That didn't work so well. The detail seems to have become lost. The reason for this is that as we zoom in closer and closer, the difference between the values of the complex number **c** become smaller. To be able to separate out which ones lead to an explosion and which ones don't, we need to run the iterations for longer. Remember we saw that behaviour where the output values bounced about for many iterations and then suddenly exploded. By cutting short the iterations at **50**, we only had an approximation of the map. Going on for longer will improve the accuracy of this approximation.

So let's increase the number of iterations from **50** to **100**. We need to change the loop condition to **(iteration <= 100)**, and the test to see if we should colour the pixels black to **(iteration == 101)**.

That really does reveal a lot more detail. We can see swirls coming off swirls. It's a haunting image in its own right.

Try different colour schemes yourself. Over the course of this book we've come across quite a few mathematical tools to help us transform the **iteration** counter into colour values.

Here's my own experiment.

```
// rate of explosion
var fraction = Math.tanh(iteration/70);
var col_1 = color(0, 0, 50);
var col_2 = color(255, 255, 255);
stroke(lerpColor(col_1, col_2, fraction));
```

I've used the **tanh()** function that we learned about before, to transform **iteration** into the range from **0** to **1**. I've then used this fraction to pick a colour on a gradient between two fixed colours,

using **lerpColor()**, which we've also used before. The reason I've divided **iteration** by **70** is to scale it down to better match the useful range of **tanh()**.

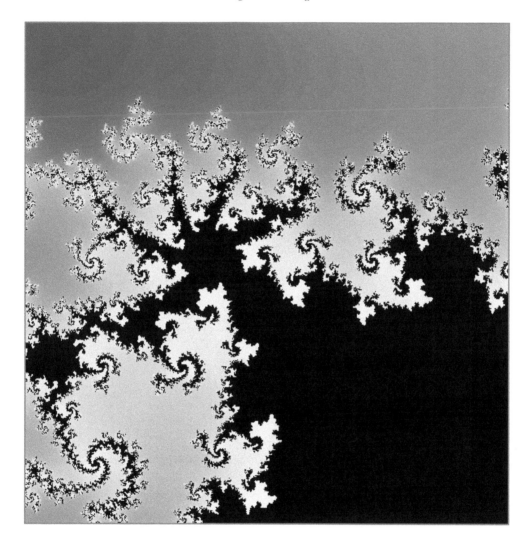

This reveals more detail when the pattern is very fine grained, where the number of completed iterations is high. But the black areas do still look blobby, so let's again increase the number of iterations, from **100** to **500**. That should be enough to really bring out the detail in those areas. I've also changed the scaling in the **tanh()** to **tanh(iteration/200)** to better match this new upper limit.

The Mandelbrot fractal is starting to reveal some really intricate and beautiful patterns. Those curling wispy patterns are very organic looking. You'll see there are several smaller versions of the main bug shape that have emerged, and each of those will have their own lightning and wispy curls to explore.

The code for that sketch is online at https://www.openprocessing.org/sketch/492777.

You should definitely explore other parts of the Mandelbrot set. There are endless surprises and stunning beauty to be found in this **infinitely detailed** fractal. What we've just said is not wrong - it is a mathematical fact that there is no limit to the detail in the Mandelbrot set. The detail never runs out.

Here are some interesting parts that I've found. I've inverted the colour scale from which colours are picked because starting from a darker blue closer to the detail seems produce more pleasing images.

These are very small sections of the Mandelbrot set, as if we were looking at it through a very powerful microscope.

That first image looks like a very ornate set of claws. And each of those claws has yet more self-similar detail. It's actually rather breathtaking. It also reminds me of "The Great Wave off Kanagawa" by the Japanese artist Hokusai. The second image is a rather delicate filament, reaching out from the main fractal into the unknown beyond. The third image is impressive in its intricacy, and I was lucky to find this very symmetrical pattern. That last image is one of infinitely many smaller versions of the main fractal bug shape. I like the way the lighting shoots off not-quite symmetrically from this one.

You can find the code for these online at https://www.openprocessing.org/sketch/492957. These four viewports are included as code comments.

Mind-Blowing Maths

I came across the Mandelbrot fractal about 30 years ago. Even now I am amazed at how such a simple function, $z^2 + c$, can produce such stunningly intricate forms.

It seems that mathematics, too often seen as regular, cold and boringly dry, has allowed us a glimpse of her hauntingly beauty without requiring us to have a degree in the subject.

I hope you agree we kept our promise to find stunningly intricate and hauntingly beautiful patterns from a deceptively modest mathematical function.

Exploring More

Exploring these fractals is really addictive, and it doesn't help that they contain an infinite amount of detail and variety to explore.

There are many fractal explorer applications, for your computer, smartphone or tablet. I've found the free **XaoS** fun to use. It renders the images so fast, you can zoom into them in real-time, as if you were falling into them. You can get it here:

- XaoS: http://matek.hu/xaos/doku.php

You don't have to install any software if you don't want to. There are excellent explorers that work entirely through your web browser. Here are a some I keep coming back to:

- http://tilde.club/~david/m
- http://falcosoft.hu/html5_mandelbrot.html

That last one allows you to copy and paste the coordinates of the viewport so you can easily use them in your own code.

Google's image search is also a great way to be inspired by what others have done. Many have developed really interesting colouring schemes, and some have even created three-dimensional versions of the fractal.

Finally, some algorithmic artists have created animated videos of diving extremely deep into the Mandelbrot set, revealing incredible detail. Imagine looking at the whole observable universe, and then zooming into it until you reached the scale of an atom. This video zooms even deeper into the Mandelbrot set:

- Mandelbrot Fractal Zoom: https://www.youtube.com/watch?v=Ujvy-DEA-UM

What We've Learned

We finally saw how complex numbers, and iterated functions can lead to chaos, and out of that chaos, intricate beautiful patterns.

Key Points

- The famous **Mandelbrot Set** is an infinitely detailed fractal that is revealed when a map is coloured to show which complex numbers explode, and which don't, when they're repeated fed back into the function $z^2 + c$, with z starting at zero, and c representing the point on the map.

- The Mandelbrot **fractal** is incredibly detailed, with many instances of **self-similarity**. In fact, it is **infinitely** detailed.

- Because the behaviour of complex numbers under this function can be **chaotic**, it is difficult to predict which points will explode. A practical compromise is to set a **maximum iteration limit**, and also stop when the **output magnitude grows beyond 2**.

- A very common way of rendering the fractal is to **colour points according to how fast they explode**, which is indicated by the number of iterations completed before the stopping conditions are met.

Worked Example: Whirling Dervish

In this worked example we're going to create a fractal pattern using the very same ideas that created the Mandelbrot fractal, revealing order out of chaos.

Let's use the very same function $z^2 + c$, but this time let's try changing the starting conditions. Let's swap how we use **z** and **c**.

With the Mandelbrot fractal we had **z** starting at **0**, and **c** representing the point on the map being tested. This time, let's have **z** starting as the point on the map being tested, and have **c** start at **0**. Actually scrap that last bit, if **c** is always **0** it might as well not be there, so let's experiment with different values for **c**.

Here's the idea summarised:

before	now
z starts at **0**	**z** starts as point being tested
c is point being tested	**c** is a constant

The code changes to do this are really simple.

```
// start with z as point on map
var z_real = map(x, 0, 599, -2, 2);
var z_imag = map(y, 0, 599, 2, -2);

// choose c=a+bi
var a = 0.1;
var b = 0.1;
```

Before we had the canvas pixel coordinates being mapped to a complex number, which became **c**. Now we've assigned them to **z**. You can also see we've chosen **c** to be **(0.1 + 0.1i)**. There's no particular logic here, the numbers were chosen just to get us started.

Nothing else needs to be changed because we're using exactly the same approach to repeatedly pushing **z** through $z^2 + c$ and feeding back the outputs until we decide to stop. Let's see what the results look like.

That's not very interesting, but the bumps around the edge do hint that this approach of swapping how we use **z** and **c** might still be worth exploring.

Let's try a different value for **c**. How about **(0.4 + 0.4i)**.

That's much more interesting. We seem to have uncovered another self-similar fractal with a nice overall symmetry and delicate detail.

The image was very faint at first, almost invisible, so the fraction used to pick a colour was changed to **tanh(iteration/100)**. The larger fraction picks colours closer to the darker end of the colour scale.

Try other values of **c** yourself, to see what other patterns you can uncover. Here are some I've found.

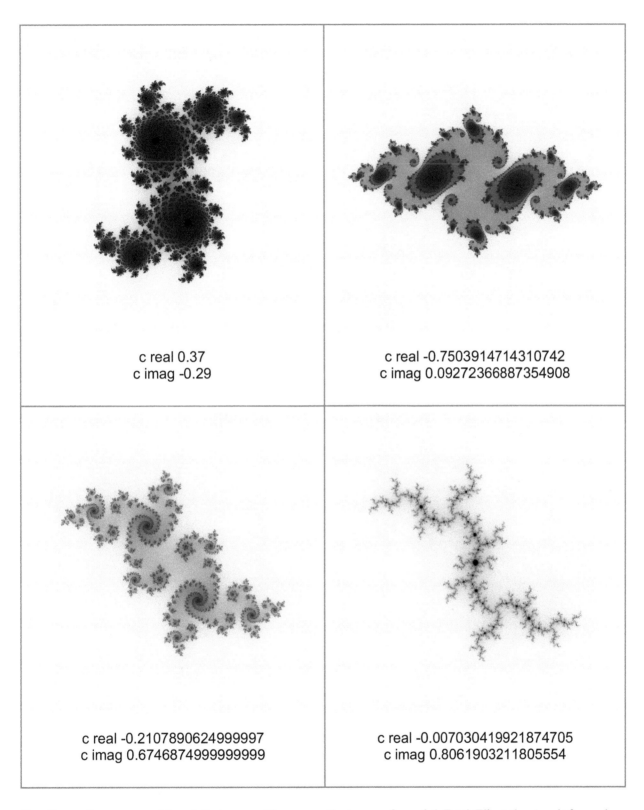

c real 0.37
c imag -0.29

c real -0.7503914714310742
c imag 0.09272366887354908

c real -0.2107890624999997
c imag 0.6746874999999999

c real -0.007030419921874705
c imag 0.8061903211805554

For these I've zoomed in a bit closer with a map that goes from **(-1.7 +1.7i)** at the top left, and **(1.7 - 1.7i)** at the bottom right. Apart from that, there were no other changes to the code.

These new patterns all have a stronger sense of symmetry than the Mandelbrot patterns. They convey a strong feeling of being self-contained. And they are varied - just these examples show patterns reminiscent of claws, curly wisps, delicate embroidery and electrical lightning.

The code for these patterns is online at https://www.openprocessing.org/sketch/494117, with the different values of **c** included in code comments.

Have a go at zooming into these patterns by defining a smaller viewport. Here are a few examples of my own close-ups.

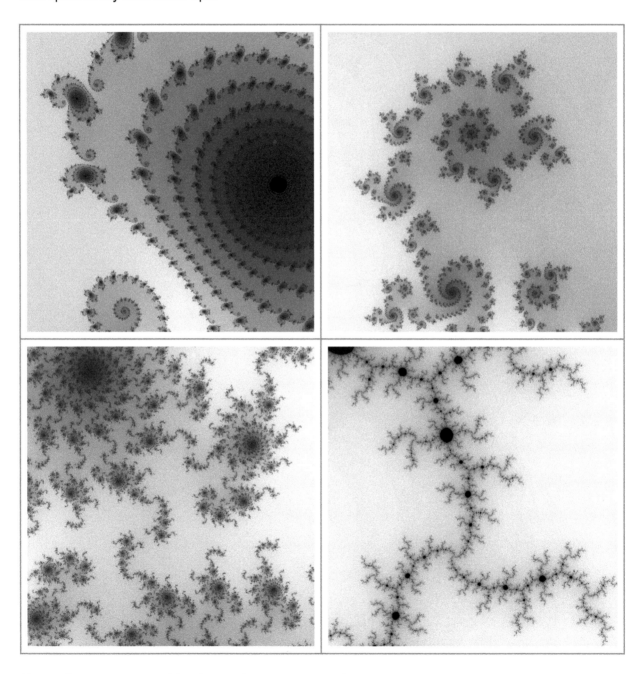

These fractals, like the Mandelbrot fractal, are also famous, and are called **Julia sets**.

Now that we've discovered how nice Julia sets are, let's think about creating a composition that we'd be happy to display.

The detail and patterns are provided by the maths, and we don't want to distract from that, or displace it with competing details. If anything, we want to emphasise the fractal forms, to celebrate the mathematics that created them.

Perhaps we can emphasise the fractal by strengthening the patterns around the fractal. Previously we used the iteration reached to pick a colour along a smoothly varying colour scale. That gave us a smooth graduation of colour around the fractal, which you can see in all of the most recent images. Let's do the opposite of smooth. If we coloured according to whether **iteration** counter was even or odd, that should give us a stronger pattern.

We only need to modify one line of the code we've already crafted.

```
var fraction = iteration % 2;
```

That's much simpler than the code we had before. What does it do? The symbol **%** takes a number, divides it by another number, and gives us the **remainder**. For example, if we had **15 % 4**, that's the remainder after **15** is divided by **4**, which is **3**. If we divide any whole number by **2**, the answer is always **0** or **1**. If the whole number was even, the remainder is always **0**, and if the whole number was odd, the remainder is always **1**. So **iteration % 2** will always flip between **0** and **1**. That means the fraction will always be **0** or **1**, and so the colouring will always be chosen from the very start or end of the colour scale.

Let's see the results.

That is certainly harsh. Although it's too strong for our final piece, I do want to use this kind of pattern because it gives us an insight into how the regions around the actual fractals behave.

Using **iteration % 3** would give us remainders of **0**, **1** and **2**. That might give us a slightly less harsh colouring scheme. We'd have to divide this remainder by **2** to scale it back into the range **0** to **1** for the fraction.

```
var fraction = (iteration % 3) / 2;
```

Let's see if it does moderate the harshness.

That's still fairly harsh, but a bit less so. Let's divide by a bigger number, say **30**, so that the fractions are much smaller. That should keep the colours being picked closer to the lighter end of the scale.

```
var fraction = (iteration % 3) / 30;
```

That is definitely less stark, but now it's far too light.

Let's combine this colouring scheme with the one we had before. We can do that by simply adding the two expressions for calculating the fraction.

```
var fraction = Math.tanh(iteration/100) + (iteration % 3)/30;
```

It may be that this fraction sometimes goes over **1**, but that should be quite rare, and it won't break the **lerpColor()** colour picker, so let's not complicate it any further by trying to avoid it.

Well, that worked really rather well. There's an almost perfect balance between the fractal detail and the supporting patterns in the regions around it. I'm pretty happy with that!

We could stop there, as that is certainly a very respectable image. But let's see what effect this colouring algorithm has on other Julia sets.

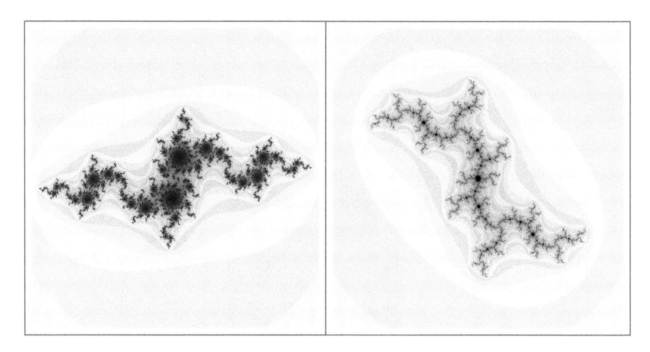

I prefer the Julia set we've been working with, so let's continue with that.

Looking at the image critically, the one thing that sticks out at me is that the big bands of colour around the fractal are a bit too prominent around the edge of the canvas. We want the viewer's eye to explore and marvel at the detail of the fractal and not be drawn away by the clunking great rings around the canvas.

We could try to reduce the darkness of these bands by using the distance from the centre of the fractal. The greater the distance, the closer to the lighter end of the colour scale we want to be. We could use something like **dist(0, 0, z_real, z_imag)** but sadly the values of **z_real** and **z_imag** are no longer what they were originally, because they've been iterated through $z^2 + c$. So we need to remap the canvas coordinates to the map coordinates, and then work out the distance.

```
// reduce contrast around canvas edge
fraction -= dist(0, 0, map(x, 0, 599, -1.7, 1.7), map(y, 0, 599,
1.7, -1.7)) / 20;
```

You can see we've divided that distance by **20**, and then we reduce **fraction** by this amount. Let's see how effective this is.

That's vastly improved as an image that can stand on its own.

Now that we have the technique refined, let's apply it to a Julia set that we really like. I like the curly one that we discovered earlier, with **c = -0.7503914714310742 + 0.09272366887354908i**.

I spent a while tweaking the colour picking code until I was happy with the overall balance between the fractal and the surrounding regions. In fact I spent hours!

```
var fraction = Math.tanh(iteration/200) + (iteration % 3)/40;
// reduce contrast around canvas edge
fraction -= dist(0, 0, map(x, 0, 899, -1.9, 1.9), map(y, 0, 899,
1.9, -1.9)) / 10;
```

I've also changed the code to use a larger canvas with width and height **1200** pixels. All those extra pixels give us a much more detailed final image.

The final code is online at https://www.openprocessing.org/sketch/494662.

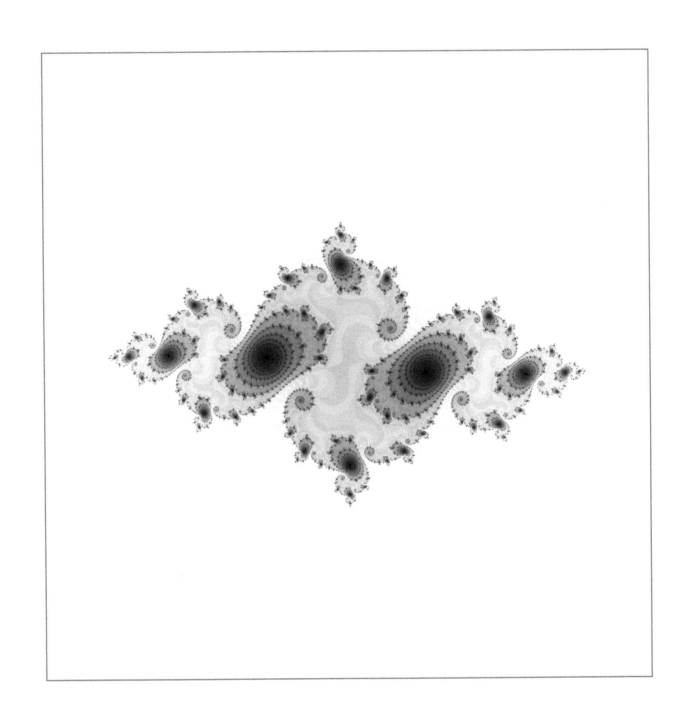

Whirling Dervish

Part 5 - Even More Building Blocks

In Part 5 we're going to explore yet more interesting and useful techniques - a new colour model, and more naturally random noise.

A More Human Colour Model

Earlier we looked at mixing colours using **red**, **green** and **blue** light. That way of mixing colours takes some getting used to, and in reality even professionals use tools to help mix the right colour. It's not the most intuitive **colour model**. Even now, I can't confidently remember how to mix a **yellow**.

Where did that colour model come from? We did talk before about displays, like smartphone screens and big monitors, having pixels made of tiny little **red**, **green** and **blue** lights to mix the desired colours. Why were they chosen to have those three colours? It's because the human eye responds most to **red**, **green** and **blue** light, and so it made sense to build displays using these three primary colours. It's interesting that other animals have eyes that respond to fewer, or more, colours. Many insects that depend on plants and flowers are sensitive to four colours, **red**, **green**, **blue** and **ultraviolet**. Some of those flowers have striking patterns, but only if you can see ultraviolet light.

Just because our eyes are sensitive to **red**, **green** and **blue** light, doesn't mean that's how our minds think about colour. The two things are different. The fact that we struggle to think which combination of **red**, **green** and **blue** makes **yellow**, suggests it's not the most natural colour model for us to think in.

Here's another challenge to the RGB colour model. If I have a colour, say **red**, which is RGB **(255, 0, 0)**, how do I use those numbers to work out the **complementary colour**? You may remember from art class that **red** and **green** were considered opposite, or complementary,

colours. So how do we get from RGB **(255, 0, 0)** to RGB **(0, 255, 0)** using only a calculation on those numbers? It's not obvious at all. If we could use a simple calculation, that would be really useful for selecting colour pairs using code, opening up all kinds of possibilities for algorithmic art.

This challenge, and many others like it, are reasons that different colour models are invented. We're going to look at a particularly useful one called the **HSB** model. Instead of **red**, **green**, **blue** for **RGB**, we have **hue**, **saturation** and **brightness** for **HSB**.

In this model, the **hue** represents colour, and as **hue** changes, so do the colours. There is no colour mixing like we have with the RGB model. Once we've selected a colour, the **saturation** and **brightness** control how light or dark the colours are. It's easier to see it in action than to talk about it.

Here's the **HSB** model as a diagram.

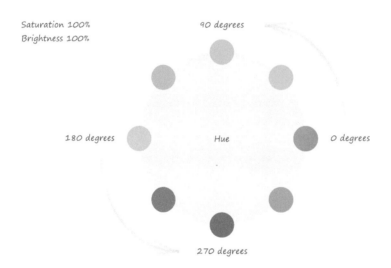

In this diagram you can see how the colour changes as **hue** goes from **0** to **360 degrees** around a circle. It's just a popular convention that **hue** goes from **0** to **360** so it can be drawn around a circle. There's no reason why it can't be set to different ranges like fractions between **0** and **1**, percentages **0** to **100**, or even **0** to **255** just like RGB values.

We've only drawn eight dots around that circle but you can imagine that we if we drew more dots, more of the intermediate colours would be shown. The colours we can see are very intense. They're not weak at all. That's because the **saturation** is set to the full **100%** for all of these dots.

In that colour wheel above, we had both **saturation** and **brightness** at the full **100%**. Let's see what happens if we turn **saturation** down to **50%**.

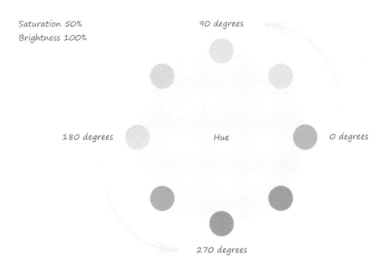

Saturation 50%
Brightness 100%

90 degrees

180 degrees Hue 0 degrees

270 degrees

As expected, the colours are less intense. It's as if we've used a lower concentration of pigment, diluted with water. If we turned **saturation** down to **0%**, all the colours would go towards pure **white**.

Now let's see what happens if we keep the **saturation** at **100%** and turn down the **brightness** to **70%**.

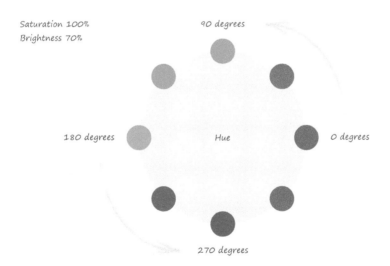

Saturation 100%
Brightness 70%

90 degrees

180 degrees Hue 0 degrees

270 degrees

You can see how lowering the **brightness** does exactly that. If we reduced brightness to **0%** the colours would go towards pure **black**.

So in summary, **hue** picks the colour, **saturation** and **brightness** change how bright or dark that colour is.

Let's write some code to draw a HSB colour wheel with more colours than the eight we've shown above.

```
function setup() {
  createCanvas(800, 600);
  background('white');
  noLoop();
  // set colour mode to HSB
  colorMode(HSB);
  // set angle unit to degrees
  angleMode(DEGREES);
}

function draw() {

  noStroke();

  // loop over angles
  for (var angle = 0; angle < 360; angle += 10) {

    // HSB colour, S and B set to 100
    fill(angle, 100, 100);

    // coordinates of colour spot
    var x = 150 * cos(angle);
    var y = 150 * sin(angle);
    ellipse(400 + x, 300 - y, 20);

  }

}
```

Most of that code will be very familiar, using a loop to count an angle from **0** to **360** in steps of **10**, and drawing a coloured dot at that angle around a circle of radius **150**, using trigonometry to calculate their horizontal **x** and vertical **y** locations.

We tell Processing that we want to use the HSB colour model with **colorMode(HSB)**. By default, Processing will consider the **hue** to be in the range **0** to **360**, with **saturation** and **brightness** in the range **0** to **100**. When we later use **fill()** to pick a colour for the dots, the first number is the **hue**, the second is the **saturation**, and the third is the **brightness**. If we weren't using HSB, these would be the usual **red**, **green** and **blue**. You can also add a fourth number, which is the alpha value for translucency, and the default range is **0** to **1**.

Let's see the result.

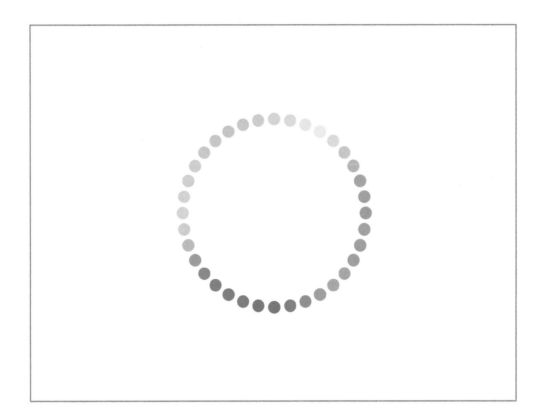

That's filled in many more of the colours that we didn't see before, like **yellow**.

The code is online at https://www.openprocessing.org/sketch/498276.

Thinking about this HSB colour model, if we pick a colour, we should be able calculate lighter or darker versions of it by simply changing the **saturation** and **brightness** values. Let's try it.

The following chart shows red, which is **hue 0**, used to draw a series of squares with **saturation** varying between **0** and **100**. The code to pick the colour is **fill(hue, value, 100)**, with **hue** set to **0** and **value** varying between **0** and **100**. The **brightness** value is set stay at **100**.

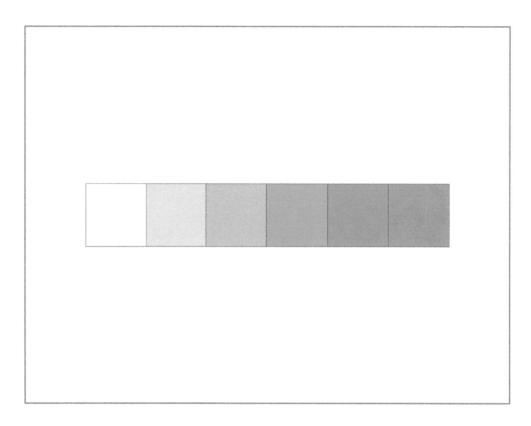

The next chart repeats this but keeps **saturation** at **100**, and varies the **brightness** between **0** and **100**. The code to pick the colour is **fill(hue, 100, value)**.

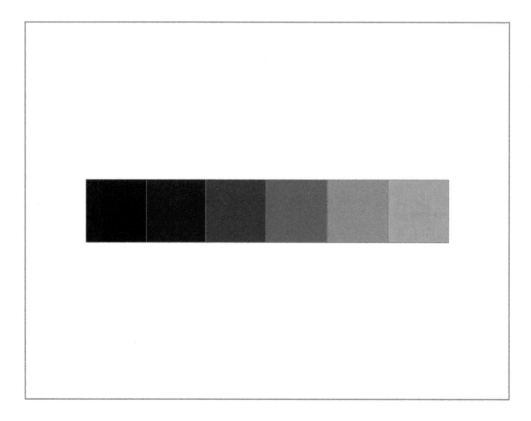

If we tried to do that with the RGB model, it wouldn't be so easy. With a colour like **red** RGB **(255, 0, 0)** we have to decrease the **red** channel to make it darker, or add equal amounts to the **green** and **blue** channels to make it lighter. It's even harder if we had a colour like **orange** RGB **(255, 128, 0)**. How do we make that lighter? We have to calculate the increase in all the channels in a way that is proportional to maintain that **orange** hue. The increases in the **blue** channel would not be the same as the **increases** in the green channel.

The code for these charts is online at https://www.openprocessing.org/sketch/498462.

Complementary Colours

The HSB model gives us another important advantage. It allows us to easily calculate the **complementary colour** to a given colour. You'll remember that complementary, or opposite, colours are pairs that look the most different. The next picture shows how we can work out the complementary colour to **yellow**.

60 degrees

240 degrees

Complementary colours are located on opposite sides of the wheel to each other. To calculate the complementary hue we just add **180 degrees**. Easy! We couldn't do that so easily with RGB colour values.

Hang on! That hue colour wheel shows **cyan** as the opposite of **red**. Shouldn't the opposite of **red** be **green**?

Colour theory is a huge and interesting field that has evolved over hundreds of years. Today there are several models for colour, and not all have the same primary and complementary colours. The traditional colour wheel that many of us learned at school was created hundreds of years ago, when painters used **red**, **yellow** and **blue** primary colours to **subtractively** mix new colours. Today we have electronic displays that **additively** mix **red**, **green** and **blue** primary coloured lights to create the colours we see. Scientists discovered that the human eye has cones at the back sensitive to **red**, **green** and **blue**, not **yellow**, and that's why these are the

primaries for mixing light. If **green** is indeed a primary colour in this model, it can't also be a complementary colour.

Not convinced? Cover one eye and use the other to stare at following bright **red** square for **15 seconds**, from a distance of about **20 cm**. Then, without taking your hand off the covered eye, look at the white square. You'll see **cyan**, not **green**.

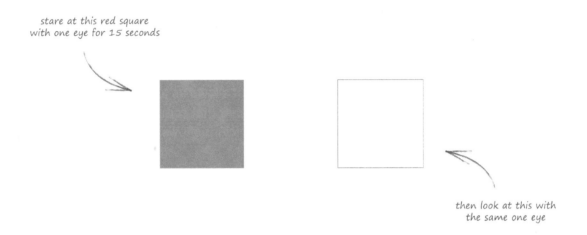

stare at this red square
with one eye for 15 seconds

then look at this with
the same one eye

You can try it with more colours online here http://faculty.washington.edu/chudler/after.html.

Let's write some code to showcase the calculation of complementary colours. Let's make a grid of circles with a randomly chosen hue, and place these over bigger circles of the opposite hue. We're very familiar now with covering a canvas with shapes placed on a regular grid so we won't show the boring code here. The interesting code is this:

```
// pick a random hue
var hue1 = random(360);
// calculate complementary hue
// adding 180 but removing 360 if larger
var hue2 = (hue1 + 180) % 360;

// small and larger circles
fill(hue1, 100, 100);
ellipse(x, y, 80);
fill(hue2, 100, 100);
ellipse(x, y, 50);
```

Let's talk through what's happening. The first **hue1** is picked randomly from the range **0** to **360**. We then calculate its complementary **hue2** by adding **180**. There's a chance that **hue1** was large enough that adding **180** would result in a number bigger than the maximum **360**. We can

make the result wrap around and continue again from **0 degrees** on the colour wheel by taking away **360** if the result is indeed bigger than **360**. A neat way to do this is to use **% 360** which leaves the remainder after dividing by **360**. We've used that **modulo %** before, and it is worth becoming comfortable with it. It really is a useful tool in algorithmic art.

After that we simply draw a larger circle of size **80** and then a smaller circle of size **50** over it, each with complementary **hue1** and **hue2**.

Let's see the results.

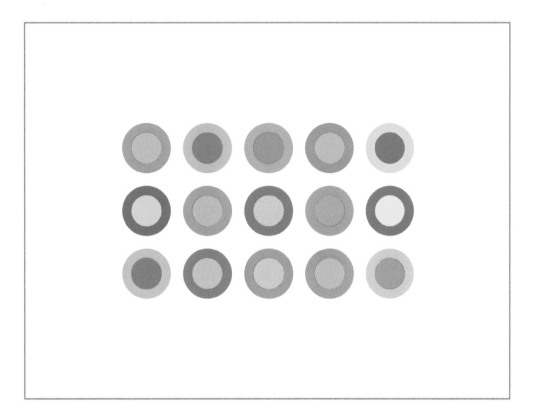

That certainly seems to work very well. The interaction of these complementary colours is to clash rather harshly, because they really are fighting to oppose each other.

The full code is at https://www.openprocessing.org/sketch/498526. Because the hues are chosen at random, the result will be different every time the code is run.

This is a good demonstration of why the HSB colour model is really useful for algorithmically picking colours. But there's more.

Analogous Colours

Sometimes we want to use related colours for colouring something we're drawing, but the complementary colour pairs are far too much in opposition. Sometimes we want a calmer, more harmonious, combination of colours that aren't locked in battle.

To get a hue's complement, we travelled right to the very opposite side of the colour wheel, to a point which could not be any further from that hue. What if we didn't run away with such enthusiasm, and instead shifted away from the hue by a small angle?

The following diagram shows us shifting around from the **yellow** hue by **30 degrees** in both directions.

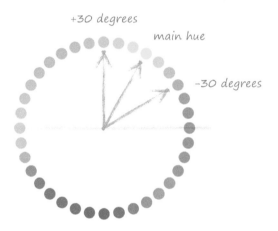

The two hues picked out are a **yellowy-green** and a **yellowy-red**, both of which are not very far from **yellow**. The idea seems to work.

Let's try the idea in code, and draw another grid but this time use triplets of coloured rectangles. The middle rectangle will show a randomly chosen hue, and rectangles on either side will be that hue reduced and increased by **30 degrees**. The interesting code is:

```
// pick a random hue
var hue1 = random(360);
// calculate two analogous hues
// adding +/- 30 but removing 360 if larger
var hue2 = (hue1 + 30) % 360;
var hue3 = (hue1 - 30 + 360) % 360;

// small, medium and larger circles
fill(hue3, 100, 100);
rect(x, y, 33, 80);
```

```
fill(hue1, 100, 100);
rect(x + 33, y, 33, 80);
fill(hue2, 100, 100);
rect(x + 66, y, 33, 80);
```

The code is very similar to our previous code drawing complementary spots. The calculation of **hue3** may look odd because we're subtracting **30 degrees** and then adding **360** back on again. Why do we do this? If the result of taking **30** off **hue1** is a negative number, we can bring it back into the valid range by adding **360 degrees**. Let's say **hue1** is **10 degrees**, subtracting **30** gives us **-20 degrees**, which is not in the correct **0** to **360** range. Adding **360** gives us **340 degrees** which is at the right place on the colour wheel when moving **30 degrees** clockwise from the starting **10 degrees**.

Let's see the results.

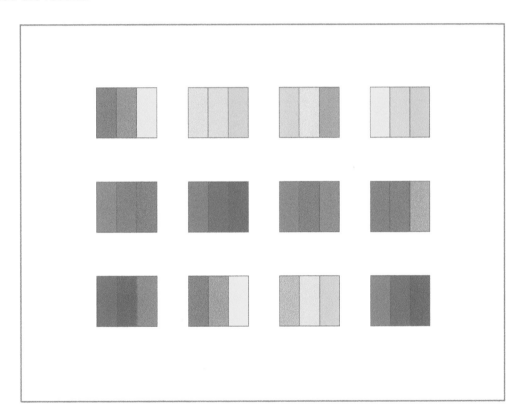

Those colour triplets are much more in harmony, they form a more natural series. This is a useful way of picking a constrained, more harmonious, palette for a composition.

Let's see what happens when the angle we shift the hue by is reduced from **30 degrees** to **10 degrees**.

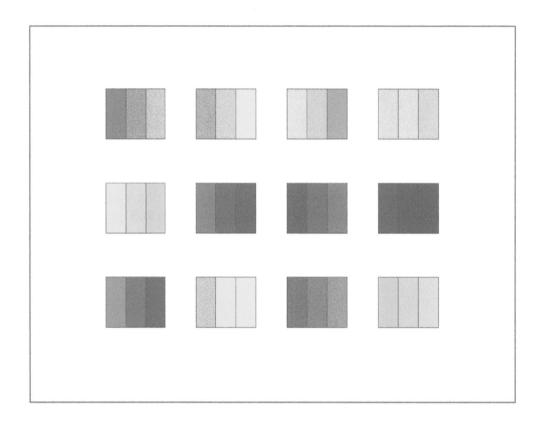

These triplets are even closer together in hue, resulting in much more relaxed combinations.

The code for these triplets is online at https://www.openprocessing.org/sketch/498641.

Almost Complementary Colours

Let's try one more idea. We saw how complementary colours are **180 degrees** apart, right on the opposite sides of the colour wheel. Let's see what happens if we pick two colours that are close to a direct opposite colour. A picture makes this idea clearer.

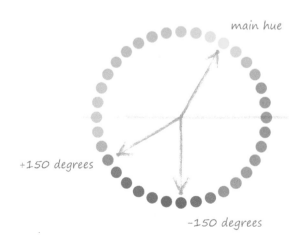

In effect, we're travelling all the way around the colour wheel, but not quite reaching the very furthest point. In code, the main hue has **150 degrees** added and subtracted to it to find these almost complementary hues. Let's see what the results look like.

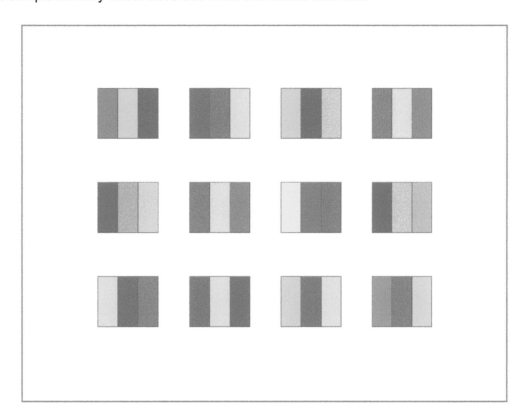

These combinations are interesting. The two hues either side are very much in contrast to the middle hue, but not as starkly conflicting as the direct opposites we first calculated. These combinations are useful when we want a more lively dynamic palette. Looking at those colour triplets again, they do seem to be wanting to dance about each other. The energy is irrepressible!

Some colour theorists call these almost-complementary colours, **split complementaries**. What a fantastic phrase!

A Panoply Of Colour Models

If you want to explore the fascinating field of colour theory and different colour models, it's worth mentioning that you'll come across something called the **HSV** model. This is exactly the same as the **HSB** model. The only difference is that the word **value** is used instead of **brightness**, but they mean the same thing.

You might also come across a **HSL** model, which looks similar, but is different enough to cause our calculations to go wrong. The **L** is for **lightness** which includes both blackness and whiteness, which in turn means the **saturation** also needs to work differently.

The best way to get a feel for how different colour models work is to play with them, not just read about them. Here is a great tool I use to compare how changing colour works across several colour models simultaneously:

- Colorizer: http://colorizer.org

Colour is a vast and deep subject that has a long history, full of debates and discoveries. Even today colour is a lively topic, far from being settled and collecting dust. In this section we saw some limitations of the RGB colour model, and saw how another one, the HSB model, can make some tasks easier.

Key Points

- Human eyes respond most to **red**, **green** and **blue** light. That is why many displays use these to additively mix pixel colours. It's also why many technologists think of **red**, **green** and **blue** as the primary colours. This is in contrast to the **red**, **yellow** and **blue** primary colours traditionally used by painters to subtractively mix paint.

- We don't naturally think in RGB. For example, tasks like working out which RGB components are required to mix a specific colour we have in mind, or to make it lighter, is difficult without tools. Different colour models are designed to make specific tasks easier.

- **HSB** is a useful colour model, where a colour is described in terms of its **hue**, **saturation** and **brightness**. **Hue** decides the colour. **Saturation** decides how intense that colour is, with a low **saturation** leading to pure **white**. **Brightness** decides how dark a colour is, with low **brightness** leading to pure **black**.

- HSB **hue** is often considered as an angle on a colour wheel, with a range of **0 to 360 degrees**. **Complementary colour**s are at opposite ends of the hue colour wheel, **180 degrees** apart. **Analogous colours** are close on the colour wheel, separated by a small angle. **Split complementaries** are located either side of a complementary hue. The ability to calculate these angles means hues can be chosen algorithmically.

Worked Example: Contemplation in Colour

In this worked example, we'll follow in the tradition of artists like Bridget Riley and Mark Rothko who created studies and experiments in colour. These works invite us to explore both colour, and the interaction of colours with each other. They are often deceptively simple in geometric design, but highly dynamic and absorbing in experience. Even more figurative artists like Henri Matisse used the dance of colours interacting with each other as a critical part of their work.

Earlier we learned how to calculate the **complementary** hue to a given one. It was at the opposite side of the colour wheel. That is, at **180 degrees** to the given hue, where it could not be any further away. We also learned how to calculate **analogous colours**, that were close to each other on the colour wheel. The angle that separated them was relatively small.

Why don't we create a composition that explores this idea of the distance between hues, and the interplay of two hues placed next to each other? Instead of only comparing complementary colours, or only comparing analogous colours, why don't we somehow try to explore the full range of distance?

Let's first create a grid of squares coloured using randomly selected hues.

Here's some basic code to get us started.

```
function setup() {
  createCanvas(800, 600);
  background('white');
  colorMode(HSB);
  noLoop();
}

function draw() {
  noStroke();

  // grid of squares
  for (var y = 100; y <= 400; y += 100) {
    for (var x = 100; x <= 600; x += 100) {
      var hue = random(360);
      fill(hue, 100, 100);
      rect(x, y, 100, 100);
    }
  }

}
```

We're drawing squares of size **100** pixels tall and wide, and placing them at regular points every **100** pixels horizontally and vertically. We're filling them with a randomly chosen **hue** from the full range **0** to **360**. The **saturation** and **brightness** are set to the full **100** for now.

If the upper limits for the **x** and **y** loop counters seems odd, have a look at the following picture.

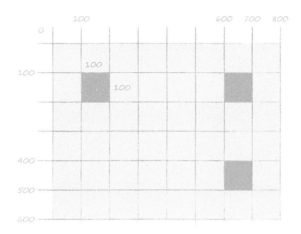

The picture shows a canvas of width **800** and height **600**. We want the grid of squares to stay away from the edges of the canvas. Let's say we want that gap to be **100**. That means the top left square should have a top left corner at **(100, 100)**. That explains the starting values for the **x** and **y** loop counters being **100**.

Now let's look at the top right square. That square needs to stay away from the edge by a distance of **100** pixels. That means the right hand edge is **700** along the horizontal direction. Because the square has a size of **100**, that means the top left of that square is at **(600, 100)**. That's why the upper limit for the **x** loop counter is **600** not **700**. Similarly, the bottom right square has a top left corner at **(600, 400)**, which is why the upper limit for the **y** counter is **400**, not **500**.

Let's see the results.

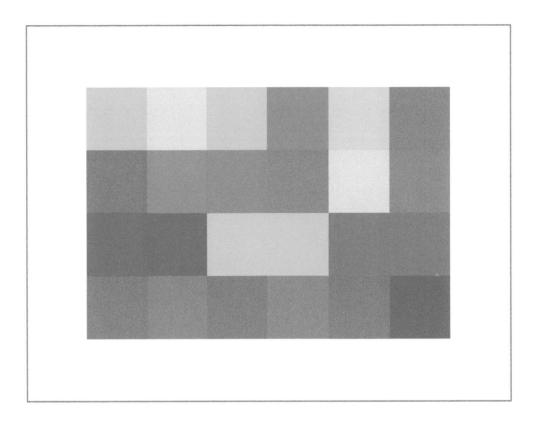

We have a grid of coloured squares just as we expected. If we want the viewer to explore the final image, taking their time, then we'll probably have to turn down the saturation as it becomes intolerable after only a few moments. Let's do that when we have more on the image so we can be sure we're getting the balance right.

Before we do any more, let's generalise the code we'd just written. We don't yet know what size of square will work best, so let's change the code so that it works with any size of square. To do that we need to work out the where the loops will start and end, and how these the loop counters are incremented.

Let's draw a diagram again to help organise our thinking.

Drawing pictures often helps figure out complicated things. It's easy to see now that the loop which counts **x** horizontally needs to start at **size**. That leaves a gap on the left of **size** pixels. That's what we want. That loop needs to end at **800 - (2 * size)**. It might seem like it should end at **800 - size**, but that's not the top left of the last square in that row. The top right square has a top left corner which is two lots of **size** from the canvas edge on the right. When we draw that square, we give it a width of **100**, which takes it to **800 - size**, leaving a gap of **size** pixels from the canvas edge. It's the same reason the vertical loop counting **y** starts at **size** and ends at **600 - (2 * size)**.

As is often the case with algorithmic art, all this thinking results in fairly small changes to the code itself.

```
// size of squares
var size = 100;
// grid of squares
for (var y = size; y <= 600 - (2 * size); y += size) {
  for (var x = size; x <= 800 - (2 * size); x += size) {
    var hue = random(360);
    fill(hue, 100, 100);
    rect(x, y, size, size);
  }
}
```

We now set the **size** variable once, and everything else is calculated using that value. Running that code again results in a similar grid of squares, but with different colours because they're chosen randomly.

To really be sure that generalisation worked, let's try setting **size** to **50**, and see the results.

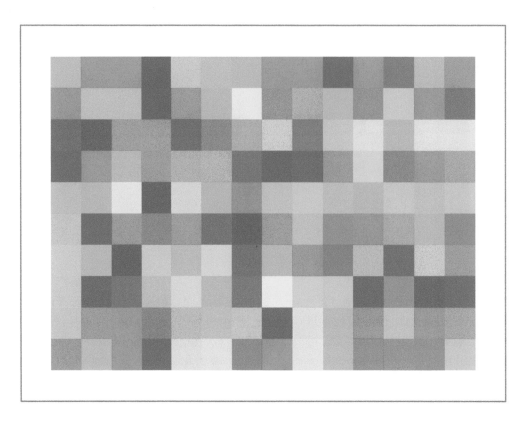

That worked. It always feels good to generalise an algorithm!

Now let's put some colour inside the squares. Our intention is to explore contrasts in hue, so why don't we start by picking the hue that is the opposite to the square's hue. We don't intend to stay with this, it's a starting point.

Let's try drawing coloured dots inside those squares. Again, a pen and paper drawing will help us work out the coordinates of these dots.

Having drawn a picture, it's really easy to see that the dots are circles with centres at a horizontal position of **x + (size / 2)**, and a vertical position of **y + (size / 2)**. That was probably easy enough to work out in our heads, but drawing pictures to plan out how more complex compositions work is a good habit.

Let's update the code.

```
// size of squares
var size = 100;
// grid of squares
for (var y = size; y <= 600 - (2 * size); y += size) {
  for (var x = size; x <= 800 - (2 * size); x += size) {
    // square
    var hue1 = random(360);
    fill(hue, 100, 100);
    rect(x, y, size, size);

    // dot inside square
    var hue2 = (hue1 + 180) % 360;
    fill(hue2, 100, 100);
    ellipse(x + (size/2), y + (size/2), size * 0.5);
  }
}
```

We've calculated a new **hue2** which is complementary to **hue1**, just like we did earlier, by adding **180 degrees to it**, and bringing it back into the **0** to **360**, if needed.

The coloured dot is a circle at the coordinates we just worked out, **(x + size/2, y + size/2)**. For now we've given the coloured dot a diameter **size * 0.5**. This way it always stays in proportion to **size**.

Let's see what kind of image this creates.

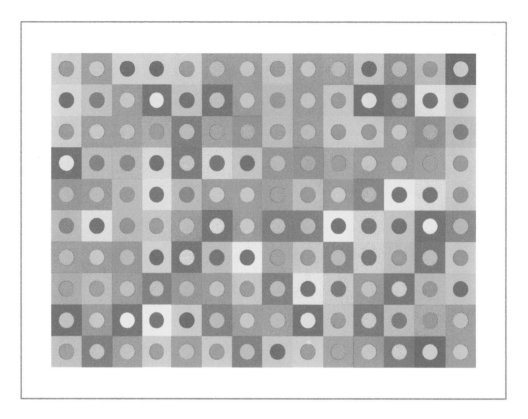

That is starting to become much more interesting. Even this simple composition has very strong dynamics, as the complementary colours oppose each other fiercely like sworn enemies, creating fervent movement across the canvas.

As interesting as that composition is, it is a little too strong, and actually rather exhausting, to view for any length of time. How can we tone down the onslaught of contrast? One way might be to vary that contrast across the image.

Let's try making that hue contrast large at the centre of the canvas, and smaller as we move away from the centre. What this means is that the hue angle between the square's hue and the dot's hue gets smaller as we move away from the centre.

Instead of adding **180** to **hue1** to get **hue2**, we'll be adding less as the distance between the centre of a square **(x + size/2, y + size/2)** and the centre of the canvas **(400, 300)** gets larger.

Let's take it step by step. First we need to work out the distance between a square and the canvas centre.

```
var d = dist(x + (size/2), y + (size/2), 400, 300);
```

We're using the convenience function **dist()** provided by Processing that we saw earlier. On a canvas of width **800** and height **600**, this distance **d** could have values approaching **500**. We need to scale that down to an angle that we can add to **hue1** to get **hue2**.

Let's think about how that scaling would work. When the distance **d** is small, we want the angle to be close to **180 degrees**, so that **hue2** is complementary to **hue1**. But we must be careful that the angle doesn't get above **180 degrees**, because that would mean the hues getting closer again. As the distance grows, we want the angle to get smaller towards zero, so that the hues get closer. We've seen a mathematical way to do this before - the **decay functions**. Let's try the bell curve because it doesn't decay suddenly, but starts decaying slowly at first, which will be useful for us in maintaining a good region of hue contrast at the centre of the canvas.

Here's the bell curve as a function of **d** divided by **200** to bring it into the curve's useful range.

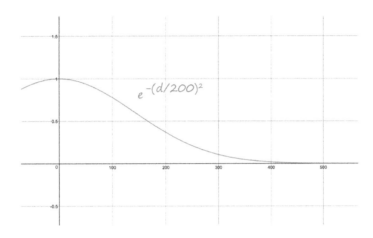

We can see that as the distance **d** grows towards **500**, the bell curve falls to almost zero. The halfway point happens at a distance of about **170**. That should be good for our canvas.

All that's left is to scale that bell curve up to a maximum of **180 degrees**. All these ideas are expressed concisely in code as follows.

```
var angle = exp(-pow(d/200,2)) * 180;
var hue2 = (hue1 + angle) % 360;
```

The bell curve scaled up to **180 degrees** becomes the **angle** which we add to **hue1** to get **hue2**. And you can see from that graph that **angle** never gets larger than **180 degrees**. Let's see if all this works.

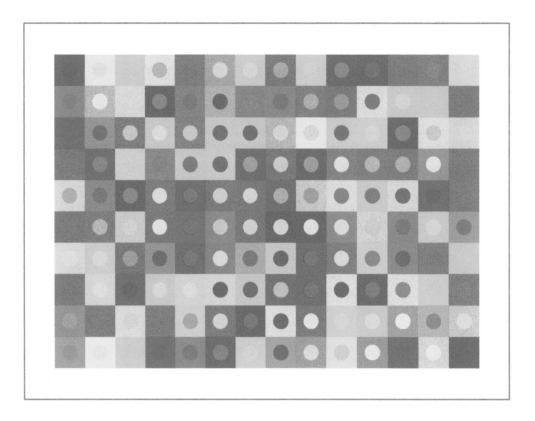

That simple transition of hue contrast from the centre of the canvas outwards provides a lot of interesting variation for our eyes to explore. Normally a pattern that is the same in all directions, like concentric circles, might not be so interesting, but the additional dimension of squares with different hues that interact with each other, as well as with the dots, and the variation of colour contrast across the canvas, makes it easy to spend a good while travelling around this landscape of colour delights!

Let's think about final refinements. We said earlier that the high saturation and brightness was too tiring. Let's turn it down. Try different values yourself. I've settled on a **saturation** of **80** and a **brightness** of **90**.

```
fill(hue1, 80, 90);
```

I also think those dots are a bit too big, they dominate the colour of the square they're sat in. Try experimenting with different sizes of circle. I settled on a radius of **size * 0.3**.

```
ellipse(x + (size/2), y + (size/2), size * 0.3);
```

Here's the full code.

```
function setup() {
```

```
  createCanvas(800, 600);
  background('white');
  colorMode(HSB);
  noLoop();
}

function draw() {
  noStroke();

  // size of squares
  var size = 50;
  // grid of squares
  for (var y = size; y <= 600 - (2 * size); y += size) {
    for (var x = size; x <= 800 - (2 * size); x += size) {
      // square
      var hue1 = random(360);
      fill(hue1, 80, 90);
      rect(x, y, size, size);

      // dot inside square
      var d = dist(x + (size/2), y + (size/2), 400, 300);
      var angle = exp(-pow(d/200,2)) * 180;
      var hue2 = (hue1 + angle) % 360;
      fill(hue2, 80, 90);
      ellipse(x + (size/2), y + (size/2), size * 0.3);
    }
  }

}
```

The code is online at https://www.openprocessing.org/sketch/499928.

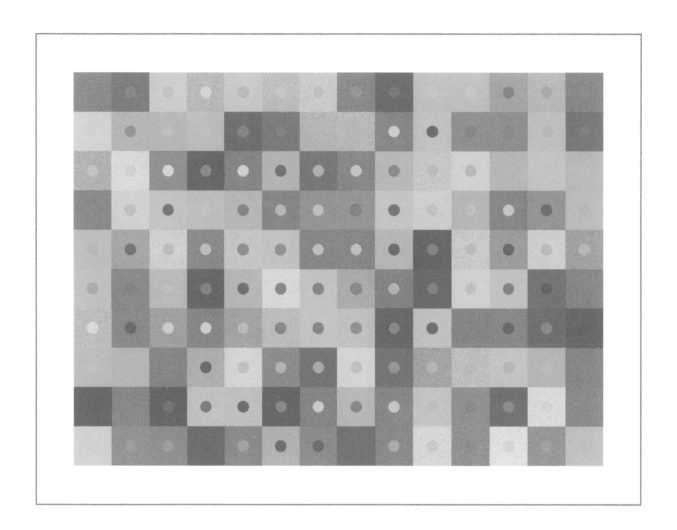

Contemplation in Colour

Not So Random Randomness

Sometimes randomness is just .. well, just too random. Let's look at an example.

Imagine we're having a lovely day walking in a national park, looking out at the beautiful horizon, observing how the hills and valleys rise and fall.

If we tried to recreate a landscape of hills and valleys, peaks and troughs, nooks and crannies, with an algorithm, we might be tempted to use randomness to decide what the skyline looked like. That is, we would use a random number to decide how high any part of the horizon was.

Let's try it. Here's some very simple code to move horizontally across the canvas and draw lines of random height.

```
function setup() {
  createCanvas(800, 600);
  background('white');
  noLoop();
}

function draw() {

  noFill();
  stroke(255, 0, 0);

  for (var x = 100; x <=700; x += 2) {
    var y = random(0, 200);
    line(x, 400, x, 400 - y);
  }
```

```
}
```

You can see we're using the **random()** function to pick a random number between **0** and **200**. That number is then used to draw a vertical line of height **y**, starting at **(x, 400)** up to **(x, 400 - y)**. That **x** is just the loop counter for how far we've moved horizontally, starting at **100**, and going up to **700**. We're incrementing it by **2** every repetition of the loop, not the usual **1**, just to make sure we can distinguish the individual vertical lines.

Hopefully that should result in a natural looking horizon.

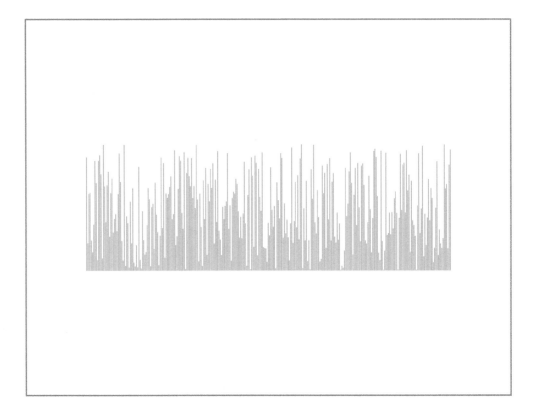

Hmm. That doesn't look particularly natural at all. The individual heights jump around too much, in a way that no natural landscape would. Sure, the heights are random, but we can see that they're too random to describe the ups and downs of a natural landscape..

Let's think about what kind of randomness would work better. Imagine standing on a bit of that hilly landscape. We'd notice that the height of the ground just to the right of us is different to the bit directly under our feet, but not by much. And if we moved to that bit of earth, we'd again notice that the earth just to the right of our feet had a different height, but the difference wouldn't be very big. In this way, the jumps or drops between one bit of the landscape and the bit immediately next to it are constrained.

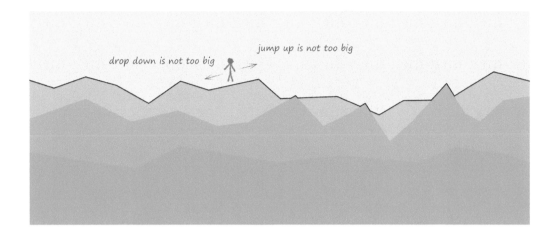

You can imagine this new not-so-random randomness would be useful in many scenarios where pure randomness just wasn't very natural. Luckily Processing has a function that gives us this new kind of randomness. It's called **noise()**, and the special kind of randomness is called **Perlin noise**.

That **noise()** function needs to know where we are on that landscape, otherwise it would have no chance of making sure the numbers it gives back are close to the neighbouring numbers. In our example, we can use a parameter to **noise()** to tell it how far along the canvas we are. Because **noise()** always returns a number between **0** and **1**, we need to multiply it by **200**, so that the heights match the scale of our previous experiment.

The code change is really simple.

```
var y = noise(x) * 200;
```

Let's see the results.

That doesn't look that much better. The reason is scale. We're using **noise(x)** and **x** is moving from **100** up to **700**. For the **noise()** function, that's actually quite a lot. So let's scale that **x** down, dividing it by **50**. That way the **noise()** parameter will vary from **2** up to **14**.

```
var y = noise(x / 50) * 200;
```

Let's see the results now.

That's much better. The jumps and drops are not so drastic now. Overall that landscape looks much more like a natural skyline of hills and valleys.

Looking closely at that last picture again we can see that each point is related to the point before it, and also related to the point after it. That's the point of **Perlin noise**. From a distance Perlin noise looks random, but look closely and we see the values are related to neighbouring values. Normal totally random numbers are not related to each other at all, because if they were, they wouldn't be totally random.

One of the best things about Perlin noise is that it works in two dimensions too. What does that mean? It means that if we pick a point on a flat surface, like a canvas, or the side of a cube, we can pass both the horizontal and vertical coordinates to the **noise()** function to give us a value. And that noise value would be related to the noise at points close to that point in any direction on that flat surface. Again, it's easier to see this in action.

Let's write some code to pick a purely random value for every point in a square on the canvas, and use that random value to colour the point. The interesting bit of code is:

```
for (var x = 200; x <=600; x += 1) {
  for (var y = 100; y <=500; y += 1) {
    var c = random(255);
    stroke(c);
    point(x, y);
```

```
    }
}
```

We're using **random(255)** to pick a number between **0** and **255**, which we then use to choose a shade of grey. Remember when we use **stroke()** or **fill()** with just one number between **0** and **255**, we're picking a colour on the grey scale between **black** and **white**.

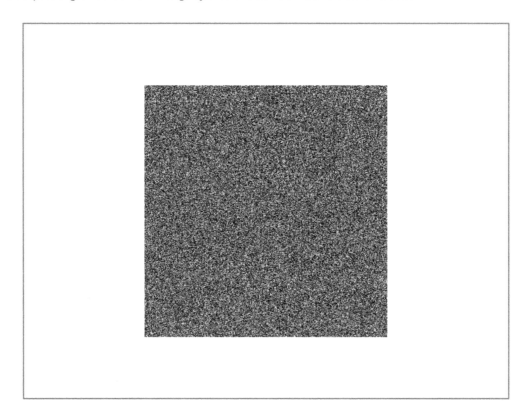

The results aren't a surprise. It's a rather busy soup of random values. If you look closely you can see it's a bit spikey, because purely random numbers don't care about being similar to their neighbours.

Let's now use Perlin noise instead. We can use **noise(x,y)** to pass the two bits of information that the function needs to decide what the noise values should be.

The code change is simple:

```
for (var x = 200; x <=600; x += 1) {
  for (var y = 100; y <=500; y += 1) {
    var c = noise(x/50, y/50) * 255;
    stroke(c);
    point(x, y);
  }
}
```

We've scaled the **x** and **y** values by dividing them by **50**, just like before. Let's see the results.

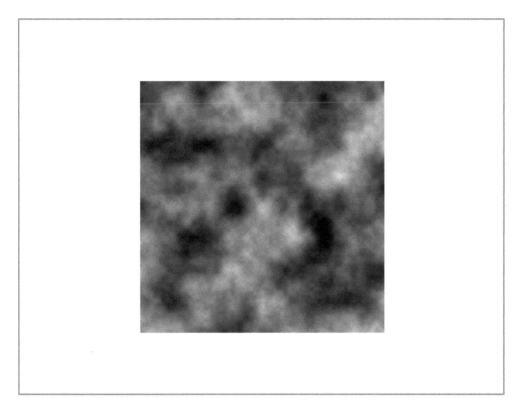

That's interesting. The variation in noise values, shown as shades of **grey**, is random from a distance, but looking closer we can see the variation is never drastic between any two closely located points.

So we've just seen that Perlin noise works in two dimensions too. What can we do with it? Algorithmic artists find all sorts of uses for noise, including creating textures that look realistic enough to have come from nature itself.

Here's a simple example of a natural texture. Let's use the **noise()** function to pick a fraction between **0** and **1**, and then use that fraction to pick a colour along a scale between **white** and **light blue**, colours you might see looking up at the sky on a pleasant summer's day. We've seen how to pick colours from a scale using **lerpColor()** before. Here's the code, none of which does anything we haven't seen before.

```
// light blue
var col1 = color(128, 128, 255);
// white
var col2 = color(255, 255, 255);

for (var x = 200; x <=600; x += 1) {
```

```
for (var y = 100; y <=500; y += 1) {
   // noise value is a fraction
   var fraction = noise(x/50, y/50);
   // fraction picks colour along scale
   var col = lerpColor(col1, col2, fraction);
   stroke(col);
   point(x, y);
 }
}
```

Let's see the sky.

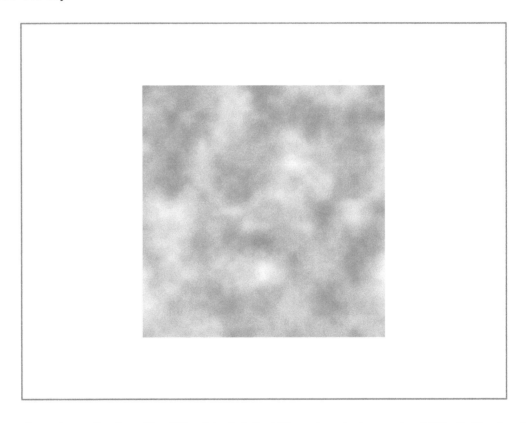

That's really rather effective. It's difficult to tell that it's not a photograph of little fluffy clouds in the sky. That **noise()** function really is very talented!

The code for these clouds is online at https://www.openprocessing.org/sketch/502021.

Let's try another texture, one that doesn't look like fluffy clouds or fire, so we can see for ourselves how versatile Perlin noise really is.

Let's start with a basic pattern of rings created by applying the **sine** function to the distance of a point on the canvas from the canvas centre.

```
var col1 = color(80, 20, 20);
var col2 = color(200, 0, 0);

for (var x = 200; x <=600; x += 1) {
  for (var y = 100; y <=500; y += 1) {

    // distance from canvas centre
    var d = dist(400, 300, x, y);

    // fraction to pick colour from scale
    var fraction = Math.pow(sin(d/10), 2);
    var col = lerpColor(col1, col2, fraction);

    stroke(col);
    point(x, y);
  }
}
```

You can see we've used the, by now familiar, **dist()** function give us the distance of a point at
(x,y) from the canvas centre at **(400,300)**. Before we apply the **sin()** function, we divide this
distance **d** by **10** to better match the **sine** function. If we didn't we'd have too many rings
squeezed together. We then square the **sine** value as a quick and easy way to turn the negative
values into positive ones. That give us a **fraction** between **0** and **1** that we can use to pick a
colour from a scale, just like we did before. Here we've chosen a red and a very dark, almost
black, red as the two ends of the colour scale.

Let's see these rings.

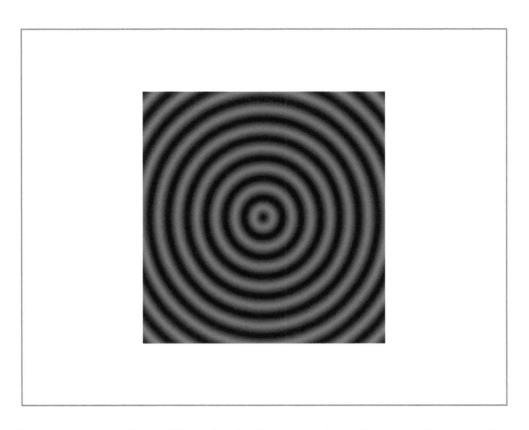

That worked as expected. To clarify again why these are rings, the colour is chosen from a colour scale using a **fraction** between **0** and **1**. That **fraction** goes up and down like a wave, because it is the result of a **sine** function applied to the distance of a point from the canvas centre. That's why the rings grow out from the canvas centre.

Now let's add the magic ingredient, Perlin noise. Where could we add it? There are a few opportunities for adding noise, and you should try some. One is to add noise to the distance **d**, before it's fed to the **sine** function. We simply insert a single line of code to do this.

```
// distance from canvas centre
var d = dist(400, 300, x, y);

// add noise to distance
d += 40 * noise(x/50, y/50);

// fraction to pick colour from scale
var fraction = Math.pow(sin(d/10), 2);
```

We've passed the horizontal **x** and vertical **y** information to the **noise()** function so it returns noise that varies in both of these directions. Like before, we've scaled **x** and **y** down to better match the scale of noise we want. Because the output of **noise()** is always between **0** and **1**, adding that to the distance won't make much difference to it. That's why we've scaled it up by **40**.

Let's see what effect this noise has.

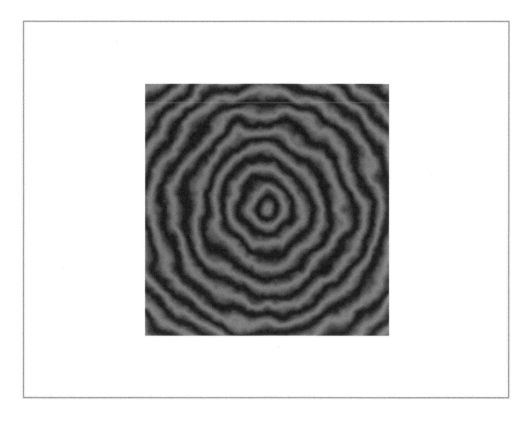

We can see the rings have been distorted. Because the added noise is Perlin noise, and not a purely random number, the distortion is fairly smooth and not too unruly. You can see why some people say they're adding **turbulence** when they're adding Perlin noise. That pattern looks like rings of coloured oil-based ink floating on water, just after being perturbed by a gentle stir.

If we had added normal randomness instead of Perlin noise, using **d += random(40)**, we'd have a haze of spiky dots.

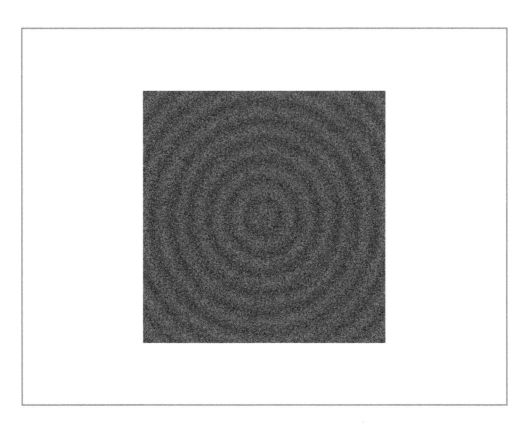

Comparing the last two images really shows the difference between pure randomness and Perlin noise.

Have a play with different scales, adding noise to different parts of the algorithms, and even starting from a different starting pattern. Even experimenting with the colour palette leads to quite varied effects. The following shows the same code but with the colour scale set between a bright **green** and a dark **blue**.

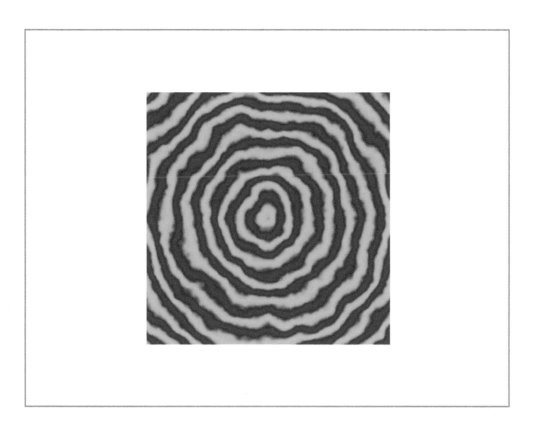

The texture looks very much like a slice of banded agate rock. That's quite an effect given the simplicity of our algorithm.

The code for this banded agate is online at https://www.openprocessing.org/sketch/502123.

What We've Learned

Sometimes pure randomness isn't very natural, and in those scenarios a not-so-random randomness can be useful.

We haven't explained how this useful Perlin noise is actually created. If you're interested, you can read more on the blog accompanying this book:

- http://makeyourownalgorithmicart.blogspot.co.uk/2018/02/randomness-and-perlin-noise.html

Key Points

- Each value in a sequence of purely **random** numbers is totally **independent** of other values. If they were related in any way, they wouldn't be **random**.

- Each value in a sequence of **Perlin noise** is related to its neighbours. Looking closely, each value is not too far from its neighbours, resulting in an approximately smooth transition between values along the sequence. From a distance, the ups and downs appear random and, like pure randomness, aren't predictable.

- The Processing function **noise()** can create **Perlin noise**, giving values in the range **0** to **1**. It needs to be passed information to tell it where in the sequence it is being asked to return a value. This information can be one, two or three numbers, which means **Perlin noise** can be **1**, **2** or **3-dimensional**. For example, **noise(x,y)** will produce 2-dimensional noise.

- Perlin noise is often used to create natural looking textures and landscapes. Examples include clouds, fire, mountainous terrains, stone and wood effects.

Worked Example: Alien Terrain

Let's go back to the idea of hills and valleys for this worked example. We'll try to use Perlin noise to create a 3-dimensional landscape, one that looks naturally formed, but has a definite unearthly alien quality to it.

Where do we start? Making something look 3-dimensional might be our biggest challenge, so let's start with that.

We could try to work out all the maths to project a 3-dimensional scene onto a flat canvas, taking into account perspective and hiding objects we can't see because they're obscured by something else. That's a lot of work. So why don't we try a simpler approach, taking inspiration from how old animated cartoons and early video games simulated the effect of three dimensions.

Have a look at the following picture showing flat rectangles placed over each other, but with each one shifted along and down a bit.

Even though each of those rectangles is a flat 2-dimensional shape, the overall arrangement seems to have depth like a 3-dimensional scene. The rectangle at the bottom right does really seem to be in front of the one behind it, and that one also seems to be in front of the one behind it.

This effect of shifting things along and down is a really simple, rather effective, way of giving the appearance of three dimensions. Let's try doing it with flat shapes representing the hills and valleys we saw earlier.

Even though each green shape is flat, the scene itself does appear to have depth.

Let's think about how we might code a scene made of these layers. Let's keep it simple to start with by drawing hill peaks of a fixed height, a bit like the rectangles in the earlier picture. As always, a pen and paper picture helps plan how we code this.

It looks like there's a lot going on in that picture so let's break it down. Let's start with the rectangle that's right at the back. We're drawing dots, representing the hill peaks, at regular intervals along the horizontal direction. That's easy enough, and something we've done many times before. For now, these dots are at a fixed height. For the next layer, we're doing exactly the same thing but shifting everything along and down a bit. And we do exactly the same shifting for every new layer, until we've got all the layers we want.

We can use the familiar loop counters to keep track of our horizontal and vertical progress along the bottom of the rectangles, and we can use a fixed height to draw dots marking the hill peaks.

Let's draw another picture with some distances to get us started.

The first rectangle starts with its bottom left corner at **(100, 300)** and we move along the horizontal direction in steps of **50**, drawing a dot directly above with a height of **200**. Then we shift everything along and down by **50** and do it all again. We keep repeating this until we've shifted down to a vertical distance of **500** from the top of the canvas.

Let's write some code.

```
function setup() {
  createCanvas(800, 600);
  background('white');
  noLoop();
}

function draw() {
  noStroke();
  fill(255, 0, 0);

  // shift for each layer
  var shift = 0;

  // layers downwards
  for (var y = 300; y <= 500; y += 50) {

    // peaks across
    for (var x = 100; x <= 500; x += 50) {
      var altitude = 200;
      ellipse(x + shift, y - altitude, 10);
    }
```

```
        shift += 50;
    }

}
```

Let's talk through what this code is doing to make sure it matches our plan. We have an inner loop which tracks a horizontal distance **x** from **100** to **500** in steps of **10**. Inside that loop we set the height, or **altitude**, of that bit of landscape to be **200**. We then draw a red dot at a position **altitude** above **y**, which is **y - altitude** because Processing counts the vertical direction downwards from the top of the canvas.

The horizontal position of that dot is **x + shift**. That **shift** is initially set to **0** and is incremented by **50** every time we start a new layer, which is the outer loop. That means each layer is shifted past the previous layer by **50** pixels. That outer loop simply moves us down the canvas in steps of **50** for every layer, starting at **300** and ending at **500**.

If you're wondering why we called the height variable **altitude** and not simply **height**, the reason is that the names **width** and **height** are reserved by Processing and automatically set to the width and height of the canvas. We probably could get away with overwriting these variables but it's not a good idea to reply on that always working in future.

Let's see if the code works.

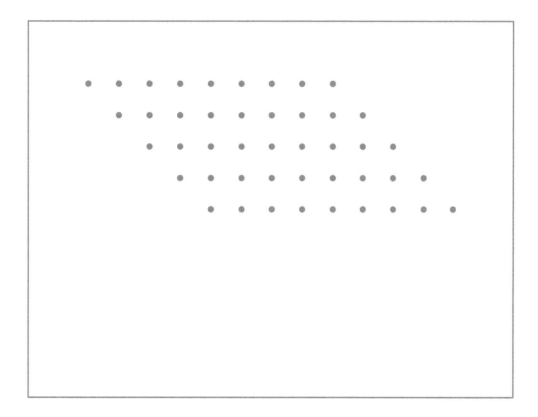

That did work. We can see five layers, and each layer has a red dot marking an altitude of **200**.

Now let's change that **altitude** to be Perlin noise depending on both the **x** and **y** locations. That should make for an interesting landscape of peaks and troughs. The code change is simple.

```
var altitude = 200 * noise(x/100, y/100);
```

We've scaled up the noise by **200** to match our previous fixed altitude of **200**. Let's see the result.

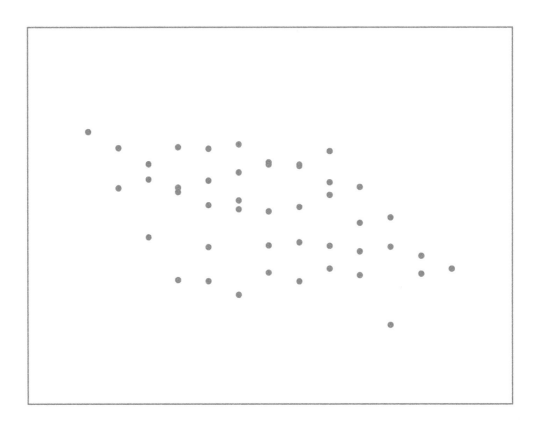

There's certainly noise in that image but it's not at all easy to see, never mind appreciate! What's wrong here is that that aren't enough dots to mark out the surface of our landscape.

Let's change the loop steps to increase by **2**. That's much smaller than the current **50**, and should result in lots and lots of dots. We'll need to reduce the size of the dots, otherwise we won't be able to see them. Let's try a diameter of **2**. That **shift** increment will also need to be reduced otherwise all the dots will fly off the right hand edge of the canvas.

```
// layers downwards
for (var y = 300; y <= 500; y += 2) {

  // peaks across
  for (var x = 100; x <= 500; x += 2) {
    var altitude = 200 * noise(x/100, y/100);
    ellipse(x + shift, y - altitude, 2);
  }

shift += 2;
}
```

Let's see if this creates the alien landscapes we're after.

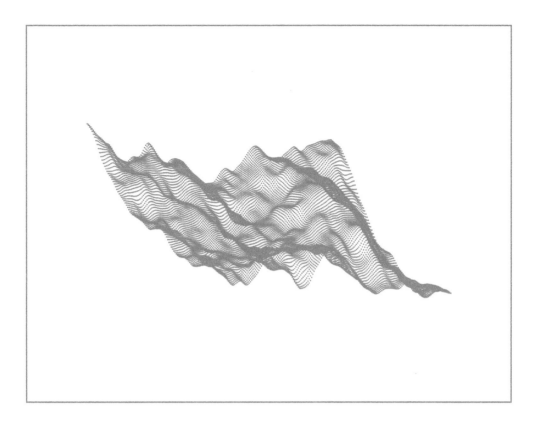

That's rather cool. Those smaller dots are now more visibly marking the contours of that surface. And it already has a sci-fi look to it, like a scan of a planet's surface.

We've also confirmed that our simplified approach to creating a 3-dimensional scene seems to work really rather well. We avoided having to mess about with more complicated maths trying to get perspective and projections right.

This last point is a valuable one in algorithmic art. If we can get away with using a simpler easier approximation, that's fine. And sometimes taking a simpler approach is the difference between making a work possible and not.

Let's run the code a few more times to get a sense of the variety of landscapes our algorithm can create.

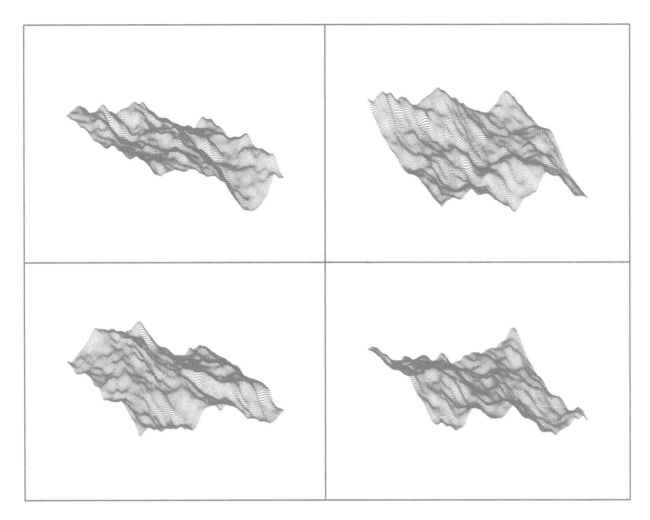

These landscapes are fascinating. They're different from each other, and yet each one is not so wild that it becomes unrealistic.

We've been lucky that without too much work we have code creating interesting landscapes. Let's now think about refining and enhancing this basic algorithm.

If we look critically back at those landscapes and try to see if there's anything that could be improved, we find that there's a uniformity to the lumps and bumps. That is, there are no bumps that are very small. Although we don't want the spikiness of purely random numbers that we saw before, it might be worth experimenting with a tiny pinch of extra **roughness**.

How do we make these landscapes **rougher**? We did try an experiment earlier to add pure randomness to a basic pattern of rings and that didn't work.

Our early experiments with noise do give us a clue about how to solve this puzzle. Remember how we had quite spiky noise when the noise parameter wasn't scaled right? Let's try a few different scalings to see this again.

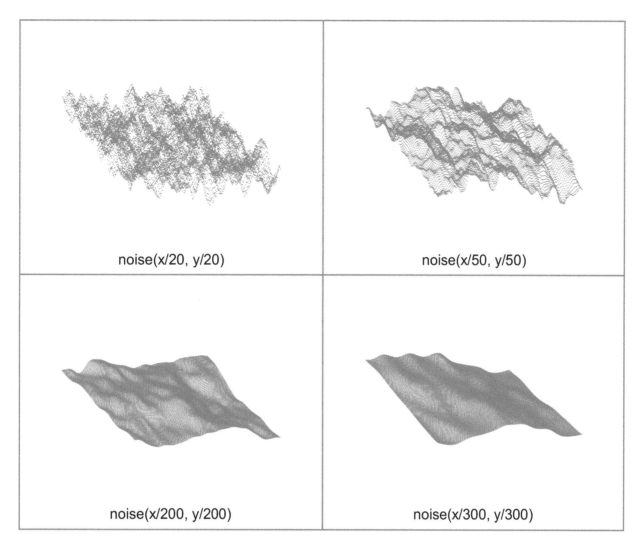

noise(x/20, y/20)

noise(x/50, y/50)

noise(x/200, y/200)

noise(x/300, y/300)

The top left landscape is very spiky. The parameters to **noise()** have only been divided by **20**. The top right shows a moderately rough landscape, and that happens when the noise parameters are divided by **50**. The bottom two landscapes are very smooth, and that's because the noise parameters are scaled down quite a lot, dividing by **200** and **300**.

It would be easy just to choose that top right image as being the answer to our puzzle. The landscape is certainly rough. But let's see if we can do better.

Have a look at the next picture showing two **sine** waves of different scales.

sin(x)

$\frac{1}{10}\sin(10x)$

The **red** wave is a simple **sin(x)**. The **blue** curve goes up and down faster because the parameter **x** is scaled up by **10**. Its peaks and troughs are smaller too, because the **sine** wave itself is divided by **10**.

We can think of the **red** wave as a smooth landscape with scaled down noise parameters. Similarly we can think of the **blue** wave as a very spiky landscape where the noise parameters are not scaled down.

What happens if we add these two waves?

$\sin(x) + \frac{1}{10}\sin(10x)$

The resulting wave has features of both the slowly changing and the rapidly changing curves. From a distance we can see the large smooth hills and valleys, and looking more closely we can see more localised roughness.

It would be good if we could do that with our landscapes, giving them larger, more slowly changing hills and valleys, but with smaller roughness detail too.

We can combine the two kinds of noise just like we combined two kinds of sine waves. We just add the values from the two different **noise()** functions.

```
var altitude = 200 * noise(x/200, y/200);
altitude += 30 * noise(x/30, y/30);
```

You can see we first set **altitude** to a value from a slowly changing noise function, **noise(x/200, y/200)**. We then add to it a value from a faster changing noise function, **noise(x/30, y/30)**, and the value is scaled up by **30** not **200** to ensure it doesn't overwhelm the main shape of the landscape. This is just like the smaller faster sine wave adding to the larger slower sine wave.

Let's see how well it works. Here's landscape without the additional fast changing noise.

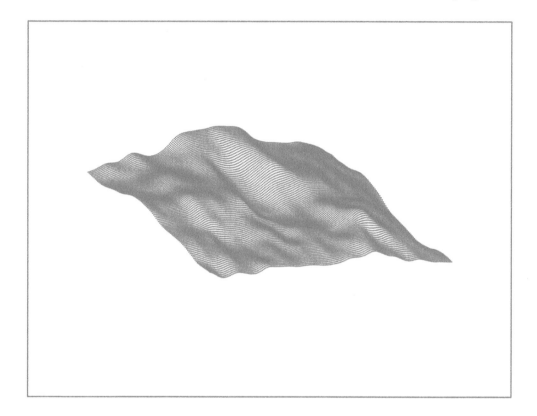

And here's the very same landscape with the additional fast changing noise.

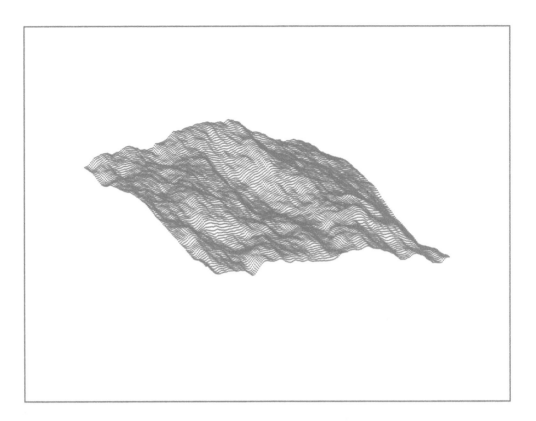

That definitely works, and it works well. Our landscape benefits from both larger slowly changing structure as well as smaller detail giving it a nice roughness.

Let's improve the rendering even more. Some of those dots are very closely packed leading to a loss of visible detail. As usual, we can make the dots translucent with **fill(255, 0, 0, 50)**. Let's also add even more dots to the surface so we can bring out even more detail. We can do this by incrementing the **x** and **y** loop counters by **1**, instead of the **2** we've been using.

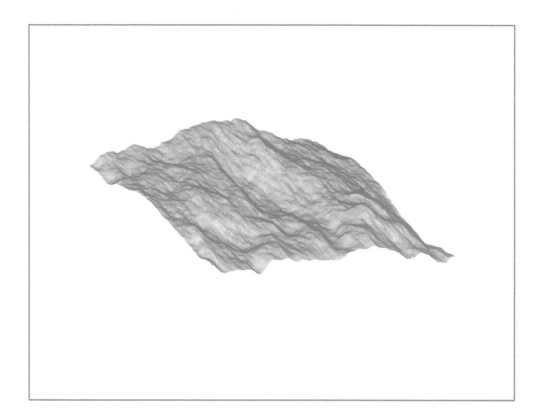

That image now looks much more realistic. It's almost an alien landscape reconstructed after being scanned using some kind of laser or radar.

Let's look at some more to get a feel for the variety our algorithm creates. And also because creating such fascinating, almost haunting, landscapes is rather addictive!

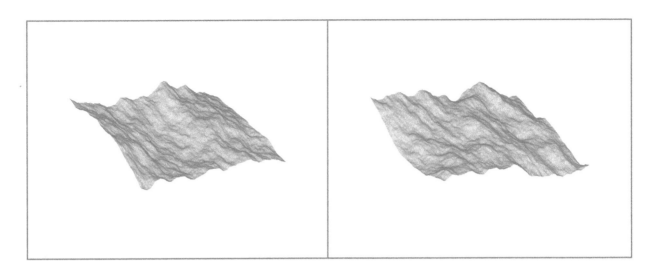

The code for this landscape is online at https://www.openprocessing.org/sketch/504970.

You should experiment with other combinations of noise. Try different scales for the noise parameters, and different scales for the noise values too. Why not try combining more than two noise functions?

We can also try experimenting with colour. Let's set the background to a nice grey, and change to the HSB colour model because it allows us to work with colour hues more directly. We can use colour to represent the different terrain heights. One easy way to do this is to map the **altitude** value to a hue using the familiar **map()** function.

The relevant code is:

```
// altitude to colour
var hue = map(altitude, 0, 230, 0, 360);
fill(hue, 100, 100, 0.3);

ellipse(x + shift, y - altitude, 2);
```

You can see we're mapping **altitude**, which can vary between **0** and **230**, to the range **0** to **360**, which is the full hue range. The reason **altitude** has an upper limit of **230** is from the addition of two separate noise functions, one scaled to **200** and the other to **30**. We've kept the saturation and brightness full for now, and set a translucency of **0.3** from its default range **0** to **1**.

Let's see the result.

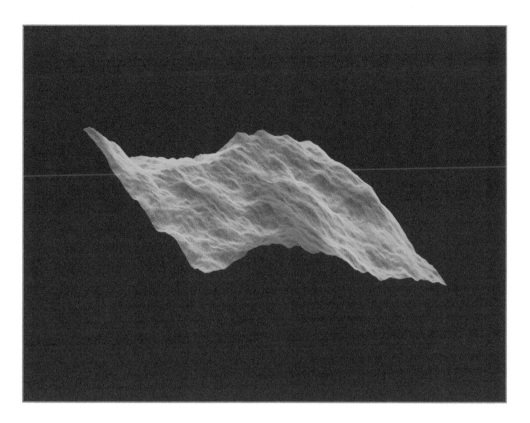

What a difference colour makes! The colours do give the impression of green vegetation and blue water. The only problem here is that the blue hue marks higher altitudes, and the green hue marks the lower altitudes. We normally expect that to be the other way around because valleys have water and hills have vegetation. This is easy to fix by mapping the **altitude** to the range **360** backwards down to **0**. This effectively swaps the colours around.

```
// altitude to colour
var hue = map(altitude, 0, 230, 0, 360);
```

And here's the result.

That's much more natural looking, but we were aiming for an alien landscape, not a landscape that looks like our very own planet Earth. The earlier images with only one colour looked much more alien. Let's try restricting the hue range to a smaller segment of the colour wheel, **270** and **360** for example.

```
// altitude to colour
var hue = map(altitude, 0, 230, 270, 360);
```

Let's see what effect this has.

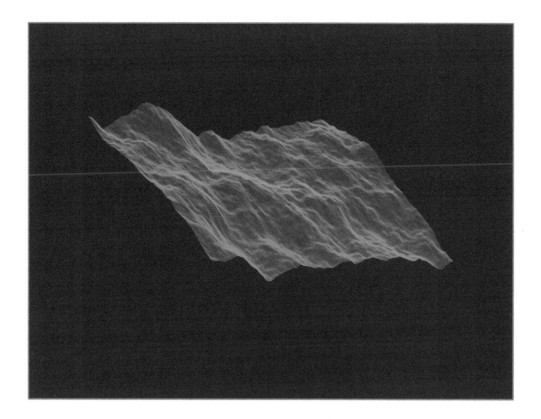

That is looking like a spooky alien terrain again. I like that fact that at first glance the image looks smoothly rendered, almost like an image from a scanning electron microscope, but on closer inspection we see lines and contours of the dots that make up the image. We could remove these by further reducing the step size, but I think they add to the image, by giving it a low-tech sci-fi feel.

The code for this alien terrain is online at https://www.openprocessing.org/sketch/506410.

Try experimenting with different hue ranges yourself. You might even try mapping the altitude to the brightness so the valleys are darker.

The final image for this worked example uses a **black** background, and reverses the hue range by mapping the **altitude** to the range **360** backwards down to **270**. This gives the valleys a warmer glow.

Here's the full code.

```
function setup() {
  createCanvas(800, 600);
  background(0);
  noLoop();
  colorMode(HSB);
```

```
}

function draw() {
  noStroke();

  // shift for each layer
  var shift = 0;

  // layers downwards
  for (var y = 300; y <= 500; y += 1) {

    // peaks across
    for (var x = 100; x <= 500; x += 1) {
      var altitude = 200 * noise(x/200, y/200);
      altitude += 30 * noise(x/30, y/30);

      // altitude to colour
      var hue = map(altitude, 0, 230, 360, 270);
      fill(hue, 100, 100, 0.3);

      ellipse(x + shift, y - altitude, 2);
    }

    shift += 1;
  }

}
```

The code is also online at https://www.openprocessing.org/sketch/505649.

As we explore the rough terrain of this beautiful, haunting, alien terrain, wondering who, or what, else has also looked upon it, a final thought lingers - this world was entirely crafted by mathematics.

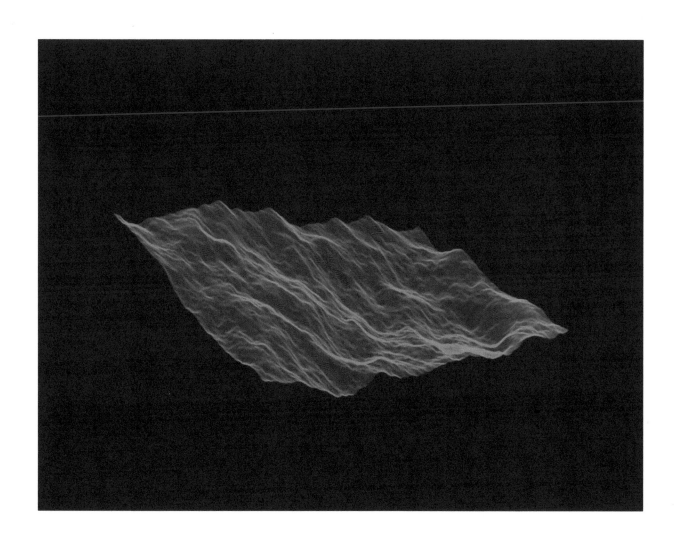

Alien Terrain

Part 6 - Even More Algorithmic Adventures

In Part 6, inspired by nature's own processes for creating new life,
we'll explore algorithms that make algorithms.

Algorithms That Make Algorithms

Everything that we've explored so far in this book has been about us, the human artist, developing algorithms, the mathematical recipes that create interesting visual forms.

Through the use of randomness, we allowed our computers to make some decisions about the locations of shapes and the selection of colours. Ceding some creative control to our computers was interesting for those of us who like to ponder on the philosophy of art.

In the coming pages we're going to go even further, and teach our computers how to make their own algorithms for making art.

That's quite a dramatic step.

Turtle Code

Getting our computers to write their own code seems like a monumentally difficult thing to do. Surely that would need our computers to become sentient beings with a frighteningly superior artificial intelligence?

Instead of trying to develop the next HAL 9000, let's start simple and take small steps to see if we can get good-enough results before things get too complicated. We saw earlier how a simplified approach to visualising three-dimensions worked surprisingly well.

The first thing we need to think about is what kind of programming language our algorithms are going to write their own code in. What's the simplest and easiest one we can think of? As nice as Processing is, it's not the simplest language out there.

Why don't we invent our own simple programming language?

Instead of a canvas, imagine we laid down a large piece of white paper on the floor, and on it we sat a turtle with a pen touching the paper. Yes, a turtle! Now imagine that turtle could obey very simple instructions, like **go forward**, **turn left**, and **turn right**. You can imagine that we could get it to draw shapes and patterns just by using these simple commands.

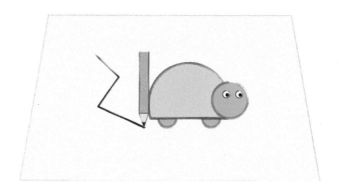

Let's write down a definition of our new programming language, which we'll call **Turtle Code**. It's a better name than Processing!

instruction	meaning
F	go forward
L	turn left 90 degrees
R	turn right 90 degrees

That's a very simple language, much simpler than Processing, and pretty much any other language you might think of. It only has three instructions, **F**, **L** and **R**. The **F** instruction means go forward, **L** means turn left by **90 degrees**, and **R** means turn right by **90 degrees**. Easy!

What would programs in this **Turtle Code** look like? Take a look at the following simple program.

The program couldn't be simpler, it's just one instruction, **F**. We know that means "go forward". You can see the turtle has moved forward from its starting position, leaving a straight line.

Let's look at another turtle code program.

This program is a teeny weeny bit more complex - it has three instructions! The program is **FRF**, which we interpret from left to right. **F** means go forward, **R** means turn right and the final **F** means go forward again. You can see the turtle has done just that. By going forward, turning right and going forward again, it has left a step shaped pattern.

Let's look at one more.

This turtle code program looks much longer than the last one. It does look a little scary, but let's not be discouraged because the instructions are all familiar - and there are only three possible instructions after all. If we follow each of those individual instructions, working from left to right, we can see the turtle marks out a square. It's worth pointing out that the turtle ends up at the same spot it started from but facing left, not upwards. If we wanted it to face upwards, like it did at the very start, we'd have to add an extra **R** onto the end of the turtle code.

You can imagine how this simple **Turtle Code** programming language, with its **3** instructions, could create quite sophisticated patterns.

So we've invented our own programming language, and that's a pretty impressive achievement by itself. Creating new programming languages is considered to be something extremely difficult and only done by elite hackers. We're not going to be put off by that notion!

What next? We need to think about how to get or computer to understand this new language and carry out those instructions.

The trick to making this apparently difficult task easy is to get Processing to do all the work for us. Processing can draw lines, so we can use it to draw the turtle's marks when it moves forward. We've used Processing to store and change angles, so we can use it to keep track of the direction the turtle is facing. And those turtle code instructions can be letters we keep in a **list**. We've used lists before, and you may remember they are just like normal variables, except they're created by enclosing a list of things inside square brackets **[]**.

Here's how we might store the **FRF** turtle code inside a Processing list.

```
// turtle code
var code = ['F', 'R', 'F'];
```

We've created a new variable called **code**. Typically we'd store a number in that variable, like **var code = 3.14**, but this time we're creating a **list** with the square brackets. Inside the brackets there are three things, 'F', 'R' and 'F' separated by commas. Those are just letters, but we know they have meaning in our **Turtle Code** language. The quote marks around the letters tell Processing to treat them literally as text and not a variable name.

That might look simple, but being able to store turtle code programs is a powerful first step towards getting Processing to understand and run them.

We now need to work out how to get Processing to interpret these instructions and act on them. How do we do that? When we're faced with a difficult computing problem it's always useful to think how we humans would solve it. We'd look at the list and work through each item, one by one, acting on each instruction as we go. That sounds like a **loop**.

We could use for a **for loop** again to visit each item in the list, and run some code for each one. Because we don't really need the loop counter, there is a simpler loop we can use. The **p5js** version of Processing has a special kind of loop that works through a list. Here's an example.

```
// visit each item of mylist
for (var item of my_list) {
  // do something with item
}
```

This looks similar to the **for loops** we've been using already, but it is simpler. Processing visits every item in that **my_list** and names it **item**. Inside the curly brackets **{ }** we can write instructions to do anything, but it's useful to do something with **item**. The loop ends after the last item in the list has been visited and the code inside **{ }** run one last time. With this kind of loop, there's no need to worry about start values for a loop counter, continuation conditions, incrementing the counter, or even working out the length of the list.

To work through each turtle code instruction in our program we need something like this.

```
// visit each instruction
for (var instruction of code) {
  // do something with instruction
}
```

We're making great progress. We can now work through a turtle code program, looking at each instruction one by one. That's not bad for such simple looking code!

We're almost there. The only thing that's left is to actually interpret each instruction and act on it. That means we need to check what the current instruction actually is. We've used **if()** to do this kind of test before.

```
// test if instruction is F
if (instruction == 'F') {
   // do something
}
```

Only if the **instruction** variable contains an '**F**' then any code inside the curly brackets **{ }** is run. You can see that if we had a series of these **if()** tests we could interpret each turtle code instruction. Something like the following.

```
// interpret instruction
if (instruction == 'F') {
   // go forward
}

if (instruction == 'L') {
   // turn left
}

if (instruction == 'R') {
   // turn right
}
```

All that's left is to fill in the details of how we actually move forward, turn left and right. We need to keep track of the imaginary turtle, so we'll need to create variables to keep track of its position and direction. We'll also need to update these after the turtle code instructions have been interpreted and carried out.

Let's look at an almost complete program.

```
function setup() {
  createCanvas(800, 600);
  background('white');
  angleMode(DEGREES);
  noLoop();
}

function draw() {
  // step size, initial position, direction
  var step_size = 100;
  var turtle_x = 400;
```

```
    var turtle_y = 300;
    var turtle_angle = 0;

    // stroke colour
    stroke(255, 0, 0);
    strokeWeight(4);

    // turtle code
    var code = ['F', 'R', 'F'];

    // visit each instruction
    for (var instruction of code) {

      // interpret instruction
      if (instruction == 'F') {
        // go forward
        var new_x = turtle_x - (step_size * sin(turtle_angle));
        var new_y = turtle_y - (step_size * cos(turtle_angle));
        line(turtle_x, turtle_y, new_x, new_y);
        // update location
        turtle_x = new_x;
        turtle_y = new_y;
      }

      if (instruction == 'L') {
        // turn left
      }

      if (instruction == 'R') {
        // turn right
      }

    }

}
```

Although that looks like a lot, there's nothing in it that we haven't already seen before. At the start we set a turtle step size **step_size** to **100**. That's the length of each step when the turtle moves forward. The horizontal and vertical position of the turtle, **turtle_x** and **turtle_y**, is initially set to the middle of the canvas. We've set the direction the turtle is facing **turtle_angle** to be **0**, which we'll take to mean straight up. We also set the stroke colour to be **red**, and fairly thick with a stroke weight of **4**.

We then create a list, called **code**, containing our turtle code, which for now is **FRF**. After that we visit each instruction in this list, and test each one, just like we talked about above. We've only filled in the code for carrying out the **F** turtle instruction.

To go forward, we need to take into account the direction the turtle is facing. That means we calculate the new position using the **trigonometric** relations from earlier in this book. If you need a refresher, **Appendix A** is a gentle introduction with some examples too.

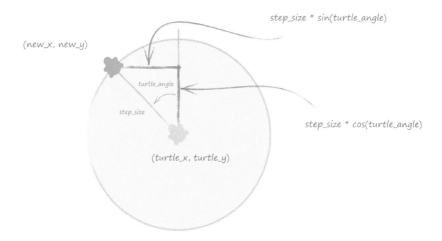

Once we've worked out the new location, which is **step_size** away from the current position, and at an angle **turtle_angle**, we draw a line to it. After that we need to update the current position with the new location.

Let's fill in the code to turn left and right. This is much simpler as we're not moving the turtle at all. All we're doing is changing the direction it's facing.

```
if (instruction == 'L') {
  // turn left
  turtle_angle += 90;
}

if (instruction == 'R') {
  // turn right
  turtle_angle -= 90;
}
```

That was almost too easy! Don't forget we set **angleMode()** to degrees in **setup()**. Let's see the results.

That worked! Even though that's not exactly an impressive pattern, what we've achieved is impressive. We've created a new Turtle Code language, and worked out how to get our computers to interpret and run a program written in that turtle code.

Take a well-deserved break. Italian gelato with an espresso is a good combination.

Let's make sure what we've built really works by trying a different turtle code program, **FRFRFRF**, which we know should draw a square. We don't need to change anything except the turtle code itself.

```
// turtle code
var code = ['F', 'R', 'F', 'R', 'F', 'R', 'F'];
```

That worked again.

Let's try another one just because it's fun. Let's take that turtle code **FRFRFRF** and change that middle **R** into an **L** to give **FRFLFRF**.

This pattern isn't that interesting. That shouldn't distract us from what is really very interesting - by making one tiny change to our turtle code from **FRFRFRF** to **FRFLFRF**, the resulting image is quite different. That's a theme we'll come back to and play with directly.

If we were going to add more instructions to our Turtle Code language, what would they be?

Why don't we add an instruction to remember where the turtle is, and another instruction to take us back to that place at a later point in our code. It's almost like marking a place in light pencil, continuing a drawing in ink, and then coming back to that pencil marked spot to continue from there. For brevity, let's use **[** and **]** as the symbols for these instructions. Let's update our language definition to include these two new instructions.

instruction	meaning
F	go forward
L	turn left 90 degrees
R	turn right 90 degrees
[remember current position and angle
]	go back to previous position and angle

Our language has grown to **5** instructions. It's still pretty small.

Let's see how these new **[** and **]** instructions work with an example, **F[RF]LF**.

Let's talk through it step by step. The first instruction **F** is the familiar go forward. Then we have the new instruction **[** which means make a note of the current position and angle so we can come back to it later. In the picture we've marked that position with a light red turtle. After that we have an **R** and an **F**, which is the familiar turn right and go forward. So far our turtle has created a step shape. The next instruction is **]** which means go back to the last location and angle we noted down. So the turtle jumps back to being where the light red turtle was, without making any marks on the way. After that we carry on as usual. The next **L** and **F** mean turn left and go forward.

The result is a T shape. The interesting part was remembering the point at the corner and jumping back to it. This ability to save our positions so that we can come back to them later should enable us to create quite intricate patterns more easily because we don't need to retrace our steps to get back to where we want to be.

Let's give this new capability to our turtle. What information do we need to make a note of, so that it can carry on later? We need to know where it was on the canvas. That's just its horizontal **turtle_x** and vertical **turtle_y** locations. We also need to know what direction it was facing, and that's just its **turtle_angle**.

Let's write some code.

```
if (instruction == '[') {
  // store current position and angle
  notebook.push(turtle_x);
  notebook.push(turtle_y);
  notebook.push(turtle_angle);
}
```

```
if (instruction == ']') {
  // retrieve previous position and angle
  turtle_angle = notebook.pop();
  turtle_y = notebook.pop();
  turtle_x = notebook.pop();
}
```

We're adding more **if()** tests for checking whether the instruction in the turtle code is **[** or **]**. If the instruction is **[** we add the turtle's horizontal and vertical positions, and the turtle's angle, to the end of a list which we're calling **notebook**, because we keep notes in a notebook. We must remember to create that list at the top of our code with **var notebook = []**. If the instruction is **]** we take the previously stored positions and angle off the end of the **notebook** list. The order is important. If the last thing we put in the **notebook** is the turtle's angle, it will be the first thing we remove.

To add information to the end of a list, we use the **push()** function. To remove information from the end of a list, we use **pop()**. Push and pop - makes sense!

Let's see if it works with turtle code **F[RF]LF**. We know the result should be the T shape we worked out earlier.

That worked perfectly.

As a nice bonus, the way we've created the ability to remember a position and go back to it later, we can actually use the **[** and **]** instructions nested within each other. Let's look at an example **F[RF[RF]LF]F**. Let's use a pen and paper to work out what this does.

First the turtle moves forward and immediately saves its position with the first **[** instruction. The turtle then turns right and moves forward again. So far we have a step shape. The next instruction is another **[** so we save that position too. This is not a problem because we're just adding the turtle's position to the end of the **notebook** list, after the previously saved position. After that we turn right and go forward. The next **]** takes us back to the last saved position, from where we turn left and move forward. After that, we have another **]** which takes us back to the very first saved position, from which we move forward, leaving the turtle at the top left.

Let's see if it really works.

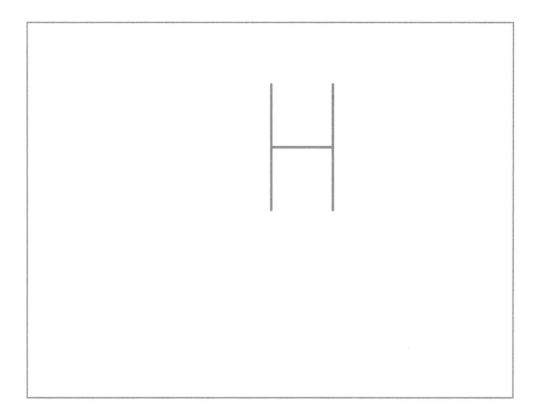

That too works.

The code we've written so far is online at https://www.openprocessing.org/sketch/508320.

Let's pause and think about what we've done, and what we have to do next. We've created our own programming language, **Turtle Code**, and we've found a way to get our computer to understand it and execute its instructions. That's an impressive feat. But we actually set out to get computers to write their own code. We still want to do that, and creating a simple language for a computer to work with is a necessary first step.

What We've Learned

The idea of our computer writing its own code to create images is both ambitious and an interesting philosophical leap. To achieve this we did some preparatory work, including creating our own simple programming language.

Key Points

- If we want our computer to write its own code, it makes sense to invent a simple programming language for it to work with. Processing isn't the simplest language we can think of.

- We developed our own very simple **Turtle Code** programming language. It has only five instructions: **F**, **R**, **L**, **[** and **]**, which mean **go forward**, **turn right**, **turn left**, **remember this position**, and **go back to previously remembered position**.

- We used Processing itself to store, interpret and carry out turtle code instructions. A Processing **list** was used to store the turtle code instructions. An **if()** test was used to determine what the current instruction was, and Processing itself was used to carry out that instruction, drawing a line for example.

- The **state** of the turtle, such as its location and angle, was kept in Processing variables. These were updated as needed when interpreting and carrying out the **Turtle Code** instructions. For example, the instruction **R** changes the turtle's angle but not its location.

- The **[** and **]** are instructions which save and restore **state**. These convenience instructions make it possible to draw more interesting patterns with much simpler turtle code, by avoiding having to write code to make the turtle go back to a previous state by retracing all its steps.

Growing Turtle Code

Having created the Turtle Code language, we're now going to look at how a computer could create its own turtle code ... by growing it.

What do we mean by grow? Well, about 50 years ago, Aristid Lindenmayer, a plant biologist, was studying how fungi, algae and bacteria grow. He developed an idea that cells divide and became new cells according to simple rules. Here's a picture illustrating the idea.

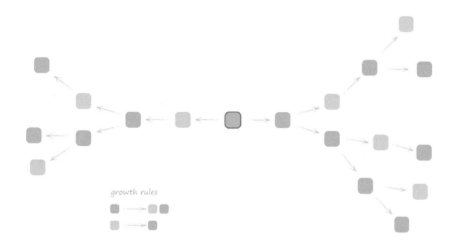

growth rules

We can see two kinds of cell. We can call them **red** ones and **green** ones to keep things simple. The simple rules for growth are:

- the **red** cells grow and split into a **green** and another **red** cell
- but a **green** cell only grows into a single **red** one.

Starting from a single **red** one, we can see how the population grows. You can imagine that if the **red** and **green** ones had different shapes, or connected differently, they'd create an interesting pattern. In fact, that was the point. Lindenmayer managed to describe quite complex patterns using only simple rules that govern their growth.

Let's try this growth idea with our turtle code instructions. Each instruction will grow into another according to simple rules.

Have a look at the following.

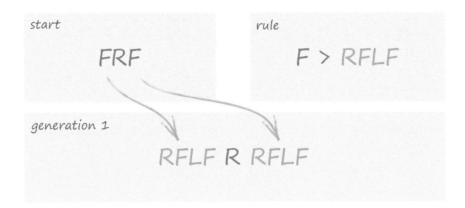

start
FRF

rule
F > RFLF

generation 1
RFLF R RFLF

The picture shows the starting turtle code **FRF**. We know this means go forward, turn right, go forward, and creates a simple step pattern. The picture also shows a rule for growing the code. That rule says that the instruction **F** grows into **RFLF** for the next **generation**. So whenever there is an **F** in the code, it gets turned into **RFLF**. And if there are many **F** instructions in the code, they all get turned into **RFLF**.

The picture also shows the result of that growth. The next generation of code is the bigger **RFLFRRFLF**. That word, **generation**, is deliberate, because we can think of the new code as being the offspring of the parent code.

What pattern does this new code create? Let's use a pen and paper to work it out.

RFLFRRFLF

The turtle moves right, turns left to go up, turns around to face down again, comes back down over the same line, and then turns to its left to continue to our right.

The result isn't that exciting. Let's grow the code again to the second generation. The working out is shown using colours to make it easier to follow. The idea is exactly the same, there is nothing new happening here.

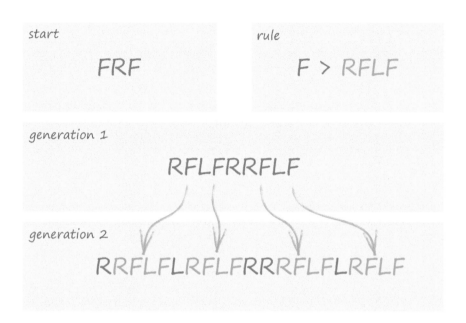

By growing every **F** into **RFLF**, the first generation code **RFLFRRFLF** becomes the second generation code **RRFLFLRFLFRRRFLFLRFLF**. That's quite long!

Let's see what it makes.

- 489 -

That's starting to look interesting. Following the code by hand is laborious and error prone, especially if we want to explore more interesting turtle code and use more than one growth rule. Luckily we have our computer to do all the hard work for us.

Let's think how we can code the growth of code, building on the code we've already written. Logically we have two steps. The first one is to grow the turtle code, for however many generations we need. The second step is to use the resulting turtle code to draw a pattern. We've done the work for this second step already, interpreting and acting on the turtle code.

For the first step, we've already worked out how to do it by hand, and that's a good basis to start coding. We start with the code from the first generation and look at each instruction, working from left to right, to see if the growth rules apply, and if they do, we replace the instruction with the new code. If no rule applies to the instruction, we just pass it onto the next generation without any change.

Have a look at the following code.

```
// empty list of next generation code
var next_gen_code = [];

// visit each instruction
for (var instruction of code) {

    // apply growth rule to F
    if (instruction == 'F') {
        next_gen_code.push('R','F', 'L', 'F');
    } else {
        // no match so let it pass unchanged
        next_gen_code.push(instruction);
    }

}

// replace code with next_gen_code
code = next_gen_code;
```

It looks like the same kind of loop we had before, where we visit each **instruction** in the **code** list. That is exactly what we're doing. Inside the loop we have the same kind of **if()** test to see if the instruction is an **F**. This time however, instead of moving the turtle forward, we're applying the growth rule for **F**. You can see that outside the loop we created an empty list for the next generation code **next_gen_code**. Inside the test for **F**, we push a series of new instructions onto this **next_gen_code**, those instruction being what **F** grows into, **RFLF**. If no rule is matched, we simply push **instruction** to **next_gen_code** without changing it. Finally, after all

the instructions in the original code list have been visited, and **next_gen_code** has been built, we overwrite **code** with the new generation code.

In this way, we've applied the growth rule for **F** to all the instructions in code. Let's see if it works.

That is indeed the pattern we saw when we grew the next generation of turtle code from **FRF** using the rule **F > RFLF**. It's nice when things work!

How do we continue growing the code for more than one generation? We simply repeat the application of the rules with a loop. The next snippet of code shows the idea.

```
// total number of generations
var generations = 2;

// loop over generations
for (var gen = 1; gen <= generations; gen += 1) {
    // ...
}
```

We simply wrap the existing code that makes the next generation with a **for loop** to repeat the application of the growth rules for as many generations as we want.

Let's see if it works, with **generations** set to **2**.

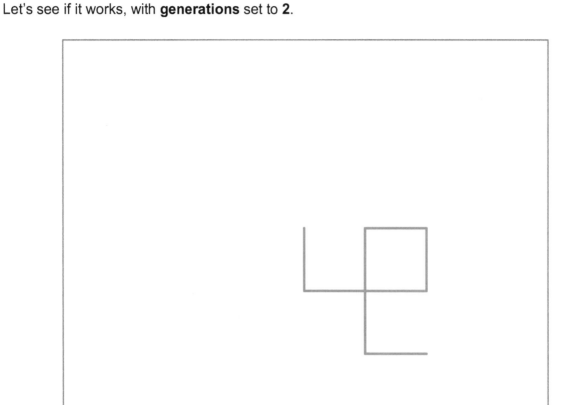

It does work! Let's go crazy and try setting **generations** to **5**. The fifth generation code should be fairly large because it grows with every application of the growth rule.

In fact, the fifth generation code is
RRRRRFLFLRFLFLRRFLFLRFLFLRRFLFLRFLFLRRFLFLRFLFLRRRRFLFLRFLFLRRFL FLRFLFLRRRFLFLRFLFLRRFLFLRFLFRRRRRRFLFLRFLFLRRFLFLRFLFLRRRFLFLRFL FLRRFLFLRFLFLRRRRFLFLRFLFLRRFLFLRFLFLRRRFLFLRFLFLRRFLFLRFLF. That's not a small bit of code!

Let's see what it makes.

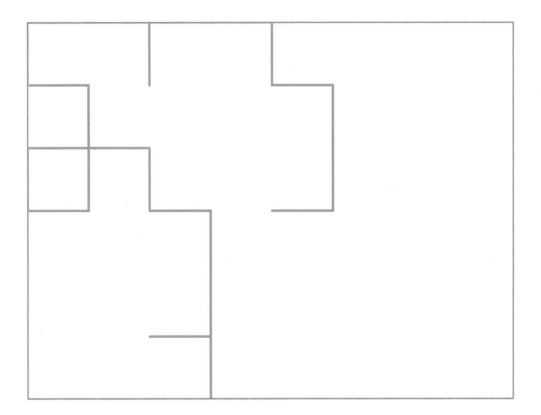

It looks like the turtle flew off the canvas.

As the number of generations grows, and the turtle code grows vastly larger, it becomes harder to predict what the right **step_size** should be so that the whole pattern fits in the canvas. We'll have to experiment to find a good **step_size** for each pattern. We might also have to experiment with different starting positions for the turtle **(turtle_x, turtle_y)** to try to get the pattern centred better.

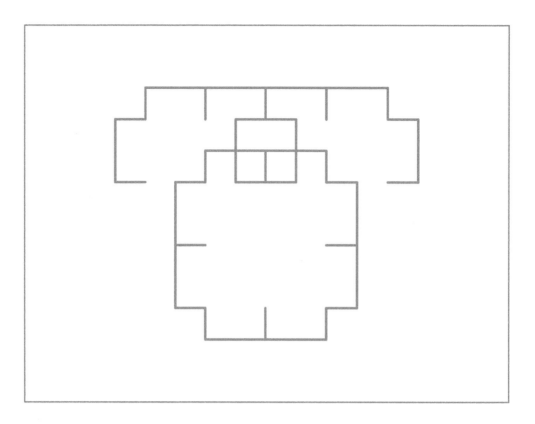

That's the same pattern but with a **step_size** of **50**, and a starting position of **(600, 250)**. The whole pattern now fits into the canvas.

Let's try **generations** set to **16**. The size of the sixteenth generation code will be massive. In fact it has **393,213** instructions. That's more than a third of a million instructions. Bonkers!

Before we draw this monster, let's set the stroke translucency to **100** to avoid oversaturation from lines crossing each other and also set the stroke weight to **1**.

Let's see what kind of pattern those **393,213** turtle code instructions create!

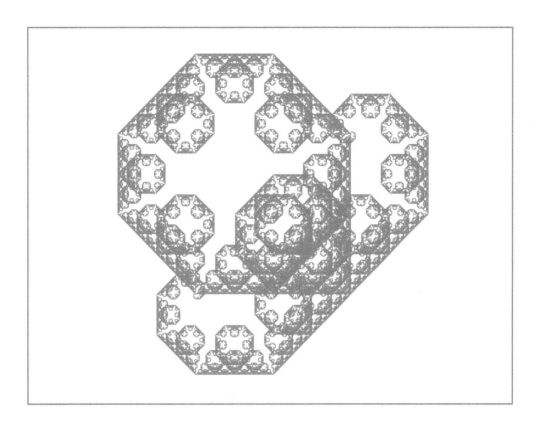

There is certainly a lot of detail in that pattern, with lots of self-similarity too.

Let's see the detail more closely. We can do this by increasing the **step_size**.

That's a really nice pattern, evoking something between electronic circuits and a level design for a 1980s video game. It's a good starting point for a proper art project.

And all that from a basic starting turtle code program **FRF**, and a very simple growth rule of **F > RFLF**.

The code for growing turtle code is online at https://www.openprocessing.org/sketch/509905.

Before you go off and try your own turtle code and growth rules, a really effective thing to tweak is the angle by which the turtle turns when it is told to turn left or right. Right now it turns a full **90 degrees**. We can change that easily.

```
if (instruction == 'L') {
// turn left
  turtle_angle += 30;
}

if (instruction == 'R') {
// turn right
  turtle_angle -= 30;
}
```

Here we've simply modified the amount by which **turtle_angle** changes, from **90 degrees** to **30 degrees**. Let's try it with a starting turtle code program **F[LF]F[RF]**. We're using the **[]** instructions we built earlier to save and recall the turtle's position.

As our turtle code gets longer, it gets more laborious to type out with quotes and commas separating each instruction. Luckily the **p5js** version of Processing has a nice shortcut.

Here's the long way of typing out the turtle code.

```
// turtle code
var code = ['F', '[', 'L', 'F', ']', 'F', '[', 'R', 'F', ']'];
```

We can use a special instruction **...** (three dots) which expands out a string of text into individual letters.

```
// turtle code
var code = [...'F[LF]F[RF]'];
```

That's much more concise, and far kinder to our typing fingers!

Let's see what the basic turtle code **F[LF]F[RF]** does.

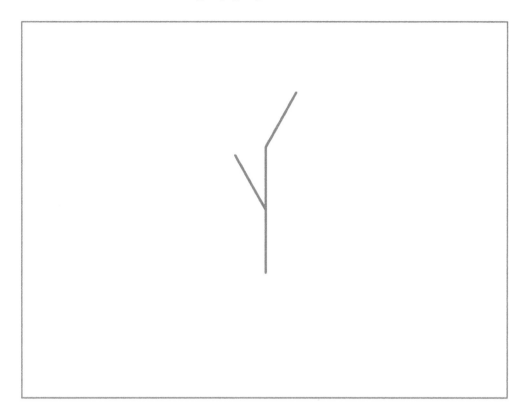

It's easy to check this is right with a pen and paper. The key thing here is the smaller angle of **30 degrees** when the turtle turns left or right.

Let's apply the growth rule **F > F[RF]F[LF]**. That looks exactly like the starting code, except the **L** and **R** instructions are swapped.

```
// apply growth rule to F
if (instruction == 'F') {
    next_gen_code.push(...'F[RF]F[LF]');
```

Here's what the first generation of the turtle code creates.

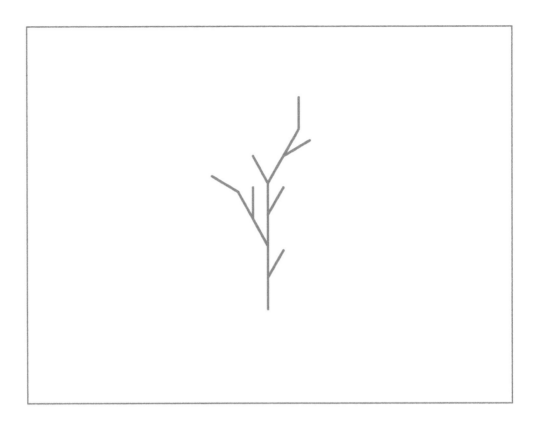

That's interesting. It's starting to look like a tree.

Let's continue until the fifth generation.

Behold! That's a really rather elegant plant form.

This is a much more organic pattern that the turtle code has created, very different from the very square and regular patterns we saw before. Exploring this tree a bit longer, we can see it really does look very natural, with more variation than the relatively simpler recursive trees we created earlier in the book.

The code for this plant is online at https://www.openprocessing.org/sketch/510583.

Natural looking plant forms like this validate Lindenmayer's revolutionary idea that we could capture many of nature's complex, often beautiful, plant forms in simple growth rules. In fact, the system of having a language, growth rules for that language, and a way of turning that language into something visual, is called a **Lindenmayer System**, or **L-System**.

You should experiment with your own turtle code and growth rules. You can try different angles for turning the turtle. You can even try having more than one growth rule. Additional growth rules can be added to the code as additional **if()** tests for the instruction being grown, and applied one after another.

Here are some of the interesting forms I've found.

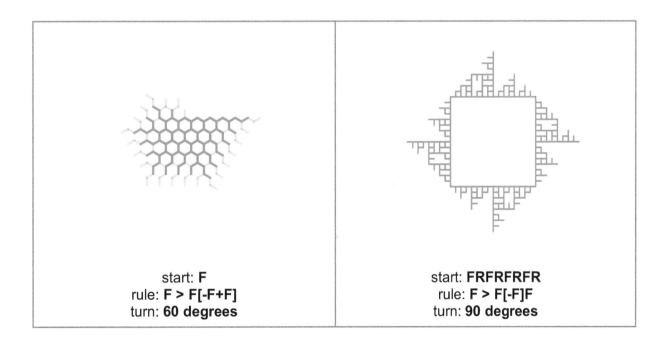

start: **F**
rule: **F > F[-F+F]**
turn: **60 degrees**

start: **FRFRFRFR**
rule: **F > F[-F]F**
turn: **90 degrees**

start: **FLLFLLF**
rule: **F > F[-F]F**
turn: **60 degrees**

start: **F**
rule: **F > RFRFLF**
turn: **120 degrees**

There's a wide range of patterns from the geometric to the more organic. I've tweaked the step size, starting position and angle for each of these to get a nice fit to the canvas.

That last one reminds me of the fractals we saw emerging from complex numbers. The code is online at https://www.openprocessing.org/sketch/510917.

There are a few tools to help you explore L-Systems. I find myself using this one quite a lot as it is both simple yet quite capable:

- L-System Sandbox: https://draemm.li/various/fractals/l-systems/

What We've Learned

We've built on our previous work developing **Turtle Code** to getting our computer to write its own turtle code.

Key Points

- Having created **Turtle Code**, and the ability for our computer to interpret and carry out turtle code instructions, there are many options for automatically writing turtle code, for example, picking random turtle code instructions at random.

- A more interesting idea is to **grow** the code, from one generation to the next, in a manner inspired by the growth of plant and animal cells. Simple rules can determine what an instruction grows into for the next generation. Such a system is called a **Lindenmayer System**, or **L-system**, after the theoretical biologist who aimed to describe complex patterns with such simple rules.

- L-systems have a starting program. This code is then grown into the next generation program by applying one or more rules to each instruction. For example the rule **F > RF** turns the single instruction **F** into two instructions **R** and **F**. The size of the code can grow rapidly with each generation.

- We found that even tiny turtle code grown using very simple rules can result in surprisingly sophisticated patterns, many of which will be self-similar **fractals** that look like patterns found in nature.

Worked Example: Fractured Reality

In this worked example we'll try to create a work that celebrates the nature in which it is created - a computer effectively writing its own algorithm for drawing patterns. That might mean emphasising the geometric nature of a pattern, or the precise intricate detail that only a machine can create. Something that evokes the feeling you get when you see the immensely detailed electronics that power the magic and wonder of our modern digital lives.

So far, our turtle code allows our imaginary turtle to move forward, turn by a given angle, and remember a point so that it can go back to it later. In many guides and tools, that's all the capability the poor turtle gets.

Let's give our turtle a new superpower. Instead of just being able to draw lines, why not give it the power to draw circles?

Let's think about how we would do his. Everything that the turtle does is because there is a turtle code instruction telling it to so. That means we need a new turtle code instruction to draw a circle. Let's call it **C** for circle.

instruction	meaning
F	go forward
L	turn left 90 degrees
R	turn right 90 degrees
[remember current position and angle
]	go back to previous position and angle
C	draw a circle

Our **Turtle Code** language now has 6 instructions. It's getting bigger.

We now need to tell our turtle how to interpret that **C** instruction and actually draw a circle.

```
if (instruction == 'C') {
  // draw circle
  ellipse(turtle_x, turtle_y, 10);
}
```

The code is incredibly simple. We test the current **instruction** to see if it is **C**, and if it is, we draw a circle centred at the turtle's current location with a diameter of **10** pixels.

Expecting lots of circles to overwrite each other, or be sat very close to each other, let's use transparency again to avoid oversaturation.

```
// colours and stroke
fill(0, 0, 255, 20);
stroke(255, 0, 0, 20);
strokeWeight(1);
```

We've given the circles a fill colour of very translucent blue, and also made the red lines more translucent too so they don't dominate the circle fill colour.

Let's recreate one of our previous patterns but add an instruction for drawing a circle somewhere in the rules. Let's start with the plant form we saw earlier. That had the following rules:

- Starting turtle code: **F[LF]F[RF]**
- Growth rule: **F > F[RF]F[LF]**

Let's see what happens if we add a **C** instruction to the end of the growth rule, just inside the last **]** instruction. We're just experimenting at this stage, there's nothing guiding that choice, other than the intuition that it might be interesting to leave a circle before returning to a previously saved position.

- Starting turtle code: **F[LF]F[RF]**
- Growth rule: **F > F[RF]F[LFC]**

And the result.

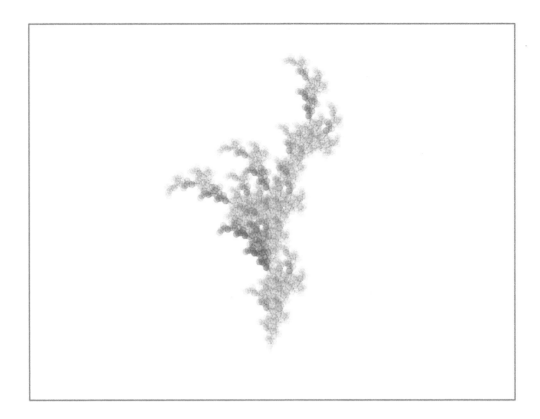

That's a very different look and feel to the image. The previous images were all about lines, but this one is very much dominated by coloured dots.

The use of transparency works really well. It adds variety with some areas less densely populated than others. And that gives in an insight into how the drawing actually happened. Let's not forget this idea because that's what we want our final piece to do.

The code for this tree is online at https://www.openprocessing.org/sketch/513537.

Let's see what would have happened if our circles didn't have any transparency.

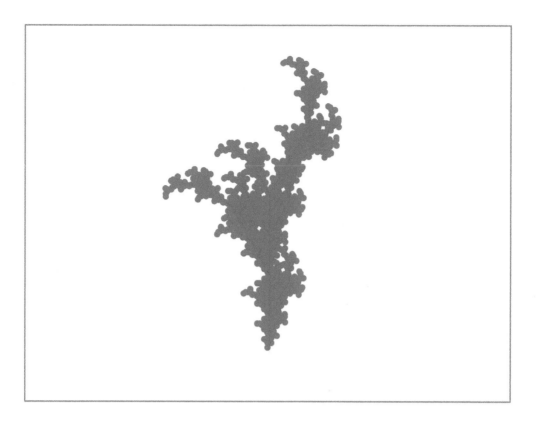

Yikes! To be fair, it is a bit interesting, reminding me of the claw-shaped fractals we came across earlier.

Every time we add a new capability to our **Turtle Code** language, it enables a huge number of new possibilities because of the many new combinations it can be used in. Try revisiting some of your earlier patterns and add some **C** instructions into the rules.

Here's a simple but powerful example of enhancing the beehive hexagonal pattern we saw earlier, just by adding a single **C** to the growth rule. The starting turtle code was simply **F**, and the growth rule was **F > F[LF][RF]** with the angle of turn being **60 degrees**. The new growth rule is now **F > F[LF][RFC]**.

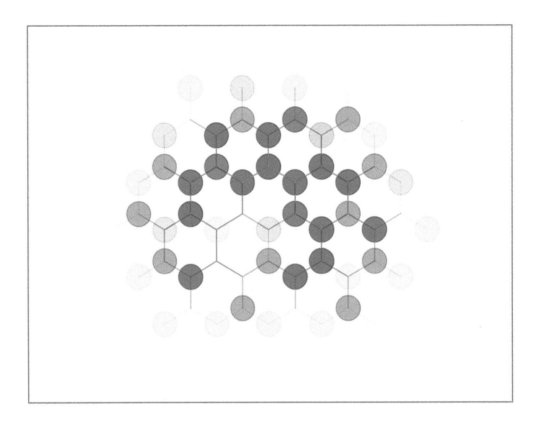

That's a strong composition. It is definitely based on the hexagonal beehive grid, but on top of that there is another story being told by the more deeply coloured dots and paths between them. The overall symmetry gives the composition a self-assured balance.

If we were to add just one more capability to our **Turtle Language**, what would it be? For me, the obvious thing our turtle is missing is the ability to pick a colour for the things it draws.

Let's call our new instruction **H** for changing the hue.

instruction	meaning
F	go forward
L	turn left 90 degrees
R	turn right 90 degrees
[remember current position and angle
]	go back to previous position and angle
C	draw a circle
H	change hue

Every time our turtle is given a **H** instruction it'll change the colour it's using. For now let's just try changing the fill colour of the circles, and leave the stroke colour of the lines as it is.

Let's switch to the HSB model because it's easier to work with colours. If we're changing the hue, we'll need a variable to keep track of it, just like we keep track of the turtle's angle. Let's call it **turtle_hue**.

```
// colours and stroke
var turtle_hue = 0;
stroke(0, 100, 100, 0.1);
fill(turtle_hue, 100, 100, 0.1);
```

We'll also need to change any existing code that uses RGB levels to HSB. Also remember the alpha values for setting translucency go from **0** to **1**, not from **0** to **255**.

For now, whenever a **H** instruction is carried out, let's just add **5 degrees** to the hue on the colour wheel.

```
if (instruction == 'H') {
  // change hue
  turtle_hue = (turtle_hue + 5) % 360;
  fill(hue, 100, 100, 0.1);
}
```

We're making sure that if adding **5 degrees** to the hue takes it over **360 degrees**, we wrap back around and start again from **0 degrees**.

Let's try this new super power! We can change the growth rule we used for the beehive pattern from **F > F[LF][RFC]** to **F > F[LF][HRFC]**.

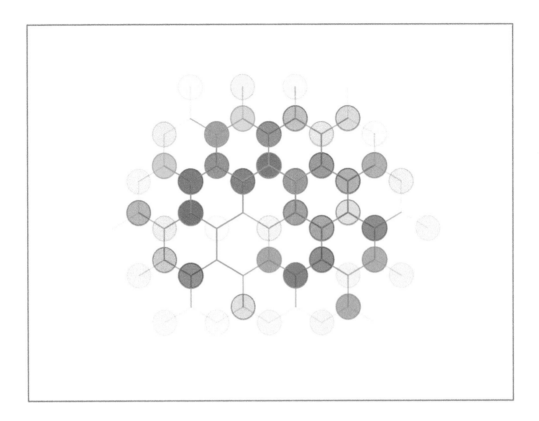

That seems to work, but I'm not sure this image is stronger than the previous one which only had different translucencies of the same hue. Introducing more colour into a composition takes much more work to get right. Let's not give up.

The code we've developed so far is online at https://www.openprocessing.org/sketch/513635.

Let's try these new circle and colour superpowers with the plant form we drew earlier. We'll add a single **H** command to the growth rule.

- Starting turtle code: **F[LF]F[RF]**
- Growth rule: **F > F[HRF]F[LFC]**

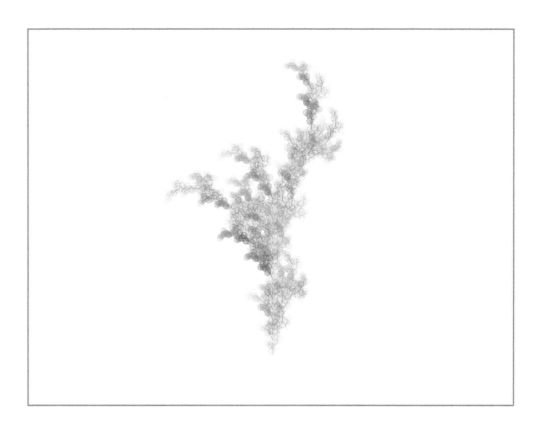

That's an interesting enough image. There are quite a few colours to explore. But again, after a while the colour doesn't seem to have any kind of logic or reason. It doesn't seem to be telling a story.

Faced with this problem, many artists would restrict their colour palette. Let's do that too.

Have a look at the following picture, showing a restricted part of the hue colour wheel.

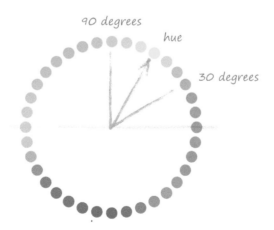

The picture shows the hue restricted to a segment of the wheel, between **30 degrees** and **90 degrees**. The turtle code **H** command increases the hue by **5 degrees**. If that hue goes past the

upper limit of **90 degrees**, we want to reduce it by **60 degrees** so that it continues from **30 degrees** again.

Let's think about how we make sure it stays in that range no matter how often a turtle code **H** instruction tries to increase it. We'll need a variable for the minimum hue, and another for the maximum hue. And every time we increase the hue we can check to see if it has gone past the maximum, and if it has, we reduce it to go past the minimum again. That reduction is the difference between the maximum and minimum hues.

Another way of saying this is that if the hue overshoots the maximum hue by **3 degrees**, the hue will be reset to **3 degrees** past the minimum hue.

```
if (instruction == 'H') {
  // change hue, keep within min-max range
  turtle_hue += hue_step;
  if (turtle_hue > hue_max) {
    turtle_hue = turtle_hue - (hue_max - hue_min);
  }
  fill(turtle_hue, 100, 100, 0.2);
}
```

You can see the code does exactly what we just discussed. We can set the **hue_min** and **hue_max** variables at the top of our code. We've also taken the opportunity to generalise the amount by which a **H** instruction increases **turtle_hue**, by creating a variable **hue_step**.

The following is a plant created with **hue_min** at **100** and **hue_max** at **230**. The circle fill alpha value is set to **0.2**, up from the previous **0.1**.

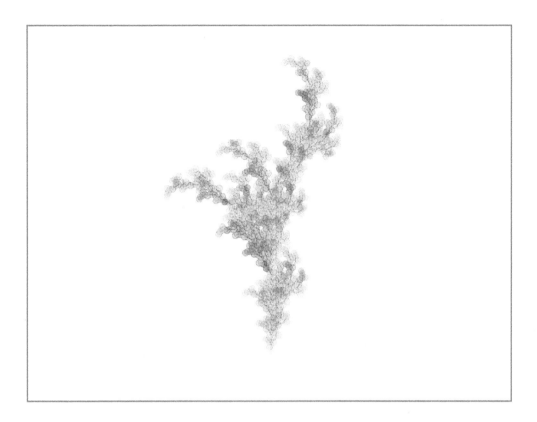

The location of the blue regions gives us a clue into how the overall plant was drawn. The variation between light and more saturated regions also gives us an insight into the development of the pattern. This is much better use of colour, and makes the image richer in its content and meaning.

Let's now think about our final image. Before we choose a colour palette and experiment with placing dots, we need a strong basic pattern. Any symbolism expressed by that structure will be infused throughout our image, so it's worth persevering to find the right one.

After lots of experimenting, I settled on the pattern created by these rules:

- Starting turtle code: **FRFRFRFR**
- Growth rule: **F > F[LF]F**
- Angle of turn: **120 degrees**

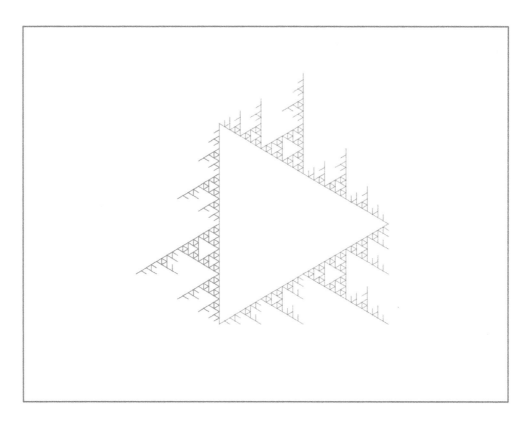

This structure has a strong simple geometric basis - a triangle, and emerging from that seem to be crystalline growths. The sharp needles give the shape a rather menacing feel.

If you look closely, the left hand side of the triangle is darker, because the lines have been traced out twice. I like that asymmetry.

Here's what the pattern looks like with colours and dots created by the growth rule **F > F[HLF]FC**.

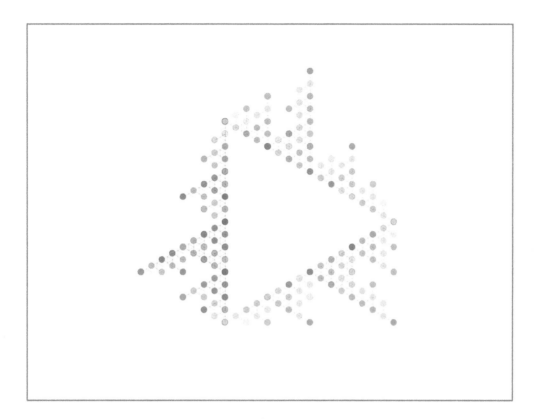

That's a nice effect. The dot colours lead the eye on small journeys, and a longer examination leads the eye around the skeletal lines connecting the dots. The overall effect is very geometric, reminding us that a computer grew the algorithm that drew the shape, with the soft colours taking the edge off the harsh geometry.

The code for this triangular pattern is online https://www.openprocessing.org/sketch/514261.

Looking critically at that image, it would be better if the pattern extended over the canvas, and even beyond, rather than having a shape entirely contained in the middle of the canvas.

This is a great opportunity to extend that shape with a new kind of rule that we haven't seen before. Have a look at the following:

- Starting turtle code: **FRFRFRFR**
- Growth rule 1: **F > F[LFx]F**
- Growth rule 2: **x > FxF**

What's going on here? We have two rules instead of one. That shouldn't be too problematic, we just apply the growth rules one after the other.

The first rule grows any occurence of **F** in the turtle code to **F[LFx]F** in the next generation of turtle code. The second rule grows any occurence of **x** into **FxF** in the next generation of code. Nothing unusual here.

What's new is the symbol **x**, which we've not seen before. In fact, we're not going to give it any special meaning. The symbol **x** won't instruct our turtle to draw a new shape or pick a new colour. It will do nothing.

The only role that **x** will have is to keep a place in the code for growth into **FxF** at a later generation of the code. If an **x** appears in the very next generation of code, it will have no effect on what the turtle draws. Only in the generation after that will it get turned into **FxF**, which does cause the turtle to draw some lines. In effect, the **x** is a turtle code time-bomb which explodes during later generations of the code.

Have a look at the following simplified example.

The starting turtle code **F** is grown into **Rx**, which becomes the first generation code. That **x** will have no effect on what the turtle does. It will lie dormant until the second generation when it grows into **LxF** which does cause the turtle to turn and draw a line. The new **x** will again lie dormant until the third generation of the code.

Let's see what pattern this new kind of rule creates.

That is much more interesting! I like how the very regular pattern is broken by dangerous looking spikes. It has the feel of a menacing alien architecture.

Let's try adding some coloured dots by changing the first growth rule to **F > F[HLFx]FC**.

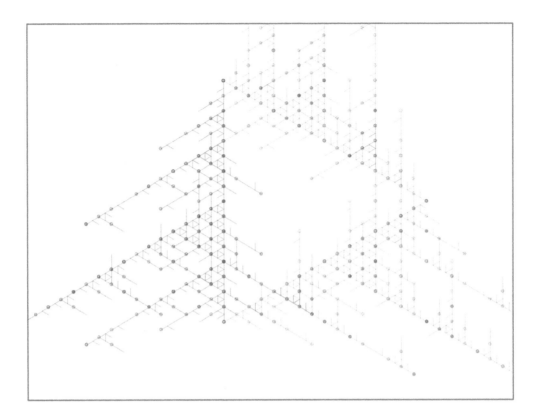

The elements are all there, but we need to find a different balance between the line weight, dot size, colour palette and the transparency of all of these bits.

The code for that experiment is online at https://www.openprocessing.org/sketch/514336.

The final image has the following settings:

- Starting turtle code: **FRFRFRFR**
- Growth rule 1: **F > F[HLFx]FC**
- Growth rule 2: **x > FxF**
- Angle of turn: **120 degrees**
- Circle outline stroke alpha **0.5**, but lower fill alpha **0.2**
- Normal lines drawn **red**, irrespective of **turtle_hue**
- Hue ranges between **180** and **330 degrees**

The code for the final composition is online at https://www.openprocessing.org/sketch/514823.

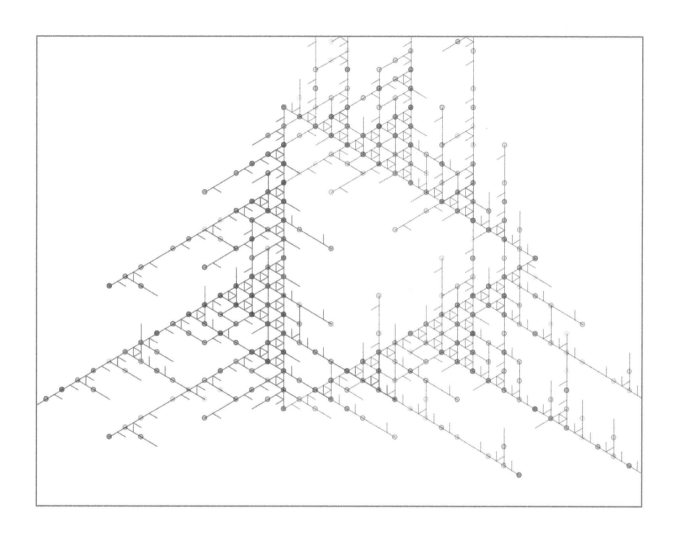

Fractured Reality

Epilogue - Algorithms As Art

Having worked through this book, we've achieved three important things.

Coding

We learned how to talk to our computer in a language it can understand. Even though we started from scratch, *ab initio* as some linguists say, we picked up enough of the language that it would not be a barrier to any of our ideas or creativity. We practised enough of the key idioms to now be considered quite competent.

By learning that language, Processing, we're in good company, because it is the language of choice for many students, artists and designers all over the world. Even better, we learned a specific form, called **p5js**, which works in any web browser, enabling our creations to be appreciated by anyone on the internet, from anywhere in the world.

Algorithms

We also saw how mathematical ideas could be manifested visually. The results were often powerful, and sometimes, surprising. We saw how simple mathematics could produce intricate, hauntingly beautiful and infinitely detailed patterns. We learned how common mathematical functions could become useful techniques in our creative toolbox, techniques we can call on with ease and confidence when the design process calls for them.

Importantly, we learned to appreciate the clever or innovative use of mathematics for creative effect. We came to appreciate the power and beauty of simple algorithms creating sophisticated images.

Process

By following the experiments and projects in this book, we saw and experienced the creative process for algorithmic art. We saw how we might be inspired, perhaps by nature itself, or the emotions evoked by science fiction. We saw how we might think aloud with a pen and paper before committing ideas to code. We saw the inevitable experimentation, learning from failure, iterative refinement and even just trying out a crazy idea without needing a good reason to. We saw the, often unseen, work hidden behind every successful work of art.

These are not small achievements. Well done!

Algorithms As Art

Because it was us, the artist, that imagined, designed and crafted those algorithms, they are not only an integral part of the art, they are the centre of it.

One cannot appreciate
Algorithmic Art ...
... If one cannot appreciate
the Algorithm

We can't fully appreciate algorithmic art unless we can appreciate the algorithm too. That's why we must share not just the result, but the method too.

Appendix A: More Loop Examples

Earlier in this book we explored how to instruct our computers to repeat tasks, a powerful technique for both arranging visual elements, as well as doing calculations.

We discovered **loops**, the instructions for repeating tasks. These loops can be a little tricky to understand or write when we're still becoming familiar with them.

In this appendix we'll build on the earlier introduction by looking at more examples. Talking through these examples, step by step, will help us really understand how loops work in **p5js**.

Example 1: Repeat Three Times

Let's start with the simplest example. Imagine we want to repeat a task **3** times.

Let's look at the following code.

```
// repeat 3 times
for (var count = 1; count <= 3; count += 1) {
  // do something
  ellipse(random(800), random(600), 10);
}
```

Let's remind ourselves of the main bits of a **for loop**. The code that we want to be repeated is placed inside the curly brackets **{ }**. We can put anything there. We could draw lines, or circles, or anything else we can imagine. In our example, we draw a circle of size **10**, centred at random positions on the canvas.

Straight after the **for** instruction is some code inside a pair of normal round brackets **()**. In fact there are three bits of code, separated by the semi-colon separator that we usually use to mark the end of a line. Let's look at each one in turn:

- The first bit of code is used to set up the loop. Usually we set a variable which will act as a **counter**, increasing with every repetition of the code. In our example, we set the variable **count** to be **1**.

- The middle bit of code is a **condition**, or test, to see if the loop should continue repeating. If the test is false, the repetition stops. If the test is true, the repetition

continues. In our example, the test is **count <= 3**, which is only true if **count** is less than or equal to **3**.

- The third and last bit of code is run just after the repeated code inside **{ }**. Usually it is used to increment a loop counter. In our example, we increase **count** by **1**. This will happen after every repetition of whatever code is inside the curly brackets **{ }**.

Let's walk through the code step by step, interpreting as if we were a computer:

- We begin the loop by setting **count** to **1**.

- We check to see if **count** is less than or equal to **3**. If it is we can continue. Because **count** is **1**, we do in fact continue.

 - The code inside the curly brackets **{ }** is run. In our example a circle of size **10** is drawn at a random location on the canvas.

 - After the task is done, **count** is increased by **1**. That means **count** is now **2**.

- We again check to see if **count** is less than or equal to **3**. If it is we can continue. Because **count** is **2**, we continue.

 - The code inside the curly brackets **{ }** is run again. A circle is drawn at a random location on the canvas. This is the second circle drawn so far.

 - After the task is done, **count** is increased by **1**. That means **count** is now **3**.

- We again check to see if **count** is less than or equal to **3**. If it is we can continue. Because **count** is **3**, we can continue.

 - The code inside the curly brackets **{ }** is run again. A circle is drawn at a random location on the canvas. This is the third circle drawn so far.

 - After the task is done, **count** is increased by **1**. That means **count** is now **4**.

- We again check to see if **count** is less than or equal to **3**. If it is we can continue. Because **count** is now **4**, we don't continue with any more repetitions.

- The loop ends.

Phew! That might seem like a lot of detail, but it's the same idea repeated three time. It is worth following it through with a pen and paper at least once if you're not yet familiar with loops. Once you see how the loop really works, it'll always be there in the back of your mind if you ever have a problem with a loop in future.

What will **count** be after the loop has ended? A common mistake is to think it will be **3**. Following all the steps above, we know it is **4**.

When we get past this initial unfamiliarity, we don't need to think at this level of mechanical detail. It's just like walking or eating, when we get used to it, we don't think about every individual step involved.

Example 2: Repeat Three Times, A Different Way

Here's another example that also repeats a task **3** times.

If it does the same thing as the last example, why would we look at it?

The reason is that it follows a slightly different style of coding that many people do use. For that reason it is worth being familiar with, so you can read their code. You might even decide this style is your style!

Let's look at the following code.

```
// repeat 3 times
for (var count = 0; count < 3; count += 1) {
  // do something
  ellipse(random(800), random(600), 10);
}
```

It's exactly the same as the previous code with only two differences:

- The loop counter **count** starts at **0**, not **1**.

- The test for continuing the repetitions is now **count < 3**, which is only true if **count** is less than **3**. Previously we tested to see if **count** was less than or equal to **3**. Now, if **count** is equal to **3**, the test will no longer be true.

Let's walk through the code again, step by step:

- We begin the loop by setting **count** to **0**.

- We check to see if **count** is less than **3**. If it is we can continue. Because **count** is **0**, we do in fact continue.

 - The code inside the curly brackets **{ }** is run. In our example a circle of size **10** is drawn at a random location on the canvas.

- After the task is done, **count** is increased by **1**. That means **count** is now **1**.

- We again check to see if **count** is less than **3**. If it is we can continue. Because **count** is **1**, we continue.

 - The code inside the curly brackets **{ }** is run again. A circle is drawn at a random location on the canvas. This is the second circle drawn so far.

 - After the task is done, **count** is increased by **1**. That means **count** is now **2**.

- We again check to see if **count** is less than **3**. If it is we can continue. Because **count** is **2**, we can continue.

 - The code inside the curly brackets **{ }** is run again. A circle is drawn at a random location on the canvas. This is the third circle drawn so far.

 - After the task is done, **count** is increased by **1**. That means **count** is now **3**.

- We again check to see if **count** is less than **3**. If it is we can continue. Because **count** is now **3**, it is not strictly less than **3**, so we don't continue with any more repetitions.

- The loop ends.

The overall effect is the same as before. Three circles are drawn at random locations.

Some coders prefer this style because they find it easier to read. The **< 3** in the for loop condition can be interpreted as the number of times the task will be repeated, and it's easy to read this quickly. But it only works if the counter starts at **0**, not **1**.

A very good reason for using this style is if you use the **count** to point to items in a **list**. The first item in a list has an index of **0**, not **1**, so it's handy if count also starts from **0**.

Example 3: Counting In Steps

Let's look at another common example. Imagine we want to count from **0** up to **100**, in steps of **20**.

Imagine that what's important to us is the start **0**, the end **100**, and the step size **20** .. but not how many repetitions it takes to get there.

Look at the following code.

```
// from 0 to 100 in steps of 20
```

```
for (var count = 0; count <= 100; count += 20) {
  // do something
  line(count, 100, count, 200);
}
```

Again it broadly looks like the first example, but with some key differences. The loop counter **count** starts at **0** so that's not different. The test for continuing the loop is **count <= 100**, which is true only if **count** is less than or equal to **100**. This is different from before, but represents our aim of counting up to **100**, and no further. The loop counter is incremented by **20** with every repetition. It was increased by **1** in the previous examples.

If we followed the code, step by step like we did before, we'd find the value of **count** will change through **0**, **20**, **40**, **60**, **80** and finally **100**. After the loop had ended **count** would be **120**.

In this example, the task is repeated six times. But it was more important for us that the value of **count** started at **0** and increased to **100** in steps of **20**.

We can use the variable **count** inside the curly brackets **{ }**. In our example we're drawing a line from the point **(count, 100)** to the point **(count, 200)**. We end up with six vertical lines, drawn **20** pixels apart horizontally. The fact that they're **20** pixels apart, and start at **0** and end at **100** was more important than the number of repetitions it took to do that.

Let's talk about how this happens in more detail, just to be sure:

- In the first repetition, **count** is **0**. The line will be drawn from **(0, 100)** to **(0, 200)**.

- In the second repetition, **count** is **20**. The line will be drawn from **(20, 100)** to **(20, 200)**.

- In the third repetition, **count** is **40**. The line will be drawn from **(40, 100)** to **(40, 200)**.

- In the fourth repetition, **count** is **60**. The line will be drawn from **(60, 100)** to **(60, 200)**.

- In the fifth repetition, **count** is **80**. The line will be drawn from **(80, 100)** to **(80, 200)**.

- In the sixth repetition, **count** is **100**. The line will be drawn from **(100, 100)** to **(100, 200)**.

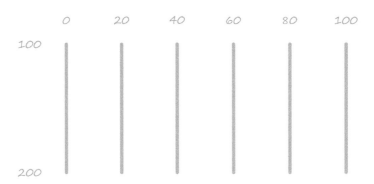

This way of thinking about loops, and writing the **for loop** code, is useful when we care about where we want to **start**, where we want to **end**, and the **size of the steps** to get there.

Example 4: Counting Backwards

This example has the loop counter going backwards, from large to small.

Let's look at the following code.

```
// from 200 down in steps of 50
for (var count = 200; count > 0; count -= 50) {
  // do something
  ellipse(400, 300, count);
}
```

Again, the overall structure of the code is the same as before. Let's talk about the differences.

The loop counter **count** starts at **200**. After every repetition of the task inside the curly brackets **{ }**, **count** is reduced by **50**. In previous examples the looper counter was increased, but here we are decreasing it.

The test to see if the repetition should continue is **count > 0**, which is true as long as **count** is larger than **0**.

If we followed the code through, step by step like before, we'd find that **count** took on the values **200**, **150**, **100**, and finally **50**. After the loop had ended **count** would be **0**.

The task inside the curly brackets is to draw a circle, always centred at **(400, 300)**, with a diameter of **count**. So we end up with four concentric circles of diameter **200**, **150**. **100** and **50**.

What's interesting is that **count** is never **0** while the task code is run. The test condition **count > 0** ensures that **count** is never **0** inside the loop. This can be useful when a variable has a physical meaning which means it must always remain larger than **0**, like the size of a circle.

Here's a variation of this idea.

```
// from 200 downwards, halving every time
for (var count = 200; count > 1; count /= 2) {
  // do something
  ellipse(400, 300, count);
}
```

Again we start count at **200**, but this time we halve the value of **count** with every repetition. We continue as long as **count** is more than **1**, that is, **count > 1**.

The values of **count** would be **200**, **100**, **50**, **25**, **12.5**, **6.25**, **3.125**, and **1.5625**. These would be the diameters of the eight concentric circles, with the inner ones being very closely packed.

The way we've written the code, we don't really have to worry what value the diameter will be as long as it's always more than **1**.

Example 5: Looping Over Lists

In this book we've seen another kind of for loop which is actually simpler than the ones we've just been looking at.

Imagine we had a series of items in a list, and wanted to carry out a task for each one.

Have a look at the following code.

```
// list of colours
var colour_list = ['red', 'green', 'blue'];

// visit every colour in the list
for (var colour of colour_list) {
  // do something
  fill(colour);
  ellipse(random(800), random(600), 50);
}
```

We start by creating a list in the usual way by enclosing a series of items between square brackets **[]**, separated by commas. In this example, the list is called **colour_list** and contains just three items, **'red'**, **'green'** and **'blue'**.

This **for loop** isn't too dissimilar to those we saw before. It still has the curly brackets **{ }**, inside which we put the code for the repeated task. The big difference is that we no longer have a loop counter, no starting values, no conditions for continuing, and no increasing or decreasing a counter.

Instead we simply have a variable that takes on the value of each item of the list for every repetition. In our example, the variable **colour** is assigned the value of the items in the list **colour_list**.

Let's talk it through step by step:

- The loop starts with the variable **colour** being set to the first item in the list **colour_list**. That means **colour** is set to **'red'**.

 - The task inside the curly brackets is carried out. In this example, the fill colour is set to the value of **colour**, which is **'red'**. That means a **red** circle is drawn at a random place on the canvas.

- The loop continues with the variable **colour** being set to the next item in the list **colour_list**. That means **colour** is set to **'green'**.

 - The task inside the curly brackets is carried out. In this example, the fill colour is set to the value of **colour**, which is **'green'**. That means a **green** circle is drawn at a random place on the canvas.

- The loop continues with the variable **colour** being set to the next item in the list **colour_list**. That means **colour** is set to **'blue'**.

 - The task inside the curly brackets is carried out. In this example, the fill colour is set to the value of **colour**, which is **'blue'**. That means a **blue** circle is drawn at a random place on the canvas.

- There are no more items in the list, so the loop ends with three filled circles drawn.

This is a nice way of repeatedly carrying out a task for every item in a list. It's much nicer than using the normal **for loop** with its required loop counters.

Remember that the items in the list don't have to be text, they can be numbers. We could have had a list of diameters, like **[100, 120. 76, 203]** and drawn a circle for each of these diameters.

Here's some code which illustrates this idea of repeating a task for every number in a list.

```
noFill();
```

```
// list of diameters
var diameters_list = [100, 120, 76, 203];

// visit every colour in the list
for (var diameter of diameters_list) {
  // do something
  ellipse(400, 300, diameter);
}
```

The result will be four circles, with diameters **100**, **120**, **76**, and **203**.

Notice how the numbers in the list don't need to be in any order of size. The loop visits each one from start to end, irrespective of what the numbers actually are.

Example 6: Loops Within Loops

Loops within loops are very common, and useful for working through every combination of two variables. It's easier to see this idea in action than to talk about it theoretically.

Have a look at the following code.

```
// horizontal direction
for (var x = 100; x <= 700; x += 200) {

  // vertical direction
  for (var y = 100; y <= 500; y += 200) {
  // do something
    ellipse(x, y, 10);
  }

}
```

We can see two loops, with one inside the curly brackets **{ }** of the outer one.

Let's look at the inner loop first. It has a counter called **y**, which starts at **100**, and goes up to **500** in steps of **200**. That's just like many of the loops we've already seen. The name of the counter **y** suggests we can think of this loop as moving along the vertical direction on a canvas.

Let's look at the outer loop. That too looks familiar. It has a loop counter **x**, which starts at **100** and goes up to **700** in steps of **200**. The name of this counter **x** suggests we can think of this loop as moving along the horizontal direction on a canvas.

So what does it mean that the loop over **y** is inside the loop over **x**?

Well, remember that for every value that **x** takes on, whatever is inside the curly brackets get run. Normally we have code that draws lines or circles, but this time we have the loop over **y**. That means for every value that **x** takes on, the whole of the **y** loop is run.

Let's spell out what happens step by step.

- The loop over **x** starts.

- The first value of **x** is **100**.
 - The loop over **y** starts.
 - The first value of **y** is **100**.
 - The second value of **y** is **300**, **x** is still **100**.
 - The third value of **y** is **500**, **x** is still **100**.
 - The loop over **y** ends.

- The loop over **x** continues. The next value of **x** is **300**.
 - The loop over **y** starts again.
 - The first value of **y** is **100**.
 - The second value of **y** is **300**, **x** is still **100**.
 - The third value of **y** is **500**, **x** is still **100**.
 - The loop over **y** ends.

- The loop over **x** continues. The next value of **x** is **500**.
 - The loop over **y** starts again.
 - The first value of **y** is **100**.
 - The second value of **y** is **300**, **x** is still **100**.
 - The third value of **y** is **500**, **x** is still **100**.
 - The loop over **y** ends.

- The loop over **x** continues. The final value of **x** is **700**.
 - The loop over **y** starts again.
 - The first value of **y** is **100**.
 - The second value of **y** is **300**, **x** is still **100**.
 - The third value of **y** is **500**, **x** is still **100**.
 - The loop over **y** ends.

- The loop over **x** ends.

Phew!

We can see that any code inside the innermost curly brackets **{ }** gets run with every combination of **x** and **y**. In the code example, we're drawing circles, which means we'll cover a rectangle with a regularly spaced grid of dots. There's a dot at every combination of **x** and **y**.

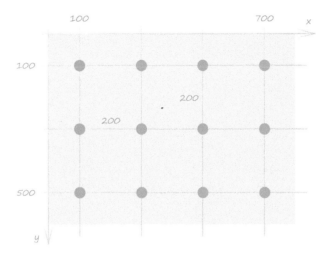

Those dots will be spaced **200** pixels apart, because that's the step **x** and **y** increase by. The rectangle will have a left hand edge with **x = 100** because that's the starting value of **x**, and a right hand edge of **x = 700** because that's the highest value of **x**. It will have a top edge at **y = 100** because that's the starting value of **y**, and a bottom edge at **y = 500** because that's the highest value of **y**.

We've just looked at a loop within another loop. There's no reason why we can't have a loop within a loop, which itself is within another loop. You'll even find some examples in this book!

Appendix B: Just Enough Trigonometry

In this book we introduced and used something called **trigonometry**. Here we'll explain it even more gently, and work through some examples showing how it works.

Many of us had a terrible time at school being bored, tortured even, by trigonometry. We'll see that the basics can in fact be quite simple, and extremely useful.

Let's start at the beginning. Have a look at the following circle.

It's a simple picture with a dot on the edge of the circle which we'll call point **P**.

The circle itself has a **size**. One way to talk about the size of a circle is to use the distance from the centre of the circle to anywhere on the edge. That distance is called the **radius**. Our circle has a radius which we'll call **R**.

By calling the radius **R**, we don't have to stick to a specific radius, like **5 cm** or **10 cm**. **R** could be anything. That's useful because our discussion will be valid for circles of any size.

How do we describe the location of that point **P** to someone else? Well, throughout much of this book, we've used a familiar system of **horizontal** and **vertical** coordinates to describe where things are. We use the same idea when we use maps to show how far east and how far north a point on map is.

But sometimes it's easier to think how far **around** the circle's edge a point is. Have a look at the following picture.

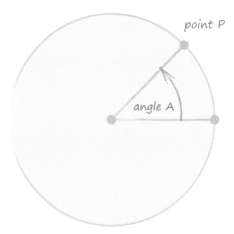

point P

angle A

This time, the picture shows how much of a turn the point **P** has done around the circle, starting from a point directly to the right of the centre. The amount of turn is called an **angle**. **Angles** are measured in **degrees**, just like **distance** is measured in **centimetres**, or **metres**, or even **kilometres**.

The following shows some examples of different angles.

45 degrees 90 degrees 180 degrees 360 degrees

We can see that if we turn around so we're facing the opposite direction to the one we started with, that's a turn of **180 degrees**. A full turn, where we go all the way around and end up facing the same direction we started with, is **360 degrees**. A quarter turn, like turning from facing **East** to facing **North**, is **90 degrees**. Half of that is **45 degrees**.

Some things are easier if we think in angles. For example, imagine a traditional clock with the hour hand moving around it. Each hour is marked at equally spaced points around the clock. If the hour hand points to **3**, then moves to **4**, it has turned clockwise. If it then moves from **4** to **5**,

the amount of turn is the same. If it again moves from **5** to **6**, the amount of turn is the same again.

Have a look at the following picture.

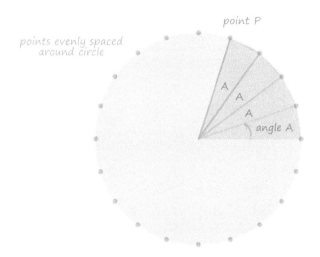

Each of the **20** red dots is equally spaced around the circle. As we move from one to the next, the amount we turn around the centre of the circle is the same. In the picture, we've marked that angle as **A**. The red dot marked as point **P** is at angle **4A**, or four lots of turn by angle **A**. The one before it is at angle **3A**. The one after point **P**, at the very top of the circle, is at angle **5A**.

What if we tried to describe these points using **horizontal** and **vertical (x, y)** coordinates?

It is possible, but it isn't a trivial thing to do. That's what we meant when we said that some things are much easier to describe in terms of **angles** and **distances** from a centre.

We could spend all our time thinking and talking in terms of **angles** and **distances**, but sadly almost all computers and programming languages think in terms of **horizontal** and **vertical (x, y)** coordinates. We know that Processing does this too.

This is the reason we need to bother with **trigonometry**. To be able to convert from our world of **angles** and **distances**, to the computer's world of **horizontal** and **vertical** coordinates.

The following diagram shows both of these ways of describing where a point **P** is.

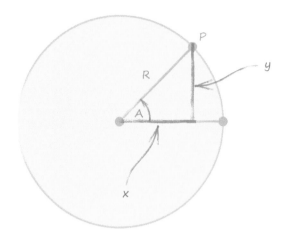

We can see that point **P** described as being at angle **A**, and at a distance **R** from the centre of the circle. We can also see it described using the traditional horizontal and vertical **(x, y)** coordinates too.

So how do we work out **x** and **y**, if we know **R** and **A**? Here's the answer.

- **x = R cos(A)**

- **y = R sin(A)**

It's as simple as that. And this conversion between the two ways of describing a point is the very core of **trigonometry**.

But what is **sin(A)**? And what is **cos(A)**? These are mathematical functions called **sine** and **cosine**. They are so common that almost every calculator has a button to calculate them, often labelled with the shorter **sin** and **cos**. Many programming languages also have functions for **sine** and **cosine** too, and in Processing they are **sin()** and **cos()**.

We actually came across the **sine** and **cosine** functions when we were exploring functions that give us sinuously varying waves. Plotting a graph **sin(A)** and **cos(A)** helps us get a feel for what these functions do.

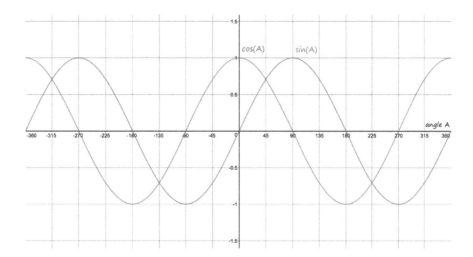

The main feature is that **sin(A)** and **cos(A)** go up and down in a smooth sinuous manner. It's not an accident that the words **sinuous** and **sine** are similar. Have a go at exploring these functions using your favourite graph plotter. Here's one I sometimes use, and it's on the web so you only need a browser to use it - https://www.desmos.com/calculator/g2rjg7bppj.

Let's go back to our point **P** again, and show this new relationship on the diagram we drew.

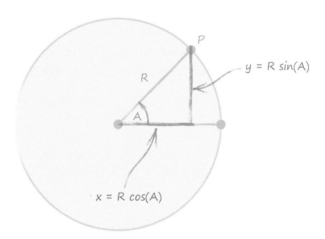

We can relate this picture to the graphs of the **sine** and **cosine** functions:

- As the angle **A** gets smaller and closer to **0**, we should expect that the vertical coordinate **y** of **P** gets smaller too. Looking back at the graph we can indeed see that **sin(A)** gets smaller and closer to **0** as **A** gets smaller too.

- When **P** is at the top of the circle, the vertical coordinate **y** should also be at its maximum too. The angle **A** is **90 degrees** when **P** is at the top. The graph shows us that **sin(A)** is indeed at a peak when **A** is **90 degrees**.

- What happens as that point **P** continues around the circle towards the point directly to the left of the centre? Here the angle **A** is **180 degrees**. The vertical coordinate **y** should be falling to **0** again. Looking more closely at the graph confirms that **sin(A)** does indeed fall to **0** again as it gets closer to **180 degrees**, after the peak at **90 degrees**.

- What happens as the point **P** goes even further around, past **180 degrees**, towards the lowest point directly below the centre of the circle? Here the vertical **y** coordinate should be negative because the point **P** is now below where it would be if **y** was **0**. In fact, at that lowest point, where the angle **A** is **270 degrees**, **y** should be the lowest number it can be. Looking at the graph confirms that at **270 degrees**, **sin(A)** is at the bottom trough of the wave.

- Similar things can be said about the horizontal coordinate **x**. For example, when the point **P** is directly to the right of the centre, where the angle **A** is **0**, **x** should be at its maximum, because the point **P** can't go any further to the right. The graphs confirm that **cos(A)** is at its peak when **A** is **0**. Similarly, when **P** is at the top, where **A** is **90** degrees, **x** should be **0**. The graph does show that **cos(A)** is **0** when **A** is **90** degrees.

These are fun observations that help us relate the wavy functions **sine** and **cosine** to our task of converting from the world of angles and distances, to the world of horizontal and vertical coordinates.

Let's do some examples to make sure we really understand how to do trigonometry. This is useful even if, in real life, we get our computers to do all the calculating.

Example 1

Here we have a circle of radius **10 centimetres**. The point **P** is at a turn of **45 degrees** anticlockwise from the point directly to the right of the circle centre.

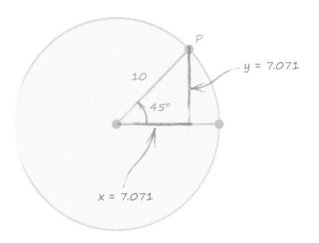

What are the horizontal and vertical **(x, y)** coordinates of the point **P**?

- We know the **trigonometric** relations tell us that **x = R cos(A)**, where **R** is the radius and **A** is the angle. Using a calculator, we can calculate **cos(45)**. It's **0.7071**. We know **R** is **10**, so **10 cos(45)** is **7.071**. So we have the horizontal coordinate **x** as **7.071**. Remember to make sure your calculator is set to count angles in **degrees**, and not another unit like **radians**, otherwise you'll get the wrong answer.

- What about the vertical coordinate **y**? The trigonometric relations tell us that **y = R sin(A)**. **A** is **45 degrees**, so we can use a calculator to find **sin(45)**. It's **0.7071** again. That's not a mistake. If you look at the graphs of **sin(A)** and **cos(A)**, they both cross each other when the angle is **45 degrees**. Since **R** is **10**, we have **y = 7.071**.

So **P** is at **(7.071, 7.071)**.

We shouldn't be surprised that the horizontal and vertical coordinates are the same, because at a quarter turn, the point **P** is equally close to the top of the circle as it is to the right of the circle.

Example 2

Here we have a circle of radius **10 centimetres**. The point **P** is at the top of the of circle, which is a turn of **90 degrees** anticlockwise from the point directly to the right of the circle centre.

What are the horizontal and vertical **(x, y)** coordinates of the point **P**?

- We know that **x = R cos(A)**, where **R** is the radius and **A** is the angle. A calculator will tell us that **cos(90)** is **0**. So **x = 0**. It doesn't actually matter what the size of the circle is in this case, **x** will always be **0**. Looking at the picture again, you can see why this is true.

- Similarly, **y = R sin(A)**. A calculator will tell us that **sin(90)** is **1**. That means **y = 10**. Easy!

So **P** is at **(0, 10)**.

We shouldn't be surprised by this either, because at the top of the circle, **y** is the most it can ever be, which is the radius of the circle **10 centimetres**, and **x** is **0** because **P** is not to the left or right of the circle centre.

Those trigonometry relations seem to be working all right so far!

By the way, if you can't find a calculator, or even a calculator app on your smartphone, you can always type **sin(90 degrees)** into the Google search box and it will turn into calculator for you.

Example 3

Here we have a circle of radius **10 centimetres**. The point **P** is directly to the left of the circle centre, which is a turn of **180 degrees** anticlockwise from the point directly to the right of the circle centre.

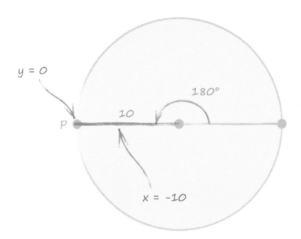

What are the horizontal and vertical **(x, y)** coordinates of the point **P**?

- Using **x = R cos(A)** again, with an angle **A** of **180** degrees, we have **cos(180) = -1**. That means **x = -10**.

- Similarly, **sin(180)** is **0**, and we know **y = R sin(A)**, so **y = 0**.

So **P** is at **(-10, 0)**.

It always surprises me that those simple trigonometric functions are not fooled by a point **P** that moves to the left of the centre point. The maths just works out to give us a negative **x** coordinate.

Example 4

Here we have a circle of radius **10 centimetres**. The point **P** has now travelled so far around that it is almost at the starting point. The angle **A** anticlockwise is **345 degrees**.

If we agree that a negative angle is just the same as a positive angle but instead turned clockwise, then we can also say that **P** is at **-15** degrees. The diagram shows both of these ways of showing the angle of point **P**.

What are the horizontal and vertical **(x, y)** coordinates of the point **P**?

- Using **x = R cos(A)** again, with an angle **A** of **345** degrees, we have **cos(345) = 0.9659**. Because **R** is **10**, that means **x = 9.659**. Easy.

- Let's try it with **A** as **-15 degrees**, which we agreed is a clockwise turn. If the maths is so magic, it should still give us the same answer. A calculator will confirm that **cos(-15)** is **0.9659** again. So **x** is still **9.659**. Phew - the trigonometric functions didn't fail us!

- Using **y = R sin(A)**, we have **sin(345) = -0.2588**. With **R = 10**, that gives us **y = -2.588**. We can see on the diagram that **P** is below the centre point and should indeed have a negative **y** coordinate.

- Trying it again with **A = - 15**, we have **sin(-15) = -0.2588** again. So **y** is still **-2.588**.

So **P** is at **(9.659, -2.588)**.

The important point this last example illustrates is that the trigonometric functions, and all the calculations, still work if we have negative angles, angles which turn clockwise instead of the usual anticlockwise.

You Did It !

You've just learned **trigonometry**.

You may be thinking this is only a tiny little bit of a vast and complicated subject, but the reality is that what we've just covered is the core of trigonometry and is very often all an algorithmic artist, and indeed many computer programmers, need for their work. I can't remember needing any more advanced trigonometry in the last 20 years!

The Good Old Days

In the good old days, we didn't have easy access to handheld electronic calculators to calculate **sine** and **cosine** values. Only large companies and universities could afford computers. Smartphone apps and the web didn't exist. If we wanted to know the **sine** of an angle, we had to look it up in a book of trigonometric values, like this old one from 1619.

Some of our algorithmic art uses Processing to calculate hundreds, thousands, even millions, of trigonometric values. Imagine doing that by hand with only a book of trigonometric tables to help us. Yikes!

Appendix C: A Bit About Complex Numbers

In Part 4 we explored how numbers behaved when fed to a simple mathematical function, with the results repeatedly fed back into the same function. We then tried using a different kind of number called a **complex number**, and found chaotic behaviour, from which emerged some really beautiful intricate patterns.

In this appendix we'll more gently introduce complex numbers and work through some simple examples of working with them.

Complex Numbers Are Not Complex

The first thing to say about **complex numbers** is that they really aren't complex at all. The name is terrible because it scares people away for no good reason.

Complex numbers have two parts. Although that might sound unusual, it's not. We've come across two-part things many times in everyday life. Here are some examples.

- Map grid references which specify a location using both longitude and latitude. For example **51.509116N, -0.128036E** points to a gallery in in London.

- Chess board positions identified by their row and column. A popular starting move is moving a pawn to **e4**.

- Spreadsheet cells referred to by a column letter and a row number. You may have calculated a sum to go into a cell named **B5**, for example.

- Points on a graph defined by how far along the horizontal and vertical axes they are, for example **(3,4)** and **(1,3)**.

Let's have a look at a complex number, to see what they look like.

$$2 + 3i$$

That **2 + 3i** is a complex number. And we've coloured the two parts to make them easier to see. One part is **2**, and the other part is **3i**.

These two parts have names.

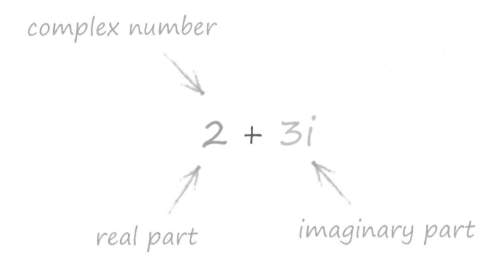

The first part is called the **real** part, and the second part is called the **imaginary** part. So in this example complex number **2 + 3i**, the **real** part is **2**, and the **imaginary** part is **3i**.

Let's try another example. The **complex number 7 + 13i** has a **real** part of **7**, and an **imaginary** part of **3i**.

What are these parts? Well, the **real part** is just a normal number, like the ones we've been using since we were children, to count apples or measure the length of a box, for example. The **imaginary** part looks like normal number too, except it has a new bit, written using the lowercase letter **i**, which we've not seen before. In fact the **3** in **3i** is also a normal number, only the **i** bit is new. We can think of **3i** as meaning **3** lots of **i**, whatever **i** is. This is just like school maths when we saw that **3y** is just **3** lots of **y**.

And just like normal numbers can be negative, zero, or even fractions, so can the **real** and **imaginary** parts of complex numbers. Here are some examples:

- **-2 + 3i** has a **real** part **-2** which is just like the normal number **-2**.

- **2 - 3i** has an **imaginary** part **-3i** which is negative.

- **0.5 + 3i** has a **real** part that is **0.5**, which is a fraction.

- **-2 - 5.33i** has a negative **real** part **-2**, and an **imaginary** part **-5.33i** that is both negative and isn't a whole number.

- **2 + 0i** has a zero **imaginary** part, leaving this **complex number** as the plain old normal number **2** in every respect. We wouldn't normally write **2 + 0i**, we'd just write **2** because that is what it is.

- **0 + 1i** has a zero **real** part, leaving a **complex number** that is **purely imaginary**. It is often written more simply as **1i** or just **i**.

There's a funny story behind the name **imaginary**. Many new ideas in mathematics faced a fair bit of resistance when were first discussed. Negative numbers, and even the idea of zero, had fierce opponents. The word **imaginary** was a way of insulting and invalidating the idea of **imaginary** numbers!

Adding Complex Numbers

So what can we do with these complex numbers? One of the simplest things we can do with normal numbers is add them together. So let's see how we might add two complex numbers together.

It's easiest to see an example first.

$$(2 + 3i) + (4 + 5i) = (6 + 8i)$$

Let's talk through what's happening. There are two complex numbers that we're adding together. These are **2 + 3i** and **4 + 5i**.

If we were in a school maths class adding **(2x + 3y)** to **(4x + 5y)**, we'd find that fairly easy. We can combine the things that are of the same kind. That means we can combine **2x** and **4x** to get **6x**. Similarly we can combine **3y** and **5y** to get **8y**. So the overall answer is **(6x + 8y)**.

We do exactly the same with complex numbers. We can combine **real** parts with **real** parts, and **imaginary** parts with **imaginary** parts, because we're combining things of the same kind.

In this example, we have **real** parts **2** and **4**, which give us **real** part **6**. And we have **imaginary** parts **3i** and **5i**, which give us **imaginary** part **8i**. So the overall answer to adding **2 + 3i** to **4 + 5i** is **6 + 8i**.

We sometimes use brackets around complex numbers to keep things tidy and easier to read. It's a matter of personal taste, but I find it easier to read **(2 + 3i) + (4 + 5i) = (6 + 8i)**.

Here are some more examples of adding complex numbers.

- **(10 + 10i) + (1 + 2i)**. The **real** parts are **10** and **1**, so combining these gives **11**. The **imaginary** parts are **10i** and **2i**, and combining these gives us **12i**. So the answer must have **real** part **11** and **imaginary** part **12i**. That means the sum is **(11 + 12i)**.

- **(-1 + 3i) + (4 - 5i)**. The real parts are **-1** and **4**, which combine to give **3**. The imaginary parts are **3i** and **-5i**, which combine to give **-2i**. That means the sum is **(2 - 2i)**.

- **(0.5 + 0.5i) + (0.5 - 0.5i)**. The **real** parts combine **0.5 + 0.5 = 1.0**. The **imaginary** parts combine **0.5i - 0.5i = 0**. That means the answer has no **imaginary** part, and is just the plain old normal number **1.0**.

That last example shows that it is entirely possible for the addition of **complex numbers** to result in a normal number.

We've just seen that adding complex numbers is really easy!

Subtracting Complex Numbers

Subtracting complex numbers is just like adding them. We combine the parts that that are of the same kind, that is, **real** parts with **real** parts, and **imaginary** parts with **imaginary** parts. Of course, instead of adding the parts, we subtract them.

Have a look at the following.

$$(2 + 3i) - (4 + 5i) = (-2 - 2i)$$

Let's again talk through what's happening here. We have **real** parts **2** and 4, and we need to combine them. Instead of adding them together, we need to take **4** from **2**, because we're subtracting the second **complex number** from the first. That leaves us with a **real** part of **-2**. Looking at the **imaginary** parts, we have **3i** and **5i**, and subtracting the second from the first leaves us with **-2i**. So the result is **(-2 - 2i)**.

If we compare that with familiar school maths, we'd have **(2x + 3y) - (4x + 5y)**, which is **(-2x - 2y)**. Combining the bits that are the same, the **x** and **y** bits, is just like how we do addition and subtraction with **complex number**s.

Let's look at some more examples, just to make sure we're completely happy with subtraction. These are deliberately similar to the previous examples so we can see the differences more easily.

- **(10 + 10i) - (1 + 2i)**. The **real** parts are **10** and **1**, so combining these gives **9**, because **10 - 1** is **9**. The **imaginary** parts are **10i** and **2i**, and subtracting **2i** from **10i** gives **8i**. So the answer must have **real** part **9** and **imaginary** part **8i**. That means the answer is **(9 + 8i)**.

- **(-1 + 3i) - (4 - 5i)**. The real parts are **-1** and **4**, which combine to give **-5**. The imaginary parts are **3i** and **-5i**, which combine to give **8i**. That's because **3i - (-5i)** is **3i + 5i**. Remember that the negative of a negative is positive, and that's why **-(-5i)** becomes **+5i**. That means the answer is **(-5 + 8i)**.

- **(0.5 + 0.5i) - (0.5 - 0.5i)**. The **real** parts combine **0.5 - 0.5 = 0**. The **imaginary** parts combine **0.5i - (-0.5i) = 1.0i**. That means the answer has no **real** part, and is purely imaginary, **1.0i**.

So far, we've not treated **complex numbers** any different to how we might do school maths combining expressions with **x** and **y** bits. We'll see a small but important difference when we do multiplication next.

Multiplying Complex Numbers

In the previous addition and subtraction examples, we've done the working out just like we would work out expressions with **x** and **y** bits, like we did at school. Let's see if this still works when we multiply **complex numbers**.

Let's think about how we might multiply **(2 + 3i)** by **(4 + 5i)**.

At school, the way to multiply something like **(2x + 3y)** by **(4x + 5y)** was called "multiplying out the brackets". Each bit inside a pair of brackets is multiplied with each bit in the other pair of brackets. That **2x** would be multiplied by **4x**, and also **5y**, from the second pair of brackets. Similarly, the **3y** would be multiplied with **4x** and **5y**. After that all the bits of the same kind would be combined to give us an answer, $8x^2 + 10xy + 12xy + 15y^2 = 8x^2 + 22xy + 15y^2$.

Let's now try this "multiplying out the brackets" with our example **(2 + 3i) * (4 + 5i)**.

$$(2 + 3i) * (4 + 5i)$$

$$= 2*4 + 2*5i + 3i*4 + 3i*5i$$

$$= 8 + 22i + 15i^2$$

That **real** part **2** is multiplied with the **real** part **4** from the second pair of brackets, and also with the **imaginary** part **5i** from that same second pair of brackets. Similarly that **3i** is multiplied with **4** and **5i**. You can see we've written out all of these combinations on that second line. Let's look at each bit step by step.

The first bit **2*4** is easy, it's just two **real**, normal, numbers being multiplied. So **2*4** is simply a **real** number **8**. Easy!

Next we have a **real** number **2** being multiplied by the imaginary **5i**. If we remember that **5i** just five lots of **i**, then it's not hard to see that twice that is **2 * 5i = 10i**, or ten lots of **i**. Similarly the next bit **3i * 4** is four times three lots of **i**, or twelve lots of **i**. That is, **3i * 4 = 12i**. So far so good!

If we had to stop now, we'd be able to collect together all the bits of the same kind to give us **real** part **8** and **imaginary** parts **10i** and **12i** That is, **8 + 22i**. But we can't stop just yet.

We have one more combination to work out. That's **3i** multiplied by **5i**. If we think of **i** as **x** or **y** or any other letter, it's easy to say this becomes **15i²**. But what is that **i²**?

Well, here we make use of a new, and very simple, rule that only applies in the word of complex numbers.

$$i^2 = -1$$

That rule simply says that whenever we find an i^2, we can swap it out for a **-1**. Although this is simple, it is also quite a drastic thing to do. That rule seems to change **imaginary** numbers into **real** numbers.

Going back to our example, that **15i^2** that was left over can now be turned into **15 * -1** which is just **-15**, a **real** number. That allows us to continue combining real and imaginary bits to get an answer.

$$(2 + 3i) * (4 + 5i)$$

$$= 8 + 22i + \cancel{15i^2} -15$$

$$= -7 + 22i$$

So **(2 + 3i) * (4 + 5i)** is **(-7 + 22i)**. That was a lot more work that simply adding and subtracting, but actually it's about the same amount of work as multiplying out brackets.

That rule, **i^2 = -1**, is special to complex numbers, and in a way, makes them what they are. You'll be pleased that we don't need to know any more rules for working with complex numbers.

We won't look at dividing complex numbers by complex numbers here, as we don't need it for anything in this book. It's actually not difficult at all, it just requires a few extra steps, and you can find lots of examples online or in good maths books.

Let's look at some more examples of multiplication to help the idea sink in.

- **(1 + 2i) * (2 - 3i)**. Expanding out the brackets gives us several bits, **1*2 + 1*-3i + 2i*2 + 2i*-3i**. That's **2 - 3i + 4i -6i^2**. Applying the rule **i^2 = -1**, turns **-6i^2** into **+6**. So we have real parts **2** and **6**, and imaginary parts **-3i** and **4i**. The overall answer is then **(8 + i)**.

- **(1 + i) * (1 - i)**. Expanding out the brackets gives us **1 -i +i -i^2**. Straight away we can spot that **-i** and **+i** cancel out, leaving us with the much simpler **1 - i^2**. Applying the rule **i^2 = -1**, turns that into **1 - (-1)** which is **2**. That's the answer, just **2**. It's interesting that this multiplication of complex numbers results in a purely real normal number.

- **5i * (1 + i)**. This is a simpler multiplication because the first complex number has no real part, it's purely imaginary. We could write it as **(0 + 5i)** but we don't need to. Multiplying out the brackets gives us **5i*1 + 5i*i**, which is **5i + 5i²**. Again, applying the rule **i² = -1**, gives us **5i + 5(-1)**, which is just **(-5 + 5i)**, the answer.

You can use Google's <u>search</u> box to do complex number addition, subtraction and multiplication. That can be a handy way to check your own working out.

Squaring Complex Numbers

In this book, we used a function $z^2 + c$ with complex numbers. That z^2 is squaring a complex number **z**. Squaring a number is the same as multiplying it by itself, and we now know how to multiply complex numbers.

Instead of working out a specific example of squaring a complex number, why don't we square a complex number **(a + bi)**? Because **a** and **b** can be anything, this complex number **(a + bi)** could be any complex number. Let's go through the familiar steps.

$$(a + bi) * (a + bi)$$

$$= a^2 + 2abi + b^2i^2$$

$$= (a^2 - b^2) + 2abi$$

We've done exactly what we did before, but used the symbols **a** and **b**, instead of specific numbers like **2** or **3**. You can see that we've applied the rule **i² = -1** to turn **b²i²** into **-b²**. The overall answer has **real** part **(a² - b²)** and **imaginary** part **2abi**.

Because we stuck with symbols **a** and **b**, which could be anything, that answer **(a + bi)² = (a² - b²) + 2abi**, will work for any complex number **(a + bi)**. Mathematicians call these things a **general result** - because they work in all cases.

That general result is useful because we can use it to write code to square any complex number **(a + bi)**. We just give the code **a** and **b**, and it'll give us **(a + bi)²** using that general result, which is easier than doing it the long way, multiplying out all the brackets and collecting bits of the same kind.

Let's see this general result in action with some examples:

- $(2 + 3i)^2$. Here the **2** is sat where **a** was above, and **3** is sat where **b** was. We know the answer has **real** part $(a^2 - b^2)$ and **imaginary** part **2abi**. Because a is 2, and b is 3, we can work these out. The **real** part becomes $(2^2 - 3^2)$ which is **(4-9)**, or **-5**. The **imaginary** part becomes **2*2*3*i**, which is **12i**. So the answer is $(2 + 3i)^2$ = **(-5 + 12i)**.

- $(1 + i)^2$. Here **a = 1** and **b = 1**. The **real** part of the answer is $(a^2 - b^2)$, which is **(1 - 1) = 0**. The imaginary part of the answer is **2abi**, which is **2i**. So the answer is the purely imaginary number **2i**.

- $(2i)^2$. Here there is no real part so **a = 0**, and **b = 2** as usual. The **real** part of the answer is $(a^2 - b^2)$, which in this case is simply **-b²**, or **-4**. The **imaginary** part of the answer is **2abi**, but because **a** is **0**, that makes the whole thing vanish, so there is no **imaginary** part. The overall answer is the purely real number **-4**.

Those last two examples show that multiplying **complex numbers** can sometimes result in purely **real** or purely **imaginary** answers.

Visualising Complex Numbers

With normal numbers like **2**, and **7.5**, we can visualise them in many ways. For example, we can imagine straight lines of length **2** and **7.5**. We might even imagine cubes representing a whole **1**, so **2** is two cubes, and **7.5** is seven and a half cubes. Every child is familiar with counting apples to represent numbers.

So it's natural to ask how we might visualise complex numbers. There are several ways, and we could have fun making some up ourselves. The most common way of visualising them takes advantage of the fact that they have two **independent** parts, just like coordinates **x** and **y**, on a graph.

Why don't we put complex numbers on a graph, by considering the **real** part as the distance along the horizontal axis, and the **imaginary** part as the distance along the vertical axis?

Here's an example showing the complex number **(1 + 1i)**.

We can see the horizontal axis marked as the **real** part, and the vertical axis marked as the **imaginary** part. Normally these would be marked as the **x axis** and the **y axis**. On that graph is a point representing the complex number **(1 + 1i)**. It is placed at a distance of **1** in the horizontal direction, and a distance of **1** in the vertical direction. That's just like placing a point **(1,1)** on a normal graph.

The origin corresponds to the complex number **(0 + 0i)** which is just **0**. That makes sense because that's the point which is at a distance of **0** along and **0** up.

Let's look at some more examples.

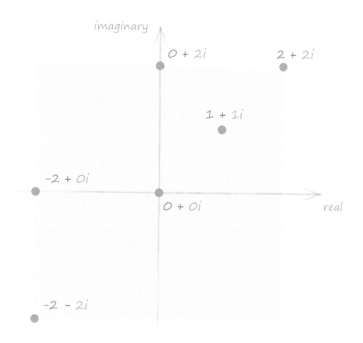

The complex number **(2 + 2i)** is placed where we would put **(2,2)**. The complex number **(-2 + 0i)** is purely **real** and has no **imaginary** part, and that's why it sits on the **real** axis. Similarly, **(0 + 2i)** is on the **imaginary** axis because it has no real part. The complex number **(-2 - 2i)** is in the opposite direction to **(2 + 2i)** which is just like **(-2, -2)** being in the opposite direction to **(2, 2)**.

So imagining complex numbers as points on a flat surface is fairly logical, and easy.

How Big Is A Complex Number?

That's a really good question to ask ourselves. We can say that a normal number **7** is bigger than the normal number **5**. We're used to that. But how do we work out the size of a number which has two parts?

We can get a good answer by looking back at that graph with some complex numbers marked as points. Would you say that **(2 + 2i)** is bigger, in some sense, than **(1 + 1i)**? It does seem to be true in some intuitive sense.

What about **(2 + 2i)** and **(9999 + 9999i)**? Is the second number bigger than the first? Is it because it looks bigger?

We can be more precise than simply saying a number looks bigger. If we work out the direct distance of a point from the origin, we can use that as a very reasonable measure of a complex number's size. Here's a picture to illustrate the idea.

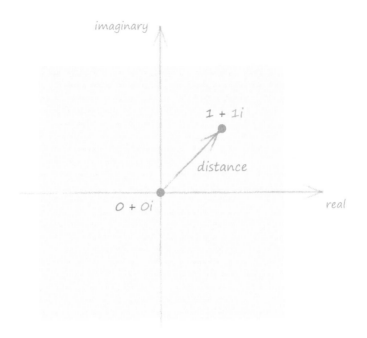

It's a reasonable measure because it doesn't depend on only the **real** part, or only the **imaginary** part, but combines both. If the **real** part is tiny, but the **imaginary** part is huge, we do want our measure of size to be big. If both **real** and **imaginary** parts are huge, we want our measure of size to be even bigger.

How do we work out that distance? You may remember how to do it from school. Have a look at the following picture.

$$c^2 = a^2 + b^2$$

That triangle shows a point at the top right which represents a **complex number (a + bi)**. That point is at a distance **a** along the horizontal real axis, and **b** up the vertical imaginary axis. In other words, we have a right-angled triangle with sides of length **a** and **b**.

The way to work out the direct distance, marked **c** in the diagram, is to square **a**, square **b**, add them together. This will be the square of **c**. That is, $a^2 + b^2 = c^2$. So to get **c**, we need to take the square root of c^2. You might remember this being called **Pythagoras' Theorem**.

Let's work through some examples, just to make sure we're comfortable with this idea.

Example 1: Triangle with shorter sides 3 and 4

Imagine a right angled triangle, with the two shorter sides having length **3** and **4**. What's the length of the longest side? Let's use Pythagoras' Theorem. The square of 3 is **9**. The square of **4** is **16**. Adding them together gives us **9 + 16 = 25**. That's not the answer yet, that's the square of the longer side. So we need to take the square root of **25**, which gives us **5**. So the length of the longer side is **5**.

$$c^2 = a^2 + b^2$$

$$c^2 = 3^2 + 4^2$$

$$c^2 = 25$$

$$c = 5$$

$(3 + 4i)$

c

$b = 4$

$a = 3$

Let's do that example again, this time using Pythagoras' Theorem written as $c^2 = a^2 + b^2$. Here **a = 3**, and **b = 4**. That means $a^2 + b^2$ is $3^2 + 4^2$, which is **25**. So $c^2 = 25$. That means **c = 5**, which is indeed the length of the longer side.

Example 2: Triangle with shorter sides both 1

Let's look at a very simple right-angled triangle, with both shorter sides being length **1**. How long is the longer side? Let's plug these numbers into $c^2 = a^2 + b^2$. That is, $c^2 = 1^2 + 1^2$. Which means $c^2 = 2$. Taking the square root of **2** to get **c** back gives us approximately **1.4142**. That's not a nice round whole number at all. In fact most distances won't be nice round whole numbers at all. Even worse, sometimes we can't write the distance accurately no matter how many decimal places we use. This really bothered mathematicians hundreds of years ago!

$$c^2 = a^2 + b^2$$

$$c^2 = 1^2 + 1^2$$

$$c^2 = 2$$

$$c = 1.4142$$

$(1 + 1i)$

c

$b = 1$

$a = 1$

Example: Complex number with negative parts

Let's see if this way of working out the size of a **complex number** still works if we have negative **real** or **imaginary** parts.

Let's take the complex number **(3 + 4i)** we just looked at. It had a size of **5**. If we take that same complex number and make the parts negative to become **(-3 - 4i)**, what should the size be? Without working it out, we should expect it to be the same because all we've done is made a kind of mirror image of the original complex number. The point **(3,4)** is the same distance from the origin as **(-3, -4)**.

Let's work it out using the Pythagoras' Theorem just to reassure ourselves the method really does cope with negative parts.

$$c^2 = a^2 + b^2$$

$$c^2 = (-3)^2 + (-4)^2$$

$$c^2 = 25$$

$$c = 5$$

c

$b = -4$

$(-3 - 4i)$

$a = -3$

You can see that the triangle now has the origin at the top right, and **(-3 - 4i)** is at the bottom left. That's because a horizontal distance of **-3** is to the left, not to the right. Similarly, a vertical distance of **-4** is downwards from the original, not upwards.

You can see that putting those negative distances into $c^2 = a^2 + b^2$ turns them into positive numbers, because squaring a negative number gives a positive number. That in turn gives us the answer **5**, just like before. That is, both **(3 + 4i)** and **(-3 - 4i)** have a size of **5**. In fact **(3 - 4i)** and **(-3 + 4i)**, the other combinations of negative parts, also have a size of **5**. That's good because a size is a size no matter the direction of the point from the origin.

In Processing, we're lucky to have a **dist()** function, which does all this work for us. For example, **dist(0, 0, 3, 4)** will work out the distance between the origin at **(0, 0)** and **(3, 4)** and give us an answer of **5**. Even though it wasn't created for working with **complex number**s, it really helps when we want to work out the size of a **complex number**.

You'll hear people referring to something called the **magnitude** of a complex number. That's exactly the same idea of size that we've just talked about.

Complex Numbers Aren't Complex!

What we've covered here is a solid base for working with complex numbers in many scenarios, including everything we need to create beautiful fractals.

And you've seen there isn't much complex about them at all. Mostly we're only adding and multiplying, and if we're working out the size we might need to square and square root numbers, and even then the **dist()** function does all that for us.

Gallery

Examples of algorithmic art crafted using techniques
no more advanced than the ones we've covered in this book.

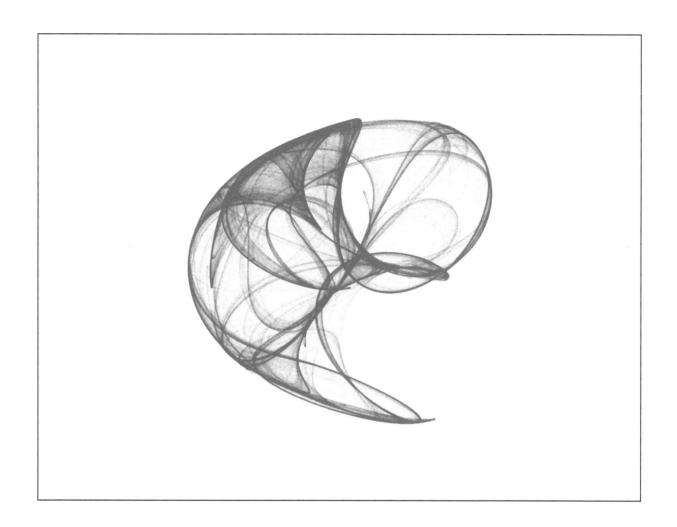

Strange Attractor

https://www.openprocessing.org/sketch/533402

The sketch follows the path of a point **(x, y)** as it is updated by **x = sin(ay) - cos(bx)**, and **y = sin(cx) - cos(dy)**. The orbit is attracted to an interesting shape known as a strange attractor.

Future Portrait

https://www.openprocessing.org/sketch/533299

This portrait is built up using lines which start at random locations, and take a direction based on 2-dimensional Perlin noise. The line darkness is based on the luminance value of the source image at the point the line starts. Together, these create a **brush stroke** texture.

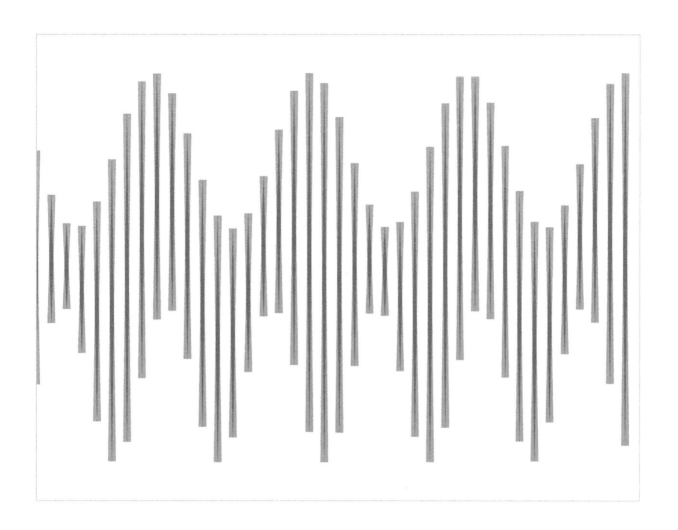

Mechanical Sympathy

https://www.openprocessing.org/sketch/533565

An abstract work which combines very simple ideas to achieve a modest sophistication. A series of upright and upside-down overlapping triangles track two slightly different sine waves. The juxtaposition of soft waves and hard triangles evokes the theme of machines mimicking organic intelligence.

Dancing Galaxy

https://www.openprocessing.org/sketch/533087

This composition shows the path of **300 particles** as their initial random positions are adjusted by 3-dimensional Perlin noise. Projected onto a 2-dimensional canvas, the result is a deliciously dynamic choreography. Translucent circles mark the start of the particles' journey.

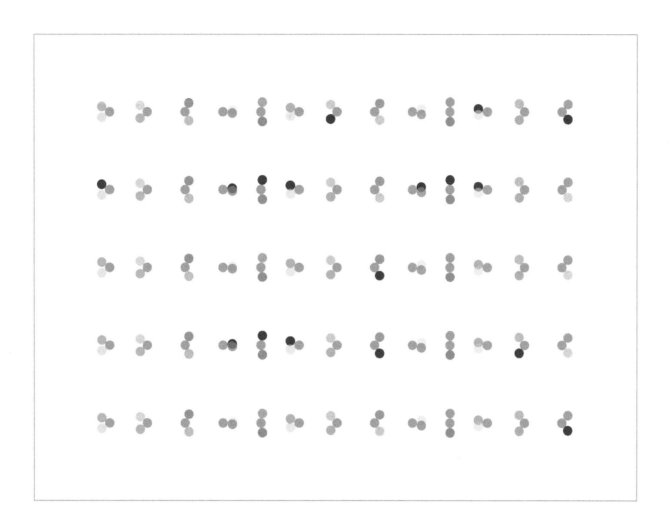

Modern Medicine

https://www.openprocessing.org/sketch/534142

This work meditates on the confidence of modern medicine in its own scientific method and apparent clinical precision. Invading that certainty are dark spots representing incurable and poorly understood disease. The geometry itself is arrogantly simple, a grid of circles with similarly coloured circles rotated neatly about them.

Quantum Birth

https://www.openprocessing.org/sketch/534159

A simulation of the intense fundamental **forces** of **attraction** and **repulsion** as they wrestle to govern the destiny of 500 particles. Evoking the cataclysmic violent birth of the universe, the scene is chaotic, and yet nascent order is emerging as we see opposite particles attract and circle around each other, forming tightly coupled spirals.

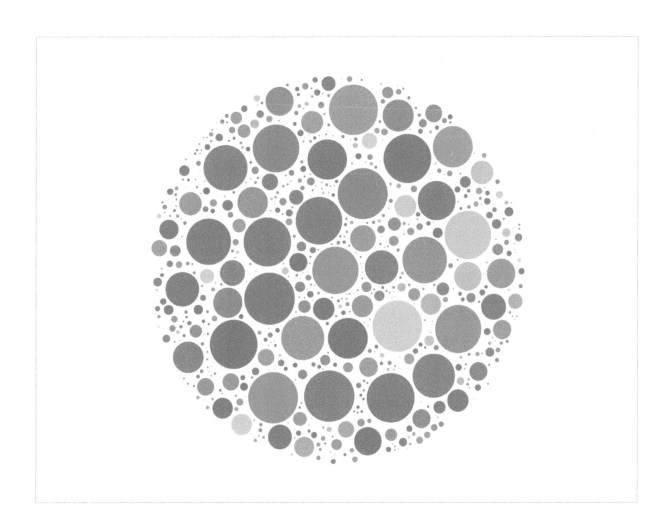

Innocent Dreams

These circles appear to be scattered entirely at random, but they're not. Each circle stays entirely within the outer invisible circle, and away from every other circle. The algorithm tests candidate circles to ensure they meet these two conditions. The gentle shape and pleasant colours evoke childhood dreams of innocence and guiltless joy.

CPSIA information can be obtained
at www.ICGtesting.com
Printed in the USA
BVHW022346080222
628392BV00009B/302